The History of
PORCELAIN

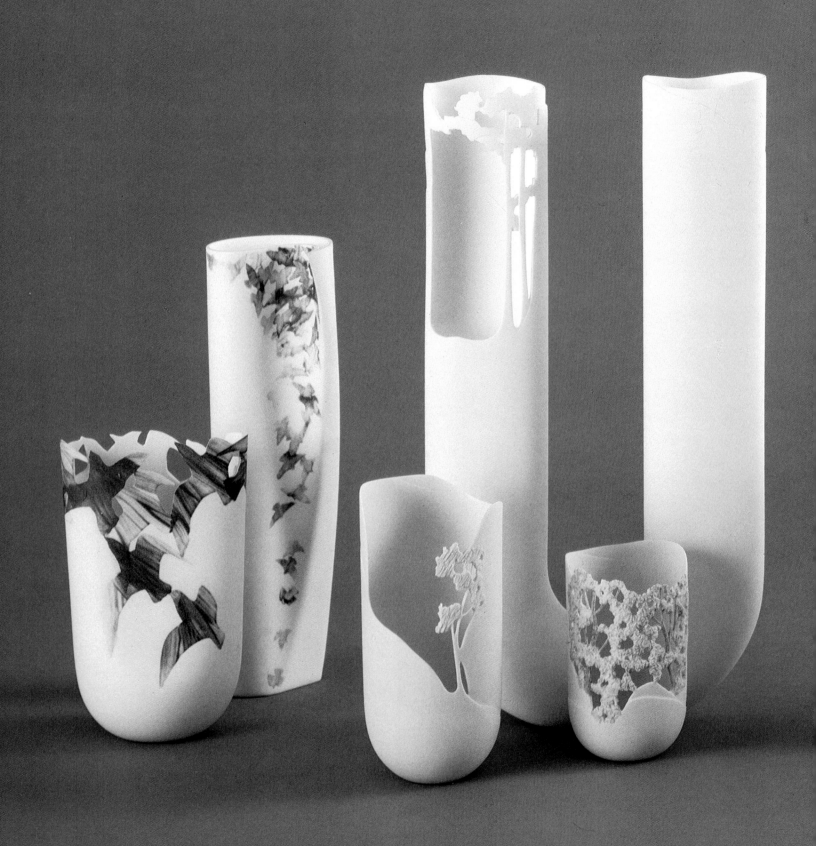

The History of
PORCELAIN

General Editor Paul Atterbury

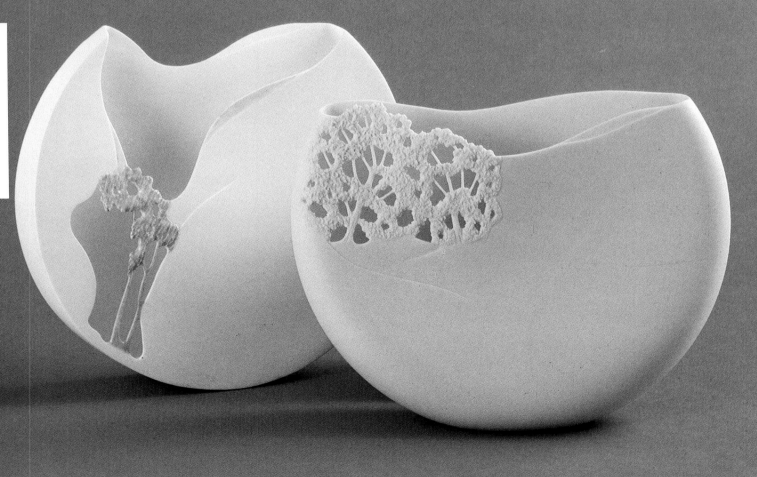

William Morrow and Company, Inc.
New York 1982

THE publishers are most grateful for the help given by Sotheby's in the preparation of this book.

Title page: Pieces recently made by Irene Sims, who works in both true hard-paste porcelain and bone china. Of the pieces shown here, the cream-coloured pieces are true porcelain, the white are bone. All are slip-cast and unglazed, with a polished finish. These pieces show the great influence which natural landscape has upon her work.

Contents

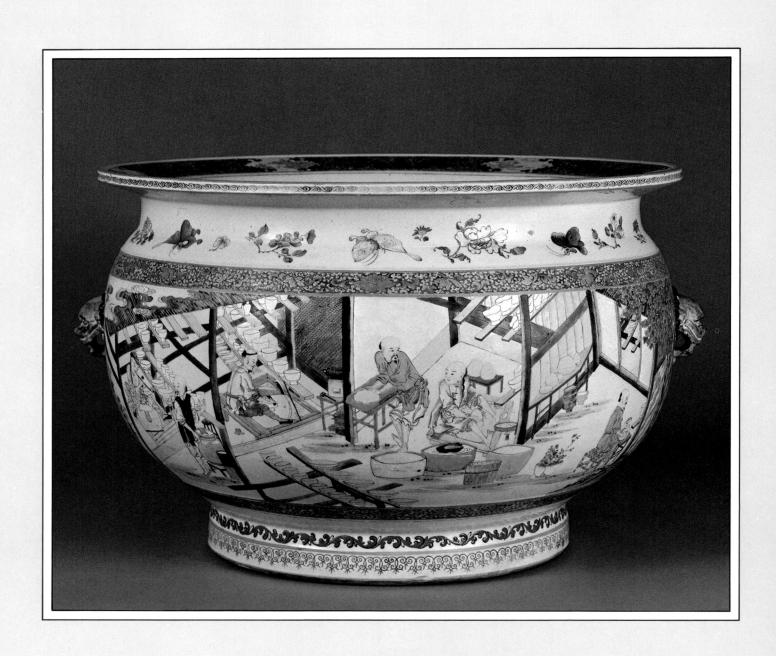

Introduction

PORCELAIN is miraculous. A type of earth or clay, mixed with powdered rock and water, can be turned into a fluid material capable of being cast, moulded or modelled into an endless variety of shapes. When baked in an oven at very high temperature, it becomes hard, translucent, completely waterproof and pure white in colour. It can then be decorated in a variety of ways, to create objects of lasting beauty or that are essentially functional.

Today, porcelain is taken for granted. In most countries in the world the material is in daily use. People eat from it, wash in it and rely on it to transmit electricity in safety around their homes. A refined version of the material is used in aero-engines and turbines, and to enable space capsules to re-enter the earth's atmosphere; other versions are used in hospitals, laboratories and for scientific research. It is now so much a part of normal life that it is easy to forget that porcelain was not successfully made in Europe until the eighteenth century. Prior to that date it had been manufactured in the Far East over a number of centuries, becoming in the process an integral part of Chinese art and culture. However, early Oriental porcelain was rarely seen in Europe. The few pieces that survived the long and dangerous journey to Europe via the Arab trade routes were regarded as exotic treasures, to be cared for like precious jewels. The material itself was seen as mystic and mysterious, the secret of its manufacture eluding generations of alchemists and savants.

This book is the first to tell fully the story of porcelain from its roots in the prehistory of the Far East to its present position as a major industrial product. Three hundred years ago, porcelain was accessible only to the very rich. Kings and princes fought over it, and paid out vast sums for the privilege of owning pieces. Today, the material is still an expensive and exclusive luxury on some levels, but on others it is readily and cheaply available from shops, stores and markets throughout the world.

Some chapters in the history of porcelain have been told so many times that to repeat them again can add little that is new; others are still largely unknown. The development of porcelain in Europe in the eighteenth century is broadly familiar to the hundreds of thousands who are connoisseurs or collectors, who visit museums and houses open to the public, and who are interested in antiques. Other aspects of the story are probably equally well known, although to a smaller number of people. On a different level, those who visit china shops today are often familiar with the qualities of the material but have only a vague and imprecise idea of its history. The purpose of this book is to place the various chapters in the history of porcelain in context one with another.

To appreciate the history of porcelain is also to be familiar with the development of industrial and decorative design, which are closely related. Throughout its history, porcelain has been primarily what would now be called a consumer product. Rarely innovative, it has rather reflected contemporary styles and fashions. The history of porcelain over a period of centuries is therefore a valuable measure of the continually changing spectrum of popular taste; to study it can be interesting and rewarding, for it is a part of the whole history of interior design and decoration, along with textiles, furniture, glass, silver, jewellery and any other of the applied arts. The styles of porcelain table-ware to be seen in china shops today are as much a reflection of contemporary fashion as are the colours of motor cars.

It would be conventional for a book of this kind to start with a definition of porcelain, but the highly variable nature of the material makes this impossible. The porcelain developed in China centuries ago has little in common with contemporary bone china. By the same token, bone china has little in common with the porcelain used in the aerospace and electrical industries. Yet they all share the same name. The word 'porcelain' has acquired a blanket status during the course of time, so precise definitions do not come

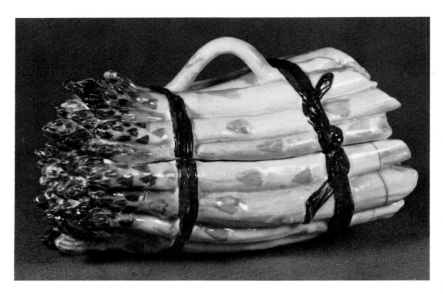

English Chelsea soft-paste 'trompe l'oeil' tureen and cover, in the form of a bundle of asparagus. This piece shows the strong influence Meissen had on Chelsea during the 'red anchor' period, when some of Chelsea's finest products were made. c. 1756. (Victoria and Albert Museum)

easily to hand. Over a period of centuries basic ingredients and methods of manufacture may be broadly similar, but the end product is infinitely variable. Indeed, its fluid and variable nature is one of the main attractions of porcelain.

The development and use of porcelain in China, Korea, Annam and Japan over many centuries is the subject of the first part of the book. The nature of porcelain was highly variable during the early period, because of regional and cultural differences combined with various technical limitations. Despite this, the results achieved have never been matched in quality or originality, and have never ceased to inspire imitations.

During the course of the seventeenth century, the Western world became aware of the decorative and functional qualities of Oriental porcelain and so a vast export trade was gradually developed. At first this was a one-way trade but, by the middle of the eighteenth century, the styles and requirements of the Western market were being reflected in the Far East. The highly ornamental Oriental porcelains, with their rich decoration in underglaze blue or polychrome enamels, effectively determined future stylistic developments in the West. To visit a china shop today is to see displays of wares whose designs are still wholly Oriental in style, albeit in debased and crude forms.

Even today, the scale of this export trade is rarely appreciated. Literally millions of pieces of Oriental porcelain made their way to the West during the eighteenth century, some in traditional Oriental styles, and others made to special order and decorated with armorials and other typically Western motifs. It is important to remember that the only large-scale manufacture of porcelain during this period took place in the Far East. The long-term influence of the export wares was considerable, establishing standards of quality, design and price that were not matched in the West until the middle of the nineteenth century.

Subsequent developments were all dependent upon the Far East to a greater or lesser extent. In relative terms, developments in the West, the theme

of the remainder of the book, are trivial in comparison to the centuries of progress and innovation in the Far East. The European porcelain industry is still in its infancy, but it is unlikely ever to outgrow the influence of its Oriental parent. Ironically, the strength and significance of the Far East is probably greater than ever before. In Japan, traditional and modern Oriental styles are produced side by side with Western designs, and the Japanese domination of the Western market is increasing steadily. The porcelain industry in the West is certainly a prime target for the all-conquering Japanese industrial revolution. At the same time, China itself is a sleeping giant, about to be awakened by Western technology and economics. It is possible that by the end of this century there will be no effective Western porcelain industry. All production may be in the East, the wheel having turned full circle.

The development of porcelain in Europe is a familiar story, but it is necessary to tell it again to place it in context. Both the true Oriental hard-paste porcelains, and the imitation, or soft-paste types that dominated production in France and England, are discussed. Although Oriental influences were predominant, a clear European style did appear, expressed most forcefully in the rococo production of the French and German factories. However, poor technology and inefficient manufacturing and marketing severely limited the growth of the European industry until the early nineteenth century. During this period, the making of porcelain was often an expensive, impractical and unpredictable industry, dependent largely upon the patronage of royal and aristocratic families. The most successful potters of the period, for example Josiah Wedgwood, wisely resisted the temptation to make porcelain.

At the end of the eighteenth century, this pattern began to change. First, the exports from the Far East had virtually stopped, giving the European manufacturers the necessary impetus to make porcelain more efficiently, and in commercial quantities. Linked directly to this was the development of a new material, bone china, a mixture of traditional porcelain ingredients and calcined bone ash. This material was pure white, translucent, strong, predictable, cheaper to produce and accessible to English manufacturers in particular, because of the recent discovery of the vast china clay deposits in Cornwall. Bone china rapidly became the dominant type of porcelain and, for the first time, British manufacturers were able to sell their products in huge quantities all round the world. During the early nineteenth century many factories, now household names, such as Minton, Spode, Derby and Worcester, were able to develop the export markets upon which their future prosperity was to depend. European manufacturers in Paris, Dresden, Vienna, Berlin and elsewhere, fought a rearguard action, armed with refined versions of true Oriental hard-paste porcelain, and with avant garde and highly finished designs, first in neo-classical and later in the richer Empire taste. However, by the 1840s bone china was king; for the first time Europe was able to challenge the Far East in terms of quality, price, variety of design and scale of output.

The period that followed continued this march of progress. It was a time of technical and artistic innovation, when entrepreneurial manufacturers were prepared to stake both reputation and financial stability upon the pursuit of novelty. Styles of the past and from other cultures were resurrected, either to be faithfully reproduced, or to be revitalized in a dynamic and adventurous way by being casually mixed and blended to form new designs and new styles. The results, shown at the various international exhibitions of the Victorian period, were stimulating, exciting, sometimes vulgar and always wonderfully confident. It was a period when English potters ruled the tastes and pockets of the world.

In the latter part of the nineteenth century the pattern began to change again. European manufacturers began to reassert themselves, partly by a steadfast concentration on traditional forms and styles, and partly by their ability to make and sell low-cost porcelain in vast quantities. The increasing importance of Europe was reflected in the many wares produced for the new souvenir and travel market, which included badged and crested china, fairings, small commemorative figures and busts, and a wide range of similar pieces, mostly made in Germany, Austria and France. At the same time, major companies such as Meissen, Sèvres, Berlin and Royal Copenhagen began to dominate the market, on the one hand building on their eighteenth-century traditions and on the other introducing many new styles and techniques. Many of these were inspired by the art and design of Japan; from there, beginning in the 1860s, a tidal wave of traditional and contemporary Far Eastern styles swept across Europe, affecting all areas of industrial and artistic production. Other cultures, for example the Middle East, India, South America and, of course, China itself, aroused similar enthusiasms. Many of these revolutionary ideas and alien styles came together to form the inspiration for the Art Nouveau movement, a sinuous, exotic, highly decorative and ultimately decadent style that affected all areas of artistic production at the end of the nineteenth century. The nature of porcelain made it particularly suitable for this style, and so highly original wares appeared at the same time in France, Holland, Austria, Germany, and to a lesser extent in Britain and America, where the concentration was more on exotic and unusual high-temperature glazes.

In many ways, porcelain development in Europe was brought to a close by the outbreak of war in 1914. When peace returned, much of the impetus and originality of the Victorian period had been lost. Manufacturers were concentrating their efforts mainly on table-wares and limited ornamental pieces, whose styles were inevitably related very closely to contemporary consumer tastes. The porcelain industry throughout the world therefore reflected the garish colours of Jazz Moderne in the 1920s, the stark geometry of Art Deco in the 1930s, and so on, in each succeeding decade. At the same time, the market for traditional patterns and styles seemed to grow year by year, though studio potters in many countries attempted to alter the course of conventional industrial design and production. During the last forty years, opinions have sharply diverged concerning the role of the porcelain industry in a market increasingly dominated by international advertising and other consumer-oriented pressures.

Throughout the long history of porcelain different variations on the same theme have been repeated over and again. Craftsmen, chemists and artists have worked endless hours to perfect first the material itself, and then the forms it should take. Then, time after time, the popular market imposed its standards on the material, and the consumer product was created. Thus it was that the European market came to influence the style of Chinese and Japanese porcelain in the seventeenth century. Thus it was that in the early nineteenth century, Spode took over where the visionary William Billingsley left off, substituting for Billingsley's lovely soft-paste body a standardized, and far more practical and economical version. And thus, in the twentieth century, the Bauhaus school developed ideas and ideals concerning the shapes that porcelain should take, only to be superseded by advertisers and porcelain factories who developed quite contrary ideals, concerning how porcelain should be marketed. Thus 'techniques' gave way to 'sales techniques' and the search for perfection gave way to the search for a perfectly marketable item. Nevertheless, the material, porcelain, continues to survive triumphantly the vagaries of time and fashion, renewing itself as a medium whenever it appears to have become most predictable.

The future of porcelain may lie in the Far East, as the increasingly powerful industries of Japan, and ultimately China, gradually win control of more and more of the traditional European markets. In any case, the next twenty years could alter the story dramatically one way or another, as porcelain-makers continue to contribute extensively to the design and production of the most popular and universal of all domestic art forms.

Contemporary Japanese water pitcher, ice bucket, and two cups, made by Masahiro Mori.

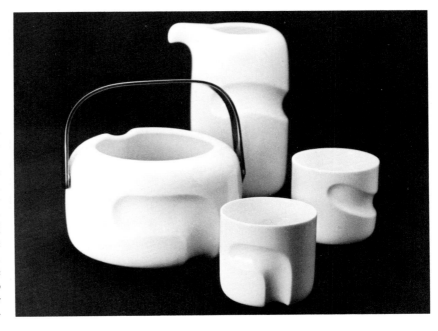

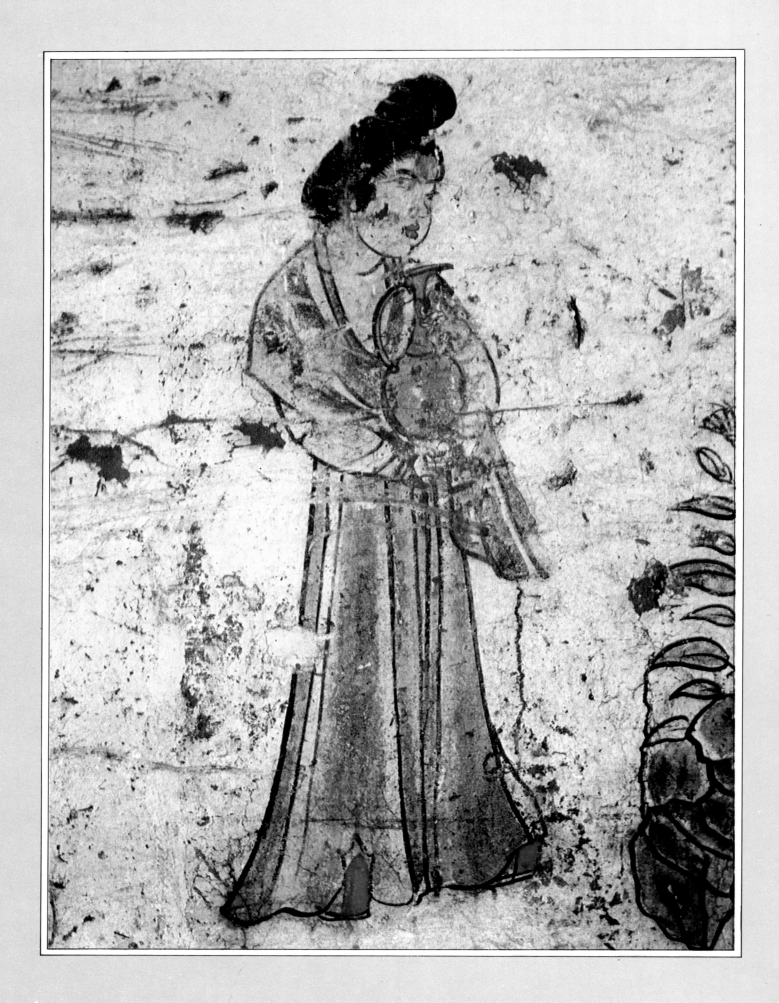

The Origins
of Porcelain

Detail from a Chinese wall painting. A royal waitress carrying a wine jug, perhaps a Yue or porcellanous vessel, which she grips firmly by the base. From the tomb of Prince Zhang Huai, buried in 706. After Tang Lixian Mu Bihua. 618–906.

THE remarkable fact about porcelain is that the Chinese made it almost a thousand years before the Europeans. And when European porcelain was developed, it was perfected in imitation of the Chinese, in a series of attempts to simulate its more obvious qualities—whiteness, hardness and an unusual translucency. In China the development of porcelain was an out-growth of the most advanced tradition of pottery-making in the world. This magnificent tradition drew on an abundant supply of raw materials, which in turn stimulated the early development of ceramic techniques.

Chinese porcelain has peculiar qualities which make it the ultimate art material. They are body texture, glaze and painted decoration. Body texture was the first to be exploited, during the Song period (960–1279). Glaze and painted decoration come into their own in the Yuan period (1280–1368), and are at their best until the late fifteenth century.

Writing in the 1930s Bernard Leach, an English potter who had travelled in the Far East, described naturally occurring porcelain clays found there but not in the West. Whether naturally compounded or man-made, the fusible rocks and white earths used to make high-fired wares and porcelain were accessible throughout China, parts of Japan and Korea.

With these materials at hand, Chinese potters quickly mastered making and firing techniques, gaining an enormous lead over the West. They were able to glaze high-temperature wares successfully by about 1500 BC, three thousand years before the Europeans made their own hardened stoneware and glazed it.

The Chinese also mastered the to basic methods of making clay shapes, moulding, and forming by throwing on the fast potter's wheel, at an early date. The wheel was being used by about 2500 BC in North Eastern China. Moulds were used to fashion decorative handles on vases copied from bronze originals in the Eastern Zhou period (770–221 BC). Moulds were ultimately the means of mass pro-

duction in the pottery industry. Workable clays which can withstand throwing on the fast wheel and pressing into absorbent moulds are called plastic clays. Oriental porcelain clays are far more plastic than European porcelain clays.

As will be seen later in this chapter, kiln design was also relatively advanced by the Shang period (1700–1027 BC). In Zhejiang, a province or *xian* of South East China, kilns established during the Han period (206 BC–AD 221) grew famous for the high-fired wares they made. Known as proto-Yue, they are the earliest of the green-glazed wares called Yue, after the old state of Yue in Zhejiang. The fired clay body of proto-Yue is pale and hard by the late third century.

Another high-fired ware from the same part of China was once called proto-porcelain because its body and glaze chemistry resembled that of true porcelain. These three wares are not porcelains, but they show that the making and glazing of high-fired ware in South China was well advanced by the third century AD. They are evidence of a necessary technical prelude to porcelain, without parallel in Europe.

Definitions of Porcelain

The word porcelain has no equivalent in Chinese. There are, simply, two types of pottery: low- and high-fired ceramic wares. Within these two groups occur a great variety of wares which are either named after their place of origin or their unique appearance.

Europeans gave their own descriptive names to their favourite wares, names like *blanc de chine* for the high-fired white wares of Dehua, or *celadon* for the green-glazed high-fired wares of Yaozhou and Long-quan. The word porcelain has been used to describe both these wares, but was used specifically for the white and decorated white wares of South China, especially those from Jingdezhen.

Chinese terms have been converted from the nineteenth-century Wade-Giles system of romanization to the new Pinyin system, used in this book. Pinyin has been the official system of the People's Republic of China since 1958, and is increasingly used internationally.

Pinyin	Wade-Giles
Cizhou	Tz'u-chou
Dehua	Tê-Hua
Ding	Ting
Doucai	Tou-ts'ai
Fujian	Fukien
Guanyin	Kuan Yin
Ge	Ko
Jiangxi	Kiangsi
Jingdezhen	Ching-tê Chên
Jun	Chün
Kangxi	K'ang Hsi
Longquan	Lung-chuan
Manzhu	Manchu
Meiping	Mei-p'ing
Qian Long	Ch'ien Lung
Qingbai	Ch'ing-pai
Ru	Ju
Sancai	Sants'ai
Shu fu	Shu-fu
Song	Sung
Tang	T'ang
Wucai	Wu-ts'ai
Xing	Hsing
Xuande	Hsüan Te
Yaozhou	Yao-chou
Yongzhen	Yung chên
Yongle	Yung Lo
Yuan	Yüan
Yue	Yueh
Zhou	Chou

This muddled historical terminology is further aggravated by modern ceramic jargon. The body, as opposed to the glaze of a pot, must be earthenware, stoneware or porcelain. The first two are made from secondary or impure clays. Earthenware is a soft, porous low-fired ware (1100°C or 2000°F) and stoneware is a fused and hardened high-fired ware (1200°C or 2200°F). Earthenware will sag and melt at high temperatures and must be glazed with a low-temperature glaze, containing lead, soda or borax and clay. Although it is not porous, stoneware is usually finished with a high-temperature glaze, fluxed with alkalis such as lime.

The modern definition of porcelain is quite precise. It is a hard, whitish ware which is translucent and resonant, and composed of two specific ingredients. These are *kaolin*, a pure white clay, and *petuntse*, a type of feldspar rock. Chemically, kaolin is aluminium silicate and petuntse is aluminium and potassium silicate. Physically, they behave like flour and fat in pastry; mixed together in the correct proportions they combine to give a workable paste which is hardened by heat—in the case of porcelain, intense heat. The kaolin and petuntse body is glazed with a high-fired glaze, made from petuntse.

The high-fired wares of South China, called *qingbai* and *shu fu* and the painted porcelains of Jingdezhen fit the modern definition of porcelain best, as do the Dehua wares of Fujian, called *blanc de chine*. Northern and southern whitewares, northern Ding wares and Longquan celadons are often called porcellanous wares.

Yue wares, famous for their delicate colour and their hardness, deserve mention as well. Although not porcelain by Western standards, they anticipate all the other wares in one or more of their qualities: they are porcelains in spirit.

Materials

Kaolin and petuntse are Chinese words meaning 'high peak' and 'little white bricks'. Kaolin, a place name, was the original mountain source of white clay used at the main porcelain kiln complex in China, Jingdezhen, in northern Jiangxi. Another source, south of the Peak, was at Sanpaopeng. In the Ming period (1368–1644) clay was brought from the Macang mountains, and from Wumentuo, Yugan and Wuyuan. Petuntse, since it is really an impure form of kaolin, was always found nearby, occurring at Yugan, Wuyuan and close by the Jingdezhen kilns at Hutian. It was made up into briquette form before being transported to the potteries.

The occurrence and properties of kaolin and petuntse in China were such that they fostered the early development of porcelain. In Europe, much later, the process was reversed: porcelain was made by imposing the highly sophisticated manufacturing techniques of the fully developed Chinese porcelain industry on whatever kaolin and petuntse was available.

Even in modern China, natural porcelain mixtures are used with very little preparation. In the 1930s W. T. Sutton visited Dehua in Fujian and saw its famous white porcelain made from ground and washed 'weathered rock'. Similarly a fourteenth-

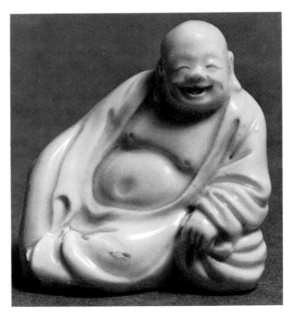

Budai Heshang. White glazed porcelain figure from Dehua, Fujian. Budai was a Buddhist lohan, or saint, of the Tang dynasty, who was often represented as a fat, contented man exposing his belly. Daoist and Buddhist subjects were favoured by the figure modellers of Dehua in Fujian, where the local porcelain clay was exceptionally pure and white. Height 6.5 cm; sixteenth century. (Gulbenkian Museum of Oriental Art, Durham)

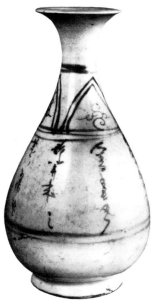

Porcelain bottle decorated with underglaze red, Jingdezhen. (1280–1368). The bottle, or yuhuchun, as the Chinese called it, is rapidly painted with an eight-column seasonal poem. The design is in four horizontal zones which correspond to the four sections from which the bottle was made. It has a thick, opaque and rather grey glaze. Height 19 cm; 1280–1368. (British Museum, London)

century Chinese historian describing production at Jingdezhen mentions neither kaolin nor petuntse. He talks about earths or clays which come from 'rocks' at Hukeng, Lingbai and Jietian.

By using weathered clays which were by accident of nature workable mixtures of petuntse and kaolin, the Chinese first made porcelain and came to understand its potential. It is tempting to assume that similar clays, unwashed and coarsely ground, were used for the earlier high-fired and whitish wares of South China, the proto-Yue green-glazed wares.

In its pure state, kaolin is unchanged by temperatures up to 1700°C (3100°F), and pure petuntse melts and boils at porcelain heat. When separate, each is non-plastic and crumbles when worked into a soft clay state. Combined in the correct porcelain proportions they are still stubborn and non-plastic, seeming to lack some invisible mystery ingredient.

In fact, for their plasticity, colour and to a certain extent thermal stability, porcelain bodies depend upon a small percentage of natural impurities, which are mainly types of potash. In the eighteenth century 'corpuscles which are somewhat glittering' were noticed in Chinese kaolin. These were probably lumps of quartz and mica, the latter being a source of potash. Potash mica is so finely dispersed and bonded throughout the kaolin that it gives great plasticity to the mixture. It is interesting that European pottery-makers failed to see the connection between the impurities in kaolin and its plasticity; although Western kaolins and petuntse contain mica, the intention of chemist-potters like William Cook-worthy (1705–1780) was apparently to effect its removal.

Techniques

The plasticity of China's porcelain clays made the introduction of casting techniques unnecessary. The later European porcelains and pseudo-porcelains were non-plastic and depended upon a manufacturing method whereby the clay is mixed with water to give a thick, creamy slop, or *slip*, and then cast into absorbent fired clay or plaster moulds. The Chinese, however, practised the more skilful method of *press moulding*. Soft clay slabs or rough wheel-thrown shapes were pressed onto convex *hump* moulds which were carved or engraved to produce a pattern on the clay at the same time. A variant of pressing, later used in Europe, was devised to make figures and eccentric hollow shapes. The letters of the eighteenth-century missionary, Père d'Entrecolles, describe the way the Chinese made '. . . animals, grotesques, idols, busts ordered by Europeans and such like things':

When the moulds are to be used they are placed in front of the fire, after which they are coated with porcelain material of appropriate thickness. The coat is then pressed in firmly by hand, and with the mould is then put to warm by the fire, to detach the pressed clay from the mould. The various sections of the whole work, after

being separately moulded, are joined together with a thick slip of porcelain materials . . . Afterwards works are glazed and fired.

The most difficult hollow shapes to make, tall vases and jars with narrow necks, were tackled in a logical way. In the same letter, Père d'Entrecolles describes how these forms were made from two bowls, each roughly half the height of the finished work, the two sections being quite hard before they were placed rim to rim and joined with a sloppy porcelain clay slip. Such forms in European porcelain were usually made by using moulds.

There are more obvious differences between China and the West in their respective glazing and firing methods, and in kiln design. In China the porcelain glaze had a long history. As a mix of wood ash and petuntse it is a high-temperature lime glaze, first used in the Shang period (1700–1027 BC). The deliberate application of wood ash, a source of lime, to a damp clay pot gave a lime and clay mixture which would melt at about 1200°C (2200°F). Contemporary potters use slaked lime as well as ash, because limestone is a far richer source of lime than wood. Nevertheless the principle is the same; lime has a fluxing effect on clay at a high temperature. The effect it had on petuntse in the porcelain clays of South China was more successful owing to the increased firing temperature required, completely fusing glaze and body. Chinese glazes were raw glazes, containing up to 60 per cent clay and applied directly to the green, or unfired, pot. Clay in a raw glaze makes it fit the pot, shrinking with it as it dries and cools after firing. Such a method saves the time and expense of a second firing to fix glaze to a once-fired or bisque clay body.

In the West there was no such continuous development of raw, high-temperature glazes. Low temperature, raw, lead-fluxed glazes were abandoned for a novel, opaque white glaze called tin glaze, made throughout Europe in the fifteenth, sixteenth and seventeenth centuries. This white ware was desirable because it looked like porcelain. It came from the Middle East, and was variously called maiolica, faience and Delftware. The glaze, containing white tin oxide, could only be applied to bisque clay bodies. It could not be applied thickly enough to a green body and tended to crawl or run away from lips and rims. Tin glaze was therefore twice as expensive and took twice as long to make as raw-glazed wares.

One Western raw-glazing method persisted and rivalled the economy and efficiency of Chinese ash-lime glazes. Cast into the kiln at top temperatures, salt vapourizes and attacks stoneware clay bodies, forming a beautiful and indestructible glaze. John Dwight (1633–1703) of Fulham made salt-glazed porcelain in the seventeenth century, but inexplicably the enormous potential of his product was never realized. Debased by less worthy potters, saltglaze became a means of producing sanitary ware. It is now, happily, enjoying an artistic revival.

The Chinese potters also had a novel and advanced type of kiln, and were expert in handling it by the time porcelain was made. This kiln, which

was, by European standards, highly efficient, was in use during the Shang period in Hebei and Henan. Metal smelting carried on under similar conditions may have suggested ways of improving kiln design at this time.

Previously heat from a roaring fire had been drawn up into the kiln chamber by the force of an updraught through a hole or flue in the top. Shang potters modified this updraught kiln to create a down-draught. Drawn up from the fire-box the heat was turned downwards, passing through the packed kiln again to the base of the chamber. There were vents and flues at the base of the kiln, to draw the heat downwards. By closing the top flue at the right moment the heat could only escape downwards, especially when the bottom flues were fully opened.

The heat was also deflected from the domed chamber top of the Shang kiln. Since the heat passed through the kiln twice, or by a longer route, the downdraught principle was more efficient and economical. The great problem with updraught kilns had been an unevenness of temperature within the chamber, which resulted in the production of motley and unfired wares.

Many of the famous Chinese wares, especially the classic wares of the Song period (960–1279) depended upon the kiln being controllable. Glazes were fired in a kiln in which the oxygen was used up or *reduced* by closing off the vents and flues. With a downdraught kiln this could be achieved without a drastic drop in temperature. Allowing the wares to soak in the reduced atmosphere produced and enhanced their final colour. It was this controlled amount of reduction which gave China's porcelains their distinctive blue tone, and it was essential to the firing of Yuan and Ming period under-glaze red porcelains.

The green-glazed Yue wares of South China were, in the ninth, tenth and eleventh centuries, popular abroad because of their delicate colour. This was achieved by reduction, using a multiple-chambered downdraught kiln. Oxygen reduction in this case caused iron oxide in the glaze to stain it green.

Close by the cities of Luoyang and Changan were kilns making green-glazed celadon wares from the tenth century onwards. These kilns were an improvement on the basic Shang downdraught kiln and are known as *horseshoe* kilns. Heat rising from the firebox

Left: Woodblock prints from a 1637 Chinese encyclopaedia, the Tiangong Kaiwu. Workers can be seen feeding the fires in the lower chambers of a dragon-backed kiln. Bundles of long sticks are being used as fuel, and freshly made bowls and vases have been placed around the kiln to dry.

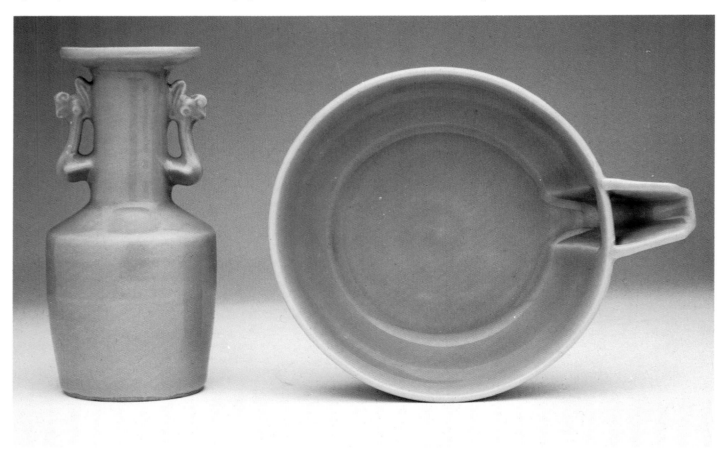

Right: Ding bowl of the Northern Song dynasty. The bowl, which has an ivory-coloured glaze, is fluently incised with a single peony flower design and finely combed details. The fragile rim is bound with a bronze band to preserve it. Diameter 16 cm; 1128–1279.

Far right: Ding bowl. A late, moulded bowl with a busy design of two mandarin ducks and foliage, within a classic scroll border. Moulded Ding wares are less delicate than the earlier incised types, and the unglazed rim on this piece has no bronze binding to protect it. Diameter 14.3 cm; 1115–1234.

 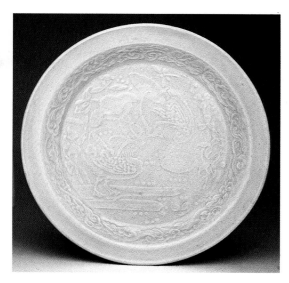

Left: Longquan celadon vase of the Song dynasty (960–1279) and Longquan celadon pouring bowl of the late Yuan or early Ming dynasty (1300–1400). The vase, known by the Japanese name kinuta, is a mallet or 'paper-beater' shape and a common form for Longquan celadon. Its two handles are moulded in the form of a phoenix, and the glaze is soft blue-green. Height 16.6 cm. The shape of the pouring bowl is especially close to Persian and Chinese pouring bowls in silver from the Yuan dynasty. Other Longquan bowls of this shape are splashed with iron and copper stains. The Japanese, who prized celadons greatly, knew this effect as 'flying colours', and it is again a fourteenth-century decorative technique. Diameter 19.5 cm.

was immediately deflected upwards by a temporary wall, called a *bag* wall. Rising to the domed roof it passed down again and out through bottom vents in the back wall, feeding a great flue stack.

The last innovation was made probably during the Yuan period (1260–1358). Southern kilns of about that time have back vents which are vertical slits and cause a crossdraught of heat from the firebox rather than an up and down flow. This crossdraught kiln, found first in Guangdong, was described in Père d'Entrecolles' letters from Jingdezhen in the early eighteenth century. The old downdraught principle continued to be used in the famous *dragon-backed* kilns of Longquan and the seventeenth century Japanese climbing kilns. Both types were simply a series of inter-connected domed and back-flued chambers rising up a hillside. Technically, they are called *semi-continuous downdraught* kilns and the heat moves through the chambers coiling up and down like a dragon.

Père d'Entrecolles was surprised to hear that no ash was found in the firemouth of the Jingdezhen kilns, even though they burned 180 loads of wood per firing. Robust, fired clay containers, now called saggars, were used in China from the sixth century to protect glazed wares from the ash being drawn into the kiln. Saggars were also a means of stacking the kiln up to the domed roof. Unlike the glazed porcelain, they would not stick together at firing temperature. Saggars were not commonly used in Europe until the seventeenth century, but were essential to the firing of white porcelain.

The old updraught kiln persisted in Europe until modern times, certainly well into the eighteenth century. Kilns like the rectangular updraught kiln illustrated in Cipriano Piccolpasso's *Li tre libri dell' arte del vasaio* (written in the 1550s), were replaced by the famous *bottle* kiln in England. This was a narrow-topped chimney into which saggars were stacked.

In spite of the abundance of coal in China, wood is still the fuel at Jingdezhen whereas in Europe coal replaced wood in the eighteenth century. However, coal was sometimes used as a kiln fuel in China for

certain wares such as the northern celadons made at Yaozhou in Shaanxi province.

In China, kiln design was pursued by a need to make delicately coloured and high-fired ware consistently and efficiently. Porcelain was the ultimate white and high-fired body. It both depended on and stimulated innovations in kiln design through its long history as a high-temperature body.

With no suitable kilns, it is not surprising that the porcelain-makers in the West came to grief. Porcelain production in Bristol, for example, was abandoned in the 1760s. It failed because of difficulties in firing the ware. How could it be otherwise when even in China firing porcelain was not foolproof? At Jingdezhen it was said a hundred workmen ruined themselves for each one who became rich.

By the 1700s it was '. . . still not easy to regulate the fires, for the state of the weather can instantly change them, the material they act upon and the wood that keeps them going' (Père d'Entrecolles).

Ornamentation

A fine-grained, white body clay is the most suitable plastic material for incised or moulded ornament, used on Ding and *qingbai* wares, and for figure modelling such as that from the Dehua kilns of Fujian. It was impractical to use coarse-bodied clays or wares with thick and opaque glazes, which would obscure the aesthetic effect of carving or modelling.

The use of painted decoration presented the porcelain painter with a fundamental problem of design; how to successfully adapt ornament to a form without destroying or compromising its visual effect. Painted decoration needed to be as good as the shape and material of this great technical innovation.

The best underglaze painted and enamelled porcelains of the late Yuan and early Ming periods achieve the highest standards of decoration on subtly related forms. Swaggering jars, vases and *meipings* made in the late Yuan period have comparably dynamic, sometimes raging painted scenes bordered with vibrant camelia or lotus scrolls and petal panels.

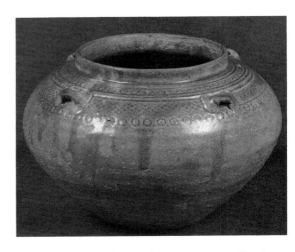

A more reserved and formal style occurs in the second quarter of the fifteenth century, painted on thinly potted and glazed forms of stem cup, bowl and saucer dish. The best Xuande period blue-and-white and Chenghua *doucai* enamelled ware are of this type, bearing subdued traces of the Yuan style.

The porcelain glaze was of the utmost importance to the success of a design. From late Yuan through to early Ming it absorbs the underglaze colour to the extent that it is within the glaze and has a depth and three dimensional effect, which is absent in the more refined glaze of the later fifteenth and sixteenth centuries.

Reactions to Porcelain

Public reaction to the appearance of porcelain both in China and Europe was much the same, a mixture of admiration and disbelief. The Chinese particularly admired its quality of resonance. In AD 847 the Governor of old Beijing played upon ceramic bowls, possibly Yue or white porcelain wares. The tune was said to surpass that of 'hanging jade stone'. An early nineteenth-century history of Jingdezhen refers to seventh-century wares as 'white in colour, of thin bodied fine clay, the best being transparent and fine as jade'. About the same time a potter was accused of manufacturing white jade from clay.

Although green-glazed wares such as Yue are closer in appearance to jade, it is the white wares which are singled out for specific praise by poets. In the eighth century there is reference to 'white bowls surpassing hoar frost and snow' and the 'snow white' bowls of Xingzhou are compared to the green bowls of Yue. Xingzhou white ware has not been identified but was presumably North Chinese.

One early Western theory about the origin of Chinese porcelain was lurid. The Portuguese Odardo Barbosa returned from China in 1516, and wrote that the Chinese 'take the shells of sea snails, and egg shells, and pound them, and with other ingredients make a paste which they put underground to refine for a space of 80 to 100 years'.

Barbosa may have fallen prey to cunning Chinese porcelain-makers, anxious to preserve the exclusiveness of their product. A writer with the Dutch East India Company in 1615 derided 'fabulists of whom there are not a few still nowadays who made people believe that porcelain is baked from eggshells, pounded and kneaded into a paste ... after such a paste has been prepared by nature itself in the ground for some hundred years'. However, the habit of storing clay (though not for eighty or a hundred years!) is universal among potters. Like wine, good clay matures and improves with keeping, becoming more plastic and homogenous the longer it is kept.

Yue Ware

The high-temperature wares of the Han period called proto-porcelains were not the ancestors of the green-glazed Yue wares, yet they were made, together with

Yue, celadon and porcelain wares, in Southern China and from clays rich in silica.

The earliest Yue wares date from the first or second centuries AD, and are called proto-Yue. The glaze is a clay, limestone and wood ash mixture and it is a raw glaze. The glaze colour is green or light brown, achieved by a high temperature reduction firing. Decorations derived from bronze jars, such as sharply cut parallel ridges and useless applied ring handles, are commonly found on proto-Yue, together with a peculiar combed, wavey-line effect around the necks of jars. By the third century rouletted patterns were being used. These were produced by allowing a small cutting-wheel to turn around pots still soft from the wheel.

Yue ware proper dates from about the third to the tenth century AD. During the Tang period (618–906) there were hundreds of kilns making Yue in southern China's Zhejiang province. The coarse, darkened and porous body of proto-Yue became fine-grained and light, with a delicate, olive-coloured glaze. Decoration was minimized to show off the body and glaze, the products of a well-controlled reduction-firing technique. Sensitive carving, resembling chased metalwork patterns, was often done on Yue flat wares and bowls. Yue was exported to Asia, the Middle East, the Philippines and Indonesia, where it was much sought after for its characteristic hardness and resonance. Thus it created a réceptive market for white porcelain.

Ding Ware

A ware closer to the Western definition of porcelain, white and sometimes translucent, was already being made elsewhere in China by the end of the tenth century. From the late Tang period to the fourteenth century, kilns situated at Dingzhou in Northern China's Hebei province were specializing in white ware known as Ding. Flat wares, such as dishes and plates were the most common forms, and were either hand carved or moulded with intricate designs, again perhaps derived from silver prototypes. The absence of any colour or painted designs strongly suggests that like Yue, Ding ware was considered desirable for its body and glaze colour. Fine, thin bowls were made by

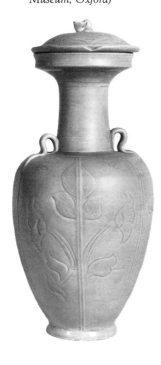

shaving or turning away excess clay, leaving a footrim on the base.

The use of moulds to simulate earlier incised patterns was a turning point in the quality and popularity of Ding ware and dates from about 1100 onwards. Moulded decoration is more complex, but though it may be derived from metalwork designs it lacks the immediacy and freeness of incised patterns. The general quality of Ding ware continued to decline with the Mongol invasion of Northern China in 1215, production ending abruptly about 1310.

Longquan Celadon

The Southern Yue wares were succeeded by another type of green ware before the Mongol invasion pushed into South China in the second half of the thirteenth century. Far from being abandoned in favour of the then well-established white porcelain, Yue wares had been made at the same kilns.

The new green ware was the celadon of Longquan. (Some scholars believe that celadon is so named after 'Celadon', a shepherd dressed in green in the stage version of d'Urfé's seventeenth-century romance, *L'Astrée*. Others believe it to be derived from the name of Saladin, Sultan of Egypt, who sent some of the ware to another Sultan in 1171.) Unlike the celadons of Northern China, Longquan was a silicous, resonant and often translucent ware, typical of Southern China.

The size of the ceramic industry making Longquan celadon in northern Fujian and in Zhejiang suggests it rivalled the industry making white porcelain in Jiangxi province from the tenth century onwards. Chinese archaeologists estimate that the main Longquan kilns held 25,000 pots each time they were fired. These dragon-backed kilns used for southern celadon wares rarely achieved the evenness of temperature necessary to produce 25,000 pots in exactly the same shade of green. Indeed, it is the variety of greens and light bluish greens among the better Longquan pieces which distinguishes them today. Like the Yue wares, the Longquan wares were sought after for their resemblance to jade. Sparse decoration emphasized the beauty of the thick, semi-opaque glaze. The old Yue method of spotting the green glaze with dark brown iron or copper stains was revived and lasted until the late fourteenth century.

Heavier carved, applied and moulded patterns and large shapes became popular in the fourteenth century. From the late thirteenth century red and brown relief patterns were floated onto the Longquan glaze or left dry within it. Southern celadon persisted into the Ming period (1368–1644). It was exported to Europe and the Middle East where it was named Martabani, after a port in Southern Burma. Over 200 kilns making green wares were situated around the port of Wenzhou, through which the Longquan celadons were shipped. Many of the kilns south of the Yangtze river competed with Longquan for the celadon market in later years, as did those in Korea, Southeast Asia and Japan, where celadon has always been highly prized.

Sammara Ware

The history of white porcelain is more difficult to follow, especially in the Tang period (618–906). Many of the northern Henan kilns were producing a crude form of white porcelain in the eighth century. Gong xian specialized in making white porcelain for the court in the Kaiyuan reign (713–756). The Hebei kilns, later to be famous for Ding ware, were making white porcelain in the early ninth century, consisting of small simple shapes, including a dish form with a rolled rim, a thick footrim and an unglazed base. This type of early northern white ware is called Sammara ware, after the ninth-century city on the river Euphrates, where examples of it have been found. The Sammara bowls are made from a coarse, white clay containing kaolin, dipped in a white slip and glazed with a sometimes bluish glaze. When broken, it is more granular than true porcelain.

During the eleventh century the independent state of Liao, situated to the north of Hebei, had occupied that province, where the Ding kilns were operating. Thin white porcelain was later made by the Khitan people of Liao. In the northern white ware tradition these wares consisted of small dishes and bowls, some with lobed rims, and vases or bottles. They are few in number compared with the other types of ware made by the Khitans and are often inscribed on the base 'official', showing they were made for royalty.

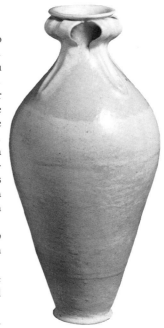

Above: Northern white-ware vase of the Liao dynasty. Height 2.7 cm; 907–1125. (Gulbenkian Museum of Oriental Art, Durham)

Qingbai Ware

With the important exception of the northern Ding-ware, Chinese porcelain in the Song period (960–1279) was a southern product known as *qingbai*,

Below: 'The Night Revels of Han Xicai', attrib. to Gu Hongzhong, painted silk, c. twelfth century. (Palace Museum, Peking)

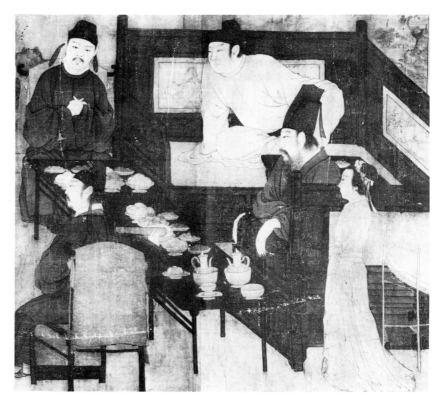

meaning 'bluish white'. Datable evidence showing how *qingbai* developed has not been found. The Chinese attribute dishes made from an opaque white porcelain and found at a kiln site near Jingdezhen, to the previous Tang period. With superior ceramic materials at their disposal the Southern Tang potters must have made a *qingbai* prototype, the first porcelain as the Western world now recognizes it.

Perhaps in the early history of the *qingbai* wares is a lost connection with the green wares of Yue. It is indeed significant that they were both made at the Jingdezhen kilns of Shihuwan, Shengmeiting and Huangnitou. The *qingbai* wares are decorated with punched or incised patterns, ultimately derived from Middle Eastern silver imported and copied under the Tang Emperors; so are Yue wares. White-glazed sherds have been found at Huangyan, a tenth-century Zhejiang kiln specializing in Yue wares.

A positive reason for the long infancy of porcelain is the political situation following the Tang period. Until the early twelfth century, much of China's wealth and patronage was in the north, centred on great cities like Luoyang. At Luoyang some 50,000 foreigners lived among the millions of Chinese. It was a metropolis in the world's most important state accessible through the land trade routes of Northern Asia. In such an advantageous position the Northern potters made the wares for which they have remained justly famous: the Jun, celadon and Cizhou stonewares and Ding wares.

Owing to a period of disunity which followed the Tang period the northern potteries were unable to exploit the strong lead they had gained over the south. The northern provinces were lost following a defeat of the Imperial forces by Ruzhen Tartars in 1127, and serious economic factors affected the ceramic industry. The defeated Song Emperor ruled Southern China from the new capital, Hangzhou. Government need for money to ward off northern invasion and foreign demand for the southern wares, Yue, celadon and *qingbai* porcelain stimulated the rise and prosperity of new kilns, especially at Jingdezhen and Longquan.

Qingbai is more resonant and translucent than earlier white wares and is covered with a transparent bluish glaze. The earliest known examples, dating from the last years of the tenth century, are undecorated and made in simple dish and bowl forms, which suggest that it was a ware in its infancy.

Chemical analysis has shown that *qingbai* is a ware containing a high percentage of silica and a low percentage of metallic oxide. As a bluish, glazed white body it is therefore the direct ancestor of famous Ming porcelains of the fourteenth, fifteenth and sixteenth centuries.

There is a superficial similarity between *qingbai* and Northern China's Ding ware. From the later twelfth century there is also the same use of moulded relief decoration on *qingbai*. But the incised scroll patterns and dotted underglaze body decoration rarely compare with the fluid and free-cut designs of twelfth-century Ding ware.

Ding ware bowls, fired upside down to prevent distortion during the firing, had to have a glaze-free

Left: Moon flask from Jingdezhen. The underglaze-blue painting is 'heaped and piled', concentrated in parts to blackness, giving a three-dimensional strength. The dragon is poised between storm-swept rocks, ready to strike at the elusive flaming pearl. Height 25 cm; early fifteenth century.

Below: Guan decorated with underglaze blue and red from Jingdezhen. The undercut relief panels are outlined with a double border of curious linear beading, and, like those in blue around the shoulder, are lobed cloud scrolls. Height 33 cm; c. 1330. (Percival David Foundation London)

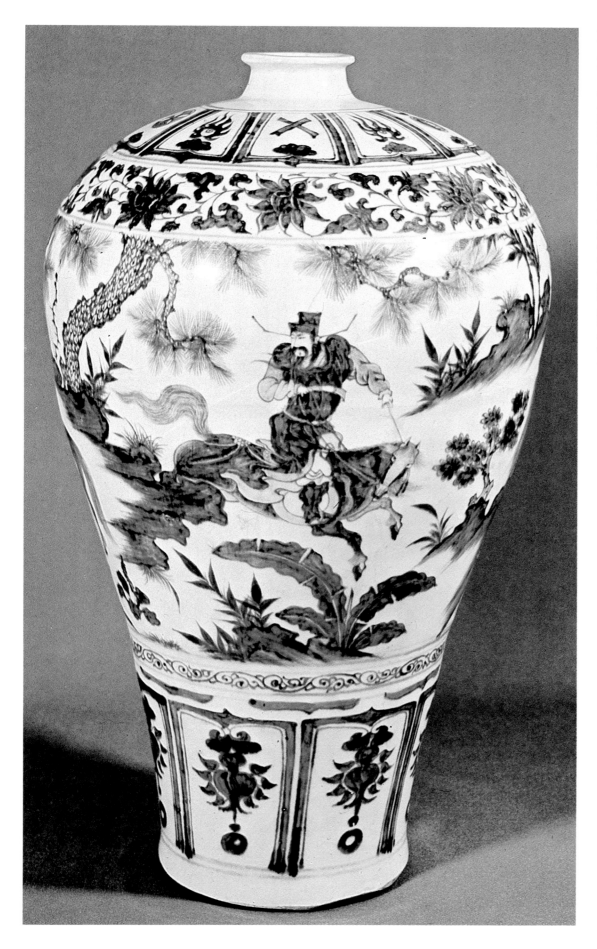

Meiping, decorated with underglaze blue, from Jingdezhen. From the tomb of Muying, a favourite of the Ming Hongwu Emperor, dated to 1369, this massive, swaggering vase is perfection. It is boldly painted in pale blue with rich, dark accents and incredible accuracy of detail. The subject is an early Han dynasty romance, 'Han Xin pursued by Minister Xiao He'. Above and below are motifs more commonly found on high-grade export dishes of about the same date. The meiping is divided into decorative zones – lotus panels around the neck, a band of scrolled lotus flowers, the central landscape, a narrow classic scroll border and a band around the base. Height 44 cm; 1369 or before.

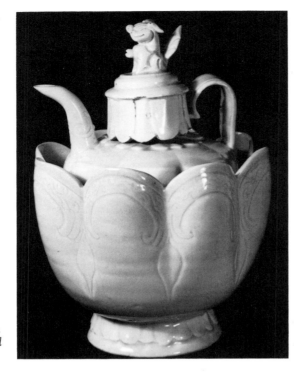

Right: Qingbai wine jug and basin from Jingdezhen. The incised decoration and complex shape recall early Ding wares of Northern China, but they lack the finesse of Ding at its best. The wine jug was designed to keep the contents warm. Height 25 cm; 1128–1279. (British Museum, London)

Below: Detail from a wall painting from a tomb in the Hebei province of Northern China. It shows a couple taking wine from a porcelain jug, basin and cups on raised stands. 960–1127.

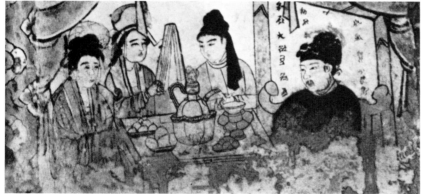

rim. This ugly feature on an otherwise perfect piece was disguised by a copper rim. The *qingbai* kilns adopted the same method of firing but often used a silver rim for bowls.

Good quality *qingbai* wares were made at the kilns around Jingdezhen in Northern Jiangxi, and at others in Fujian and Guangdong during the Song period. With the green-glazed wares from the neighbouring Zhejiang province they enjoyed popularity abroad, being found as far away as Ceylon and the Philippines. That *qingbai* wares were not commonly made in the Yue kilns of Zhejiang is suggestive of a commercial rivalry between green and white wares.

Jingdezhen

The removal of the Chinese court to Hangzhou in 1127 coincided not only with the increased production of *qingbai* porcelain but also the increase in the number of porcelain kilns in and around Jingdezhen. The name Jingdezhen was introduced about the same time.

A consular report made in 1905 by Walter J. Clennell noted:

> ... a great industry, employing hundreds of thousands, does not remain localized in a single spot for 900 years without giving to that spot a character of its own. This is perhaps what struck me most forcibly in Ching-tê-chên–that it is unlike anything else in China. The forms, the colour, the materials used in the buildings, the atmosphere, are somewhat reminiscent of the poorer parts of Manchester, but resemble no other large town that I have ever visited.

Clennell must have known that the poor district of Manchester was, at the time, the worst slum in Europe.

The Jingdezhen kilns, in the north west corner of Jiangxi, surrounded by hills, with ample supplies of wood and water, had been established in the fifth century. They became privately owned in the Song period (960–1279) by potting families. From an *Appendix on the Pottery Industry* written in 1322 it seems that different kilns were working for different markets. If the market demanded it, a kiln could manufacture two or more different types of ware to meet an order rather than sticking to the ware for which it was famous. The *Appendix* suggests that established independent potters were constrained to become, in effect, the employees of the bigger firms.

Industrialization continued in the thirteenth and fourteenth centuries, especially under the alien Mongol Yuan dynasty founded by Kublai Khan in 1280. The *Appendix* lamented the creation of new bureaucratic controls at Jingdezhen. By that time production showed the labour force was skilled and capable of manufacturing to consistent standards. Kilns were built according to regulations, which determined their capacity and therefore their production, which was duly taxed.

A tradition of using casual labour for the heavy work of packing and unloading the kilns was carried on. In 1905 Clennell said there were still labourers 'who only came for the season, living in rows of barrack like sheds, and do not bring their families with them'.

Situated between two rivers, with no shortage of fuel or water power, Jingdezhen could easily import certain raw materials when necessary. All porcelain production was still exported by water transport in the 1970s. The 'inexhaustible' supplies of kaolin and petuntse in the surrounding hills sustained the expanding industry. The *Appendix on the Pottery Industry* tells how porcelain glaze was also prepared from local materials. Petuntse was burned with mountain brushwood to make a refined but typical southern Chinese ash/lime glaze.

Shu Fu

Towards the end of the thirteenth century a change in taste occurred and other types of white porcelain appear alongside *qingbai*. One with a milky opaque

glaze, sometimes very white and sometimes slightly blued, is easily identified. Heavier, more robust forms are made, contrasting with the delicately trimmed *qingbai* bowls, and alternative types of decoration to incised and moulded relief are used.

A peculiar type of relief linear beading is found, as are softened relief patterns executed in porcelain slip. These varieties of white porcelain are called Transitional, because they are halfway between the *qingbai* and the opaque, blued glaze of the late Yuan and Ming period porcelains. Perhaps the change may be explained by a renewed admiration for earlier, opaque-glazed white wares, especially the prestigious northern Ding type.

In 1388 we hear of porcelain made in Jiangxi province during the Yuan dynasty, '. . . the small footed bowls with moulded decoration having the words Shu fu inside are the best'. Shu fu (privy council) ware, thought to have been made for the court, gives its name to the main Transitional white ware, and was also made at Jingdezhen. Not as finely potted as *qingbai*, shu fu is distinguished by its thick, creamy glaze and square section footrim. It established itself alongside *qingbai* by about 1350.

Transitional white seems to be an underestimated porcelain, as the underglaze-painted porcelains which followed it receive much more attention. The varying whiteness of glaze is complemented by the relief and linear beading decoration. Any attempt to make a purer white glaze than *qingbai*, however, was destined to be temporary. It reqired perfect control of the kiln, balancing the amount of oxygen passing through the chamber so that, when reduced, it had no effect on the glaze colour. From the Song period the amount of ash used in porcelain glaze was decreased and the firing temperature increased to about 1350°C. With these final adjustments in the interest of greater economy and consistency, a less blued and more opaque *qingbai* glaze became standard in the Jingdezhen kilns during the Yuan period (1280–1368).

The Dehua Kilns of Fujian

Originally making *qingbai*, the Dehua kilns of Fujian became famous for the whiteness of their porcelain by the sixteenth century. The fame of Dehua came to rest on figurework normally attributed to the fifteenth and sixteenth centuries, Buddhist, Daoist and Confucian subjects being favourites.

The figure was a good vehicle for exploiting the obvious purity of the Dehua body material, and many Fujian pieces are exquisite sculpture as well as being fine ceramic forms. The decoration of vases and bowls continued in the familiar vein of Ding and *qingbai*: incised, moulded and applied relief. The latter was a speciality of Dehua, a technique whereby separately moulded clay shapes, such as prunus blossom sprigs, were applied to the unglazed, damp clay body. This technique, called sprigging, was exploited by eighteenth-century Western potters.

Needless to say, Dehua porcelain had an immediate appeal abroad. It was the white translucent ware

of China in an unadulterated form. It has been excavated throughout Asia, the Philippines and Indonesia. A quality best described as smoothness distinguishes the wares of Dehua, especially in the detailed modelling of figures, which is well handled and rhythmical. The glaze seems to penetrate and merge with the body, being almost colourless.

Blue-and-White Wares

Alternatives to *qingbai* porcelain appeared in southern China after about 1300. So too did a type of painted porcelain which eclipsed the popularity and fame of every other Chinese ware, including the celadons of Longquan. Blue-and-white porcelain, the most influential type of ceramic ware ever made, reached the height of its technical and aesthetic development in the fifteenth century, in the *Imperial* style.

The high temperature to which porcelain was fired restricted the sources of effective colour to three metallic oxides; iron, copper and cobalt. In the eighth century, cobalt had been imported from the Middle East, and used to colour low-fired lead glazes. During the 1320s it was mixed with porcelain glaze and painted onto porcelain shapes before they were glazed and fired. Beneath the slightly blue-toned glaze this intense colour was an effective way of decorating the already famous porcelain of Southern China.

The sudden introduction of underglaze blue may have been stimulated by the presence of a new regime in China. Since 1280 the alien Mongol dynasty encouraged foreigners and employed them in governing the Chinese. New ideas and influences came with them to China, and, predictably, the demand for high quality export goods of all types was stepped up.

The earliest underglaze-blue painting was preceded

Above: Shu fu stem cup from Jingdezhen. This cup has two dragons in moulded relief inside the bowl, but has the distinct milky, opaque glaze and plain splayed foot of shu fu porcelain. Height 11 cm; c. 1350. (British Museum, London)

Below: Blue-glazed dish with white-glazed relief from Jingdezhen. Designs on dishes of this shape were normally painted in underglaze blue. Here the colours are reversed, the white glazed phoenix, horse and plant motifs floating on a blue glaze. Diameter 35.6 cm; c. 1350. (Topkapi Saray Museum, Istanbul)

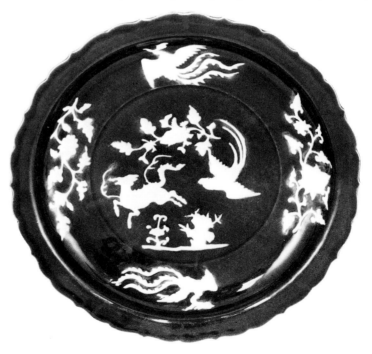

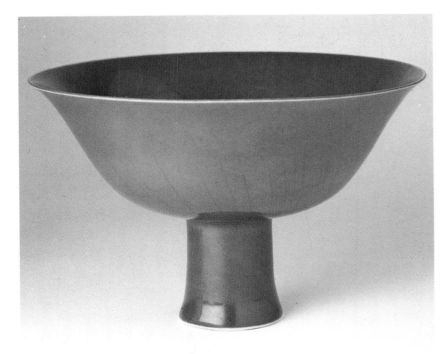

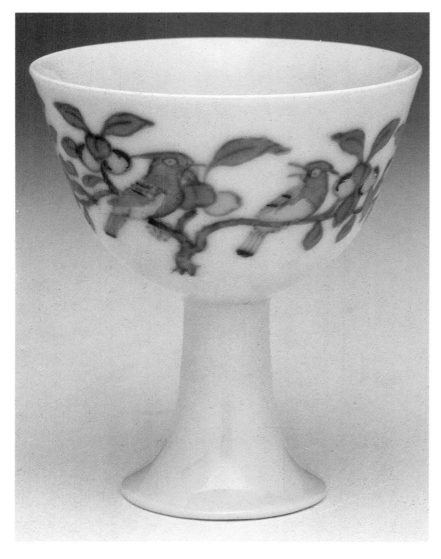

by painting in underglaze iron oxides, and some linear patterns painted on bottles in underglaze copper oxide. These rapidly painted linear patterns also appear in underglaze blue on Transitional white wares made in the late Yuan period (1280–1368). The other discernible style of painting in early underglaze blue is an outline and wash technique. It was used on better quality wares, generally intended for export.

The earliest of these new and high grade export wares were large dishes, some sixteen inches in diameter, and tall heavy vases. The more flamboyant dishes have complex designs with a strong Middle Eastern flavour. They were made between two flat moulds which produced attractively shaped rims and sometimes relief motifs to intensify the blue design.

Plant and animal forms, although arranged in unnatural complexity, are of Oriental origin. They include peony, lotus, camelia and lily, the dragon, phoenix, peacock, deer, lion and a perch or bass-like fish with a fat, oval tail. Spikey-leaved flowers with white outlines are also seen on the large dishes, and the vase forms known as *guan* and *meiping*. A *meiping* is a cylindrical form, swelling at the shoulder and curving sharply inwards to a narrow neck. The *guan* is an ovoid or squatter shape with a wider neck and mouth.

On Song and Transitional white *meipings*, the decoration is divided into horizontal sections. Yuan and early Ming period blue-and-white *guan* and *meiping* forms are treated in a similar way and a common motif is the round-tailed fish.

Blue-and-white not intended for export to the Near East and Southern Seas generally consists of small forms such as stem cups, bottle vases and dishes. They sometimes have copper red or cobalt blue monochrome glazes. Another group of dishes are those found with a white relief motif such as a dragon or flower, applied over a cobalt-blue monochrome glaze. Overglazed with the standard semitransparent porcelain glaze, this rare type of sprigged ware again anticipates European eighteenth-century techniques.

Ming and Imperial

The early blue-and-white phase ended with the Mongol regime's defeat by native rebels and the creation of a new dynasty in 1368 called Ming. Jingdezhen and the surrounding area had witnessed some particularly brutal fighting and the policy of the new government added to its injuries by abandoning the lucrative export trade built up by the Mongols. The export embargo stimulated a type of decoration not dependent upon imported pigment. Plates and bottles in shapes which suggest a late Yuan or early Ming origin are decorated with underglaze-red copper oxide. This technique specifically depended for its effect upon precise control of the kiln atmosphere and temperature and was often adversely affected by a thin glaze. The fugitive aspect of the red, turning to grey and ruddy brown tinged with yellow, or to cherry and bloody reds, was used as well

as underglaze blue decoration, which eventually displaced it.

During the first two reigns of the Ming period (1368–1644) there is little evidence that blue-and-white sustained its popularity, except in the domestic market. Some other type of ware, it has been tentatively suggested, enjoyed courtly patronage. A surprisingly small number of blue-and-white wares are attributable to the reigns of Hongwu and Yongle (1368–1424). Hongwu's celebrated naval expeditions of 1374 and 1383 and those of his son, Yongle, may indeed be an attempt to break with the past and seek out new markets abroad, as far afield as the coast of Africa.

Unlike blue-and-white, the Longquan celadon industry never recovered its prosperity after the Mongol collapse in 1368. It went into decline as the name Ming became synonymous with decorated

white porcelain. A new native style gradually replaced the Yuan style in the fifteenth century. It was more restrained, regular and ordered. Blue-and-white was in favour and ordered by the Court in 1433, by which date this Imperial style had established itself. A profusion of motifs is abandoned for one, two or three related ones. Increased naturalism in the painting of leaf floral sprays is evident, and there is a greater degree of balance between the motif and the white ground than before.

A darker underglaze pigment was used in the Xuande period (1426–1435) deliberately concentrated to blackness in parts, giving the blue a three-dimensional effect. At this time Chinese cobalt was mixed with that being obtained from the Middle East. To supplement the few still used floral and animal motifs came a strong element of landscape. Floral designs incorporated actual trees, anchored to

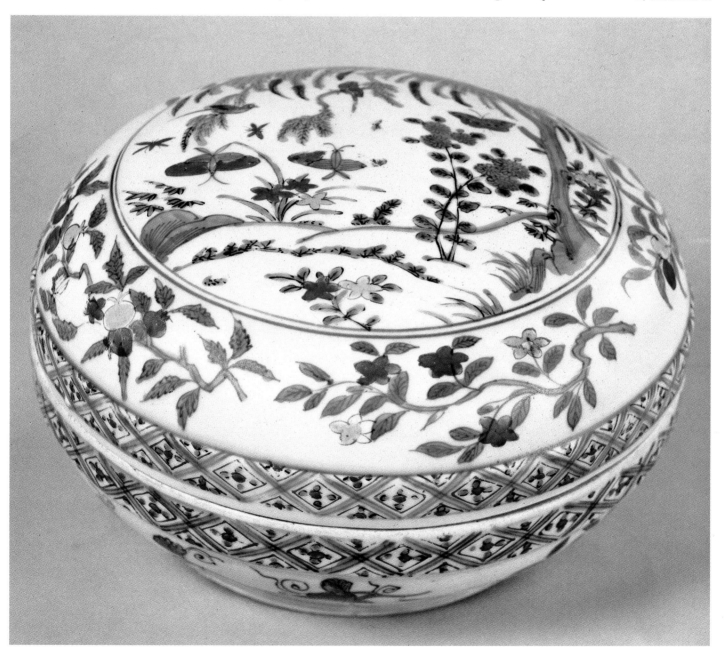

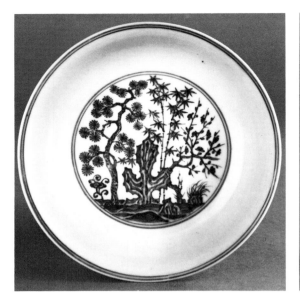

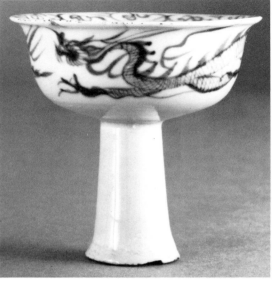

Far left: Dish decorated with underglaze blue from Jingdezhen. The old Yuan period design of 'The Three Winter Friends' is used here in the formal Imperial style of decoration. Diameter 17.6 cm; 1426–1435. (British Museum, London)

Left: Qingbai stem cup with moulded relief and underglaze-blue decoration from Jingdezhen. The simple, rapid style is quite distinct from the Ming 'Imperial' style. Diameter 9.3 cm; c. 1350. (British Museum, London)

a strip of land. Pine, bamboo and prunus, called 'The Three Winter Friends' often figure in the landscape. It is to the finest wares decorated in this way that the word Imperial is applied. The only apparent imperfection was a textured, orange-peel glaze effect which had disappeared by the 1470s.

The porcelain of the Chenghua (1465–1487) and Hongzhi (1488–1505) periods matched the new sophisticated qualities of design with a perfected body and glaze. To some it is too perfect. The old heaped and piled strength of the blue pigment is replaced by a light, soft, outlined blue and a thin, light and translucent porcelain. Dragon and floral scroll patterns are supplemented by people in a landscape. The latter, so popular on European blue-and-white, was a late fifteenth-century innovation.

Doucai, Wucai, Sancai

Having established a superb technical and aesthetic standard in blue-and-white, China turned to other methods of decoration in the mid-fifteenth century. The Yuan period (1260–1368) had witnessed the use of colours other than blue, but a more significant breakthrough came in the Chenghua period. It was inspired by Northern Chinese ceramic decoration. Stonewares made in Hebei since the Song period and called Cizhou ware had overcome the problems of a limited colour range at high kiln temperatures with a second separate firing. This fixed coloured lead-glaze patterns painted over the fired high-temperature glaze.

Mid-fifteenth-century porcelain decorated in this way used red and green enamels, commonly found on Cizhou ware. The first and most attractive Ming overglaze enamel innovation was called doucai or 'dove-tailed' colours. It sits conveniently between blue-and-white and fully fledged overglaze enamel decoration of the Zhengde period (1506–1521).

Doucai was an underglaze blue pattern embellished with overglaze enamels, which appear to be contained within the underlying blue pattern. An inferior style of overglaze enamelling called wucai, or 'five colours', superseded the earlier red and green enamelled wares in the Chenghua period (1465–1481) using also yellow, turquoise, purple and black. Red or black outlines replaced the underglaze blue of doucai ware.

With blue-and-white, doucai and wucai were the classic Ming wares, imitated by a ceramic revival in the Kangxi period (1662–1722) and by the best European porcelain factories, albeit unknowingly. By the late fifteenth century enamels were applied directly to the fired, unglazed porcelain body. The Ming sancai, or 'three colours', ware is decorated in this way, and is generally called 'enamel-on-biscuit'. Elaborate designs were cut into the unfired body, anticipating where the enamels would be applied and enhancing their depth and colour.

In the sixteenth century enamel-on-biscuit was varied by the addition of already familiar wucai colours; purple, black and turquoise. All enamelled types were used until the seventeenth century, and were imitated in the early eighteenth and the nineteenth centuries in a mixture of doucai, wucai and sancai techniques. The imitator's genuine reverence for tradition made it acceptable for him to execute the appropriate reign mark on the base of each piece.

Other important innovations using low-fired enamels which date from the fifteenth century include the painting of the white areas of a blue-and-white piece with yellow enamel background and the use of overglaze enamel and enamel-on-biscuit together and in the same colour. There were also coloured porcelain glazes, as opposed to overglaze enamel grounds, which are mainly found on bowls and dishes. They are coloured with cobalt blue, which is unusual, or a perfected copper red. The latter is a double-glazed ware, a copper-stained glaze being applied first. Red glazes are at their best in the fifteenth century; they are intensified by a white rim on bowls, from which the glaze has run away in the firing.

Yellow and bluey-green glazes are applied over the

porcelain glaze and for that reason could have been applied at any time, not necessarily at the time of manufacture. They appear first in the late fifteenth century, and the earliest pieces are often conspicuous for the impurity of the colour or, as in the case of the bluey-green glazed wares, crazing.

'Late Ming'

In the sixteenth century a slow process of political decline in China began. The Emperor's position was weakened by an increasingly corrupt and elitist administration. There were new demands on the southern potteries with the arrival of Europeans in 1514, and with the expanding commercial activities of the Japanese.

The selfish and ambitious activities of a caste of eunuchs established throughout the Chinese Civil Service and government are represented by a strange revival of blue-and-white porcelain. As Muslims, the eunuchs commissioned wares which were inspired by the art and literature of Islam or decorated with Arabic verse. These Islamic wares are usually those objects used in a study, such as brush holders and table screens. The established tightness and formality of the Imperial style becomes less organized, painted in an old-fashioned, free outline and wash technique.

The formal horizontal division of tall forms is broken up in favour of an illustrative style of painting, inspired by picture books of the day. Their spontaneity recalls in spirit the earliest blue-and-white of the fourteenth century. These wares of the Jiajing (1522–1566) and Wanli (1573–1619) periods seem to enjoy a temporary liveliness and non-conformism. The derogatory term 'late Ming' is chosen for these neglected porcelains, decorated in underglaze blue and overglaze enamels.

A specific type of ware from the Wanli period is decorated in a distinct wild style and is called *kraak* porcelain; *kraak* being the Dutch word for the Portuguese carracks which carried it to Indonesia. It is the Ming porcelain commonly found in attics and cellars today. A plethora of decorative motifs are painted in an unmistakable grey-blue wash and are arranged in panels to surround a central scene on dishes. The poor but glossy glaze will easily chip and flake away from the edges and is described by the Japanese as 'moth-eaten'. Occasionally the base and footrim have chatter marks; irregularities in the trimming of the base and foot are common to late Ming export wares.

Another of the seventeenth-century styles which went beyond the reign of Wanli (1573–1619) was called Transitional blue-and-white. It differed from *kraak* ware, as did Transitional white from *qingbai* porcelain by being more robustly potted. Transitional ware is more skilfully painted than *kraak*, well glazed and pleasingly shaped. Some shapes seem peculiar to the period, like the cylindrical vases with swollen middle sections. The decoration is often sufficiently well executed as to anticipate the glorious designs of the Kangxi period (1662–1772).

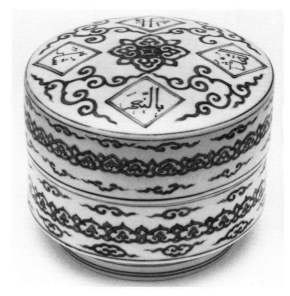

Left: Box and cover decorated with underglaze blue from Jingdezhen. The Arabic verse on the cover shows it to be made for Muslim officials of the royal household and Chinese government in the sixteenth century. Diameter 18.2 cm. (City of Manchester Art Galleries)

Below: Underglaze-blue decorated vase with lid from Jingdezhen. Typical Transitional design in free outline and wash technique. Height 38.25 cm; c. 1640. (City of Manchester Art Galleries)

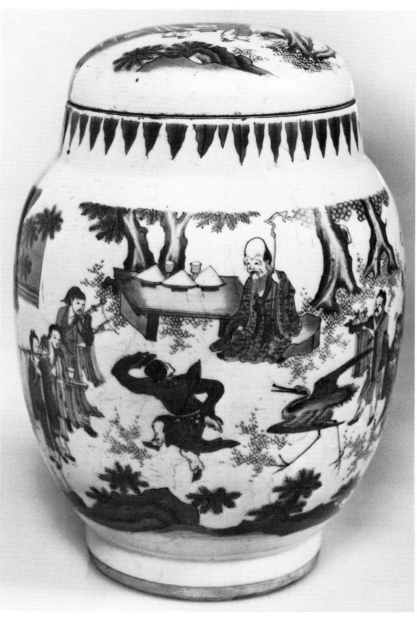

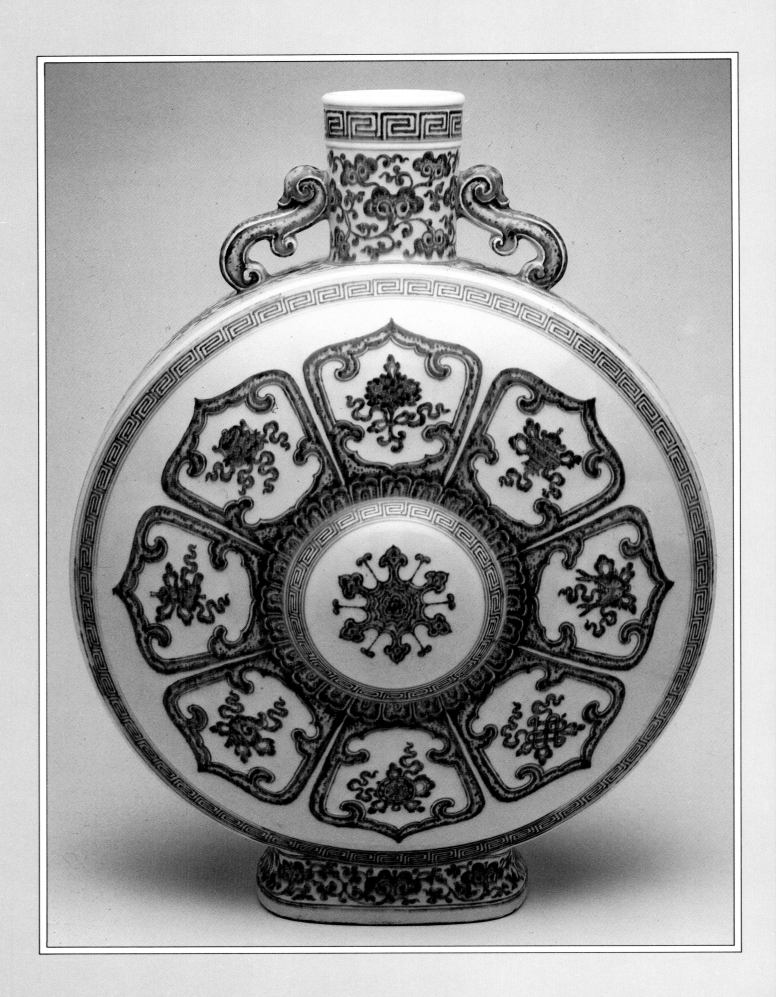

Chapter Two

Qing Dynasty Porcelain for the Domestic Market

ALTHOUGH much consideration has been given to Chinese export porcelain both within the pages of this book and elsewhere, less has been written about those porcelains manufactured during the Qing, or Manzhu dynasty (1644–1912) primarily for the domestic market.

Until the present century our understanding of Chinese porcelain was confined almost exclusively to a range of wares designed specifically for European consumption in the seventeenth and eighteenth centuries. Little or nothing was known of what is now described as 'Chinese taste' porcelain, though some nineteenth-century collectors, particularly the French, who coined most of the terminology relating to Chinese porcelain, appreciated the somewhat academic style of the famous 'ruby-back' plates as representing the finest wares of China. Of all export porcelains, these are certainly the closest in style to the wares favoured by the Chinese themselves.

Alongside polychrome wares, highly regarded monochromes such as *sang de boeuf*, *clair de lune* and celadon were imported into Europe, and some of these were hardly inferior to products retained for the Chinese home market. Many of these monochromes were subsequently fitted with ormolu mounts especially for the adornment of the great houses of the French nobility. Western appreciation of Chinese-taste wares was much aided in the 1920s by the enterprise and discernment of a few enthusiastic scholars such as the Honourable Mountstuart Elphinstone and Sir Percival David.

Dehua and Jingdezhen

The latter-day history of Chinese porcelain is basically restricted to two centres of ceramic manufacture. Dehua in Fujian, a province of southern China, has been noted for the production of porcelain and pottery since the Song dynasty (960–1279), though it is recognized today more for its output during the

Qing dynasty (1644–1912). The white porcelain of Dehua known as *blanc de chine*, is particularly fine, manifesting a perfect bond between body and glaze. The glaze can vary in colour from a pale blue through a dead white to a rich, creamy ivory. It was extremely popular in the export market and was copied by many of the major European factories, such as St. Cloud, Meissen, Bow and Chelsea. The range of wares included figure subjects mainly of Buddhist significance, such as Guanyin, the Goddess of Mercy. Other vessels manufactured in large quantities but not necessarily for the foreign market were censers with bombé sides, magnolia and prunus-blossom libation cups (modelled after rhinoceros horn originals), beakers and cylindrical, or rouleau, vases.

The wares can be extremely difficult to date partly because they are so rarely marked. Where marks do occur they are invariably spurious early Ming reign marks and should be treated with great circumspection. The best guide to dating is probably to be obtained by examination of the 1721 inventory of the collection of Augustus, the Elector of Saxony, which is housed in the Johanneum Palace. The list is sufficiently detailed to enable one to identify much of

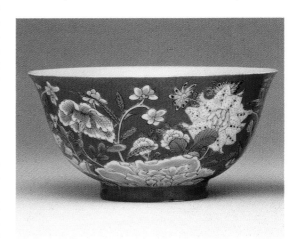

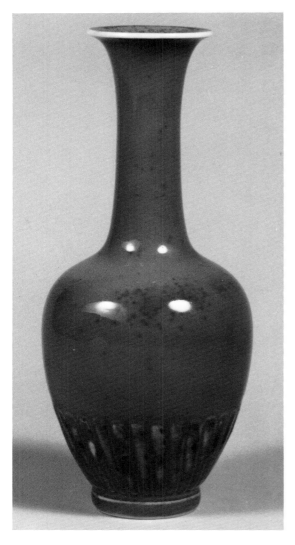

the ware which was presumably manufactured in the preceding twenty or thirty years.

The other major centre is that of Jingdezhen in the province of Jiangxi, an area rich in those raw materials essential to the manufacture of porcelain. Porcelain has been made at Jingdezhen since the Tang dynasty but like Longquan, Jingdezhen probably only gained eminence by its proximity to the imperial courts at Hangchow and Nanking, after the arrival of the Song Emperor, following the invasion

of the northern territories by Chin Tartars in 1127. This area has the greatest significance for scholars of later Chinese ceramics, as most of the export and domestic ware of the seventeenth century was manufactured here. Kangxi had ascended the dragon throne in 1662 at the age of eight, under the stifling regentship of Oboi. In 1669, Oboi was removed from office with the aid of the Emperor's powerful uncle, Songgotu. It was not long after this that the terrible 'Three Feudatories' civil war broke out.

In 1675, during the upheaval following the overthrow of the Ming dynasty by the Manzhus, Jingdezhen was destroyed as a result of the rebellion of the Ming insurgents Wu San Gui and Wu Shin Fan. The kilns were rebuilt in 1677 and placed under the directorship of Zhang Qichong, who immediately forbade the use of the imperial *nienhao* (mark) presumably because of the inferior quality of the porcelain, which had been in a serious decline since the loss of imperial patronage towards the end of the Ming dynasty (1368–1644). To what extent this edict was enforced is uncertain, and it may well have been abandoned when Cang Yingxuan took control of the Imperial Factory in 1683.

The Reign of Kangxi (1662–1722)

Cang's directorship heralded the beginning of an era lasting over half a century, during which time there were many innovations. New glazes were introduced and techniques which had been virtually forgotten during the Ming dynasty were rediscovered. The existing polychromatic decoration included the use of the Ming *sancai* (three colour) palette of manganese (black), yellow and green lead silicate enamels for application on figures of Buddhist immortals, like Guanyin or the Hehe Erxian, or on figures of animals and occasionally on sacrificial vessels. The more intricate *wucai* (five colour) combination was enhanced by the introduction of a brilliant translucent blue enamel as a replacement for the underglaze blue of the Ming period and second Transitional period (c. 1620–1683).

Copper red was reintroduced as a monochrome during the later years of the seventeenth century,

Left: An extended oviform vase with a pinguohong (peach bloom) glaze. The glaze, derived from copper oxide, was used on about half a dozen standard shapes during the late seventeenth century, of which this is one. Height 21.6 cm. (Percival David Foundation, London)

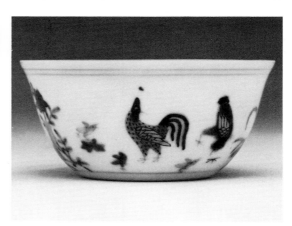

Far left: Early Ming chicken cup decorated with the doucai (clashing or contrasting colours) palette. Marked as being from the Chenhua period, 1465–1487. Compare the bold brushwork of this piece with the more tentative painting of the Qing piece (left) copied 200 years later. Height 8.2 cm.

when it was renamed *lang yao* (ware of the potter, Lang, or *sang de boeuf* in Western terminology). A variant on this glaze, *pinguohong* (or peach bloom) was also introduced at this time. This was a pinkish-red glaze, often with zones of pale, moss-coloured suffusions. It is invariably found on small vessels such as beehive-shaped water pots, round, covered boxes, brush washers with incurved sides, or tall, elegant extended oviform vases with deeply recessed bases. Both these glazes are derived from copper oxide fired in reducing conditions.

Other glazes popular during the reign of Kangxi were turquoise, also a derivative of copper, and several varieties of yellow, produced either from iron or antimony and usually pale in tone. There were also four distinct types of green—cucumber green, apple green, a rich translucent dark green called snakeskin, and a revival of the Song iron oxide, celadon green. The blue group of glazes derived from cobalt contained four main types: mazarin, a solid deep purplish blue; blue soufflé or powder blue (the effect being achieved by blowing the cobalt onto the surface of the vessel through a bamboo tube with a gauze filter); lavender; and a pale blue celadon glaze somewhat misleadingly called *clair de lune*. Finally, there is mirror black, a development of *café au lait* glazes produced from iron and manganese oxides.

Throughout Kangxi's reign there was perhaps less emphasis on slavish reproduction of earlier wares than during the succeeding reigns of Yong Zheng (1722–1735) and Qian Long (1736–1796) when there were some brilliant copies of Xuande period (1426–1435) and Chenhua period (1465–1487) porcelains. These have caused considerable problems in dating. Especially notable are the imitations of Xuande period underglaze copper red and underglaze blue-and-white. Particularly difficult to differentiate are the small *doucai* cups modelled on Chenghua originals. It is only by recognition of the more laboured characteristics of the potting or design, in

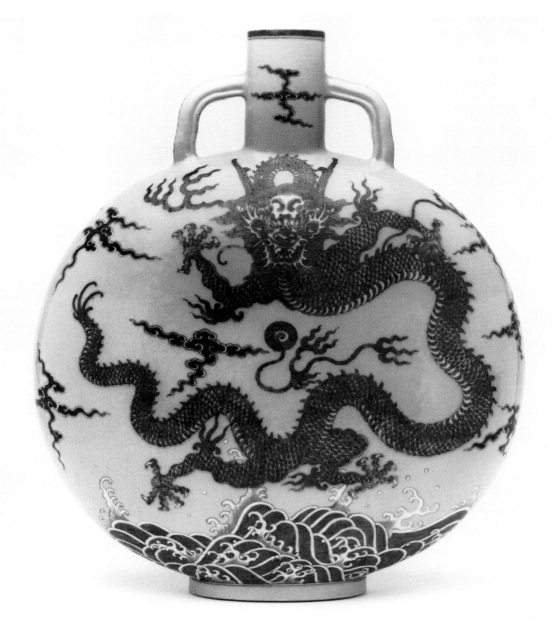

Qian Long moonflask with lime-green ground, and copper-red and underglaze-blue design of a dragon dancing above the waves. The form and style are based on an early fifteenth-century vessel, though the colour combination was purely an innovation of this period. Height 27 cm; late eighteenth century.

conjunction with a more evenly applied glaze on the later pieces, that one can distinguish the Kangxi imposter from the Ming original. The early piece reveals more of the man who made it. For example, on the larger early vases one can detect the seams where two or three sections of the pot have been luted (joined together with slip), the foot usually shows the facets of knife paring and the glaze undulates and varies in intensity, manifesting, on white ground objects, a definite bluish tone where it is thick or where it has collected in a crevice or angle. The Kangxi vessel is generally neatly potted and supported on a smoothed footrim, and the very thinness of the applied glaze naturally gives a whiter appearance.

The Transitional and Kangxi periods (which, in fact, overlapped) witnessed a movement away from a repertoire based predominantly on birds, flowers and dragons and towards subjects such as landscapes and romantic figures. One happens upon non-perspective courtyard scenes from popular romances, in which elegant women consort with rod-like dignitaries. These are done in pencilled outlines which are filled with cobalt washes of varying intensity, and they often contain a smaller panel inset depicting another aspect of the story. Another theme was the isolated scholar or sage, meditating on an island, surrounded by precipitous rocks. This is best epitomized by an attractive group of wares painted in a style known as 'The Master of the Rocks'. Even if the manufacture

was by this time highly organized, with some pieces passing through as many as seventy pairs of hands, one is often left with an impression of artistic spontaneity.

A subdivision of the blue-and-white group is that known as 'soft paste'. This term is ambiguous, as the material is not dissimilar from ordinary blue-and-white ware, the major difference being the lower kiln temperature of soft paste. The body is particularly sympathetic to the brush and the slightly duller blue against the pale buckwheat-coloured ground gives a

less austere effect. Most pieces of soft paste are small and they are frequently painted with children or genre subjects.

The Reign of Yong Zheng (1722–1735)

The following reign of Yong Zheng saw the appointment in 1726 of Nian Xi Yao as superintendent of the Imperial factory. He was, however, only resident at Jingdezhen for two years before he was sent to Huaianfu as Commissioner of Customs, though he still retained his control of the kilns. Many of the great ceramic innovations of this period have been attributed to him, but as he was living a great distance away, he could only have maintained infrequent contact with the operation, and thus much of the responsibility for these achievements must have belonged to Tang Ying who became his assistant in 1728.

The monochromes of this period are generally more refined and elegant versions of those manufactured in the reign of Kangxi. They include most of the glazes already mentioned as well as some new glazes like sapphire blue, tea dust, robin's egg and the transmutation glazes. Another aspect of Yong Zheng's reign was the interest in producing retrospective wares—that is, copies of Song or Ming porcelains or stonewares including Guan, Ge, Ru and Long Zhuan wares. Also attempted were copies of Xuande

blue-and-white and copper-red wares which are certainly superior to the Qian Long examples with their simulated 'heaped and piled' effect.

An important influence at this time was the Imperial Court's preoccupation with European culture. The previous Emperor, Kangxi, had actively encouraged Westerners and had shown particular favour to the Jesuits. He had thought highly of both their technical and artistic skills and engaged many in an official capacity. In 1715, Castiglione, a Jesuit brother, had arrived in Peking, where he was attached to the Imperial Court. His ability as a draughtsman eventually attracted the attention of Nian Xi Yao to whom Castiglione taught the rudiments of European painting techniques in the use of perspective and shadow. Contemporary with these events at the end of Kangxi's reign was the introduction from Europe of a rose-pink colour derived from gold chloride and tin, called 'Purple of Cassius' in 1650, after the discoverer, Andreas Cassius of Leyden. This, in combination with existing enamels, supplanted the *famille verte* scheme and became

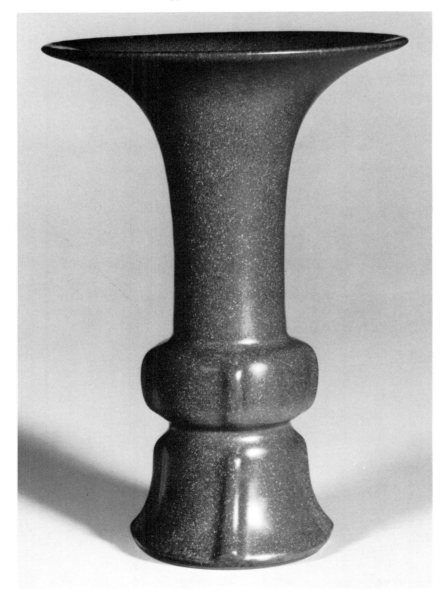

known as *famille rose*. This palette, known to the Chinese as 'foreign' ('falang') was used not only on those bowls bearing the characters 'Kangxi' and 'Yong Zheng Youzhi' which were allegedly decorated in Peking for imperial use, but also on the famous Gu Yue ware which Castiglione was known to have decorated.

This group given the nomenclature Gu Yuexuan (literally translated, Ancient Moon Terrace) originally included a series of small glass objects finely painted with floral, avian and figure subjects. This term was broadened to incorporate porcelain decorated in a similar fashion. The ware was at its best during this period and in the early part of Qian Long's reign, apparently ceasing to be produced upon the death of the director in 1754.

The Reign of Qian Long (1736–1796)

The accession of the Emperor Qian Long in 1736 coincides perfectly with the promotion of Tang Ying to director of the Imperial Factory. Tang, the most famous of the kiln directors had, according to Tao Lu of Jingdezhen, 'a profound knowledge of the properties of the different kinds of earth and of the action of the fire upon them ... and in the reproductions which he made of the celebrated porcelains of ancient times every piece was perfectly successful'. It was fortuitous that a strong emperor held a firm grip on the country, restraining or eliminating any internal opposition to his sovreignty. This allowed economic expansion a long period of prosperity and as a result the ceramic industry thrived, especially in the export market. The potters displayed great artifice not only in their studies of classical Song and early Ming wares but also in their execution of *trompe l'oeil* objects. They copied natural materials like jade and carnelian, mother of pearl, wood, and shells; they were inspired to emulate antique bronze vessels or lacquer ware, and the repertoire of monochromes was enlarged. Ancient bronze and iron rust were innovations of Tang's directorship.

Apart from the export-ware market, blue-and-white lost favour, and the only notable blue-and-

The most refined and delicately painted porcelains, known as Gu Yuexuan (Ancient Moon Terrace) were considered to have been most successfully produced after about 1730. Gu Yuexuan pieces were all small, and garlic-headed vases and wine pots (as above) are among the most usual shapes. Gu Yuexuan originally included a series of small, milky glass objects (as below) which are decorated in a similar manner to those made later, but without the poetic inscription. (Percival David Foundation, London).

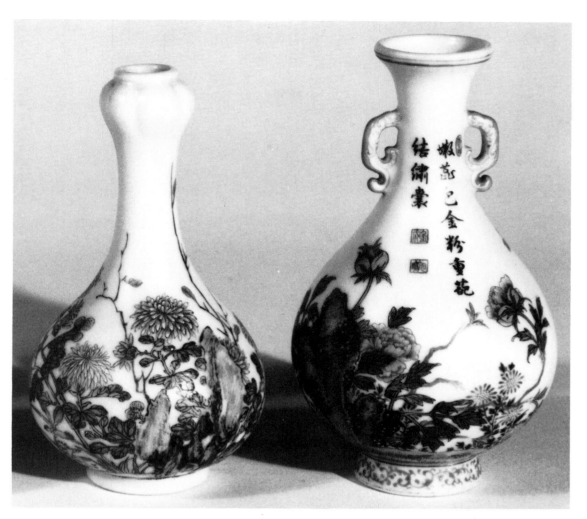

white pieces made during this reign were the large vases decorated in early Ming style. Following the departure of Tang Ying in 1753 there was a decline in the standard of workmanship and though there were still fine pieces being made, potters began to show a preference for complicated forms and over-elaborate decoration in European enamels.

The reigns of Qia Qing (1796–1820) and Dao Guang (1821–1851) showed a continuing downward spiral with virtually no innovation, perhaps due in part to the fact that the dynasty was plagued by internal revolts. The Emperor Xian Feng inherited a precarious throne, and in 1853 the Taiping rebels devastated large areas of central China including the kilns at Jingdezhen. This point represents the nadir of the Qing (Manzhu) ceramic tradition.

The kilns at Jingdezhen were reopened in 1864, during the reign of Dong Zhi (1862–1875). In fact, during this period, the powerful dowager Empress, Zi Xi ruled for her son, who was a minor. She encouraged improvement of the prevailing standards at the Imperial Factory, showing personal interest in it. Many fine porcelains were produced at this time, and also later, under the directorship of Guo Baozhang, who was appointed by President Yuan Shikai (1900–1909).

Particularly outstanding porcelains of the early twentieth century are the symmetrically decorated vases painted in the revived Gu Yuexuan style. Some examples of these have passed through major auction houses in recent years catalogued as dating from the eighteenth century. The quality of the painting is so fine as to be regarded by some authorities as transcending decoration, and being equal to painting on silk or paper.

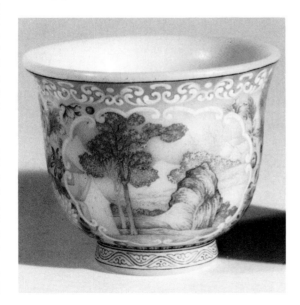

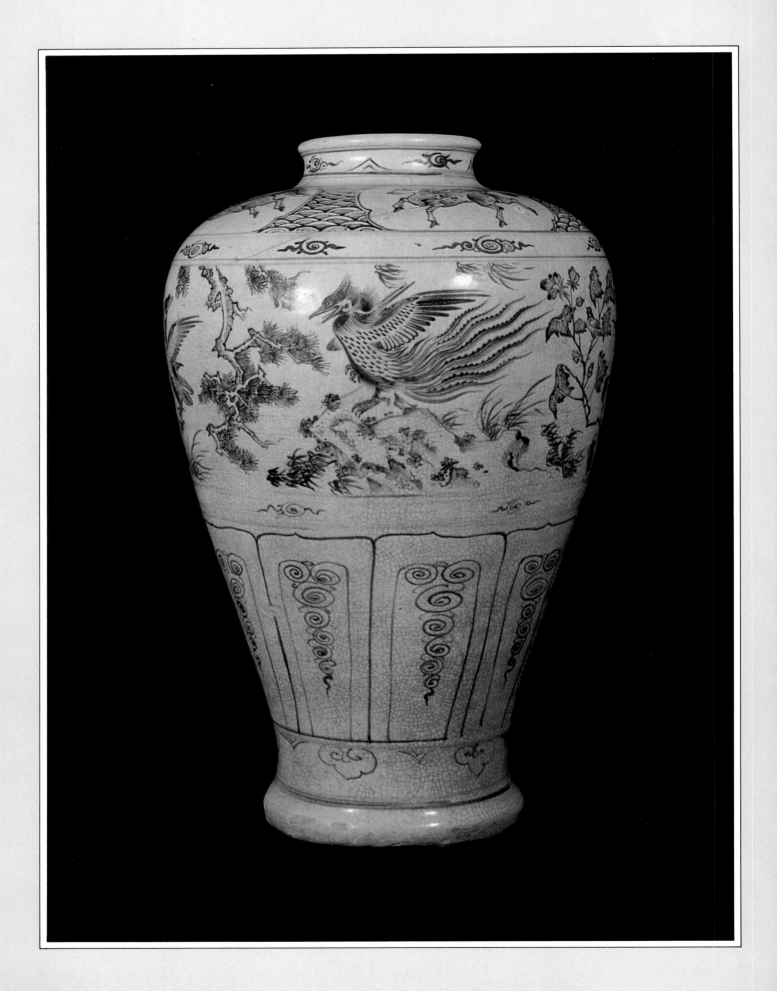

Chapter Three
Korean and Annamese Porcelain

KOREA is a mountainous peninsula which juts out from the shoulder of China below Manchuria, flanked on the east and west by the East and Yellow Seas respectively. The eastern sea-board is overlooked by the rugged Taebaek range, cloven at intervals by mountain passes through which pour torrential rivers onto the narrow coastal plain. From the western side of the range, spurs extend towards the Yellow Sea, enclosing like conduits the longer, less precipitous rivers which cross the most fertile region of Korea.

The early history of the country is that of tribal people occupying a naturally compartmentalized terrain, yet struggling for domination of the rich central zone. In the course of these hostilities alliances were sought with either Japan or China, and thus foreign customs and influences were introduced.

The Silla Dynasty
(57 BC–AD 935)

The pottery of the pre-Silla period (that is, before 57 BC) has an affinity with both Chinese and Japanese tomb ceramics. After centuries of invasion from Manchuria and China, as well as tribal struggle, the Silla regime, with the help of Tang China, gained ascendency over the central, eastern and south-eastern portions of the peninsula in 660. The pottery produced during this dynasty was generally composed of a grey clay fired at a temperature sufficient to obviate the application of a glaze. It is to be noted, however, that some pieces have a partial and accidental dressing of wood-ash glaze. The wares are predominantly monumental in construction, often derived from Chinese Han metalwork. A characteristic feature of this group is a tall, splayed foot pierced with rectangular openings. The decoration in these later Silla wares consists mainly of scale diapers, whorls or simple repeated geometric motifs which are either stamped or incised.

The Koryo Dynasty
(918–1392)

After years of internal feuding, the Silla dynasty was overthrown, and the Koryo dynasty was established. The founder, Wang Kon, proclaimed his intention of establishing a cultural identity for Korea which would be removed from the influence of China. In fact, however, during the first period of the Koryo dynasty, until about 1100, Chinese influence continued to dominate Korean porcelain, with respect both to materials and to forms.

It is a matter of conjecture as to when celadon was introduced into Korea, but it was probably some time near the beginning of the eleventh century. It is of great interest that the earliest dated piece of Korean pottery was made in 993. This vessel is covered in an unevenly applied feldspathic celadon-type glaze.

It has been shown that Korean potters in the early years of this dynasty drew their inspiration primarily from the Yue wares in Zhekiang, a southern province of China which enjoyed religious compatibility and close trade links, by means of a narrow and safe sea passage, with Korea. Aside from Yue wares, other recognized sources of Chinese influence include Ding, Cizhou and the exclusive Ru wares. Xu Jing, the celebrated scholar and calligrapher who accompanied a delegation of Chinese officials to the Korean capital, Kaesong, in 1123, wrote of Korean celadon:

> This is the most distinguished of all wares: the others resemble the old ware of Yueh and the new kiln wares of Ju-chou. ... They make bowls and dishes, cups and tea-bowls, flower vases and hot-water bowls, all copied from the forms of Ting ware ...

There is, indeed, common use of shapes in the two countries, evinced, for example, by foliated cup-

stands, melon-shaped ewers, lotus bowls and mae-pyong (Chinese: *meiping*).

If Chinese influence was dominant during the early centuries of the Koryo period, it certainly was not after about the beginning of the twelfth century. There is a totally different feel to these later Korean ceramics. It has been said that they have no immediate aesthetic appeal, but that 'they wait for you'. On the contrary, from my very first acquaintance with these wares I was deeply impressed by their grace of form and almost spiritual detachment. Yi Kyu-bo (1168–1241) saw the Korean potteries as 'denuding the forests and blotting out the sun with all their fires'.

The glaze on these ceramics is generally a pale, milky-green colour, somewhat bluer than its Chinese Longzhuan contemporary, and often crackled. Although most of the Koryo celadon was produced for the court, or for nobility, it rarely displays the mechanical sophistication of potting and the near-perfect glaze which is found on its Chinese counterparts. The individuality of the Korean potter is always evident. The vessels are frequently unevenly thrown, and the glaze may show areas of oxidation, but these idiosyncracies are an essential part of the Korean aesthetic. Technical considerations are clearly not seen to be of paramount importance; yet Korean porcelain at its best is lovelier than most Chinese.

It is in the use of inlaid decoration devised in the twelfth century, that the Korean potter decisively isolates himself from his mentor. The soft body was incised with channels following the design matrix, which were filled with black and white clay before

the whole was covered in the celadon glaze. Early designs were mostly floral. Cranes among cloud scrolls also appeared frequently, and occasionally ducks among reeds and lotuses, or children playing among vines are to be found.

Another Korean innovation was the use of copper red, which appears in the thirteenth century, long before the underglaze red of the Chinese Yuan dynasty. It is, however, not a particularly successful colour, and is mostly limited to use in conjunction with inlaid white decoration.

As the Mongol invasions pushed through Korea from the north to Japan in the thirteenth century, all types of ceramic declined in quality, and few innovations were made. The Court fled to Kanghwa Island and remained there in exile.

The Yi Dynasty (1392–1910)

Nevertheless, during the period of Mongol occupation the porcelain and celadon industry of Korea was not allowed to fall into decay, and the first few centuries of the Yi dynasty were characterized by highly original white wares, which were much esteemed by foreigners and by the Korean Royal Household.

Better raw materials became available in the fourteenth century, and there are references to the white clays of Songch'on, Pongsan, Kwangju and Yoju, near modern Seoul. Hadong clay was a natural porcelain mixture and petuntse was brought from

successful, or who could find a supply of high-grade cobalt ore. Native supplies of cobalt from Sun-ch'on are mentioned in 1464, but proved unsuitable for decorating porcelain. Chinese cobalt, including that obtained from the Middle Eastern mines at Kashan, must have been imported at great expense. A decree of 1461 limited the production of blue-and-white by prohibiting its use except by the warrior class. The rarity of blue-and-white before 1650 was also due to the scarcity of cobalt resulting from the Japanese and Chinese invasions of 1592 and 1636.

The earliest blue-and-white porcelains made in Korea derive from Chinese Xuande period originals of the late 1420s and early 1430s. In 1428 Chinese gifts of porcelain encouraged their manufacture. Jars and dishes painted with underglaze-blue chrysanthemums linked by thin scrolling stems are the most typical designs.

A new, and characteristically Korean, style may have superseded these wares about the time of the Japanese invasion in 1592 but it was hampered in its development by the ensuing war until the early seventeenth century. Whatever its date, it is unmistakable in appearance. Flasks, jars and bottles, often faceted, are painted in a unique, sparse style, with wispy sprays of lotus or prunus.

Earlier Chinese painted decoration of the Cizhou type influenced Korean potters to experiment with underglaze pigments such as iron and copper oxides. These red colours were now combined with cobalt blue or used instead when it was unobtainable.

Simplicity was a feature of early Korean porcelains and celadons, brought about by the scarcity of suitable decorating pigment. Designs were confined

Above: Korean bottle of the Yi dynasty reflecting the influence of early Chinese underglaze pigments. Height 28.5 cm. (Fitzwilliam Museum, Cambridge)

Yanggu in the north or Pusan in the south.

The most important group of kilns was in Kwangju, and in 1466 the Royal Family took control of the manufacture of undecorated white porcelain by a contract system. It was reserved for court use and for ritual purposes. Delicate, ribbed rice-cake stands, incense boxes, modelled water droppers, stem cups, wine bottles, were all commonly made or moulded in white porcelain with an unctuous blue-toned glaze. Many faceted jars, cups and bowls were also made.

In 1469 the making of blue-and-white porcelain in Korea was encouraged by the Royal Court, with the promise of wealth and rank to those potters who were

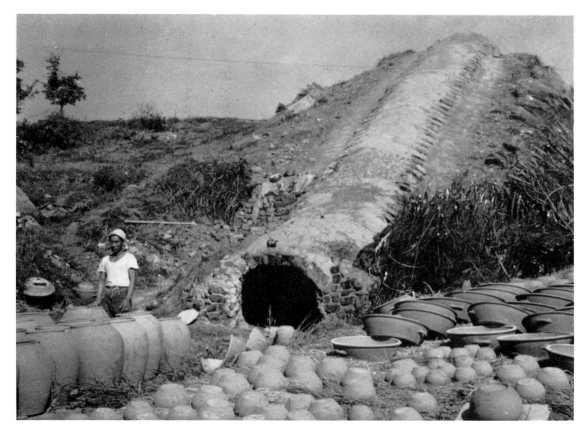

Left: Modern version of a traditional type of kiln, the tunnel kiln, which has been in use in China and Korea since the Ming dynasty.

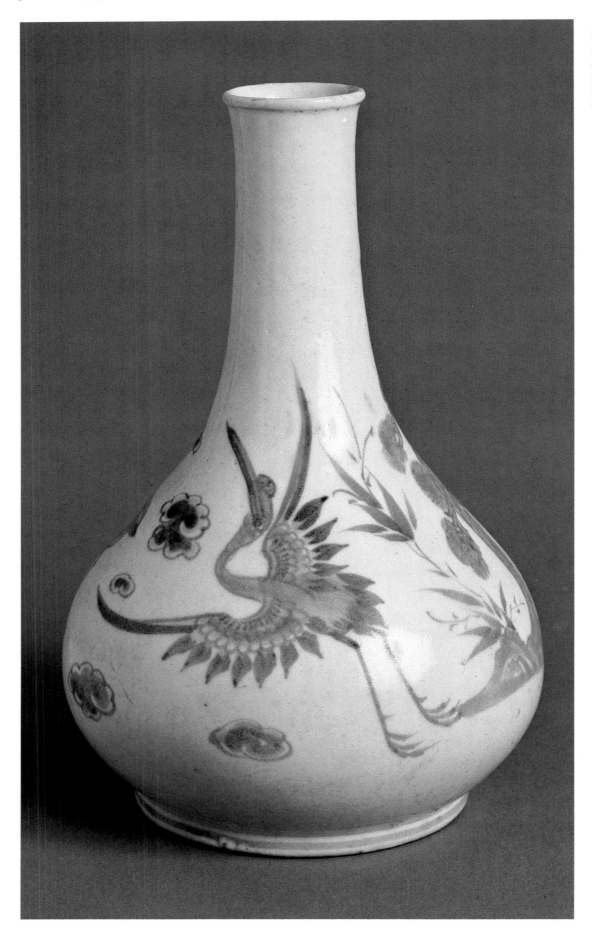

Eighteenth-century Korean bottle decorated in underglaze cobalt blue. The delicately painted crane, a typical motif, symbolizes longevity. (Fitzwilliam Museum, Cambridge)

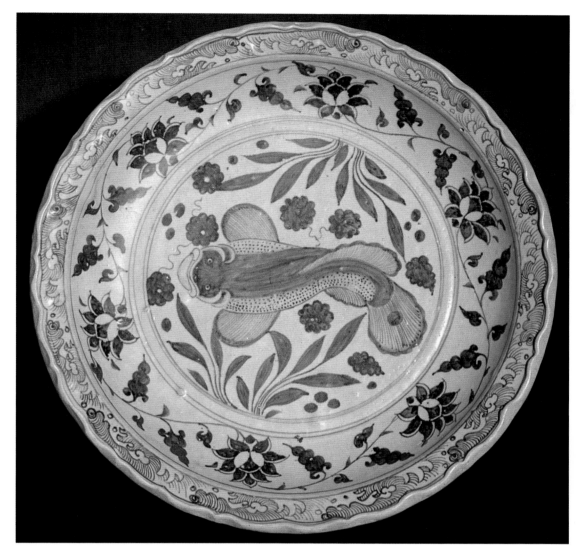

Porcelain from Annam reveals a marked Chinese influence. The Annamese dish (left) closely copies the fourteenth-century Yuan example shown below, and is probably late fourteenth or early fifteenth century. Diameter of Annamese dish 39.5 cm, diameter of Yuan dish 39 cm.

to a minimum or, most characteristically, to a single area on the surface of the form. Even the positioning of a motif on the form can be of the utmost importance to the design and effect.

The use of Chinese cobalt continued to be restricted until 1754. It seems quite clear that the very scarcity of cobalt was in large part responsible for the beauty of Korean porcelain. The heavy potting and simple decoration of seventeenth-century Korean porcelain can be a more satisfying aesthetic combination than that of the finest fifteenth-century Chinese porcelains. But in the mid-eighteenth century, when cobalt supplies became more plentiful, decoration on porcelain wares became commensurately more elaborate. There were no further developments of importance in the history of Korean porcelain, and in the nineteenth century, during a period of social turmoil, the Imperial Factories went bankrupt.

Annam

Annam is the former name of that region of Southeast Asia which occupies what is now the major portion of North Vietnam.

There is much mystery surrounding the manufacture of porcelain in Annam. Until the 1960s, Annamese porcelain was rarely distinguished from Chinese, and even experts frequently confused the two. Serious research on Annamese wares was only initiated after excavations in the Philippines and the East Indian Archipelago in the 1960s revealed porcelain wares similar to some which had been excavated in kiln sites in Annam, indicating that many porcelain wares, which had previously been taken to be Chinese, were in fact made in and exported from Annam.

It is now clear that porcelains were made in Annam before the fifteenth century, and, indeed, it appears that the first use of cobalt in Annam was more or less simultaneous with the first use of cobalt in China, in the fourteenth century.

The vicinity of Hanoi has abundant supplies of feldspar and kaolin to furnish the three major kiln sites of Huong-canh, Tho-ha and Bat Trang. During the fifteenth century, Huong-canh produced mainly domestic pottery of relative unimportance, but Tho-ha and Bat Trang manufactured fine wares, especially in blue-and-white.

Annamese ceramics have been classified into three groups – monochromes, those with underglaze, and those with overglaze decoration. All, however, utilize the same close-grained paste. The most important are the latter two groups. The earliest use of underglaze iron and cobalt has obvious affinities with the blue-and-white and copper red used in China during the Yuan dynasty (1280–1368). During the first quarter of the fifteenth century, Annam was occupied by Chinese forces. The Annamese potters drew inspiration from Chinese decoration, as, for instance, in the somewhat cursorily drawn flower-heads which were popular. They also imitated Chinese shapes, such as pear-shaped bottles (you hu chun ping).

Soon, however, the Annamese developed their own repertoire. This included bold painting with indigenous cobalt ore, as well as more careful, delicate painting with the cobalt blue containing less manganese, which was imported from the Middle East. It has been suggested that this more expensive, cleaner-looking blue was reserved for imperial use, or at any rate for the sophisticated members of the aristocracy.

Apart from standard items such as saucer dishes, bowls and baluster vases, the more common objects encountered are small, circular covered boxes (either lobed or plain, with or without knobs), globular or mushroom-shaped oil jars, kendis (globular drinking vessels with spouts, which in Annam were either of zoomorphic derivation or of Middle-Eastern influence), and water-droppers based on animal forms

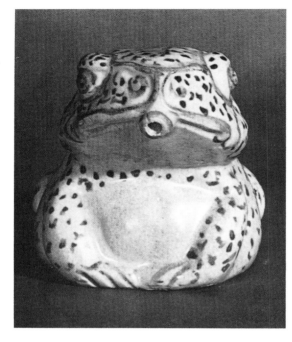

such as crabs, frogs, tortoises and ducks. Decorative motifs generally employed were peony and lotus, *ruyi* (fungus) heads, cloud and foliate scrolls and trellis diaper reserves.

The wares characteristically have a greyish milky glaze over a grey proto-porcelain body, the surface of which shows many tiny holes (pinholes) and signs of tearing which suggest that the vessel was thrown

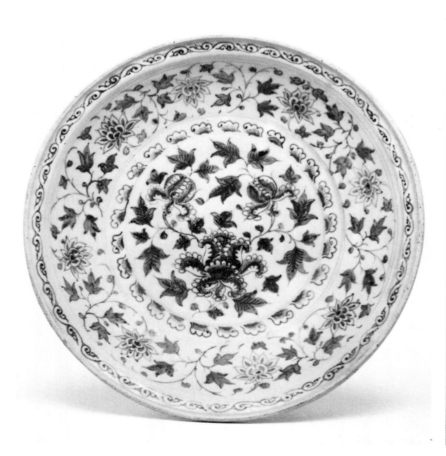

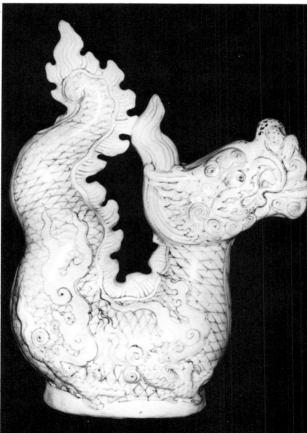

when the clay was dehydrated. On smaller objects such as water or oil jars, which are the most numerous, the foot is recessed to a depth of between one and two millimetres. Larger ceramics, including saucer dishes, are almost invariably unglazed at the rim. A common failing on Annamese blue-and-white, especially when the native, less pure cobalt has been employed, is the frequency of oxidization. The heat of the kiln has allowed the underglaze decoration to penetrate the thin glaze and turn black. There has been much conjecture regarding the wash of chocolate brown slip which appears on some pieces but not on others of identical form and decoration. It has been suggested that the pieces with this slip were reserved for temple use.

The best Annamese porcelain seems to have been made during the same period that there was an interregnum in China – between the death of the Chinese Emperor Xuande in 1435 and the assumption of the throne by Emperor Cheng Hua in 1464. There is a dearth of Chinese pieces dating from this period, and it would appear that the potters of Annam were commercially aware enough to take advantage of this opportunity to export their own wares. At the same time, they were inspired to greater artistic heights. The only absolutely authenticated case in point is the celebrated blue-and-white bottle, now in the Topkapi Museum in Istanbul, which bears an inscription dating it indisputably at 1450. This gives a yardstick by which to date other blue-and-white wares of the period. This bottle exemplifies the influence of early Ming ceramics on Annamese wares as well as some of their purely indigenous characteristics. In the main zone of peony meander, for instance, the foliage has pointed leaves in a manner which is typical of those found on fourteenth-century Chinese blue-and-white or copper-red-and-white wares. The peony flowerheads however, although they follow the Chinese configuration, are executed in a solid almost three-dimensional manner, unlike their Chinese counterparts. The overall appearance of the bottle does not display the technical or graphical sophistication of the Ming wares produced before or immediately after this piece. A factor which contributes to its homespun character is the very nature of the body of Annamese ceramics: it is, as is Chinese soft paste (*hua-shi*), a medium more sympathetic to the brush, and one which does not allow that cold, detailed beauty of hard-paste porcelain. The border motifs again have obvious Chinese antecedents in the use of lappets (oblong panels) and classic scrolls. They are not, however, strict copies but distinct Annamese variations which appear time and again on smaller utensils. The form of the bottle is rudimentary and does not display any of the elegance of a contemporary Chinese vessel. The impression left by this and the majority of Annamese wares, with the exception of the charming animal-form water droppers, is that they were manufactured primarily for functional rather than for decorative use.

Two other blue-and-white vessels, probably manufactured at the Bat Trang kilns, are dated 1575 and 1665. These are in the possession of the Ecole

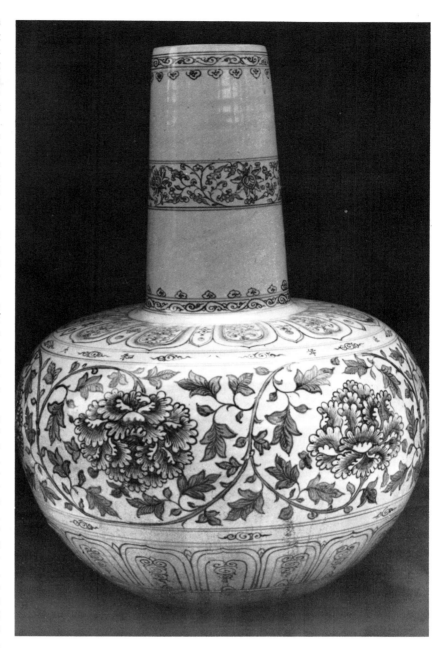

Française d'Extrême Orient in Hanoi. From the fact of their existence, as well as of the existence of similar, though undated wares, it can safely be assumed that Annamese porcelains were produced, probably without interruption, well into the seventeenth century. Polychrome wares are much rarer than blue-and-white and on loose stylistic criteria can probably be ascribed to the second half of the fifteenth century and after. The enamels used included green, tomato red, and occasionally gilding, but they seem to be more evanescent than their Chinese counterparts, and extant examples show considerable rubbing and flaking.

Though the quality achieved during the middle of the fifteenth century was never again equalled, during the sixteenth and seventeenth centuries Annamese porcelain continued to be made to a fairly high standard. After the seventeenth century, no recognizably Annamese porcelain has been found.

The famous blue-and-white bottle which is the one indisputably dated Annamese piece and thus used to date all other pieces from the same period. Height 43 cm; 1450. (Topkapi Saray Museum, Istanbul)

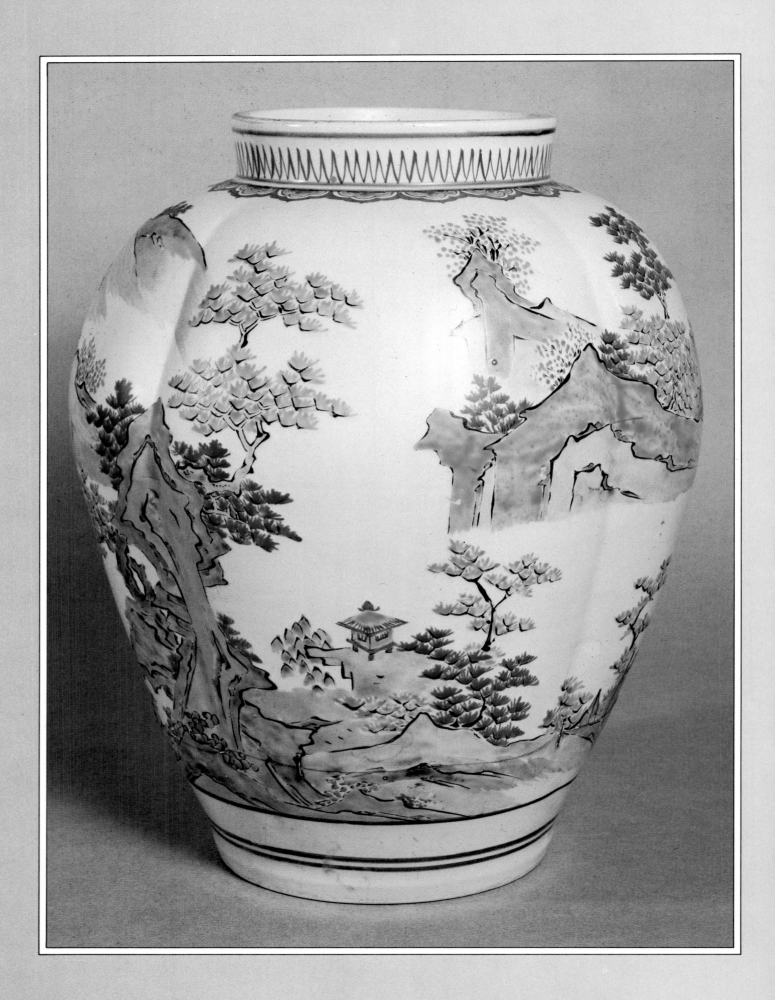

Japanese Porcelain

JAPAN is traditionally a country of stoneware; although porcelain had been made in China since the eighth century, it was not made in Japan until the beginning of the seventeenth century. Japan owes much of its cultural heritage to Chinese influence, whether through Chinese teaching or through Chinese imports. Among these was porcelain. Excavations at the sites of ancient palaces, seaports, temples and *Sutra* mounds (mounds in which Buddhist texts, or *Sutras* were buried) in Japan have yielded large quantities of imported porcelain dating from the ninth century onwards. Some of these pieces are of shapes suitable for Japanese usage but not for Chinese (such as *Sutra* cases) and it is clear that these pieces must have been made specifically to order for Japan, implying a steady and well-established trade. Most pieces are ordinary trade wares, bowls and dishes of white ware and celadon, but during the Song dynasty (960–1279) China also exported fine quality pieces that were clearly for aristocratic taste. Some of these pieces still exist in old Japanese collections. As porcelain was not yet made in Japan, these imported wares were copied in stoneware: the best copies were the glazed jars and bottles made at Seto in the fourteenth century.

The Tea Ceremony

Chinese wares were particularly prized for use in the tea ceremony, an aristocratic gathering of friends that was to become, in the sixteenth century, a formal, ritual way of divesting the mind of everyday troubles through the preparation and drinking of tea, in simple surroundings, and using utensils that would be admired for particular aesthetic reasons.

It is these aesthetic principles that have so influenced later Japanese art, and especially Japanese ceramics. At first, the Japanese preference was for Chinese wares of acknowledged perfection of shape, but soon the simpler Chinese wares, especially the

Song *temmoku* (the Japanese name for iron-brown-glazed stoneware) teabowls came to be admired for their strength and lack of sophistication. During the course of the sixteenth century other wares came to be appreciated – first the crude Korean food bowls and then even some Japanese country-made stonewares, particularly those from Shigaraki. From 'found' wares to specially ordered wares was but a step, and by the 1560s several kiln areas of Japan (notably Mino) were making tea wares to order. But porcelain, though it had to be imported from China and Korea, was still favoured for the tea ceremony.

Korean Influence

At the end of the sixteenth century, the situation suddenly changed. The Japanese general, Hideyoshi, invaded Korea, and many Korean potters were brought back to Japan either as immigrants or as captives. These potters started kilns in various places on Kyushu, the southern island of Japan which is closest to Korea. Among the most important stoneware products of this period are the Karatsu wares of the Hizen province in north-western Kyushu. Although wares had been made at Karatsu before this period, around the turn of the century there was a marked change in both decoration and shape, showing Korean influence.

The finding of porcelain clay in the town of Arita, also in Hizen, is attributed to the Korean immigrants, but stoneware in Karatsu style had clearly been made in Arita for a long time, and it is curious that these potters should have been sitting on a mountain of porcelain clay without making porcelain. In the early seventeenth century, Chinese porcelain, mostly blue-and-white, was becoming fashionable again in Japan, and it seems clear that some of the Karatsu-style potteries of the western part of Arita began to make porcelain concurrently with stoneware, to compete with Chinese imports.

Below: Woodblock print by Utagawa Kunisada showing two blue-and-white bottles, probably of Hasami porcelain, standing in a room, perhaps a restaurant. From the mid-eighteenth century Ukiyo-e prints showing such pieces tell us much about their usage and date. c. 1830. (British Museum, London)

While in Japan the Arita kiln, Tengudani, is usually held to be the first Japanese kiln to make porcelain, this seems to be unlikely—despite the fact that a known Korean potter's name is linked with the kiln. The Tengudani kiln never made pottery, and it is possible that the idea that it was the first to produce porcelain arises from an assumption which is more likely to be true—that it was the first kiln to make *only* porcelain.

If it is not known which kiln was the first to produce porcelain, it is incontestible that as soon as

production began, several kilns started making it almost simultaneously during the early years of the seventeenth century. The first porcelains were simple and rather crude, with a thick opaque grey body and a heavily blue glaze. Decoration tended to be sparse but boldly drawn in sweeping lines; this style of painting has led to its identification as a 'Korean' style, but it should be noted that what Korean influence is there is second hand and comes from Karatsu stoneware, for the Korean potters of the late sixteenth century had not been making blue-and-white. The decoration available to the early porcelain potter was not only blue-and-white but also a rather poor quality celadon and a brown or black iron glaze presumably meant to imitate *temmoku*.

Earliest Japanese Wares

These earliest wares, called in Japan *Shoki-Imari* (Early Imari), are of considerable interest, but are little known in the West because they were not made for export. They fall roughly into three categories, the first and earliest being the so-called Korean style already mentioned.

The second was a style which appeared in the 1620s, which resembled Chinese Tianqi wares (Tianqi was a Chinese Emperor who reigned from 1621 to 1627). These wares were imported from China in great quantities from the 1620s until the 1640s, and the Japanese wares, which were so similar in shape and decoration, were obviously competing for the same market. In fact, this style was quite alien to contemporary Chinese taste and was clearly created especially for the Japanese market. It should therefore be seen as a Japanese style owing its origin to the *Shoki-Imari* wares rather than as a real Chinese style. Most of these early pieces, whether Chinese or Japanese, were not for use in the tea ceremony, though they were greatly influenced by 'tea taste'. This Tianqi style itself breaks down into two substyles—one dashing and rather painterly, with vigorous but disciplined brush-work, and the other a geometric style, which is sometimes purposely imbal-

Left: Small blue-and-white petal-lobed dish of the early seventeenth century. This type, called Shoki Imari in Japan, was made before the Dutch started to buy Japanese porcelain. This dish is partly in a Japanese style of decoration, and partly in a Chinese style which was itself a response to Japanese demand, being made specially for the Japanese market. The mixture of geometric patterning and floral decoration is quite usual, while the panelled border reflects earlier Chinese styles. (Ashmolean Museum, Oxford)

anced. These two styles are of course in no way contradictory and are often combined in one piece. As the kiln furniture available to the Japanese porcelain-potter was relatively simple (compared to that used by the Chinese) the early wares are nearly all fairly small, being mostly bottles, plates, bowls and cups, and are characterized by small footrims. By the 1640s saggars were being used and bigger pieces could be made.

The third style, which appears probably in the 1650s, is a refinement of the Tianqi style, which is, in effect, reduced to its essentials; this in turn has a very considerable effect on the later porcelains of Arita. While large quantities of celadon and iron glaze continued to be made, often in conjunction with blue-and-white, or even with each other, there were as yet no enamel colours. Underglaze red had been used briefly in the 1640s or so, but it was not very successful and was quickly dropped.

The Period of Isolation

Beginning in the early 1620s, a policy of isolationism was adopted by the Tokugawa ruler, in an attempt to abolish Christianity in Japan, and by 1639 Japan's self-imposed isolation from the rest of the world was virtually complete. All European trading nations had been driven away except the Dutch. The only access the outside world was allowed to Japan was through trading stations conceded to the Dutch East India Company, and to the Chinese in Nagasaki Harbour. The Dutch trading station was a small reclaimed mudflat called Deshima Island. The conditions imposed by the Japanese Government upon the Dutch and Chinese traders were extremely severe and only the enormous profits that accrued from the trade

persuaded the Dutch to accept them. The main Japanese export was copper, and no porcelain was exported during this period.

Until the middle of the century, the Chinese exported porcelain to Japan, and the Dutch bought all the porcelain they wanted from China, though during the 1640s the Japanese did begin to export porcelain to Southeast Asia and to the Ryukyu Islands in small quantities.

The Export Trade

Around the middle of the century, following the fall of the Ming Dynasty in China, the situation changed radically. Instead of importing Chinese porcelain, the Japanese started to export their own porcelain. The Dutch, wishing to continue to sell goods for which they had a ready market, as well as needing the porcelain for ballast, began to order Japanese porcelain which was in imitation of late Ming styles. This led to the enormous export trade of Japanese porcelain in the second half of the seventeenth century, and in the early decades of the eighteenth, after which it decreased in volume, though it continued until well into the nineteenth century.

The first official purchase of Japanese porcelain by the Dutch occurs in 1650; the first order for specially made objects in 1553, and the first really large order in 1659. Whereas the 1658 order had been for 5257 pieces, the 1659 order was for 64,858 pieces. In Japan, the sudden flow of orders from Holland in particular caused widespread changes in the organization of the Arita kilns. Certain kilns ceased to function, while the twelve or thirteen kilns that seem thereafter to have specialized in the export trade became much bigger than before.

Right: Tankard in blue-and-white Arita porcelain with a silver lid added in Europe. The shape is typical of Japanese export copies of European shapes made to order for the Dutch. The decoration is based on the Chinese Transitional style. Height 16 cm; c. 1669. (Ashmolean Museum, Oxford)

Far right: Early enamelled jar made for export. The palette is based on predominant blue and yellow, thus distinguishing this type from other early enamelled wares. Several groups of enamellers must have been working in competition before the well-known styles emerged. Height 21.4 cm; c. 1660. (Ashmolean Museum, Oxford)

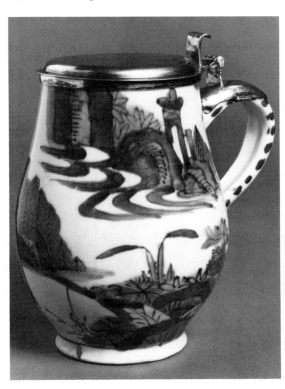
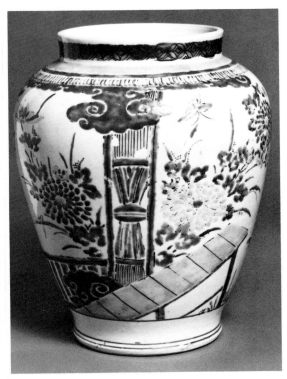

The earliest porcelains were mostly blue-and-white wares, variations of the Chinese Transitional (c. 1620–1683) and Wanli (1572–1620) styles. The Dutch had supplied models of these for the Japanese to copy, but the models supplied were not the Chinese originals but wooden models made in Holland and presumably painted by the potters of Delft. This explains the somewhat eccentric painting of many mid-seventeenth-century Japanese porcelains. The shapes, too, are of European usage and do not usually conform to normal Japanese demand. Very often the shapes were taken from German stoneware, just as later they were to be taken from European silver, glass and even pottery.

The origin of the use of overglaze-enamel colours in Japan occurs almost simultaneously with the first Dutch exports. Japanese tradition would have it that a Japanese potter learned enamelling from a Chinese at Nagasaki in 1643. We are, however, unable to identify any Arita enamelling as early as this, and the earliest Japanese palette of enamels differs from that of the Chinese in that it lacks a yellow and possesses an overglaze blue. It must be suggested that its occurrence in the 1650s, when Japan began exporting porcelain to Holland, is more than coincidental, especially when it is remembered that enamelling also began in Kyoto at about this time (in this case on a low-fired body). The earliest known mention of enamelled Arita ware occurs in the diary of a Kyoto tea-master in 1653. The earliest European reference to enamelled Arita ware is in the shipping lists of the 1659 order, where there is considerable detail given regarding colours and shapes and even some indication of pattern. The colours include red, green and gold, but we are unable to identify any of the wares listed with existing pieces.

At about this time a new porcelain was first produced in Kanazawa on Honshu, the main island of Japan. This was to lead to the famous Kutani ware. No doubt the Maeda Lord of Kanazawa had noted the success of the Nabeshima lord of Saga, in which area Arita lay. Kutani porcelains have proved a most fertile field for argument for Japanese ceramic historians ever since, and will be discussed later.

The Arita export porcelains were shipped from the port of Imari to Nagasaki and thence to the rest of the world. This has led to the confusion in nomenclature whereby in Europe we usually call the blue-and-white wares Arita and coloured wares Imari, save only for one specified group, the Kakiemon. The Japanese called all these wares Ko-Imari, or Old Imari, except the Kakiemon. But it should be remembered that they are in fact made at some dozen kilns in Arita.

The earliest known blue-and-white export wares for the Dutch were intended for the apothecary's shop in Batavia (Jakarta) the headquarters in the East of the Dutch East India Company. Soon models were sent to be copied, and the instructions given to the Japanese as to how these pieces should be decorated. A typical order is for '5000 fine coffee cups with feet, according to the sample with blue flower-work painted on them as may be seen in the model'.

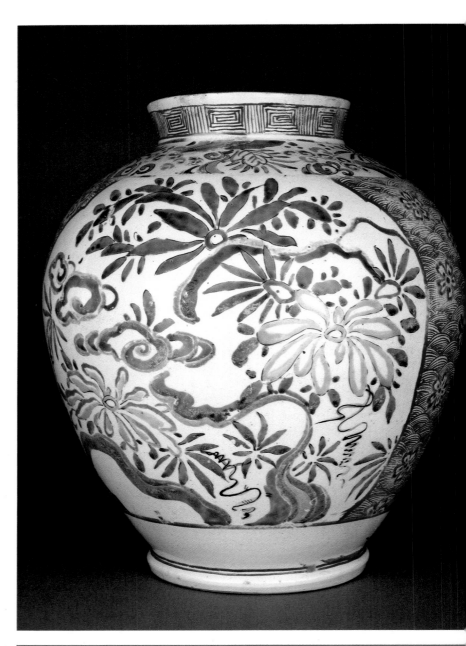

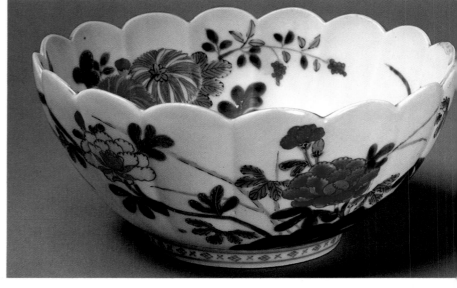

Left: Early enamelled Arita jar of the 1660s or 1670s, decorated in one of the other combinations of colours found in the early period only. The shape is more typical of the early period than is that of the jar on page 45, but the shape of that jar was used for seventy years or so in various sizes, whereas this shape occurs only rarely later. (British Museum, London)

Right: Large Imari bottle whose dark and rather coarse enamels and style of decoration within the cartouches is typical of one group of early Imari. Formerly it was thought that these pieces were made at Kutani, but it is now recognized that they are from Arita; they are thus called Imari wares in Kutani style. Height 39 cm; c. 1660–80. (Ashmolean Museum, Oxford)

Below left: Lobed and fluted bowl in the most typical of the Imari styles and palettes of the period after 1680. The use of underglaze blue, applied so as to leave gaps for the later addition of overglaze enamels, is very common. Diameter 20.8 cm. (Ashmolean Museum, Oxford)

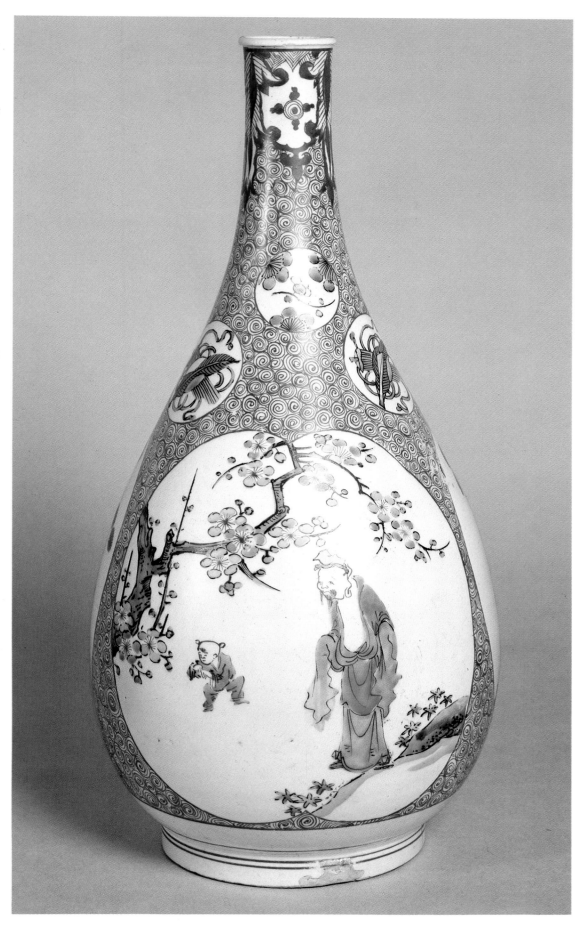

In 1659 the factor (agent) in Deshima wrote to Holland:

> I had contracted with a certain person for about 200 pieces after my own invention, to be made curiously, on a blue ground with silver tendril-work ... But seeing later on that all corners and shops were filled with them and that they were now as common as grass I have taken less of them ...

This demonstrates the strong influence of Dutch taste on the Arita potters; they were catering for a specific market. Thus the export wares, being based on a European variation of Chinese taste, are rarely in 'tea' taste. The shapes reflect this too. They are shapes already well known from Chinese wares for the European market, and from Dutch tin-glazed earthenware and German stoneware; jugs, mugs, bottles, bowls, dishes with wide rims, and later such things as butter-dishes, salt-cellars, and shaving-dishes.

Formation of New Styles

The earliest enamelled wares, those of the late 1650s and 1660s, seem to be divided into three or four groups which can be classified by the palette of enamels used, and only to a lesser extent by the style of painting at this early stage. The earliest pieces tend to have no underglaze blue but to be entirely in enamels. If underglaze blue is present it is usually confined to circumferential rings, or to simple patterns at rim, feet or neck. The use of underglaze blue in conjunction with overglaze enamels implies a more sophisticated form of mass production than appears to have existed in Japan at this period. Until the nineteenth century, Japanese porcelain was not biscuit fired; the underglaze-blue pigment would be painted on to the unfired body and then glazed before it was fired. This contrasts with the practice in Europe.

The groups of enamellers responsible for the various palettes of enamels may not have been potters, for one sometimes sees objects of basically the same shape and possibly from the same kiln that are yet enamelled differently. Japanese tradition suggests that these enamellers may have been very specialist. The range of styles on enamels seems, in the third quarter of the seventeenth century, to have narrowed down somewhat before the full flowering of the two main styles which came to dominate Arita porcelain, the Kakiemon style and the other more general Imari style (which can be further divided into many sub-styles).

Imari Wares

Imari wares vary very considerably. At their best they are delicate and beautiful, differing from Kakiemon wares in the colour of the body and in the palette of enamels. Some of the best Imari wares have no underglaze blue but many of them use with great virtuosity the mixture of underglaze blue and overglaze enamels. It is easy to deride the worst of these wares as coarse and crude but it should be remembered that these pieces were made specifically for export, and accurately reflected the taste of the buyers. The size and ostentatious magnificence of the Imari wares increased during the seventeenth century, culminating in the great vases and over-decorated garnitures that were considered obligatory for every nobleman's house throughout Europe. The greatest collection of these in Europe was to be found in Dresden, where Augustus the Strong, a most rapacious collector, has left us an invaluable inventory, and the collection that is described in this inventory. It is therefore possible to identify large quantities of Japanese porcelain as being certainly made before 1731, the date of Augustus's death.

The range of enamels used in Imari wares is wide, but typical are aubergine, two shades of green, blue, turquoise and a rather dull red. There is also considerable use of gold and, in some cases, of black. Silver rarely appears after the 1670s, as it oxidizes too quickly. The underglaze-blue painting on these wares does not outline the picture, but it leaves blank the space to be enamelled, allowing a later outline of black enamel to be put round any flowers or leaves or figures depicted. This is also the case with the less fine of the Kakiemon wares (in contrast to the Nabeshima wares that will be discussed later). Often, however, there are very elaborate shapes of cartouches (scroll-like decorations), or similar outlining patterns painted in underglaze blue which then contain overglaze enamel pictures. As the eighteenth century progressed, the vigour characteristic of the

Large Imari dish in a commonly used palette of dark enamels. The decoration is of various flower and animal scenes within a variety of differently shaped cartouches whose patterns are derived from textile design. Large dishes of this type were made in quantity for Europe at this time. Diameter 54.6 cm; c. 1700. (Ashmolean Museum, Oxford)

Large Kakiemon covered bowl with a knob modelled as a shishi (lion dog). This bowl was made at an Arita kiln before the foundation of the Kakiemon kiln, that is, before about 1670, but it was decorated in the style and in the palette of enamels used at the later Kakiemon kiln. It was therefore decorated by a group of enamellers who later either set up the Kakiemon kiln or who specialized in working for the new Kakiemon kiln. Although it is here called Kakiemon, the actual body with its underglaze-blue circumferential lines is really Arita. Height 35 cm. (Metropolitan Museum of Art, New York)

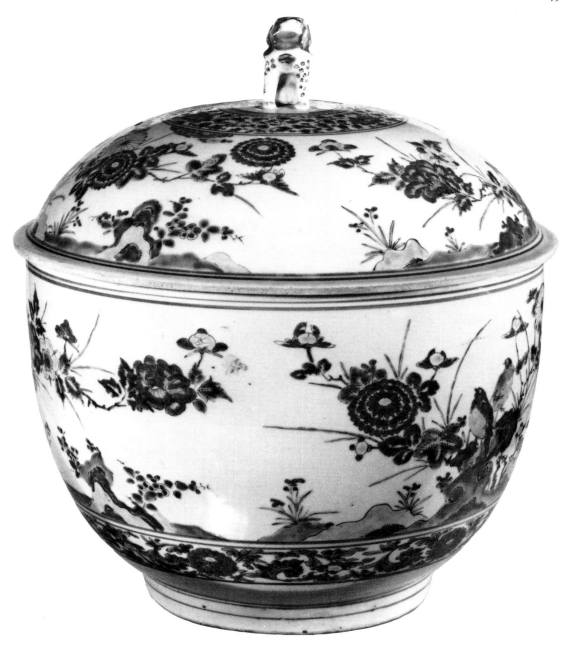

early Imari painting was less in evidence. The later pieces are notable either for their somewhat elegant and mannered painting, or for their slipshod execution. Quality improved in the early nineteenth century, as a result of the increasing influence of outside styles, but the arrival in Japan of European techniques in the middle of the nineteenth century changed production methods, styles and workmanship very considerably.

Kakiemon Wares

The Kakiemon style, when fully fledged, clearly derives almost directly from one of the early enamelling groups. The style is named after the Kakiemon family, whose members were enamellers before they became potters. The famous Kakiemon kiln seems to have been founded in the last twenty years or so of the seventeenth century, whereas Kakiemon-style enamelled pieces are found earlier than this. The Kakiemon wares, like wares of almost every kiln, are of different qualities, depending upon the different markets they are designed for. The finest Kakiemon wares are justly famous for their delicate beauty. Their leading characteristic is that of sparse decoration in beautifully coloured translucent enamels on a pure, rather milky-white body, the glaze of which lacks the characteristic blue tinge of other Arita wares. The inferior pieces of the same date have some painting in underglaze blue which is glazed and fired, leaving spaces for later enamelling. The Kakiemon are the best of the Japanese export wares and were shipped to Europe in considerable numbers. It seems likely that the Chinese bought more of these wares than the Dutch, selling them to other European East Indian Companies in various trading stations in the Far East and in Southeast Asia, for

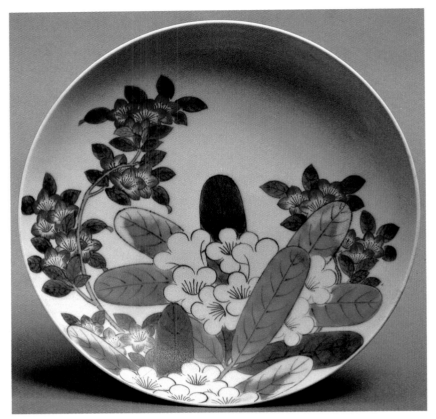

Dutch collections are relatively short of Kakiemon wares while English, French and German collections seem to abound in them. In some ways it is surprising that these fine and delicate wares were so highly prized in Europe, in view of the general inclination towards brasher and more obviously exotic wares. But it was these Kakiemon wares which provided the inspiration for the European porcelains made first at Meissen and then at other factories in Germany, France and England. It may be noted parenthetically that the first underglaze blue of Meissen was not particularly successful, so that the obvious ware to copy was one that had no underglaze blue.

Kakiemon wares were, of course, instantly imitated by other kilns in Arita, and the famous milky-white body has been found at several other kiln sites. The style has continued, with fluctuations in quality, and mirroring changes in taste, up to the present day.

Nabeshima Wares

Towards the end of the seventeenth century the Nabeshima Lords of Hizen began to use especially fine quality porcelain for their own use, and for presentation. This led to a new style, the so-called Nabeshima style. The history of this is complex. In the 1680s, during the greatest period of export porcelain production, certain kilns had continued to

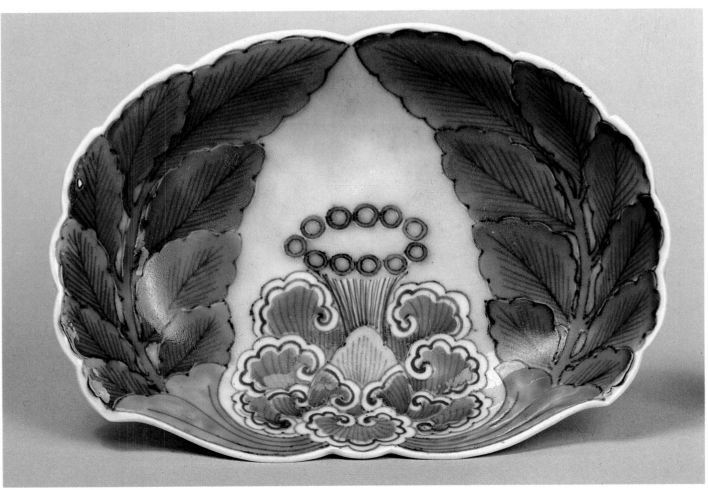

Left: Nabeshima dish of highest quality, flower pattern outlined by underglaze blue. Diameter 20.5 cm; c. 1720. (Ashmolean Museum, Oxford)

Below left: Nabeshima dish with formalized flower pattern. Width 16.2 cm; c. 1710. (Victorian and Albert Museum, London)

Below: Green Kutani dish decorated in dark and brilliant enamels. Diameter 34 cm; late seventeenth century.

make wares for the domestic market. Some of these kilns made an elaborately decorated, often eccentrically shaped style, called in Japan the Matsugatani style, which seems to be ancestral to the Nabeshima wares. At the end of the century, there was a switch of favour, so that the kiln ordered to make the presentation wares was at Okawachi, some eight kilometres from Arita, and not at Arita itself. The wares made at this kiln vary in quality depending on the market they are intended for. We are only concerned here with these presentation wares. The Nabeshima wares are nearly all bowl-shaped dishes on a tall foot, or small cups. The bowl-shaped dishes generally come in three sizes and may be either in underglaze blue only, or in underglaze blue and overglaze enamels. The style of painting is elaborate and careful and imitates the Chinese *doucai* technique of filling in with overglaze enamels a previously

painted underglaze-blue outline. The decoration is most often in the form of flowers or of elaborate formal patterns, and quite often celadon is used in careful conjunction with other colours. The foot of the bowls is always tall and is nearly always decorated with the famous comb pattern. The best of these wares were made in the period around 1720, but production seems to have continued on and off throughout the eighteenth century, and they were much imitated in the nineteenth century, particularly at Mikawachi.

Kutani Wares

As mentioned earlier, porcelain was also made on the island of Honshu from the 1670s. The term Old Kutani has been used for these wares, but the term

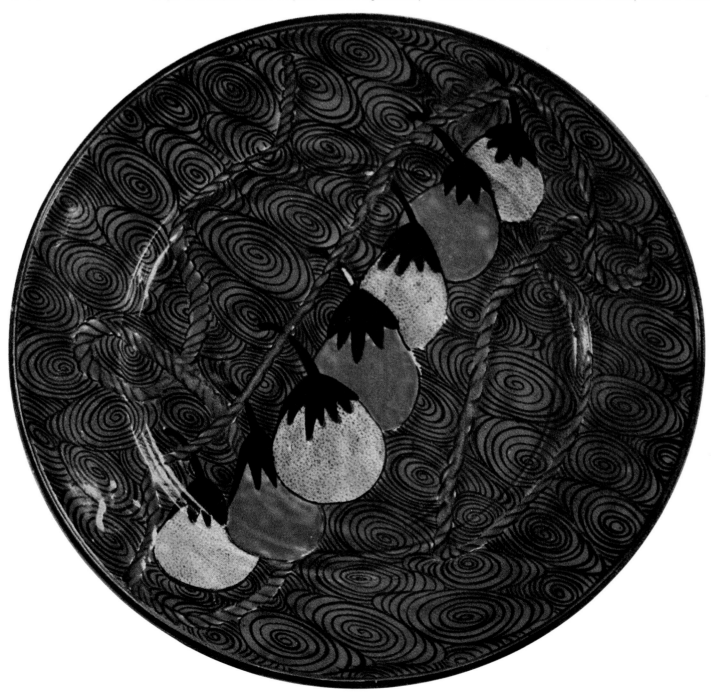

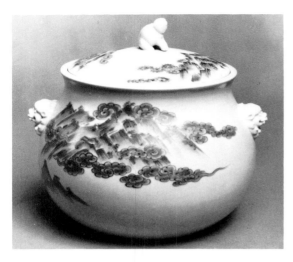

also includes several other wares that can now be seen to be unrelated. Excavation of the Kutani kiln site had revealed that none of the so-called Old Kutani wares were actually made at this site, and no other kiln site of comparable date is known from the area.

So many types of ware have been grouped together as Old Kutani that it is difficult to characterize them, but in general the term has referred to wares with bold, rather painterly styles of decoration in palettes of enamels that are darker and coarser than those of contemporary Arita. Three main styles stand out. The first is the simplest, and possibly the earliest, and is typically found on rather flat dishes where a single bold design is found in the centre. The second and most elaborate style is carefully and beautifully painted, often in a style derived from Chinese

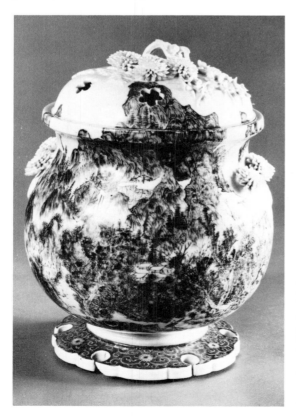

painting, with a flower, or a sage in a landscape, and often there is a border or subsidiary pattern of geometric design, boldly drawn. The third style is called *Ao-Kutani*, or Green Kutani, because of the heavy green enamel that frequently covers most of the dish, the back as well as the front. Designs on these pieces are often crudely but boldly drawn, and the green enamel may be replaced by yellow. The body of these pieces is coarser and greyer than is usual for porcelain and both the glaze and the enamels may look smeared and uneven.

There is much argument in Japan about which of these wares are seventeenth century, and which are not. Not only that, but there is argument about where they were made. It is now quite certain that some of the seventeenth-century pieces were made in Arita, but it is equally certain that we do not know where others were made. In absence of further data it seems reasonable to continue to call the seventeenth-century pieces of this style Kutani, while leaving their origin an open question. The difference in palette of enamels might well be explained by a difference in the market for them. Most of the Imari pieces went to Europe, while very few Kutani pieces did. Most of the Kutani pieces that were exported seem to have gone to Southeast Asia. In the nineteenth century, there was a revival of the style at the Yoshidaya kiln in the same geographical area, and there have been other revivals since.

Later Wares

The late eighteenth century saw a great increase in the number of kiln areas making porcelain in Japan. It is clear from Japanese wood-block prints that porcelain was becoming an acceptable substitute for lacquer or stoneware in the new restaurants and probably also in the houses of well-to-do merchants. Thus small kilns sprang up in many parts of Japan catering to this new market and making charming, simple, unassuming wares that are to this day hardly known outside Japan, and in Japan are simply treated as folk art.

The best known of these 'folk' kiln areas is probably Hasami, some eight kilometres (five miles) south of Arita, where several kilns made celadon and blue-and-white. Two kilns there made some wares for the Dutch at Deshima, including bottles painted (and later stencilled) with the Dutch name of the contents—*Mostaard, Japanschzoya*, and so on. Similar kilns also commenced at Kihara (also near Arita), on Shikoku and Honshu Islands.

Better quality wares were made at Mikawachi—generally known as Hirado—and Kameyama near Nagasaki. The Hirado wares are frequently of fine, white porcelain carefully modelled and painted, in complex shapes. Often there is pierced work as a pattern, and sometimes high-relief modelling. Kameyama was probably a little later than the others (it began perhaps about 1820) and the painting is usually in a soft Chinese style.

Often in Chinese style also are the porcelains from Seto, on Honshu. Seto, which only started making

Left: Hirado covered bowl in blue-and-white from the Mikawachi kiln. The Hirado potters were famous for their very fine white clay body of smooth and even texture, and for intricate and elaborate shapes into which the body was formed. The underglaze blue was usually soft in colour and delicately painted, differing from contemporary Arita wares. Height 19.8 cm; early nineteenth century. (Ashmolean Museum, Oxford)

Left: Incense burner and cover, decorated in underglaze blue with a landscape in Chinese style. Height 32.5 cm. In response to increased demand, several kiln areas turned to porcelain in the early nineteenth century, including Seto and Kyoto. Their products are not easy to distinguish, for there was no unified style in a given kiln area; in each of the larger kiln areas there were many kilns, and other smaller kiln areas also made similar wares.

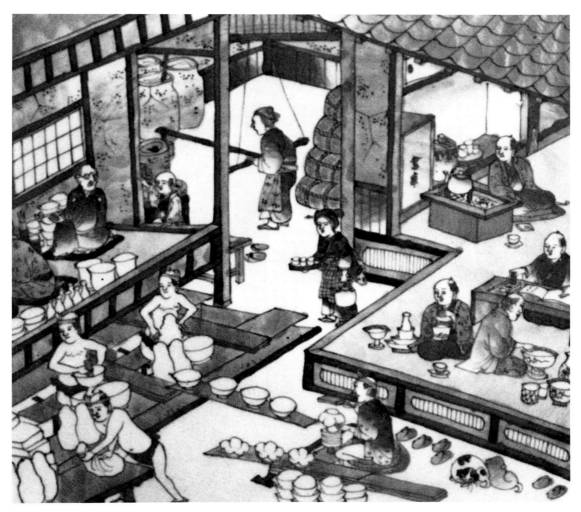

porcelain in the late eighteenth century, was to become the major porcelain-producing area in Japan in the nineteenth and early twentieth centuries, surpassing Arita. The Seto potter Tamekichi was a good painter in the *nanga* style (literally 'southern painting' style; *nanga* was a school of painting which was non-professional, and which was also known as the 'literary men's style'.) Many Seto pieces are decorated with fine Chinese landscape designs.

Copies, or pastiches, of Chinese pieces were made at several kiln areas in the nineteenth century. Many pieces of blue-and-white porcelain that appear at first sight to be Chinese wares are in fact Japanese pastiches of a cross between the Wanli and Tianqi styles. Some of these may have come from Kyoto. There most of the porcelain was made in production quantities, but some was made by the artist potters, notably Okuda Eisen, Aoki Mokubei and Ninami Dohachi.

The arrival of European techniques of potting in the early nineteenth century takes us beyond the scope of this chapter. But it is worth noting that many porcelain potters in Japan still use traditional methods of production. Pre-eminent among these are the Kakiemon and Imaemon families of Arita. Porcelain is, of course, made in huge quantities in factories, too, and there are several factories which still use some traditional methods.

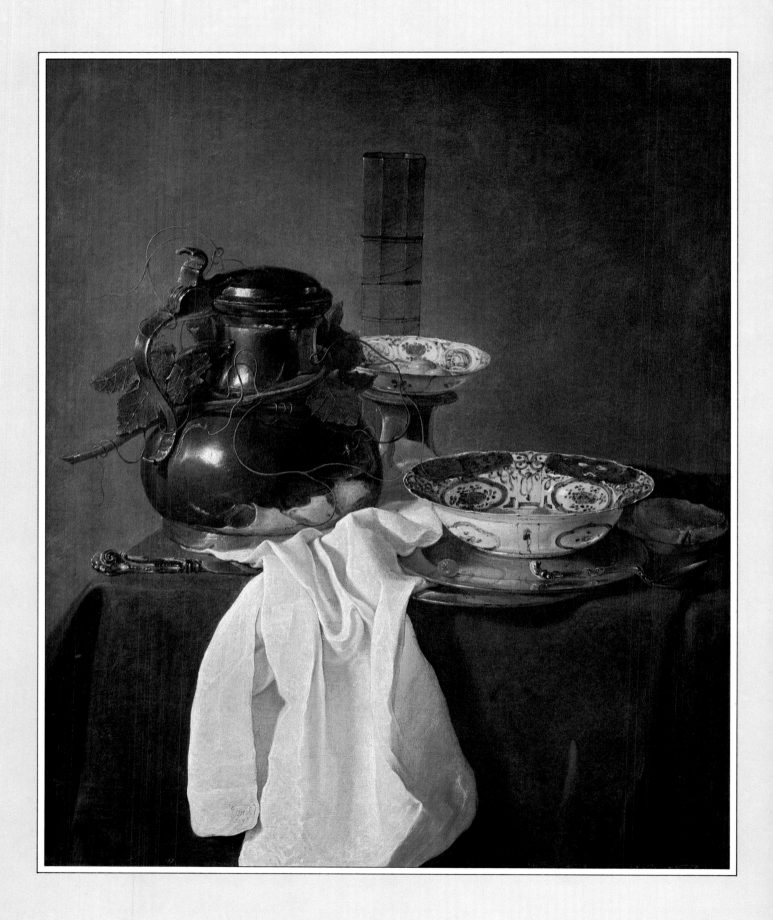

Chapter Five
China for the West

Typical seventeenth-century Dutch still-life featuring the recently imported and very popular Chinese porcelain dishes painted in underglaze blue. This type is termed 'kraak' or 'carrack'. Painting by Jan Jansz Treck. (National Gallery, London)

WELL before the opening of the eighteenth century the word 'china' had entered the English language, although its use was then rightly restricted to imported porcelains from China. Dr. Samuel Johnson's *Dictionary of the English Language* gave the following definition:

CHINA n.f. (From China, the country where it is made) China ware; porcelain; a species of vessels made in China, dimly transparent, partaking of the qualities of earth and glass . . .

Today, the term is applied very loosely to all types of earthenware and porcelain with no regard to its country of manufacture. This chapter will show how the early Chinese porcelain craft grew to become a well-organized industry supplying a very large part of the world, how in particular the trade to Europe was developed, and why these imports prompted the introduction of the art of porcelain manufacture in Europe.

Early Seventeenth Century Trade

In the early years of the seventeenth century, trade between China and Europe was being developed by the various European trading companies which were to flourish so vigorously in the eighteenth century, shipping vast quantities of Oriental commodities to the West. It must be remembered, however, that the reputation of the Chinese porcelains had been established well before this time. The Chinese had for many centuries been engaged in trading with Asian islands and countries, one of the favoured exports being various types of ceramic objects. This trade spread to the Near East and today the greatest collections of pre-1620 Chinese porcelain are to be found in Teheran and in the Serai at Istanbul. These

near Eastern collections which are so important to modern students of porcelain were perhaps in part supplied by the English East India Company, for in May 1617 the directors sent to the King's Treasurer in Isfahan in Persia a few hundred Chinese Ming period porcelain dishes from the English trading post at Bantam in Western Java. Prices for these ranged from five shillings to two pence each.

These Chinese porcelains were most probably purchased by the British traders from the Chinese junks which carried their wares far and wide across the South Seas, for while the English East India Company had a trading post in Japan early in the seventeenth century it had not yet established a direct trade with China.

It is important to realize the scope of the European East India trading companies, particularly of the English and Dutch companies. They were concerned as much with the sale of European and other goods in the East as with the purchase of Chinese and Japanese commodities. They also traded with the Near East, with India and with numerous Asian countries. The headquarters of the Dutch company in the East was Batavia (Jakarta), which served as a central clearing house for various trading nations. The headquarters of the English company was at Bantam and Surat until 1685, when it was moved to Fort St. George at Madras in India.

The European companies even supplied the Japanese and Chinese potters with some of their raw materials. 'Red Persian earth' was supplied 'for the painting of porcelain for which it is suitable, also to colour red lacquer-work'. Cobalt was probably also supplied for the blue-and-white porcelains and each English East India Company vessel carried out to China tons of English flint which was almost certainly used in the manufacture of the Chinese porcelain.

Having just mentioned the English East India Company, it is convenient here to give details of this commercial concern. On 31 December 1600 the first English Company received its Royal Charter giving it

The amount of Chinese blue-and-white porcelain imported into Europe by the Portuguese in the sixteenth century was probably quite modest and was mainly intended for their own consumption. The great European craze for porcelain or 'china-ware' as it was normally called, started and spread because of the unrest and warring between the various nations. In the early 1600s the Dutch captured some Portuguese trading vessels loaded with Oriental goods such as silks, lacquered wares and blue-and-white porcelains. This prize cargo when sold in Amsterdam caused a minor sensation, and fetched a vast sum. The Dutch were not the only nation to take in war or in private pirate action the Portuguese ships. In December 1620 William Eaton, the English agent in Hirando (Japan) reported that the English vessel, *Elizabeth*, had taken a Portuguese ship containing over four thousand china dishes and basins. These would have been of Chinese origin, broadly painted

Left: Typical thinly potted Chinese plate of 'carrack' type painted in underglaze blue. Diameter 21 cm; c. 1650.

Below: Rare Chinese export teabowl and saucer painted in overglaze enamels showing European merchants making purchases in a Canton shop. Diameter of saucer 11.4 cm; c. 1740.

a state monopoly in trade to and from the East. The full title of this company was 'The Governor and Company of Merchants of London trading into the East Indies'. However, a new entirely separate company was chartered in September 1698 under the title of 'The English Company trading to the East Indies'. For a period these two companies were in competition with each other and were familiarly called the Old and the New Companies. These were amalgamated in March 1709 under the new full title, 'The United Company of Merchants of England Trading to the East Indies', which was normally shortened to the 'Honourable East India Company' which, at that period enjoyed a working capital of over two million pounds—a vast sum for that time.

European Trade

However, the English were by no means the first to trade with the East. The Portuguese were the first Europeans to trade with the Chinese at a period when they were the leading maritime nation. In 1498 Vasco da Gama had sailed round the Cape of Good Hope to India, opening up a vast trade with the East and within a few years Portuguese trading vessels were at Canton. After a false start this trade was established on a regular basis in 1554. The Portuguese were permitted a settlement on the island of Macao, a key position down river from Canton, from where they were able to control, or stop all other Europeans seeking to trade at Canton.

The porcelains available to the Portuguese were, at this time in the sixteenth century, mainly decorated only with cobalt-blue designs applied before the surface glaze was added; wares which we term 'underglaze blue' or simply 'blue-and-white'. This blue-and-white was the standard type of porcelain exported throughout the seventeenth and eighteenth centuries. Not only is it aesthetically satisfying, and so suited to the decoration of all porcelains but also it was relatively cheap when compared with the coloured and gilded designs which became fashionable in the eighteenth century.

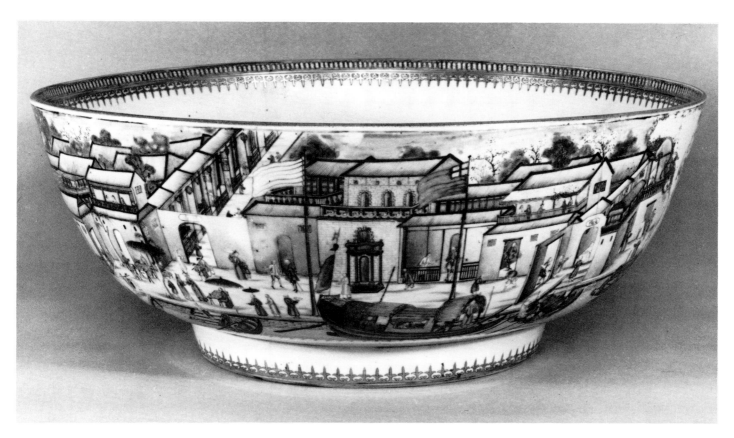

Above: Chinese export punch bowl enamelled with a continuous view of the European 'factories' or 'hongs' along the Canton waterfront. Diameter 33 cm; c. 1785.

in underglaze blue. This type of Chinese export-market porcelain, now known as *kraak*, was extremely thinly potted–having almost too fragile a feeling. However, after more than 350 years it is still surprisingly plentiful in Europe and there must have been other sources of supply besides the plundered Portuguese vessels that gave it its name. It was a standard type of Chinese export ware, sold over a wide area in large quantities.

The highly salable, profitable *kraak* porcelains captured from the Portuguese started the Dutch trade in porcelains and the popularity of the novel blue-and-white wares prompted the Dutch earthenware potters to emulate the style by coating the standard clay-coloured pottery with a coating of an opaque-white glaze containing tin oxide. These efforts to emulate the Oriental porcelains were crude and largely unsuited to trim small items such as tea wares, as the earthenware body was thick and the white glaze tended to chip away in use exposing the porous clay body below. Yet it was to be nearly a hundred years before commercially acceptable white porcelain was made in Europe, and in England the first porcelain factories were not established until the mid-1740s.

The Dutch East India Company (*Vereenigde Oostindische Compagnie*) was established in 1602, basically to capture the East Indian trade from the Portuguese and the Spanish. At first they were unable to trade direct with the Chinese mainland, but in 1624 they established a base in Formosa where they were able to obtain a good supply of Chinese merchandise. The Dutch also established trade with the Japanese, though they did not enjoy the sole

rights to Japanese wares as some authorities have stated. The great Dutch central market for Oriental goods was Batavia, and in peacetime other European nations also traded there.

In the seventeenth century the Dutch East India Company undoubtedly shipped more Chinese and Japanese porcelain to Europe than any other nation. In the eighteenth century the English company imported far greater quantities than any other. The following table shows the comparative figures for the amounts shipped from Canton in the 1777–1778 season at a period when Canton was the only Chinese port open to the European traders.

Britain	348 tons of china ware shipped in 8 vessels
Holland	111 tons of china ware shipped in 4 vessels
France	100 tons of china ware shipped in 6 vessels
Sweden	99 tons of china ware shipped in 2 vessels
Denmark	39 tons of china ware shipped in 2 vessels

In addition to this, the Portuguese and the Spanish shipped an unrecorded amount from their base down-river at Macao, the India-trade vessels also shipped a quantity to India in the eight such 'Country' vessels at Canton in this season and the Chinese themselves would have shipped mainly utilitarian wares to various Asian markets in their trading junks. Within a few years the vessels of the newly established United States of America would be added to the

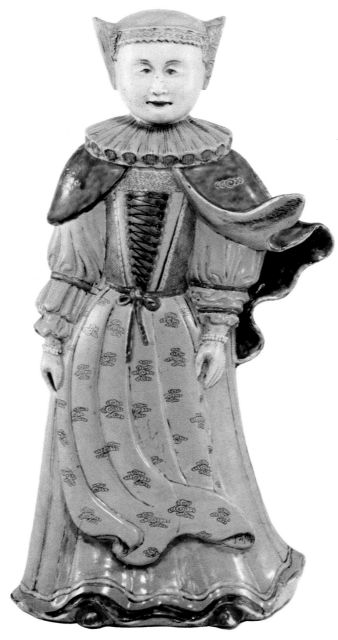

Large, fine quality Chinese figure of a Dutch lady – sometimes believed to depict the wife of Governor 'Duf' (Diederick Duivver, Governor of the Dutch East India Company. Enamelled with famille rose type colours. Height 41.9 cm; c. 1730.

than the official purchases of the various companies. The best examples of these private-trade orders are the articles decorated with the armorial bearings of European personages. At least in the case of the English imports the private trade purchases pre-dated and no doubt inspired the Company's bulk imports of Chinese porcelain.

There was a hard-working committee for private trade, and private trade purchases were closely regulated. The permitted amount of goods – the 'indulgencies' – were carefully tabulated. Thus, according to a list dating from 1683, the captain of a given ship was allowed £200 worth of goods for every hundred tons of ship's weight, while the lowly midshipmen could each only carry £10 worth. On these purchases, the Company levied 'permission money' at the rate of 6 per cent for Englishmen and 8 per cent for other nationals.

Small amounts of private trade imports were handled in the following manner. In October 1699 the directors '... ordered that the goods brought home by Mr. Hillier and Mr. Brewster, Supra-cargoes of the *Nassau*, for their private accounts be valued by the Committee of Private Trade and sold at the Company's candle [that is, by auction], except such part only as are designed by them for presents, which are to be delivered to them on the usual terms ...' The supra-cargoes (supercargoes in modern spelling) were responsible for the commercial success of the voyage, selling the exported European goods at the best price and investing the Company's funds to the best advantage in Oriental products.

The vast majority of private trade imports were sold 'at the Company's candle' as was required under the Company's charter. The Company's own bulk imports of china ware were sold twice a year but the smaller private trade purchases were included more often.

The china trade was of little consequence to the directors of the East India Companies who were as much concerned with the export and sale of European goods to the Orient, as with the import of Eastern goods to Europe. The relative lack of importance credited to Chinese porcelains is reflected in the English East India Company's purchase orders; for example in 1705 the Company's single china trade vessel the *Oley* was to bring home:

60 tons Singlo tea
20 tons Imperial tea
20 tons Bohea tea
20 tons copper
15 tons Quicksilver or Vermillion
15 tons wrought silks
15 tons raw silk
10 tons china ware
3 tons china cloth
2 tons rubarb and china-root

That is to say, ten tons of heavy china ware against one hundred tons of the light-weight teas of the period and thirty tons of light silk. This great bulk of light-weight tea and silk, cargo that had to be loaded in the upper parts of the hull well clear of any seepage

nations listed above, but at this time the bulk of Chinese porcelain shipped to North America came via Europe, mainly from the English East India Company's sales held in London.

Private Trade and Ballast

Europe had been regarded as the great international mart for Oriental porcelains or 'China-ware' but a distinction must be made between the two basic types of purchase. There were the bulk orders of the various European East India companies, contrasting with the often individual pieces and small purchases of the ship's officers and crew, the permitted 'private trade'. Most examples of Chinese export-market porcelain illustrated in this and other standard reference books are in fact private trade items, rather

of sea water explains the original main purpose of the china-ware cargo – it acted as a vital form of ballast, or kentledge, that would not be spoilt by the sea. This basic fact explains the remarks made by the supra-cargo of the *Macclesfield*, the first British vessel to establish the trade at Canton in 1699:

> ... china ware of which there is no quantity in ye place at present and such as there is, is likewise very dear, so if there were not a necessity upon us to buy some for kintlage, we should hardly meddle with any ...

This basic need to have a heavy water-resistant 'flooring' for the lighter teas and silks also explains the Company's standard orders only for articles that could be purchased in bulk and which would 'stow close' to make the homeward-bound vessel 'sail-worthy' or to 'stiffen' the vessel, to use contemporary terms. Typical orders read:

> 20 Tons of strong useful china ware for Kintlage
> ... (1697)
> China ware of the useful sorts, especially plates
> and dishes which stow close. (1699)

The Role of the Supra-cargoes

That the supra-cargoes could, at this period, use their own discretion as to what to buy (though until later in the eighteenth century, their choice was limited to the ready-made articles available in Canton) is shown by the following excerpts from an exceptional order, dated 28 January, 1702 and given to the four supra-cargoes of the *Fleet*, bound for Canton.

> It must be your first care to provide Kintlage commoditye to stiffen your ship and make her sail worthy, and which will be first wanting to lade on board her. We have in our said list inumerated severall sorts of heavy goods proper for that purpose if the same can be procured at encouraging prices ... china ware of the usefull sorts especially plates and dishes which stow close. Buy us also some large, some middling, some smaller punch bowls, some great china flower potts, fitt to sett orange Trees in and other lesser dimensions fitt for smaller Trees and flowers.

Chinese export plate and typically small teapot. Both are enamelled in the famille rose manner and are of commercial – rather than superb – quality. Diameter of plate 22.8 cm; c. 1740.

Do all you can to inform yourselves what sorts of goods and especially china ware and drugs were brought us by the ship last departed or departing from Canton or other parts of China, for England, which may be a direction to you to buy up the less or more or vary in those sorts of goods always remembering a handsome sortment of goods of great variety turns to better account, especially in china ware and drugs than to over do in any particular which serve only to clogg the markets and depreciate the commodity.

We do not particularize the colours, paints, sizes, nor several species of chinaware which we would have you provide but leave that to your management and fancy, as being upon the place and therefore best able to know what sorts are procurable there, and by your observations you are enabled to give a good guess what are most likely to meet with best acceptance here. What hollow chinaware you buy fill up with sago or other more profitable commodity . . .

In the detailed list of goods 'proper to be provided at Canton' the directors of the East India Company or their advisors detailed the following types of china ware to be brought home on their vessel:

China Ware of the strong usefull sorts such as dishes, plates of all sizes, bowles, cups, saucers whereof ten thousand fine and course, plates– pewter plate fashion (with a condiment flange), these being a kintlage commodity you may procure thereof ten to fifteen tons.

Ditto of the finer sort, and of variety of fancifull pieces such as rarely or never have come to England with some large pieces you may buy up ten to fifteen tons, the odder the shapes and fancyes ye likelyer to sell here.

Brown cups and saucers of the useful sorts which formerly were of no esteem, will now sell well if pretty wide at the bottom, whereas the painted china ware heretofore much sett by, yet now by reason of the great quantityes imported, sold extreemly cheap . . .

The reference in these 1702 instructions to clogging the market and to the low price of painted china which had been imported in great quantities draws attention to the Company's sole means of disposal of its imports–sale by the candle. Sale 'by the candle' was in fact a special kind of sale by auction. A pin was stuck through a candle, about an inch from the top. Bidding could continue until the candle was burnt down to the pin. When the pin dropped into the candlestick, the last bidder was declared the purchaser. The directors had little or no control over the price that the goods would fetch–they were dependent on the market and on the salability of the imported selections. The Company's own imports were sold in very large wholesale lots angled at the china-ware dealers–the 'chinamen' rather than at the individual buyer.

Rare Chinese export candlestick painted in underglaze blue. This European form would have been copied from a metal prototype taken to China. Height 15.2 cm; c. 1730.

One vessel on a single voyage brought home to London at least 321,360 items of Chinese or Japanese porcelain, that is, nearly a third of a million pieces. No wonder the Company soon became overstocked as indicated by the December 1706 instructions given to the supra-cargoes of the *Stringer*, bound for the Chinese port of Chusan:

China ware, we are vastly overstocked with all, however it being a kintlage commodity and the ship must have a weight in her bottom to make her sailworthy therefore buy twenty tons to be chiefly plates . . .

Special Orders

However, by 1710, the now combined old and new companies trading as the 'Honourable East India Company' were ordering a larger range of objects painted to set designs and often based on European models sent especially to China to be copied in porcelain. The porcelains were now being specially ordered, and the choice was no longer left to the supra-cargoes to buy what they thought fit from the existing stocks of the Chinese merchants. The forty tons of china ware ordered for the *Rochester* amounted to over a quarter of a million pieces, including relatively light-weight objects such as pierced fruit dishes (made to a wooden English

and coffee were more popular drinks. The cups, which were in the main handleless bowls or beakers did not always have saucers. One order clearly states 'coffee, tea and chocolate cups sell best without saucers, therefore buy up fewer saucers'; another order explains one mode of use for some such cups: 'Procure chocolate cups to be made higher and narrower than what have usually been bought, that the more of them may stand upon a salver.'

The early eighteenth-century Chinese export market teapots tend to be rather more common in enamel colours than in blue-and-white, but this may be due to the fact that more care was probably taken of the more expensive coloured examples. These teapots were reputedly adapted from Chinese wine-pots. They had high handles arranged over the cover like a kettle, the covers lack the vent-hole, and the spout also lacks the strainer-holes associated with a modern teapot. Nevertheless these early wine-pots adapted to the European method of making tea can be charming and are full of character. All early teapots are small, reflecting the high cost of tea, which was taken only as a luxury by the more wealthy classes. Other early items of tea equipment also reflect this basic fact, being very small by modern standards. Indeed, the delicate, thinly potted, small teabowls could almost be taken as doll's china! Some very rare larger-sized pots probably held other beverages such as punch.

By at least 1694 the English East India Company was stipulating its precise needs. The requirements specified in January 1694 include '. . . a quantity of fine teapots, blew and white, purple and white, red and white, a grate to be made before the spout within side . . .'

In fact, however, Chinese teapots made before 1720 very rarely have this 'grate' or pierced strainer-

pattern), punch bowls and the whole range of tea-wares from spoontrays to tea canisters, the order for such goods to be placed with the merchants at Amoy for delivery in Chusan.

The stock of Oriental porcelain in the Company's London warehouse at this period was very large, including, for instance, 270,000 cups and saucers alone, as well as thousands upon thousands of other standard items, such as plates and teapots. In addition there was in the separate private trade warehouse a vast assortment of porcelain, mainly of a more ornamental nature, including vases, figures and individual orders such as the armorial wares. At this period the Company's committee for private trade was concerned with the 'great importation of Private Trade' and with the fact that the private purchases of individuals were fetching from 'sixteen to near nineteen thousand pounds' at its auction sales—representing a truly vast amount of china ware.

The London Market
1690–1720

Hundreds of thousands of Chinese cups were imported into England during this period–indeed a 1681 buying instruction stated 'that which will turn us best to account are cups of all kinds'. These were not necessarily for tea, for at that period chocolate

John Dobson
at the China Jarr
In S.t Martins Court, near Leicester Fields.
LONDON:
Sells all Sorts of China, Earthen-
Ware, Stone and Flint-Glass, at
the Lowest Prices.

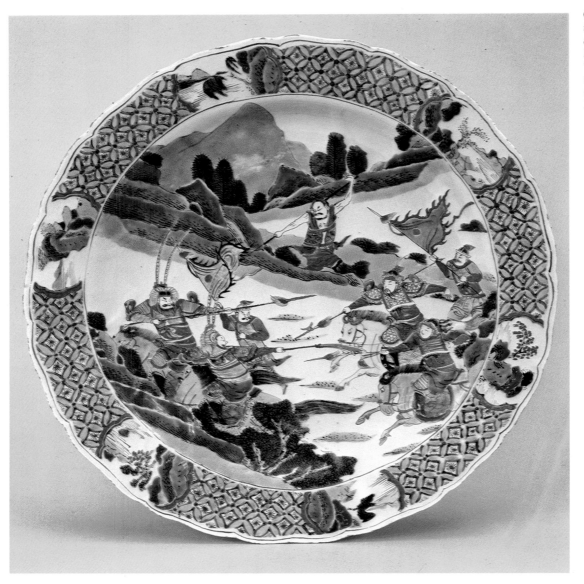

Chinese deep dish enamelled in the famille verte manner depicting a superbly drawn battle scene in an early style. The European manufacturers could never rise to such heights. Diameter 35.5 cm; c. 1710.

holes. By at least 1703 the Chinese were making teapots with handles at the side opposite the spout, and at a London sale held in September 1704 both 'over-handled' and 'side-handled' Chinese teapots were being auctioned.

Some pots being offered in London included mixed groupings of teapots. One such single lot offered on 17 March 1708 comprised:

> 158 teapots blue & white – 3 sorts
> 32 ditto over handles
> 9 ditto ribbed with feet
> 22 painted ditto.

These were officially valued at 2/6d each (12½ new pence) and were sold at a farthing advance on this valuation.

Apparently, not all the spouts were straight and some difficulty seems to have been experienced in their pouring qualities for an order was issued in December 1717 for: '2,000 teapots, blue and white, taking particular care that the spouts be made straight to pour well.'

By about 1710 teapot stands were being ordered, and by January 1713 the English Company had procured a tinned metal pattern for such stands; the instructions for that season included the notation: '4,000 small dishes ... to be deep and square, according to the pattern in tin, for the teapots to stand on. 2,000 blue and white, 2,000 do. in colours.'

These early eighteenth-century Chinese porcelain square trays with metal-type canted corners are still quite common, but they look extremely clumsy when placed under the delicate teapots of the period. The standard shape of Chinese porcelain tea canister too was almost certainly copied from a European metal pattern piece. Apart from tin pattern pieces the Europeans were also sending out to China wooden models and glass pattern pieces.

Other tea-wares in use before 1720 included small trays for the silver teaspoons, small covered canisters for the tea-leaves, covered sugar bowls and slop bowls with, of course, handleless teabowls and saucers and coffee-cups. Plates do not appear to have been used at the the table at this period although by the middle

of the eighteenth century all teasets included two plates, of enlarged saucer form. Coffee-pots were not part of the standard porcelain tea equipment.

During this pre-1720 period many imported teapots were in the white Fujian porcelain, the so-called *blanc de chine* and some teapots were made in earthenware bodies–not in porcelain, the concern of this book. In particular the unglazed red-bodied small teapots made at Yixing were extremely popular, perhaps because of their price, for on 13 March, 1700, 978 such 'red teapotts' cost the English Company approximately £21 or 3d (3 old pence) each–less than 1.5 new pence!

Enamelled Designs

The majority of the early imported porcelains were decorated in underglaze blue, but although Père d'Entrecolles' famous leter of 1712 noted that 'In Europe people hardly see anything else but a vivid blue on a white ground . . .' this is clearly not the whole story. Many existing seventeenth-century orders relate to coloured ware 'painted with redd, green and yellow'. Gilding was also added at quite an early date and to quite standard objects–'20,000 handled chocolate cups in colours and gold'.

These early enamelled designs fall into two main types. The cheaper designs incorporate underglaze-blue with overglaze-red and green enamels in the general style of the Japanese Imari wares. This is a type of decoration which was popular over a long period and much copied by English factories of the 1750–1775 period–notably the factories at Bow, Liverpool, Lowestoft and Worcester. The finer porcelains are decorated only with semi-translucent overglaze enamels with a prominent green tint–the *famille verte* colours, to use the later French term. The beautiful, almost liquid-looking colours often lie thickly on the surface (there is a tendency for them to flake away) and include an overglaze blue which is very often surrounded by an iridescent halo. These warm, soft-looking *famille verte* colours can be counted among the classics of the ceramic art. In Chinese porcelain they normally fall within the period 1700–1730 (some rare early Worcester porcelain of the 1750 period emulates Chinese examples). These glaze-like *famille verte* colours were replaced by the so-called 'European' almost opaque colours, in which a carmine or plum colour predominates, the *famille rose* palette.

Blanc de Chine Figures

The Chinese porcelains imported into Europe in the 1690–1720 period therefore comprised mainly blue-and-white pieces with some rarer examples decorated in the Imari style and some with *famille verte* overglaze enamels. In addition there were the un-decorated white porcelains–the *blanc de chine* wares which included a selection of figures and groups. The useful wares were not at this period bought and sold as complete table services as we might expect today;

instead, large quantities of individual articles were included in each sale. These different lots were then purchased and divided up by the trade-buyers–the 'chinamen' who presumably made up sets to the public requirements.

The period from 1700 to the 1720s saw the large-scale importation of white *blanc de chine* porcelains made at or near Dehua in the province of Fujian, quite near to the port of Amoy whence the Dutch and English imported such pieces. Indeed the log of one English vessel records the loading of such white figures at Amoy on 23 December 1703: '. . . took in 11 chests of China ware and 22 baskets of white images'.

In quality this white porcelain ranges from delight-fully almost classical beauty to inferior export wares. The undoubted popularity of such undecorated porcelains probably rested on their cost (many statues were valued at 2d and 1d) and novelty value. At this period no white-bodied European porcelain was available and the tin-glazed earthenwares were opaque, clumsy and friable; into this Europe came white porcelain figures, groups, animal models and a host of useful objects. They remained popular for many years, for in the 1745–1760 period the leading London porcelain factories of Chelsea and Bow were producing good copies of Chinese *blanc de chine* wares. They and other factories would not have done this, had there not been a demand for the wares.

While such white Chinese porcelains were avail-able in England by at least 1697, as shown by the inventory of Queen Mary II's possessions at Kensing-ton House, there seems little doubt that the Dutch were the great buyers of such wares in China. This is underlined by the descriptions given to many of the models in the English sale records where one finds listed 'Dutch men' 'Dutch troopers' and 'Dutch Familyes' suggesting the origin of the models and the nationality of the people for whom they were first made.

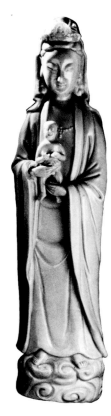

Above: 'Blanc de chine' export figure of the Chinese goddess Guanyin – or as the Europeans called her 'Sancta Maria'. Figures of this type were sold at auction in London for 7/3 to 13/– in the early eighteenth century. Height 42 cm; c. 1700.

Left: 'Blanc de chine' group of a very popular type for the export market. Early eighteenth-century records of the English East India Company describe them simply as 'Dutch Familyes'. They were valued at between 1/6 and 3/– each. Height 17.1 cm; c. 1700.

The 'Dutch Familyes' can be linked with a model quite commonly found in the British Isles and one listed in the London sale records from 1703. These were then valued at 3/- (three shillings), 2/6d, or 1/6d each. Some were embellished with unfired pigment which has largely flaked away from the white body over the years, but most were imported and sold in their pure white state. The old belief that these groups depicted Governor Duff, as the Chinese called Diederik Duivver, the Governor of the Dutch East India Company during the 1729–1731 period, is upset by the appearance of this subject in the English records at a much earlier period.

This group and some others were obviously made especially for the European market but many other *blanc de chine* models or objects were more to the taste of the Chinese home market. Many which depict Taoist immortals or animals have an international appeal, as do the little toys or seals valued in the English records at a mere half-penny each. The most typical of the *blanc de chine* models depict the Chinese goddess Guanyin; these were made in many sizes, in numerous different models (with or without a child) and in various qualities. In Europe the Chinese Guanyins were called 'Sancta Marias' or in the case of those with children 'Women each with a child'. Examples of these models sold in London in April 1702 were valued at prices ranging from 8/- to 1/- but were sold at 13/- to 7/3d each. All prices quoted here are the auction prices, to which at least one dealer's profit must be added before the cost to the private buyer is arrived at. It is by no means inconceivable that the Guanyin-type white figures retailed at one pound or more, a point that again underlines the novelty and popularity of any porcelain in Europe at this period.

Importing Japanese Porcelain

In the sample lots sold from the *Union* in 1705, several items from the Amoy cargo were described in the original sale list as being Japanese. In fact most English vessels trading at this Chinese port brought

Typical Japanese export-market ewer painted in underglaze blue. Such items, decorated in various patterns and sometimes fitted with metal covers, were imported into Europe in great quantity. Height 26.6 cm; c. 1700–1720.

home to England large quantities of Japanese porcelain as well as Chinese china ware of all types. It is a widely held belief that the Dutch were the sole importers of Japanese porcelain into Europe. This is a gross error. The British shipped large quantities in the early part of the eighteenth century–indeed they established a trade with Japan before they traded with the Chinese. This Anglo-Japanese trade was a two-way one, as in the early seventeenth century English earthenwares were sent to Japan! However, the British withdrew from their Japanese base in May 1623. Subsequent efforts to re-establish the English direct trade with Japan were unsuccessful. Nevertheless the English and presumably other trading nations were able to purchase Japanese goods from at least three other sources.

First, Japanese goods were purchased from the Dutch trading base of Batavia–a kind of international marketplace. The London sale held in November 1708 included Japanese porcelains brought home on the *Katherine* from Batavia. Secondly, some Japanese merchandise was imported via Formosa (Taiwan). The archives of the Dutch East India Company record that in 1676 the English vessel, *Eagle*, brought Japanese porcelains to Bantam from Formosa. The Dutch had established a base there in 1624 which was to become the centre for their porcelain trade. Thirdly, Japanese goods were available in the Chinese ports where the English normally purchased their Chinese merchandise. It was delivered to these ports mainly by the Japanese and the Chinese trading junks. This trade in Japanese porcelains to Chinese ports was established by at least 1658, for in

Left: Japanese dish for the Dutch market, decorated in underglaze blue. The initials VOC represent the Dutch East India Company. Diameter 36.6 cm; c. 1700–1710.

November of that year the Dutch recorded the departure of seven Chinese junks from Nagasaki Bay for Amoy with Japanese porcelains of various types. The English East India Company was interested in the Japanese goods available at the Chinese port of Amoy by 1677. The Minutes then recorded:

> ... upon ye whole debate we do offer it as our opinion, that the trade of Amoy be settled as being very hopeful for obtaining Japan and other goods at the best rates ...

A few years later, in August 1681, the directors of the English East India Company were instructing their Chinese Trade vessel, the *Amoy Merchant*, to await the arrival of the junks with fresh goods, even if it meant losing a year's passage. The instructions end, '... to stay at Amoy until the return of the Junks from Japan, wherein we promise ourselves – we may have the opportunity and choice of all sorts of fresh goods from Japan to complete his loading.' It would appear that by then there was competition for the Japanese goods in Amoy and the English here wished to enjoy the first choice.

The 'new' company which had been chartered in 1698 was also interested in the purchase of Japanese porcelains. Its 'president' in China, Allen Catchpole, writing from the Chinese port of Chusan, reported in November 1701 that he had no great hopes of establishing a direct trade with Japan. He also added that he had 'no expectation that so cunning a people as the Chinese will assist them in effecting it – for the Chinese traders make great profits on the Japan goods which they sell to the English.'

Japanese porcelains were available very early in the eighteenth century at the Chinese trading ports of Amoy, Chusan and also further south at Canton. Early in 1703 Edward Barlow, upon leaving the Canton anchorage of Whampoa, noted that he was, '... praying to God for a good passage to England, being a full ship and laden with goods namely 205 chests of China and Japan ware porcelain ...' In the following year the supra-cargo of the *Kent* at Canton

reported the bartering of English cloth for Japanese wares, a transaction worth just over one thousand pounds.

Japanese and Chinese Compared

Typical examples of Japanese porcelain of the 1690–1720 period compared with their Chinese contempories tend to be rather thicker in the potting and therefore heavier in weight. In general the Japanese articles tend to be of a more utilitarian nature, although some rare figures and animal models were made.

Japanese plates, dishes and other flat-based objects were normally fired on small stilts or pyramids which left on the bases small pimple-like blemishes when they were knocked away. This characteristic is to be found on some later English pieces, notably those from the Chelsea factory, but they do not occur on Chinese porcelains.

The glaze on Japanese porcelains tends to be rather thicker than that on the Chinese specimens. The underglaze blue also tends to be decidedly greyish or of a slaty hue when compared with the purer, bright Chinese blue. The Japanese also has a slight tendency to run in the glaze while the Chinese blue is static and the painted design is always sharp.

Decoration on Japanese Porcelain

The decoration on early Japanese export market wares found in Europe falls into three main types. The pieces painted only in underglaze blue in their various forms and patterns make up about 45 per cent of the total.

Equally important are the 'Imari' designs. This name is derived from the Japanese port from which most of the wares were shipped, and not from the

Right: Two Oriental plates painted in underglaze blue. The Japanese plate on the left is copied from a Dutch Delft original, while the one on the right is a Chinese copy of the Japanese. Diameter 21.3 cm; c. 1700.

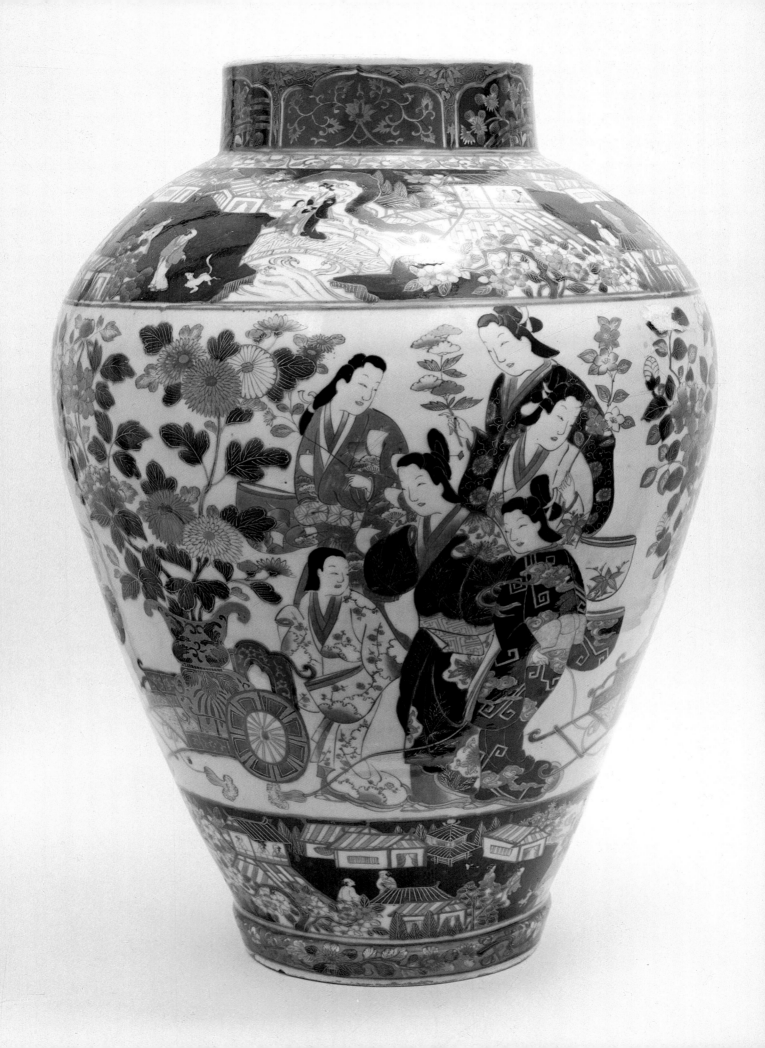

Left: An important Japanese vase of large, ovoid form. It is decorated in underglaze blue with iron-red gilding and overglaze enamels, in the so-called 'Imari' style. Height 63 cm; c. 1680–1700.

Right: Japanese export ewer from Arita, enamelled in iron red, yellow and green. the contemporary Dutch silver mounts incorporate the date 1671. A fine and rare example. Height 22.3 cm.

Right: Japanese dish decorated in the restrained Kakiemon style with iron-red, blue, green, yellow and black enamels with slight gilding. Diameter 23.6 cm; 1680–1700.

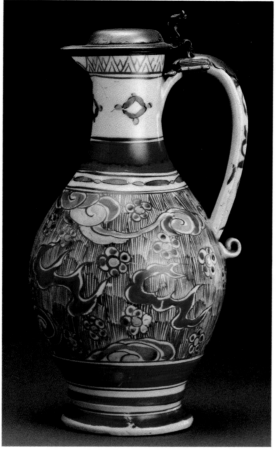

of 1719 reads: '15,000 cups and saucers in colours to be painted after the Japanese patterns'. In all probability the English were seeking Chinese copies of the colourful Imari porcelains, copies that would be somewhat neater in the potting and also rather cheaper than the Japan wares, which had to withstand at least one extra middleman's profit before being available to the European buyers in the Chinese ports.

The third type of early Japanese export porcelain, perhaps the most interesting, is considered most desirable today and is certainly the rarest, comprising at the time of importation less than 10 per cent of all imported Japanese porcelain. This is the overglaze-enamelled porcelain associated with the Kakiemon family of Japanese potters and porcelain painters. Typical specimens are somewhat sparsely decorated, paying tribute to the delightful white porcelain body or canvas. In complete contrast to the somewhat over-decorated Imari patterns, these restrained Kakiemon-type designs are perhaps more atuned to the Japanese taste. Some vases and other items in this style, however, are more highly decorated, perhaps with the European buyers in mind. Such vases were sometimes mounted in ormolu in Europe and are today to be found gracing palaces and stately homes. The early European porcelain manufacturers in Germany, France and England favoured good copies of these Japanese Kakiemon-type porcelains which, judging by the Bow and Chelsea copies, remained in fashion at least up to the mid-1750s—some fifty years after the originals were imported.

Antique Japanese porcelains are quite rare in Europe today, probably representing less than 5 per cent of all the Oriental ceramics available. The main period of importation by the English Companies would appear to be between 1700 and 1720, although on the evidence of the rather later European copies, the styles remained popular. The apparent fall-off of purchases was probably due to the high price, and to the difficulty of procuring supplies in commercial quantities and of acquiring items made to special order as England did not have direct access to Japan, as well as to the fact that the Chinese

place where they were made. These Imari or 'Japan' patterns are rich-looking with the blue, red, green and gilt ornamentation filling most of the available surface area. To the buying public in the early 1700s such Japanese wares must have seemed highly desirable and decorative and most English stately homes still retain a good selection of Japanese porcelain of this type, particularly the large covered vases which were made in pairs or in larger sets. The same taste is today typified in the traditional 'Japan' patterns produced by the Royal Crown Derby factory while some Japanese manufacturers still produce extremely close copies of the original designs.

However, some English records suggest that many of the typical imported Japanese porcelains – the large vases and dishes – were purchased as the captains' and officers' private trade. In 1712, the English supracargoes were advised, 'If any Japan Junks are at Canton while you are there . . . you may buy some (porcelains) of the above sorts but none that are large pieces such as jars, beakers, or great dishes or bowles.'

These colourful Imari patterns probably comprised some 45 per cent of the Japanese porcelain imported into Europe in the early eighteenth century. The great centre for the manufacture of these pieces and for most of the blue-and-white was Arita in the province of Hizen.

It is interesting to note here that as early as 1713 the English Company was ordering Chinese porcelains to be made to Japanese designs. A typical order

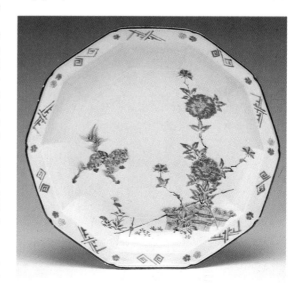

porcelains were generally of better quality. Nevertheless, the Japanese porcelains played an important part in the story of East–West trade in Oriental ceramics.

Other European trading concerns were also importing Japanese porcelains; as late as 1739 the French ordered some Japanese wares in preference to Chinese wares, although the Dutch did not import any Japanese porcelains between 1757 and 1795.

In the mid-1770s the English East India Company was still, unsuccessfully, endeavouring to trade with Japan. However, the country remained closed to foreign trade until the middle of the nineteenth century and the arrival of Admiral Perry's black ship. By 1870, Japanese fashions had returned to Europe with a vengeance, and soon the illustrated catalogues and advertisements of the leading European stores such as Liberty & Co. of London were overflowing with a torrent of mass-produced Japanese objects, including Satsuma-type wares and copies of the earlier Imari-styled porcelains.

Chinese Imports after 1720

From the 1720s onwards the amounts of Chinese porcelain shipped into Europe increased almost yearly, although of course a graph would not show a straight climbing line, since wars, bad trade or a glutted market all took their toll. It would also seem that the Japanese porcelains and the white *blanc de chine* wares all but ceased to be purchased after the 1720s.

The enamelled porcelains showed the greatest change in style, the old semi-translucent, glaze-like *famille verte* tints being almost entirely replaced by the European-styled *famille rose* palette. These new-style colours are in the nature of added enamels rather than coloured glazes; they tend to be nearly opaque. The French term *rose* here describes a typical and much used carmine or plum-colour, not a scarlet. These *famille rose* colours came into favour in the early 1720s although at first the results were not entirely successful and difficulties were experienced in mixing or firing some colours.

The study of the various changing styles of decoration in Chinese porcelains made for the European market is assisted by the private trade orders, in particular the pieces decorated with armorial bearings. These special orders can often be quite accurately dated, and they illustrate in the changing styles of border and other motifs a surprising number of variations in fashion.

History of Two Services

It may be of interest here to follow the history of one service shipped home to London from Canton in December 1731. It bears in the centre the arms of Sir Charles Peers, who had been Lord Mayor of London in 1715, a commissioner of Customs and a director of the East India Company. It can therefore be assumed that this service was a rich one, being rather more elaborate in design and make-up than other services of the period. We are fortunate that the original invoice for the order has been preserved, as it shows the original components. The main 'table' or dinner service comprised:

56 circular dishes rather like enlarged meat plates or platters after the contemporary pewter examples. These dishes were in five different sizes and the fifty-six cost in Canton just under £13·50.
12 large and deep soup dishes in two sizes
200 meat plates
100 soup plates
12 sauce boats
12 trencher salts.

In addition, two matching teasets were ordered (these cost under £2·50 each in Canton), 6 quart-size mugs, 6 pint mugs, 4 pairs of ewers and basins and 2 sets of bowls, five in each set. The total came to £76 sterling in addition to which Sir Charles would have had to pay various charges both to the Customs and to the Company.

It is interesting to see in this order and in others of the period that the dinner services did not include covered tureens, nor were side or dessert plates supplied. Although twelve trencher-like salts were ordered (after a silver or pewter pattern), no other condiment was invoiced. The sauce-boats in this order are curiously wide and shallow and the contents must have cooled very rapidly. The smaller items, such as the salts, the sauce-boats and most of the tea wares, bore only the Peers crest, not the full elaborate armorial bearings.

This service includes a great deal of intricate gilding in the border, but this is rather thin and watery-looking and most of the surviving pieces show that this Chinese gilding on the hard-paste porcelain was not very durable. The border panels of flowers are painted in a typical *famille rose* palette although the enamels are rather more translucent than one might expect. The central shield displays the so-called European opaque tints, the white and black.

While the original invoice showing that these armorial porcelains were shipped on board the *Harrison* under the command of Captain Samuel Martin at Canton in December 1731 is still available, we cannot be sure when the order was placed or where the decoration was added.

The *Harrison* was first taken into the Company's service in 1727. Her first voyage to Canton commenced in October of that year and she was below Canton in August 1728; perhaps at that period the order for the Peers service was placed with a Chinese merchant. The *Harrison* arrived back in London in July 1729 and sailed again for Canton in December 1730. She sailed again from Canton on July 27th 1731 and returned to London in July 1732 with a mixed cargo including 58 chests of china-ware (two of which included the Peers service) and 281 bundles of china.

The porcelain services were certainly made, that is formed, glazed and fired at Jingdezhen, the great

special commissions increased, so the practice evolved of having white porcelain blanks enamelled by the painters at Canton. This obviously saved time and expense and the Europeans could take their treasures home on the same voyage. It is not known, however, at what exact date this practice was established.

One account of 1769 relates how William Hickey was shown the Canton enamellers at work:

> ... In one long gallery we found upwards of a hundred persons at work sketching or finishing the various ornaments upon each particular piece of ware, some parts being executed by men of very advanced age and others by children even so young as six or seven years ...

Returning to our consideration of Sir Charles Peers' service it seems likely that at this relatively early date (c. 1730) the decoration would have been carried out at the place of manufacture, that is at inland Jingdezhen, especially for such a large order as this. Certainly export wares available at the other two Chinese ports used by the Dutch and the English would have been enamelled at Jingdezhen. The Canton porcelain enamellers would only have come into prominence once all trade was restricted to that one port.

If this contention is correct then Sir Charles Peers would have had a long wait for his porcelains. The original order with drawings of his armorial bearings and crest would have been dispatched from London on an outgoing vessel in 1728 or 1729. On the vessel's arrival at Canton the order would have been

inland centre for the manufacture of porcelain in the Province of Jiangxi. Here there were reputedly some five hundred kilns giving it an appearance at night of a large city on fire! At Jingdezhen any underglaze-blue decoration was painted, as this was applied to the unfired, unglazed porcelain in the middle of the manufacturing process.

As the trade with the European nations grew and the number of individual orders for private trade

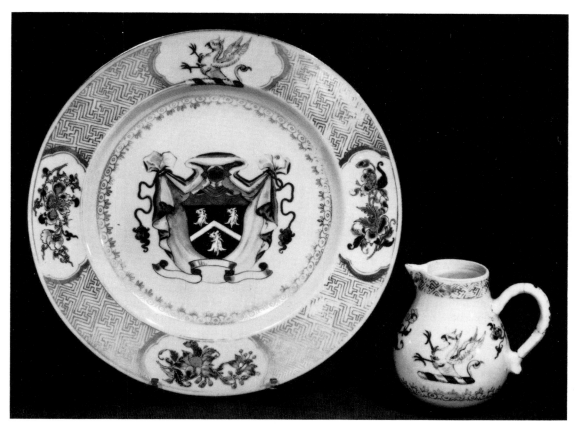

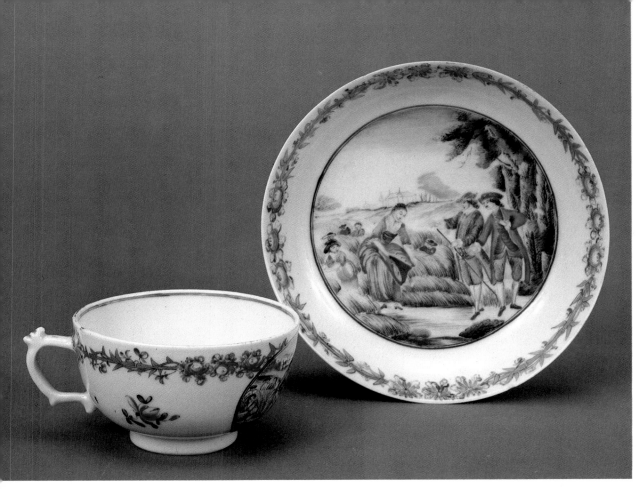

given to a Chinese merchant for forwarding to Jingdezhen. On completion, the large service was sent hundreds of miles down to Canton for forwarding to London on an available British vessel one or two seasons later. We know this service was invoiced in Canton in December 1731, and the *Harrison* arrived back in London in July 1732. We must remember, however, that these were the days of sail. All vessels were dependent on the prevailing seasonal winds and if they missed these for any reason they 'lost their passage' and had to wait another year! European vessels left for China early in the year aiming to arrive at Whampoa, the permitted anchorage below Canton, in the late summer. The return voyage was started from about December to February depending on the time spent selling the outward cargo and purchasing and stowing the homeward goods and in making the vessel ready for the long return journey. At best the round trip took eighteen months, often two years or more. Sometimes the vessel was lost on voyage.

Sir Charles Peers' son who was in the Company's service in India ordered a Chinese dinner service at the same period but this was decorated in underglaze blue only. In Canton these plates cost the equivalent of £2·33 a hundred or 2 new pence each and they were made to a special order! Being decorated in underglaze blue in the middle of the manufacturing process, before the plates were glazed and fired, this service would have been decorated entirely at the inland centre of Jingdezhen. The fact that no overglaze enamel colour or gilding was required on this order accounts in part for the very low initial

cost of the service.

The blue service was shipped from Canton in November 1731 on board the *Canton Merchant* for the British base at Fort St. George at the Port of Madras in India. This fact is of importance, as the trade between India and China was very extensive, being carried on in what the British called 'Country ships', quite independently of the European vessels. The surviving English East India Company records do not include details of the Indian trade but it was undoubtedly large, and much Chinese export market porcelain must have been forwarded from India to other markets, including Europe.

Other Private Trade Orders

Many of the armorial services made especially in China for European families are of great interest and beauty, and many can be approximately dated by reference to the family marriages or rank as depicted in the armorial bearings. One service in particular, made for the Lee family in about 1730, is interesting as the border panels show the extremes of the West–East voyage of the trading vessels – the River Thames and the London skyline as drawn by a Chinese porcelain painter and the approaches to the anchorage at Whampoa below Canton.

Other private trade orders were made to commemorate marriages. On one magnificent plate, the ornate gilt centre design not only incorporates the initials of the couple but also their dates of birth and the date of their union. The rather naive rendering

of the cupids serves to remind us that while the Europeans could not paint realistically Oriental figures, the Chinese rendering of European types also left much to be desired!

European figure subjects were also copied on the so-called Jesuit china, on which European prints or drawings very often of a religious or mythological nature were painted in blackish tints. While the Jesuits held great sway in China and were the most privileged of all Europeans, often helping the various East India companies, the description Jesuit when applied to these black 'pencilled' copies of prints is merely a generic term for a large range of export market porcelain popular in the mid-eighteenth century. Designs of European figure subjects were also rendered in full colour, and of this type the Judgement of Paris design is the best known. The Oriental rendering of the female form, however, can hardly have titillated even the most homesick of sailors.

Of more historical interest we have in Chinese export market porcelains some rare mugs depicting the Duke of Cumberland and inscribed 'In remembrance of the Glorious Victory at Culloden, April 16th 1746'. The Chinese were also making similar mugs, apparently for the Scottish market, depicting the Scottish hero, the Young Pretender, Prince Charles Edward Stuart. They catered for the loser as well as the victor! It is interesting that such commemorative pieces should have been ordered from China just at the period when the English porcelain manufactories were being established. It is all the more remarkable that most of the London livery companies placed their orders for fine punch-bowls

with the Chinese rather than encouraging the local factories at Bow and Chelsea.

Even when English porcelain factories were fully established, the Chinese seem to have held a monopoly in many standard lines. They made many large, thinly potted, finely painted punch-bowls, colourfully enamelled with European hunting scenes, yet the nearest the English came to emulating these evidently salable items were the rather rare black-printed Worcester examples. Sets or garnitures of vases were also left almost completely to the Chinese potters. In porcelain, too, the Chinese commanded almost the entire market in dinner services, with their tureens, runs of large platters and delicately potted plates.

The reason was simply commercial. Chinese potters, thousands of miles away, could in their true once-fired (hard-paste) porcelain out-pot and under-sell the home factories, which in most cases were only able to produce a type of artificial twice-fired (soft-paste) porcelain. This, although fired at a lower temperature than the Chinese (some 1250°C, or 2280°F against some 1400°C, or 2550°F), was of a less stable nature. There was a significant difference between the vitrified Oriental hard-paste porcelain and the more granular, often porous soft-paste porcelain.

The English porcelain manufacturers could only match the Chinese and Japanese imports in certain lines and in some styles of decoration where better-trained painters were employed working in a style unfamiliar to Oriental hands—delicate European flower-painting, landscape and figure subjects on tea services and other small items, such as sauce-boats.

Above: Chinese mug inscribed to commemorate the Battle of Culloden in 1746. Height 15.2 cm.

Below: A well enamelled Chinese export punch bowl bearing one of many versions of European hunting scenes copied from contemporary prints. Diameter 33 cm; c. 1770.

Obviously the Chinese could not match the Chelsea or Derby figure models or the essentially European groups of dancers, lovers or gardeners. The Chinese made many animal models but these are generally crude in comparison with the European examples—especially when the European models were taken from originals by highly trained and talented sculptors. The rare Chinese copies of European figure, animal or tureen forms have a primitive naivety only matched by some of the worst English copies of Oriental masterpieces!

Early English Porcelain

Looking back, we may wonder why the Chinese potters of the eighteenth century did not agree to make only the lines and styles in which they undoubtedly excelled, and why English manufacturers did not concentrate solely on those lines which the Chinese did not understand. Such an agreement might make good sense to a modern-day accountant or efficiency expert but if such a scheme had been entered into we would have lost most of our very delightful porcelains—all those attractive early Worcester essays in the Chinese manner as well as over 50 per cent of the Bow factory's output or nearly all the pieces from the Caughley factory. We would

likewise have missed most of the interesting Chinese private trade imports. No, copy and original both have their respective charms and perhaps perfection is not the only criterion.

Certainly as the story continues into the 1760s and 1770s perfection is not reached in the mass imports ordered by the East India Company where, once again, relatively inexpensive stock lines were those in demand, to floor the holds below the main cargo of teas.

The amount of Chinese porcelain ordered each season for the English Company was laid down by the directors in London who gave their supra-cargoes detailed written lists of their requirements. These supra-cargoes formed a Council in Canton ordering their goods for delivery on vessels arriving in the following year. In the selection of enamelled porcelain ordered from the Chinese merchant, Exchin, in Canton in September 1774, apart from the services, the individual pieces number over a hundred thousand items, plus a larger order (187,600 articles) to be decorated in underglaze blue. The amazing aspect of this 1774 order from the directors of the English East India Company is that all the enamelled porcelains are table-wares—tea-wares, breakfast or dinner services plus some mugs and bowls, and that all were to be supplied in only two patterns! The larger order for the same range of articles painted in

Below: Chinese porcelain teabowls and saucers are being used in this oil painting of an English family at tea, by J. Van Aken. c. 1720. (Tate Gallery, London)

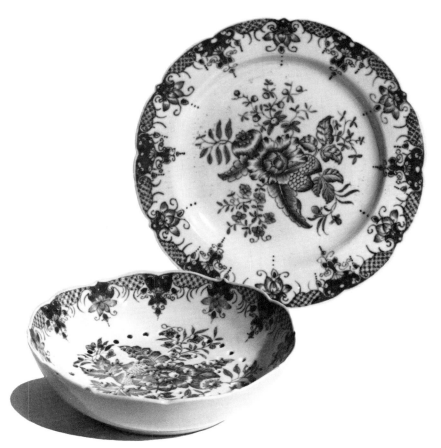

also reflect a change in taste. Few special services displayed large flamboyant armorial bearings; smaller devices were then in vogue, such as a crest only, or a crest with initials.

The Decline of the Chinese Trade

However, by the late 1770s the English East India Company's trade in Chinese porcelains was dwindling. The supra-cargo reported from Canton in 1779:

As the orders this year received from the Honble Court give us reason to suppose that China ware is not now an article in so high demand as some seasons past we have come to the resolution not to make any contract for the ensuing year as the quantity we have remaining will be sufficient to load eight ships and in case we should want a small quantity it will be much better to purchase a few chests than be encumber with a large quantity by engaging beforehand for it . . .

It follows that the vessels returning to London in the later half of 1779 carried only leftovers from the 1778 season, a fact which probably did not overly concern the Company. However, in the 1782 season the patterns should have been new even if the assortment of useful table-wares remained static because of the non-arrival of fresh instructions the agents in Canton reported back to London, '. . . we thought it necessary to contract with Exchin for 1,200 chests of China ware, the quantity contracted for last season . . . the patterns to be new.'

This last stipulation perhaps indicates that the Chinese merchants or the producers decided what patterns their goods would bear. There are no statements to the effect that the supra-cargoes ever examined samples and selected new designs, only 'the patterns to be new'!

Above: Chinese hand-painted copy of a Worcester blue-painted cress dish and stand. Diameter of stand 22 cm; c. 1775.

Below: Chinese export two-handled bowl enamelled with the crest and family motto of Robert Ouchterlony, and almost certainly copied from his painted book-plate shown on the right. c. 1785. (Ashmolean Museum, Oxford)

underglaze blue was to be completed in four patterns only. How any European porcelain manufacturer would have rejoiced if his selection of patterns could have been restricted to six designs a year! But then these bulk imports of the East India Companies were made to sell down to a price and in the restricted simple designs they succeeded in underselling any European manufacturer.

It must be remembered, however, that the private trade orders comprised some better quality wares and the more adventuresome pieces. Just because the bulk orders of the Companies did not include vases it does not mean that none were imported. By the 1770s the private trade orders for personalized objects

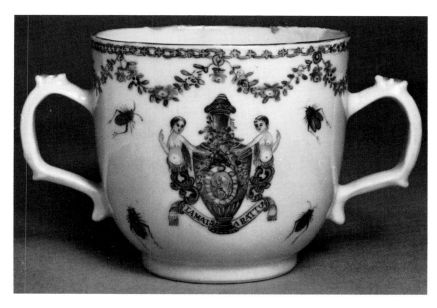

The trade in Chinese porcelains in the British Isles was, of course, effected by the basic trading conditions and the general shortage of money, and was not helped by the apparent lack of direction from the directors of the East India Company in ordering a good selection of patterns made to suit the European market. One authoritative account of October 1788 stated, 'In the India House sale this week I am informed out of more than eighteen hundred lots there was not five hundred sold.'

This was at a period when the Staffordshire industry was producing inexpensive and serviceable earthenwares and English porcelain factories were producing tasteful up-to-date designs. The more expensive markets were being influenced by French taste so that Wedgwood and the Derby porcelain factory products of that period show no Chinese influence at all.

East and West Combine

An interesting combination of East and West occurs in some Chinese blue-and-white of the 1780s and 1790s, when these standard items, mainly tea-wares, were further embellished in England. The point was

that hundreds of sets of identical patterns were being sold to the dealers at the Company's auction sales and in order to make one dealer's selection appear different or better from those otherwise similar pieces offered by his competitors some of the large dealers had various gilt borders and other embellishments added. Sometimes the English gilders added their personal tally-marks inside the footrim. These often take the form of numbers (up to at least 47, indicating perhaps a large establishment engaged in gilding Chinese porcelains). At other times initials can be found. These English gilt Chinese blue-and-white porcelains can be very attractive and are quite modestly priced. The accounts of one London firm of retailers, Turner Abbott & Newbury of 82 Fleet Street, include several such gilt Chinese tea services. The prices relate to November 1792, and one entry in particular shows the relatively high cost of adding the new gold borders:

12 Nankin large cups and saucers £1-10-0
Gilding do. 12/-

Teasets were listed ready gilded with 'chain and leaf' or 'gilt chain border' at £4-14-6 and £5-15-10 each wholesale, with suggested retail prices of £6-6-0 and

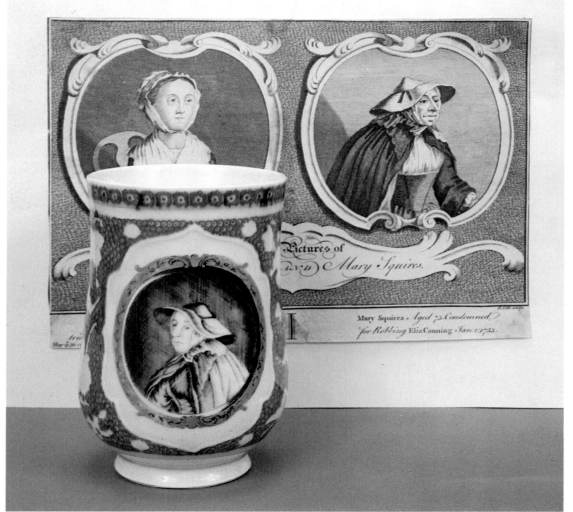

Left: A rare Chinese export mug with an underglaze-blue ground, the panel copied from an English engraving of the well-known gypsy Mary Squires. c. 1755.

Right: A superb Chinese tureen of a standard form, part of a large dinner service made for the Slater family and decorated with panels of European views. Diameter 33 cm; c. 1790.

Right: An attractive Chinese blue-and-white teabowl and saucer of a standard type. The enriched gilt over-border was added on arrival in England. Diameter of saucer 12.7 cm; c. 1790.

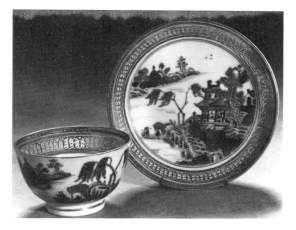

pattern which does not occur on Chinese porcelain in the form introduced in England—it is purely an amalgam of the parts of several Chinese export market designs of this general type.

On the other hand one does rarely find Chinese hand-painted copies of English blue-printed patterns and forms. Such Oriental pieces often bear copies of the English marks such as the Worcester crescent mark, clearly showing that the English prototypes were sent out to China to be copied.

The End of Bulk Imports from China

£7-7-0. We may assume from the separate account just quoted that some third of this cost related to the added gilt enrichments.

The hand-painted, underglaze-blue 'pagoda' pattern was copied by almost every English porcelain manufacturer from about 1790 until well into the 1820s. The English copies, started with the Caughley examples, are all printed, not hand-painted, in an effort to reduce costs. This 'Pagoda' pattern may be regarded as the forerunner of the still popular 'willow'

In December, 1791 a decision was made in London which was to have a major influence upon both Chinese export market porcelain and the manufacture of English porcelain. The directors of the East India Company voted to discontinue their bulk imports of Chinese porcelain. This resolution came as a surprise to all and was kept secret for some considerable time. In fact the stocks held in the Company's warehouse or still in passage from China ensured that the trade buyers at the Company's sales

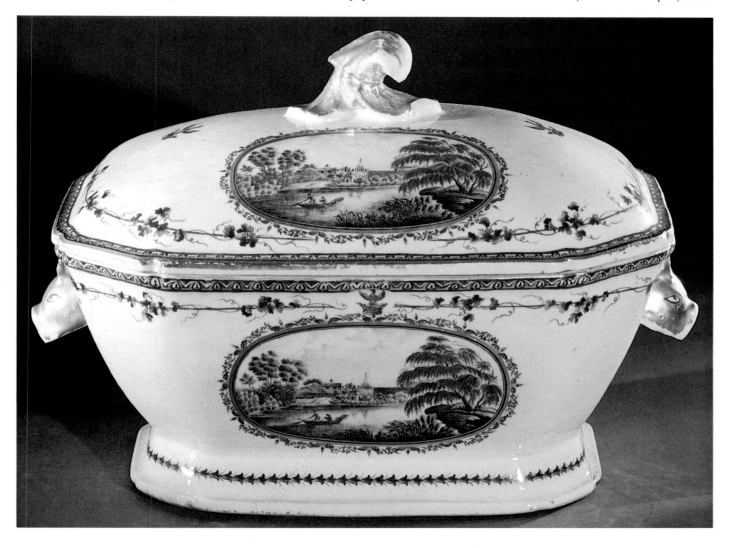

did not realize that no fresh imports were arriving until early in 1795. In reply to a petition from these dealers the Company stated in March 1795:

> ... the reasons urged by the dealers in China ware in their memorial are not sufficiently forcible to induce the Committee to recommend to the Court to depart from their former resolutions as to the non-importation of china-ware.

In China, too, the decision had its effect on the Company's merchants and presumably on the decorators and on the manufacturers of Chinese porcelain. The position in Canton is summarized in a letter from the Committee of Supra-cargoes dated Canton 14 May 1795:

> We have lately had an application from Exchin our late China ware merchant to afford him some relief from the loss and inconvenience he has sustained by the discontinuance of that article in the Honble. Company's investment.
>
> It appears by the Honble. Courts Instructions on that head that the Select Committee were directed to send home no more china ware than they had existing engagements for and accordingly it was discontinued in the year 1792, there being then no existing contracts.
>
> The plea urged by Exchin is, that although no contract was made at the close of the season 1791 the then President of the Select Committee had encouraged him to make a quantity under the presumption that it would be wanted, but as no china ware was ordered that year, it has been upon his hands ever since, till this time that his losses and misfortunes have compelled him to have recourse to the Honble. Company for relief. The amount of the china ware is about 60,000 Tales.

The amount of stock left on Exchin's shelves was worth some twenty thousand pounds sterling, a truly vast amount when it is remembered that tea services, for example, were valued at only 60p each.

A quantity of private trade continued to be imported but as this mainly comprised the special pieces it did very little to make up for the loss of the Company's bulk importations. The private trade buyers do not seem to have taken any of Exchin's surplus stock even although the letter states later that he would take any reasonable offer for it.

The private trade imports were however affected by the state of war existing in the latter part of the eighteenth century. For example in 1780 we read 'authentic Intelligence by way of Lisbon that all the five East Indiamen are certainly in the possession of the combined Spanish and French Fleet'. Whole shiploads were lost, and imports were also lessened by the very high import duty, fixed in 1799 at over a hundred per cent.

While the English East India Company lost some of their chartered vessels in time of war, the British Navy also captured vessels of other nations. In 1795

ten Dutch vessels were so taken and later their cargoes were sold in London. Harry Phillips' catalogue of December 1797 lists:

> An extensive and valuable assortment of India [meaning Chinese] china, being part of the cargoes of the *Zuyderberg*, *Schelde* and *Delft*, Dutch East-Indiamen comprising extensive and beautiful Nankin and Country table and dessert services, breakfast sets, tea and coffee equipages, large jars and beakers, bowls, long dishes in sizes, meat, soup and dessert plates, tureens, sauce boats and particularly two singular elegant enamelled and painted tea sets, inimitably pencilled in a variety of landscapes ... and a variety of curious and valuable articles.

By the year 1800 the amount of tea imported from China by the Engish East India Company had risen to no less than twenty-eight million pounds (28,000,000 lbs); at the same time the imports of standard tea-wares from China had dropped to a mere dribble of private trade imports. Very little porcelain was entering Great Britain from Continental sources. The market for porcelain tea services was therefore wide open to our own manufacturers, such as Miles Mason, who had been a London dealer in imported china ware.

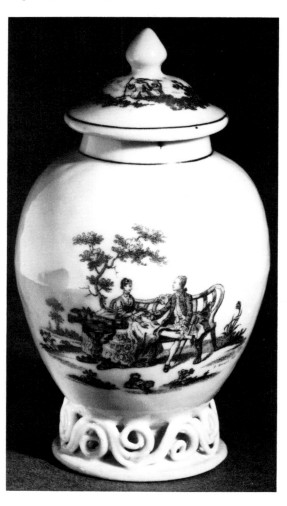

A very rare Chinese tea canister from a tea service. On arrival in England, it was transfer-printed over the glaze with a print signed by the engraver, R. Hancock, who worked for the Worcester factory. Height 13.3 cm; c. 1760.

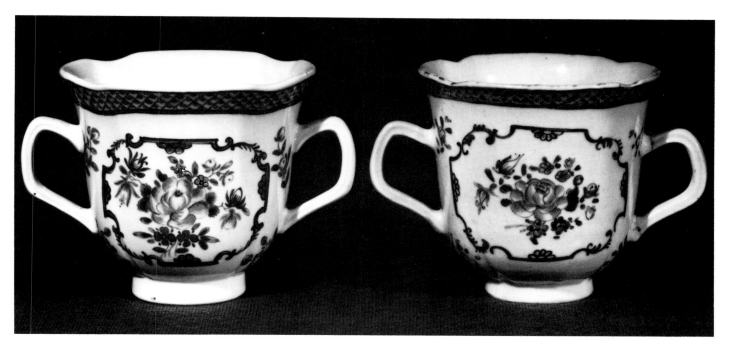

The Caughley two-handled cup on the left was made in soft paste as a near contemporary match to the Chinese hard-paste original shown on the right. English porcelain factories undertook a large amount of such matching and replacement work. Height 7 cm; c. 1785.

To all intents and purposes, the Chinese export market porcelains made solely for the European market after about 1730 do not bear any mark on the underside, although the undersides of some flanges to plates and dishes sometimes have painted decoration. Some examples made before about 1730 bear standard Oriental symbols, such as a leaf. Such Chinese symbols were often painted within a double-lined circle, a feature which sometimes occurs alone under Oriental porcelains. Japanese export market porcelains sometimes bear a square seal-like mark in underglaze blue.

Pattern numbers do not occur on Oriental porcelains, the only exceptions being the numbers or initials added by English gilders who had added gold embellishments to late eighteenth-century Chinese blue-and-white porcelains.

Chinese Porcelains Decorated in Europe

Some rare examples of Oriental porcelain bear European painting or transfer printing. Decoration of white Chinese porcelain was in the main carried out by independent decorators working in London and other centres, painting on whatever blanks they could obtain. As early as 1726, the English East India Company was ordering 'some entire white china of all the before mentioned sorts' but mostly the English decorated Chinese porcelains appear to be of the period 1750–1770. Most of this painting is done to an extremely high standard–far superior to the usual Chinese enamelling–and this rare class is worthy of study. Much of this decoration is believed to have originated from the studio of James Giles, 'china and enamel painter' of Berwick Street, Soho. In 1763 James Giles claimed to copy 'patterns of any china with the utmost exactness, both with respect to

the design and the colours, either in the European or Chinese taste . . .'. Several other (unnamed) decorators were no doubt practising their craft on Chinese blanks as well.

Replacements

In the course of use many Oriental dinner or tea services suffered damage and the owners often had replacements made at English factories. Some such replacements made to match Oriental services are of later date. For example, in October 1804 Miles Mason, the former London 'chinaman' advertised himself as one who 'through the medium of his wholesale friends, proposes to renew or match the impaired or broken services of the nobility and gentry'.

The services Miles Mason had in mind were almost certainly Oriental ones of Chinese export market type.

It therefore can happen that services are of mixed make, with English porcelain additions to a basically Oriental set. In this way it is possible that some Oriental designs were added to the pattern books of various English manufacturers and consequently these patterns were later issued as their own!

Thus, in this book or any other dealing with English porcelains, many illustrations will be found depicting patterns that are either outright copies of patterns on Chinese porcelain or that are intended to show that influence. This emulation was no mere chance; Oriental patterns suited the porcelains so well, they were what the buying public demanded, and they were what the manufacturers had to produce if they were to succeed.

It is remarkable that so many present-day collectors seek out the now extremely costly European copies, yet neglect the original Chinese porcelains that inspired these, often inferior, copies.

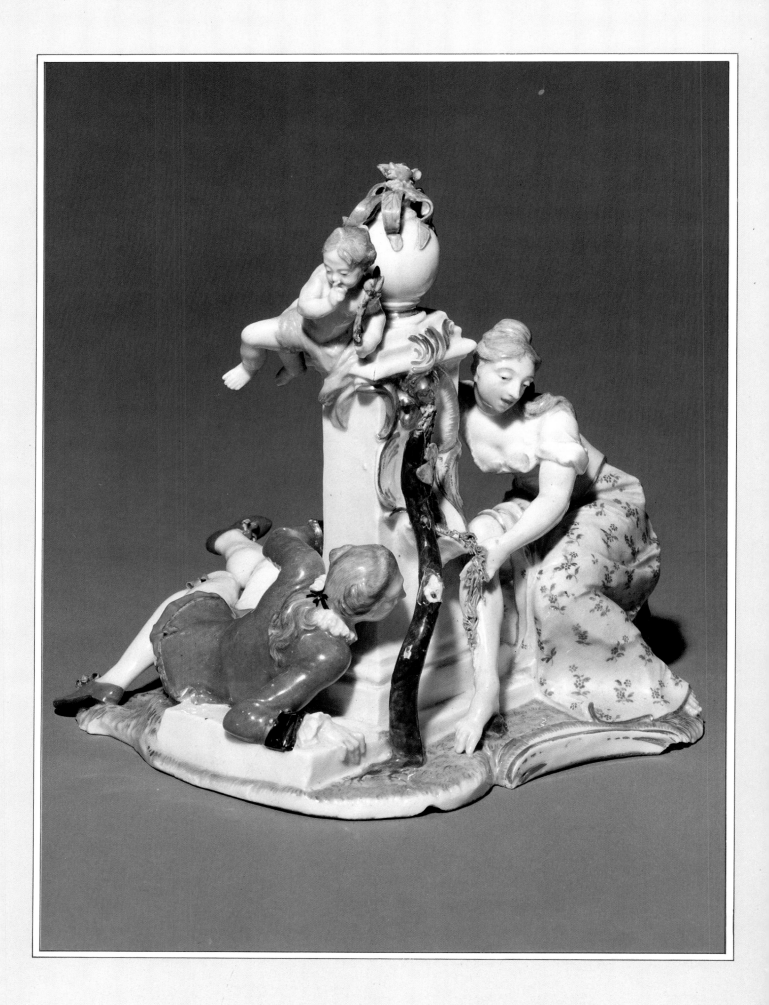

Chapter Six
The Development of European Porcelain

Left: A Nymphenburg group of 'Der Lauscher Am Brunnen' or 'the Rascal at the Fountain', modelled by Franz Anton Bustelli. Bustelli was master-modeller at Nymphenburg from 1754 to 1763. During this brief period he created some of the most beautiful of European porcelain figures. Height 17.5 cm; c. 1760.

Right: Florentine triple-spouted wine flagon in the shape of a grotesque head, with moulded and underglaze-blue decoration. Medici soft-paste porcelain, c. 1575–1587. (Musée National de Céramique, Sèvres)

MARCO Polo was not the first European to visit China, but it is due to his long stay in that country that the word porcelain is used today to describe the physical appearance of this particular ceramic material. Marco Polo was a rich Venetian merchant who sailed East with his father Nicoló and his uncle Maffeo in about 1271, arriving at the Court of the great Mongol leader, Kublai Khan in 1275. He made friends with Kublai Khan, who dispatched him on various missions and was greatly pleased by his intelligent reports of his travels. Polo became so indispensable that for seventeen years he was not allowed to leave China until, one day, he and his party were commissioned to escort a princess to Persia, where she was to be married. During their journey they heard news of the death of Kublai Khan, so they returned directly to Venice. The city was at war with Genoa at the time and on 27 September 1296, Marco Polo was taken prisoner. During his captivity in Genoa he dictated to a fellow prisoner the book of travels in which porcelain is first mentioned.

Porcelain first Described

In describing the people and customs of the Province of Karian, Marco Polo praised their wine as 'clear, light-coloured and most pleasant to taste' and re-marked upon the white 'porcellana' shells found in the sea, which the people used as money and wore around their necks as ornaments. These were cowrie shells, known in Italian as *porcelletta* (meaning 'little pig') on account of their shape. Marco Polo applied the same word, *porcellana* or porcelain, to the manufactured ceramics of China, possibly because the sheen on these products reminded him of the sheen on the surface of the cowrie shells.

Marco Polo was the first European to describe porcelain manufacture, which he witnessed in the city of Taicheu in the Province of Fujian, where he found nothing of interest but 'cups and bowls and dishes of porcelain'. His interest was captured and he made enquiries about the materials used for fashioning and decorating the ware. He recorded that 'Great quantities are sold in the city, and for a Venetian groat you may purchase eight porcelain cups.' He must have made some purchases. According to tradition, a little porcelain bottle, preserved in the Treasury at St. Mark's Cathedral in Venice, is one of the pieces brought back from China by Marco Polo. Very little of this early imported Chinese porcelain remains in its original state. The restricted number of pieces brought into Europe in the fourteenth and fifteenth centuries were often enriched by gold or silver mounts or adapted to European use by the addition of metal spouts or handles. By the second half of the fifteenth century, Italian merchants could

import Chinese porcelain from Egypt, Syria and Turkey, where it had become plentiful. In 1461 the Sultan of Egypt was able to present twenty pieces of porcelain to the Venetian Doge, Pasquale Malipiero. Other gifts were made to Lorenzo de' Medici (the Magnificent) who already possessed a famous collection. Unfortunately, this was sold in 1494 after Lorenzo's death.

At this time, when the rich and cultivated were using Oriental porcelain on their tables, the production of maiolica (tin-glazed earthenware) was at its peak, and many maiolica pieces were decorated 'alla porcellana', with stylized flowers in blue on a white background. Such decoration was often used for the borders of plates surrounding a central portion that had already been decorated pictorially in the 'istoriato' style. Although rich patrons were still commissioning 'credenze' in maiolica, porcelain was preferred, so European potters began to experiment with glass and clay to try to reproduce this white, translucent material. Venice was a centre for the manufacture of maiolica and glass, and enjoyed a flourishing international trade. While in Venice in 1504 Ercole d'Este, Duke of Ferrara, bought several bowls made of 'porcellana contrafatta' (imitation porcelain). In 1518 a mirror-maker in Venice told the Senate that he could produce 'porcelain of every kind, like that called Levantine'. None of these early specimens are to be found today, but it can be assumed that they were imitations made with opaque white glass.

Early Experiments in Italy

Meanwhile, European collections of Oriental porcelain were growing. With the return of the Medicis to Florence, the collection of Cosimo I de' Medici reached the considerable number of 400 pieces, and when, in 1587, Cardinal Ferdinand I succeeded to the throne, his entire collection of 500 pieces of Oriental porcelain was brought to Florence from Rome. In 1590 some of these pieces were presented to Christian of Saxony and are today to be found in Dresden.

The descriptions of the porcelain in the old Medici inventories are fairly accurate, and from these it is apparent that in the sixteenth century pieces decorated in blue-and-white were quite numerous compared with the rarer 'porcellane verdi', the celadons, or green porcelain pieces. During this period of expanding Oriental collections most of the serious experiments attempting to reproduce porcelain took place in Italy. Two brothers, Camillo and Battista da Urbino, were engaged in 1561 by the Duke Alfonso of Ferrara to make maiolica and porcelain; they failed in the latter endeavour, and after ten years their experiments were abandoned. Meantime, at the Florentine Court, under the patronage of Cosimo de' Medici, first Grand Duke of the Florentine Republic, independent experiments in porcelain production were attempted. Like his grandfather, Lorenzo, Cosimo was a great patron of Florentine arts and crafts, and it was under him that tapestry weaving

and the *pietra dura* mosaic workshops flourished. Bernardo Buontalenti seems to have been the supervisor for most of the Grand Duke's artistic ventures. He was a painter and sculptor and architect as well. In the second, 1568, edition of Vasari's famous book, *The Lives of the Most Eminent Painters, Sculptors and Architects*, it is predicted that Buontalenti 'in a short time will be making vessels of porcelain'. It is probable, however, that no porcelain was produced until after Cosimo's death in 1574, when he was succeeded as Grand Duke by his son Francesco, who was also interested in the patronage of the arts, including porcelain production. In a report written in 1575 by Andrea Gusoni, the Venetian Ambassador in Florence, it is recorded that under Francesco's patronage, as the culmination of ten years of experiments, with the help of a 'Levantine', the method of making Indian (that is, Oriental) porcelain had been rediscovered. Two years before this was written, Flaminio Fontana, member of a well-known family of maiolica-makers from Urbino, was in Florence and was paid for firing some pieces of porcelain. It is not known how much he was really involved in the discovery, but he deserves at least some credit for the firing process.

Florentine porcelain of the sixteenth century was indeed a great achievement, but in nature and composition it was entirely different from the Chinese. It was made by mixing together an impure kaolin (*terra di Vicenza*), lime and white sand with finely ground-up glassy material and rock crystal. The glassy constituent gave the fired clay the required translucency, but it was not possible with this mixture to achieve the hard body characteristic of Oriental porcelain. This Medici product was the first of the soft-paste porcelains produced in Europe; other versions were developed much later, particularly in France and England. The Medici pieces were, as one might expect, rather thickly potted and clumsy in appearance, and the white colour varies with different degrees of greyish shade. The majority of pieces are decorated in underglaze blue, sometimes bright and sometimes dull, and the colour has a tendency to

run. The shapes and decoration are in native Renaissance style, only slightly influenced by Cino-Islamic models. The decoration on the polychromatic pieces is very reminiscent of that used on the maiolica from Urbino. Ferdinand must have been very proud of his porcelain, for in 1582 he sent some pieces as a gift to King Philip II of Spain. Medici pieces often bear a mark incorporating the letter F and a representation of the dome of the church of Santa Maria del Fiore.

Porcelain production in Florence almost certainly came to an end with the death of the Grand Duke in 1587, and, although it is believed that porcelain production was carried on at nearby Pisa until 1630, so far no authenticated piece has come to light to confirm this. Surprisingly, the Florentine formula was not taken up by rival potters or princely patrons, and it was over three quarters of a century before porcelain was again produced in Europe. This time the impetus came through the fashion for imported exotic goods created by the opening of the Cape of Good Hope sea route and the founding of the great European Mercantile Companies. The demand for things Oriental, including porcelain, was great, but the maiolica makers of Italy, the Delft potters of Holland and the faience makers of France were none of them able to do more than produce objects with a superficial resemblance to Oriental porcelain.

French Imitation Porcelain

When King Louis XIV decided to build a secluded Trianon in the grounds of his palace at Versailles, it had to be in the fashionable Chinese style. In 1669 Le Notre and Le Vau were given the task of designing the garden and the building. Le Vau died in 1670 and was succeeded by François Dorbay. The Trianon de Porcelaine became one of the favourite retreats of Louis and his mistress, Madame de Montespan. The building was in a very heavy Doric order and had a steep mansard roof. To make it appear Eastern the architect introduced a variety of bizarre ornaments. The roof was entirely covered in faience tiles, blue with a little green and yellow on a white base. The balustrade and both levels of the roof were ornamented with a great quantity of faience urns, decorated in blue and white. Between the urns on the balustrade a number of gilded amorini were grouped to form festoons, while on the tier above them was a line of birds in naturalistic colours. The blue and white pattern of the roof tiles was carried down on the façade. The broad wooden window casements were painted 'en façon de porcelain' and this motif was repeated on the iron gates and continued on the fountains and statuary in the gardens. Indoors this taste of 'lachinage' (deception) was carried still further. The Chambre de Diane was panelled in blue and white Dutch tiles, while other rooms were richly covered with Chinese silks and embroidery.

In 1684 the Trianon was used to receive the Ambassador from the Court of Siam and his retinue. The visitors were particularly impressed by the gardens which featured such novelties as orange trees growing without the customary protective tubs. This had been achieved with the aid of a collapsible greenhouse erected around the trees when the season demanded. But with all its novelties the Trianon had its limitations. Having been built primarily as a royal lovers' retreat, it was too small for state functions, and when Madame de Montespan fell from favour, the building fell into disuse. Another disadvantage was that the faience tiles were too porous for outdoor use, so that each year the frost brought a new batch of them tumbling down. Eventually it was considered too expensive to preserve and was demolished.

At the time of the construction of the so-called Trianon de Porcelaine, France was not producing any porcelain and the building had to make use of imitations in faience and Delft. A patent for the making of porcelain had been given as early as 1664 to one Claude Reverend of Paris, but he was really only an importer of Dutch Delft and possibly a faience maker himself. Had there been any French porcelain available at the time, the architect of the Trianon would certainly have made use of it. Some French porcelain factories were established later during the reign of Louis XIV. In 1673 another patent was granted to a faience maker of Rouen, Edmé Poterat on behalf of his sons Louis and Michel, who were both knowledgeable about faience and porcelain-making. In 1694 the Poterats applied for a renewal of their faience patent, at this time stating that 'the secret' (for porcelain) was being little used. Louis, who claimed he was the only one who knew the secret, died in 1696, and his formula died with him. Although the Poterat factory had been going for twenty-three years, there is very little porcelain to show for it. Their rare products are like the Medici porcelain, an artificial or soft paste. Extant pieces of Rouen porcelain vary in the appearance of the glaze and in the quality of the blue decoration, neither feature being particularly good. The decoration is

Right: Rouen ewer, of faience painted en camaieu (monochrome painting in various tones) in blue, with lambrequins (fringe-like ornaments) and birds. c. 1715. The Rouen faience factory was founded in 1526 by M. Abasquesne. Much tin-glazed earthenware decorated in the Italian maiolica style was produced there. (Metropolitan Museum of Art, New York)

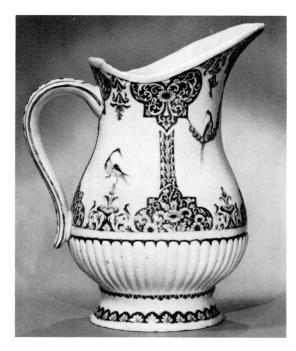

similar to that found on Rouen faience of the period, consisting of underglaze-blue painting of stylized leaves and richly brocaded borders.

The Rouen porcelain decoration resembles that employed later at St. Cloud. A group of pieces marked in blue with the letters A.P., usually under a star, were formerly attributed to Rouen, but as the letter A has never been explained in connection with Poterat, these pieces are now thought to have been made at St. Cloud. Certainly some of the shapes among this group of pieces have great similarity to Meissen and Vienna models as do the products of St. Cloud. From the account of a visit to St. Cloud written by Dr. Martin Lister in 1698, it is clear that the factory was established by then:

I see them also in the Mold, undried and before the Painting and Glazing was applied, they were as white as Chalk, and melted upon the Tongue like raw Tobacco Pipe Clay, and felt between the teeth soft like that, and very little gritty; so that I doubt not, but they are made of that Clay.

As to the Temper of the Clay, the Man freely owned to me, it was 3 or 4 times well beaten and wet, before it was put to work on the Wheel; but I believe it must first be melted in fair Water, and carefully drawn off, that the heaviest part may first sink; which also may be proper for Courser Works.

That it requires two, and sometimes 3 or 4 Fires to bake it, to that height we saw it in the most finisht Pots: Nay, some of them had had 11 Fires.

I did not expect to have found it in this perfection, but imagined this might have arrived at the Gomron [Gombroon] Ware, which is, indeed, little else, but a total Vitrification, but I found it far otherwise, and very surprising, and which I account part of the felicity of the Age to equal, if not to surpass the Chineses in their finest Art.

As for the Red Ware of China [Yixing stoneware], that has been, and is done in England, to a far great perfection than in China, we having as good Materials, viz. the Soft Haematites, and far better Artists in

Pottery. But in this particular we are beholding to two Dutchmen Brothers [the Elers] who wrought in Staffordshire and were not long since at Hammersmith.

They sold these Pots at St. Clou at excessive Rates; and for their ordinary Chocolate Cups askt Crowns a-piece. They had arrived at Burning on Gold in neat Chequer Works. He had some Furniture of Tea Tables at 400 Livres a Sett.

True Porcelain Created

Three remarkable characters collaborated to produce the first true European porcelain. First was Augustus the Strong, Elector of Saxony, a powerful prince with an aggressive determination to surpass his rivals in artistic patronage as he had done in war. Throughout his life he was an avid collector of ceramics. Second was Ehrenfried Walther von Tschirnhaus, a distinguished physicist and natural philosopher. Third was Johann Friedrich Böttger, a young alchemist of dubious reputation, noted for his secretive experimentation and rash claims to be able to transmute base metals into gold.

In the early part of the eighteenth century potters were referring to maiolica and faience as 'porcelain' and advertising such products as being 'as good as, or surpassing in quality, the porcelain of the Orient'. Tschirnhaus, the physicist, shared no such illusions. After a visit to the soft-paste porcelain factory in St. Cloud in 1701 he reported that none of its products was as good as 'real porcelain'. His recognition of the distinctive properties of true hard paste, and his determination to reproduce it, motivated him during many years of experimentation. As early as 1694 he had put into the mind of Augustus the idea that porcelain might be produced locally, explaining that he had already done some preliminary experiments to that end. It was still in pursuit of the same quest that he made the journey to St. Cloud near Paris.

While Tschirnhaus was in France, the Prussian authorities were demanding the return of the alchemist Böttger, who had some time before escaped to Saxony when his failure to redeem his promises to make gold caught up with him. Augustus decided not to give up such a potentially profitable individual. Instead, he put him under lock and key in Dresden and set him to work for Saxony. Of course no gold was forthcoming, so eventually Böttger was made an assistant to Tschirnhaus in the ceramic experiments.

A long time passed before the collaborative efforts of Tschirnhaus and Böttger produced anything worthwhile. Their first achievement was the production of a variety of hard, red stoneware that somewhat resembled porcelain. This was made from a mixture of coloured clays fused with loam. According to Heintze, the mixture consisted of 12 per cent washed loam and 88 per cent red bolus, the latter made from red Nürnberg earth, a yellow argillaceous earth from Zwickau, Borner earth from Berggiesshubel and later on some red clay from Okrilla. A new factory was built in 1707 on the

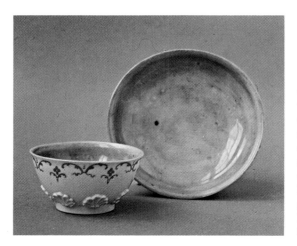

Left: Meissen bowl and saucer of Böttger porcelain. The attractive lustre was obtained by using the 'fulminating gold' technique, which was introduced around 1716. The tinyness of this and many other teabowls, cups and pots of the period is an indication of the high price of tea at that time. Height of cup 3.8 cm; c. 1720. (Victoria and Albert Museum, London)

strength of this discovery, situated on the Venusbastion in Dresden. A council was set up to run the new enterprise, with Tschirnhaus in charge of technical development and Böttger in charge of administration, with a chemical expert, Dr. Bartholomai, looking after the preparation of the paste.

Böttger set great store by their new ceramic material, and in fact the factory expanded rapidly, but the search for hard, white porcelain continued. Tschirnhaus died in 1708 and it is possible that he never saw the final outcome of their long collaboration, for it was not until a report to the King, dated 28 March, 1709, that Böttger first made the claim that he could make 'good, white porcelain with finest glazing and painting in such perfection as to at least equal, if not surpass the Eastern production'. His claim was characteristically boastful. In reality it took several more years for the Saxon porcelain to equal and eventually to rival the Oriental ware.

The very first examples of white porcelain were produced by combining clay from Colditz with a flux obtained from calcified alabaster. The factory on the Venusbastion soon proved too small for the development of both stoneware and porcelain, so fresh premises were made available in the old Albrechtsburg fortress at Meissen, not far from Dresden. The move began on 6 June 1710, but it took time to adapt the old building to the factory's needs. Even by September of that year only the stoneware section was functioning.

Meissen

In spite of the problems of the impending move, the Meissen workers did not lose the opportunity presented by the Leipzig Easter Fair of 1710 to exhibit their new stoneware to the public for the first time. They also put on show a few pieces of white porcelain. The public response, however, was disappointing, probably owing to the imperfections and lack of sophistication of the productions. At that time, none of the principals at the Royal Meissen factory, as it was now known, were skilled craftsmen or designers. Böttger, Bartholomai and Nehmitz were novices in the ceramic field, and even Fischer, the court potter, was used only to faience or earthenware. The Meissen personnel were not yet in a position to exploit the new material to the full by making the exciting shapes and decorations for which it is so well adapted. The simple style of the earliest pieces, cups and vases, failed to display the beauty of the new material to the best advantage.

It was the King himself who came to the rescue. He fully realized the limitations of the factory staff. He ordered the court goldsmith, J. J. Irminger, to assist the factory and to produce designs and shapes for the new wares. This he did, as well as helping the potters to produce items of their own design. At first much use was made of Chinese models, sometimes loosely imitated, sometimes faithfully copied, but in a very short time an indigenous German style developed and proved to be particularly successful with the new red stoneware. It was considerably

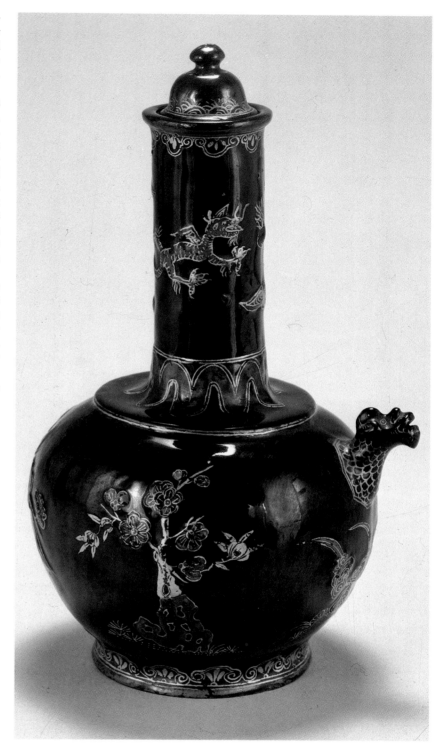

influenced by the baroque style, then in vogue. Vases became taller and more slender, and were enriched with moulded or applied decorations in the form of acanthus leaves or espagnolettes, eagle heads and prunus flowers. Octagonal teapots, reminiscent of metal prototypes, with snakes' heads or dragon designs for the spouts, faceted handles and elaborate scroll work soon became part of the repertoire, in addition to sculptural pieces such as busts and figurines. New techniques for polishing and engraving were developed that were particularly suited to

Above: Meissen Böttger stoneware ewer and cover after a Chinese original. The glaze is lustrous black, and the moulded decoration includes dragons and flower sprays 'japanned' in red, outlined in gilding. The spout is in the shape of a dragon's head. Impressed repairer's mark. Height 19 cm; c. 1728.

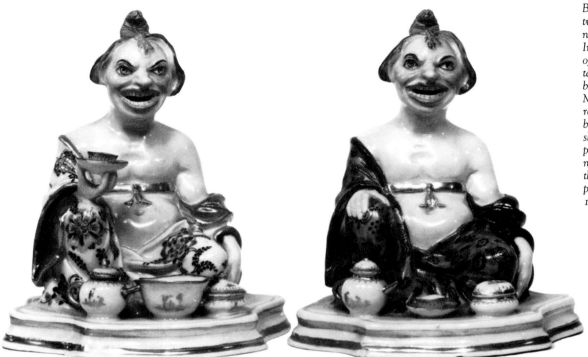

Böttger pagoda figures. The two seated figures have natural-coloured features. In front of them is an array of tea-wares, including teapot, sugar-box and slop bowl. These very early Meissen figures are reminiscent of Fujian or blanc de chine, and they show the care and attention paid by the Meissen modellers to details, even at this first stage of European porcelain production. Height 12 cm; c. 1715.

the hard stoneware. Objects were decorated using one or other method, or a combination of methods, resulting in an almost polychromatic effect from variations in light and shade and smooth and matt surfaces. Glazes were used on occasion, but purely for aesthetic reasons, because the body was totally nonporous even when unglazed. Pieces were also decorated with gold, or silver lacquer and enamel colours.

All these artistic innovations brought with them appropriate financial success and public appreciation, as well as the appearance of various imitators. This did not cause Böttger to rest content. Experiments with the white porcelain continued and both body and glaze were steadily improved. The first white pieces sent to Augustus, and the ones exhibited in 1710, had been merely trial pieces and far from perfect. In the course of time new clays were found at Aue, on the property of a Mr. Schnorr, which, in combination with the clay from Colditz, produced a remarkable improvement. Further beds of kaolin were found at Raschau near Schwarzenberg as well as some less satisfactory varieties at Geyer, Zschopan in Silesia and other places. The most successful formula proved to be 4 parts of Schnorr's clay, 2 parts of argillaceous clay from Colditz, 1.5 parts of fine white silica and 1.5 parts of alabaster. The silica clay was added to make sure that the paste would bake to a pure white. The Colditz clay contributed some impurities in the shape of iron and titanium. The alabaster helped to give the porcelain its translucent quality.

Böttger had also to devise a suitable glaze, and for this he used a mixture of 100 parts of silica, 10 parts of Colditz clay and 20 parts of unrefined borax. The borax was later replaced with lime. From the beginning Böttger wanted to have coloured decoration, but this was impossible, for suitable techniques and craftsmen were not yet available in Meissen. The porcelain produced in this early period was often spoiled by contamination from smoke in the kilns, due to the saggars in which it was fired cracking under the high temperatures required. Nevertheless, there were some successes.

At this time the porcelain was not yet the milky white colour that has since become so familiar. The decoration was often applied to the surface in the form of flowering branches derived from Orientalstyle decoration. The shapes of the early productions were in some ways similar to those used in the stoneware pieces. Although it was Böttger's ambition to produce highly decorated porcelain rivalling the imports from China, he never fully achieved this. By about 1715, however, the body had much improved, moulds were introduced and production was expanding, although problems with the baking temperatures continued. Writhing and also cracking remained troublesome. Even at this early stage some figures were attempted, but few emerged from the kilns unscathed. These very early Meissen figures are reminiscent of Fujian or blanc de chine, and some are in fact exact copies of the Chinese prototype. Examples are included in the collection made by Augustus. Often the early porcelain was decorated with gilding or cold colours, but very few pieces so embellished have survived. Callot figures may have been produced during this period, but so far no mould confirming this has emerged. If in fact these figures were made by Meissen, they could have been freely modelled, or alternatively the moulds used could have been discarded.

Böttger and other key workers at Meissen were sworn to secrecy about the factory processes. In fact, although they were fairly well treated as to working conditions, and given reasonable salaries, security

was so stringent that they were kept virtual prisoners. This state of affairs, plus the long hours spent experimenting, may have been responsible for a deterioration in Böttger's mental health. He took to drink and bad companions, and may have given away a few secrets in his drunken bouts. He died in 1719 at the early age of thirty-seven, but his work lived on. He had been a truly adventurous spirit in his day, and his discoveries, first of the red stoneware, then of hard, white porcelain, were not a matter of luck, but the result of his sustained interest in science and his methodical, painstaking researches. He manufactured no gold for Augustus, but his contribution to Augustus' glory and fame, as well as to his material profit, was in the end something better. Augustus is remembered today more for his ownership of the first European porcelain factory than for his successes in battle. While Böttger's name today is synonymous with his famous stoneware, Tschirnhaus, the driving spirit of the early days, is unjustly forgotten. It is sad that neither of these two pioneers lived to see the great fame and prestige that Meissen was to achieve. For half a century Meissen was the leading European factory, dictating the nature and style of table-ware throughout Europe.

A change had to be made in the management of the factory after Böttger's death and Dr. Nemitz, who had been for many years his assistant, now took charge. At the time of Böttger's death the factory was aiming to produce porcelain decorated in underglaze blue, and with as many overglaze colours as possible, to make more pieces and to have some better quality items. From 1720 onwards the products were sorted into categories according to quality—good, medium and 'garbage'.

Throughout the eighteenth century great prestige was attached to the ownership of a porcelain factory, and workmen connected with the business were eagerly sought out by kings, princes and rich entrepreneurs who thought nothing of offering bribes to 'arcanists', or to people connected with the industry who were thought to be arcanists. Industrial espionage was one of the problems that Meissen had to contend with from the earliest days. Despite the strict security measures, some piracy had taken place even before Böttger's death. In 1718 the Vienna factory was founded with the help of the enameller and gilder Konrad Cristoph Hunger who had formerly worked at Meissen. He had come to Dresden from France and been encouraged by Böttger to apply his skills to the development of underglaze-blue decoration. He is supposed to have transferred to Vienna in 1717 to work with Du Paquier on the development of porcelain. Du Paquier soon found that Hunger's skills were not up to this task, so he went himself to Meissen where he was able to bribe the arcanist Samuel Stölzel. It must have been Stölzel who realized that kaolin was not available in Vienna and who put Du Paquier on to the idea of importing it from Schnorr in Aue. The Vienna factory failed to prosper, however, and the promises made to Hunger and Stölzel were not kept, so the two men quit. Hunger left for Venice in 1719, remaining there for five years making porcelain from Saxon kaolin, after which he returned to Meissen as an enameller in gold. Stölzel left in 1720, returning at once to Meissen, where he received from the King a pardon for his treachery.

After his reinstatement at Meissen, Stölzel was regarded with some suspicion and was kept apart from the other key workers, but he soon earned respect for the improvement he made to the kilns, facilitating the production of plates and vases without distortions. When Köhler, the manager, died Stölzel was appointed in his place. Stölzel was also responsible for bringing back with him to Meissen in 1720 a man who was to contribute largely to the factory's worldwide reputation—the painter Johann Gregorious Höroldt. It has already been said that during Böttger's lifetime the painted decoration was

Below: Engraving by Jacques Callot from 'Varie Figure Gobbi' (1622). (Victoria and Albert Museum, London)

Below right: Meissen bowl decorated with panels outlined in gilt and iron-red scrolls, and painted in polychrome with a pair of dwarfs. Diameter 17.8 cm; c. 1720. This type of decoration shows how porcelain-painters were influenced by engravings, and it is possible that the dwarfs were taken from prints by François Collignon, one of Callot's pupils.

grinders by 1731. At first Höroldt enlisted as assistant painters people who had already received some training in the ceramic field, but later he looked for people whose main talents were imagination and a natural capacity for drawing. These apprentices were made to go through a period of training that lasted a minimum of six years.

The painting department evolved rapidly under Höroldt, whose creativeness in the decoration of porcelain has never been equalled. He borrowed from Oriental prototypes, but was never a slavish copier; in fact he created an Oriental fantasy world of his own. His palette of yellows and reds was without rival. His adaptations of Japanese patterns were lively and distinctive. He was also responsible for introducing coloured grounds. In this technique all but a small reserved panel of white was coloured, after which the panel would be decorated with exotic painting. A yellow ground was already in use in 1725, but by 1731 there was a choice of yellow, dark blue, sky blue, peach blossom colour, steel green, light and dark grey, purple and red. In addition, there is mention in 1733 of a 'yellow glaze' invented by Höroldt.

Höroldt's rapid success at the factory was the cause of some misery for him, as people became envious of his position. At the beginning of his career at Meissen, Höroldt did not feel too secure. The factory was under the supervision of the Prime Minister, Count Karl Heinrich von Hoym, who was also the chief manager from 1729 to 1731. He was a Francophile, and he seems to have granted untold privileges for the purchasing of Meissen porcelain to a Parisian dealer, Rudolf Lemaire. Lemaire was given a contract whereby, on deposit of 1,000 talers a year, he could receive a large quantity of goods for sale by him in France and Holland. Some of the designs were made exclusively for Lemaire. Not all of Lemaire's demands were acceded to by the factory; for instance, his request for pseudo-Oriental marks was refused and the goods supplied to him were ordered to bear the customary sword markings. Nevertheless, von Hoym continued to give Lemaire's orders preference over all others, and new designs bought by him were not made available to the general market for a year. Höroldt suspected that von Hoym was intending to give Lemaire some important position at the factory, perhaps even his own job, but this did not happen. When in March 1731 Saxony struck up a political friendship with Austria, von Hoym fell out of favour and the King himself took over the management of the factory. Höroldt was reassured as to his position and remained connected with the Royal Factory until his retirement in 1765. He died in Meissen in 1775.

Breakfast services took first place among the Meissen productions during Höroldt's first ten years there, but the King's interest was in larger pieces, such as vases and dishes, and attempts in this direction were made continuously. By the end of 1731 a dinner service is mentioned for the first time. Although most larger pieces were made for the King, this table service was ordered by the Chief Treasurer, Count von Friesen. The King also wanted sculptural

Meissen vase with 'Indian flower' decoration. 1735. (Museum of Decorative Arts, Prague)

not far advanced. Mostly the decoration used was moulded or applied, but there was also available the 'pearlmutter' or mother-of-pearl lustre. This was made with 'fulminating' gold and was of a peculiar variegated reddish-brown with a metallic lustrous quality. It appears on quite early pieces. It was probably produced from a solution of gold, using ammonia, but the process was given up owing to the danger of explosion–hence the term 'fulminating'. Höroldt's skill and imagination transformed this state of affairs. He soon obtained the title of Court painter and was eventually put in charge of the decorating department at Meissen. His work was so much in demand he had to take on assistants. By 1725 he had ten journeymen and five boys, increasing to twenty-five journeymen and eleven boys and two colour

works to be made in larger sizes and better quality. In order to fulfill this task the management decided that 'a good sculptor who makes different models, and several capable boys, could be engaged'. Up to the date of this decision, on 23 March 1727, the task of producing models had been fulfilled by Fritzsche, a sculptor who had little imagination but was good at copying. Fritzsche being fully occupied with work in hand, Johann Gottlob Kirchner, then living in Dresden, was engaged. He proved slow to become accustomed to the new material and to familiarize himself with the technique required for porcelain. After some complaints that his models were unsuitable for porcelain he was dismissed in 1728. The King then appointed as sculptor, Johann Christian von Ludwig Lück, who proved to be very industrious, producing numerous handles, tobacco pipes and snuff boxes. He was sent to the Leipzig Fair to collect drawings and engravings to stimulate new ideas in the design department of the factory. In the end, however, his work was considered even less satisfactory than Kirchner's, and in 1730 the latter was reinstated and made model master. His salary was increased and his duties were to manage the modelling department, to teach drawing and modelling to the apprentices and to record in a book of drawings all the new and existing patterns in use at the factory at that time.

With Kirchner in charge of modelling and Höroldt at the painting department, the factory flourished and expanded. The King's greed for porcelain never diminished and now he had the ambition to decorate with porcelain the newly bought Hollandische Palais (later renamed the Japanese Palace). The plan was to fill the ground floor with Japanese and Chinese porcelain while the productions of the Royal Factory would be on display on the upper floor. These rooms were to be furnished with porcelain, each room containing pieces of a particular colour, celadon, yellow, dark blue, pale blue, purple, green and peach-blossom coloured grounds.

Other rooms were to be furnished with large vases and life-sized sculptures of animals. For the chapel, life-sized figures of the apostles and a ceramic altar, pulpit and organ were planned. Nothing on this scale had been attempted before, new techniques had to be invented and mastered, and the enormity of the task was not helped by the King's impatience. Kirchner was the only man capable of undertaking such a daunting commission. In 1731, in order to expedite matters, Augustus engaged the sculptor Johann Joachim Kändler. Although only twenty-five years old, Kändler was a well-educated man who had been a pupil of the court sculptor Benjamin Toural. Although commencing as Kirchner's collaborator, Kändler soon overtook his senior.

Original design of a tureen, together with the Meissen tureen made after it, made by Johann Jaochim Kändler. Height 21.5 cm. Mid-eighteenth century. Two of Kändler's great table services, together with the original designs, are in the dining room at Alnwick Castle, the seat of the Duke of Northumberland.

By the time Augustus died in 1733, Kändler had produced seven large birds and one of the apostle figures, and was also designing table-ware. The King's successor, Augustus III, was also dedicated to the completion of the ambitious plans for the production of sculptural porcelain, and more sculptors were soon recruited to help Kändler establish the fame of the Meissen factory. Of these the three most respected were Eberlein, Edhrer and Reinicke. Kändler's brother, Christian Heinrich, also joined the factory and became a sculptor of some merit.

Kändler found nothing too difficult to attempt, and his efforts proved extraordinarily productive.

Apart from creating the figures wanted for the Japanese Palace, he introduced into the Meissen designs a truly European style. He delighted in inventing new designs. He remodelled most of the old table-ware, changing the stiff baroque design of the Oldozier pattern into a contemporary rococo delight. He applied his talents even to the introduction of new designs for breakfast services 'of which a thousand variations could be had, looking so beautiful and requiring so little exertion to design and to produce'. Evidently the virtues of simplicity were beginning to be appreciated. When asked to design a table-set for Count von Brühl, the director of the factory, Kändler produced the now world-renowned swan set. The embossed decoration on the plates depicted swans floating on water surrounded by water plants and bulrushes. The tureens were in the shapes of enormous shells adorned with mermaid handles and the oil and vinegar cruets took the form of little putti riding swans.

Best known of all Kändler's creations are his figurines. Even when working on this small scale he displays an unparalleled understanding of material and technique. The figures of Harlequin, Columbine and other characters from the Italian Commedia dell' Arte are among the best works of this kind, although

Below: Plate from the famous swan table service, designed by J.J. Kändler for Count von Brühl, the director of Meissen. Height 23 cm. Begun in 1737, this set was not completed until 1741.

his repertoire extended to such diverse subjects as miners, animals and mythological and allegorical pieces. At the start of his career with Meissen, Kändler's modelling style was predominantly baroque and his figures were given very simple square or rectangular bases with only an occasional ornamentation of applied flowers. Later the bases became richly carved and developed into scrolled pedestal forms. His scrolled tree trunks surmounted by realistically modelled and natural-looking coloured birds are greatly admired to this day.

Meissen's initial success and international reputation was shattered by the advent, in 1756, of the disastrous Seven Years' War. Once before, during the Second Silesian War, Frederick the Great of Prussia had invaded and pillaged Meissen, taking away on that occasion as spoils of war 52 cases of porcelain containing 120 table services, 74 breakfast sets, 61 birds, and various other things. Very early in the Seven Years' War Meissen was again invaded and the factory ransacked. The troops took away what little cash they could find and packed up, for dispatch to Frederick, some thirty cases of porcelain. The contents of the three porcelain depots at Dresden, Leipzig and Meissen were seized and sold off. W. K. Wegely, the owner since 1752 of the rival Prussian factory at Berlin, was bent on causing even heavier damage, but the Dresden agent and the Minister of Commerce intervened and succeeded in saving the Meissen factory from total destruction. Even so, work carried on only with great difficulty, the factory having lost much of its machinery and a number of kilns. Most of the workers and arcanists were evacuated during the invasion, for it was realized that they could be of invaluable assistance to Wegely. As it turned out Wegely was able to persuade only four apprentice painters to transfer to Berlin. The victorious Frederick kept on demanding porcelain services for himself and his favourite generals. Kändler remained at the Meissen factory throughout this troubled time, working as indefatigably as ever, and doing his best to satisfy these demands, in spite of much criticism from his superiors, who resented Frederick's impositions.

Designs influenced by classical antiquity were now much in demand. Occasionally Frederick himself would produce a design he wanted to see in porcelain. Kändler was aided at this time by P. Reinicke and F. Mayer. It is possible that the graceful French street criers were made by Kändler and Reinicke. They were modelled after some French drawings signed C. G. H. and dated 1753 and they may have been ordered by the French merchant Huet, who was possibly a descendant of an earlier merchant of that name who had been connected with Meissen since 1730. During the war period, 1756–1763, one other sculptor of note emerged, Carl Cristoph Punet. Judging from the high wage he was paid, his talents must have been highly regarded, but his work appears rather stiff and coarse in comparison with that of Reinicke, whom he replaced. Punet died of consumption in 1765.

Meissen remained in a difficult financial position after the peace of 1763, due to the damage the factory had sustained and the swift rise of many more fortunately placed competitors. Augustus III died in 1763 and his successor, Elector Friedrich Christian, did his best to put the country and the factory back onto its feet. He put his wife, Maria Antonia, in charge of the management of the factory. He reigned for only three months, but during the regency of his brother Xavier, which lasted until 1768, no drastic changes were made. Realizing the low state into which the arts had lapsed, Xavier founded an art school and appointed as its principal the then court artist and professor at the Dresden Academy, Christian William Ernst Dietrich. Höroldt and Kändler were obliged to take advice from him on artistic matters, and Dietrich introduced a method of teaching the Meissen painters which was based upon academic routines. He insisted that they should copy classical styles, and to this end he provided them with plaster models of statues from antiquity. It was soon realized, however, that such methods were unsuited to the training of porcelain painters and in 1770 Dietrich was finally recalled to Dresden.

Notwithstanding the ruler's interest and patronage the Meissen factory was still losing ground to its competitors. In an effort to increase sales Meissen pieces were put up for auction in various towns in

Saxony. French taste had become all the rage, so Fletscher, the co-director of Meissen, went to Paris to pick up ideas and buy some French models. Two Meissen painters went with him. They found temporary employment at Sèvres, learnt how to produce and utilize the 'effective and beautiful royal blue' and subsequently introduced the necessary techniques at Meissen. After this, still more representatives from Meissen went abroad in search of new techniques and styles with which to counteract the declining popularity of their products. In 1764 Delaistre was replaced by a French sculptor, Michel Victor Acier and in 1766 Teichert reported to the commission that he had found a new 'beautiful biscuit paste'.

Despite all this activity, changes were slow in coming, old models remained in use, table sets were being made to designs hardly different from those of the 1730s and 1740s and the traditional rococo style flourished more flamboyant than ever. Eventually, however, the influence of Dietrich began to percolate through, resulting in the emergence of an amalgam of classical and rococo styles. Vases were now decorated with moulded or painted swags and garlands of flowers or laurel leaves. Greek key patterns were used to decorate the bases of figures and the borders of plates. Kändler was displeased. He realized that porcelain was not well suited to the imitation of antique designs and he was reluctant to adopt the new style. Nevertheless, changes did occur. A new range of articles appeared in the catalogue of 1765, including such things as thimbles, flowers, pen holders, scissor cases, spools, needle cases, earrings and waistcoat buttons. As early as

1765 women began to be taken on. They were mostly wives or daughters of existing employees, probably recruited for reasons of economy, since they were paid considerably less than the men. They mostly worked on the blue underglaze painting and on the application of imitation lace to the clothing of the figurines.

The year 1774 marked a more definite turning point. The Elector of the day, Friedrich Augustus III, appointed a new manager, a man he thought capable of revitalizing the Meissen concern. This was Count Camillo Marcolini. He set about the task of restoring financial stability and artistic prestige with energy and eagerness, but the odds were against him. Rival factories kept improving their products and the markets were diminished by the prohibition on the import of Meissen porcelain imposed by Austria, Prussia, Denmark, Sweden and Portugal and by the high duties, 40 to 60 per cent, demanded by Russia, France, England and Spain. In addition, the Turkish market was lost because of the political situation there and the Dutch market diminished by the setting up of a new factory in that country at Loosdrecht. The importation of creamware from England, and the imitation of such wares by factories all over Germany, destroyed the market for the classical pieces that were Meissen's most prestigious output. Even for ordinary table-ware the situation was little better, for small Thuringian factories in the hands of independent entrepreneurs had flooded the market with cheaply priced porcelain. Although porcelain marked with the swords symbolic of the Elector of Saxony may have been preferred by the

Meissen porcelain, enamel and ormulu table ornament. The field is enamel; sixty-three ormulu stems support naturalistically modelled and coloured porcelain flowers, within porcelain panels moulded with wreaths, rushes and rococo scrolls on an ormulu frame. Supplied to the court of Augustus III of Saxony. Width 58 cm; mid-eighteenth century.

Right: Meissen figures of a baker's boy, a coppersmith and a miner. The baker's boy was modelled by Peter Reinicke, who joined the Meissen factory in 1743, and his work was highly thought of by Kändler, who modelled the coppersmith and the miner. The baker's boy and the coppersmith are after engravings by Michel le Clerc. The figures of the miners may have been inspired by a festival of miners which was held at the Saxon court. Mid-eighteenth century.

Right: Meissen crinoline figure of the Marquise de Pompadour wearing the stage costume of Galatea. For this work, Kändler was inspired by a now lost pastel by Cochin representing Mme de Pompadour and the Prince de Rohan in Lully's opera 'Acis and Galatea', which was produced at Versailles in 1749. Width 27 cm; 1753. A male companion figure to this one, dressed in the costume of Acis, is sometimes erroneously called Louis XV.

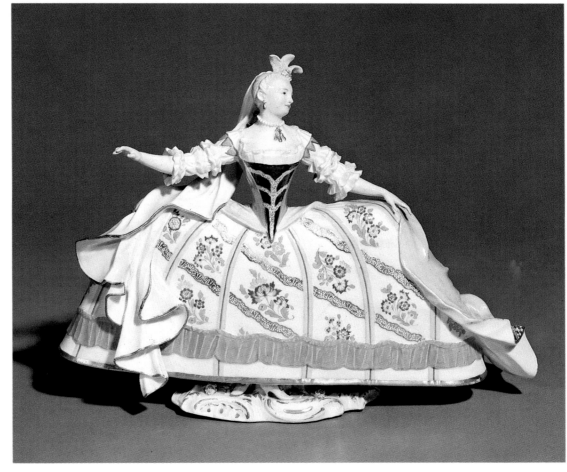

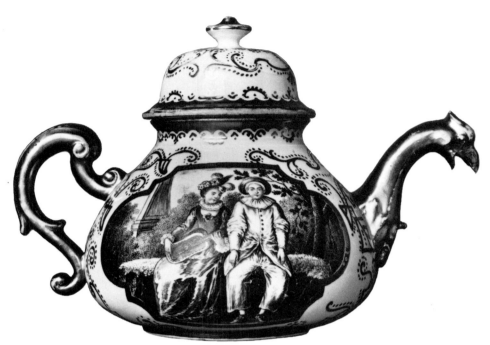

Above: Meissen porcelain teapot and cover. The shape of the teapot is reminiscent of contemporary silver. Height 12 cm; c. 1740. (Museum für Kunst und Kultergeschichte, Dortmund). The decoration is based on a detail of the engraving by E. Jeaurt, 'Pierre Content' (above right), which in its turn is after Watteau. (Cabinet des Etampes, Bibliotèque Nationale, Paris)

Russian and Polish people, this was of less help than it might have been because rival factories were marking their productions with faked Meissen marks or with rough imitations. To save the Meissen factory from closure the wages of the workers had to be lowered. In 1775 any porcelain marked with crossed swords other than Meissen was banned in Saxony. These regulations were strengthened in 1779 when the sale of any unmarked porcelain was forbidden as well.

Some of Marcolini's measures achieved positive results. Wages were raised again in 1777, and the porcelain depot in Warsaw, which had had to be closed in 1772, was re-opened and additional ones were established in Cassel and Spa. Unfortunately, Marcolini's directorship was troubled not only by lack of money and marketing problems, but also by internal strife. Kändler and Acier were in continuous disagreement, with rows going on between the two of them as to which one should have his way. Kändler, however, was rapidly failing in health. Anticipating his impending death he gave sculpture lessons to three young men (Juchtzer, Starcke and Lück) twice a week. He had them sit close to him to study his method of working 'so as not to take his art and knowledge with him to the grave'. He died in 1775, having spent forty-four years labouring for Meissen. Subsequent decline could not take away the fame and success that Meissen had originally achieved, largely through Kändler's untiring devotion, fertile imagination and unsurpassed artistic talents.

Acier replaced Kändler, but by the time he retired in 1781, the artistic and commercial problems were no nearer solution. During his directorship the art department put more and more emphasis on neo-classical design. Large quantities of biscuit statuettes of Greek gods and goddesses were produced. Busts of classical poets and philosophers were also made in biscuit, but the modelling was cold and stiff. This was the time that Wedgwood production was achiev-ing an international reputation almost as great as that of Böttger's stoneware in an earlier day. The Wedgwood designs were ideally suited to the neo-classical style that was in so much demand for architecture and interior décor. Meissen tried with-out much success to imitate the Wedgwood designs; Acier and the arcanist at Meissen probably never realized that the pastes used by Wedgwood were totally different from Meissen porcelain and much better adapted to the neo-classical styles. Meissen's imitations in porcelain were aesthetically unpleasing and financially unrewarding, and Meissen was never to recover the greatness of its first fifty years.

Vienna

As has already been indicated, industrial espionage during this period meant that porcelain in Austria developed along closely parallel lines with that of Meissen, in Saxony.

With the conclusion of peace between Austria and Turkey in 1718, the Holy Roman Emperor, Charles VI (Charles III of Hungary) sought to re-establish industrial prosperity. It was a time for the granting of privileges to existing industrial enterprises and for the establishment of new ventures. Although still more or less in its infancy, porcelain-making seemed a promising new industry. Böttger's discovery of hard paste at Meissen in 1709 was proving lucrative for the owners of that concern and was arousing envy in the rest of Europe. Claudius Innocentius Du Paquier certainly believed in the potential profitability of porcelain, and the example of Augustus the Strong's support for Meissen doubtless gave him reason to hope for similar help from his own Emperor.

Du Paquier had been on the staff of General Steinau's army during the recent military operations. When and where he learned the art of potting and the chemistry of paste remains a mystery, for the

secret of Meissen was closely guarded and Böttger himself had been virtually kept prisoner by Augustus for nearly twenty years. It is believed that Du Paquier went to Meissen early in 1718 and met Timann, a half brother of Böttger, from whom be bought the blueprint for the glazing kiln. Simultaneously the Emperor's ambassador in Dresden, Count Virmont, was trying to locate and persuade an experienced porcelain-worker to come to Vienna to work with Du Paquier. Christoph Conrad Hunger, recently returned from France, persuaded Virmont that he was in possession of the secret for porcelain-making. In fact, he was an enameller and gilder by profession and had no more than a passing acquaintance with Böttger, with whom he had discussed the problems of decoration with underglaze cobalt blue. The lonely Böttger, in one of his drunken bouts may have unguardedly mentioned some of the problems involved in the porcelain-making. However that may be, on 27 May 1718, a special patent was granted by the Emperor to Du Paquier and his three partners, one of whom was Hunger. This was for a period of twenty-five years and awarded a wide range of privileges, but no direct financial assistance from the State; it included a proviso that the artists employed were to be Austrian and the raw materials were to come from the Austrian territories.

Du Paquier's factory opened at Rossau, a suburb of Vienna. The paste formulae used by Hunger gave disappointing results, but eventually Du Paquier, with the help of two French mediators, managed to lure Samuel Stölzel, one of the Meissen arcanists, with promises of a salary of a thousand thalers, lodgings and expenses for the maintenance of a carriage. Like Böttger and other key workers at Meissen Stölzel was operating under difficult conditions. He was almost a prisoner and his salary was hardly 150 thalers a year. He arrived in Vienna in January 1719, and quickly pointed out that the local clay was unsuitable. He persuaded Du Paquier to import some from Schneeberg in Saxony, the clay source used by Meissen with which he was familiar. Thus the second European hard-paste porcelain factory was born. The achievement was commemorated with a two-handled fluted chocolate cup and saucer bearing two lines of a verse of thanksgiving inscribed on it in incised letters, together with the date, 3 May 1719. (This is now in Hamburg at the Kunstgeverk Museum.)

These events marked the beginning of espionage and bribery in the ceramic industry. Augustus must have felt the loss of Meissen's secret as a severe blow, but he did not react immediately. The marriage already planned between his son and the Emperor's niece, which took place that same year, must have been more important than the loss of an arcanist, but eventually he took some counter measures. He arranged for Anacker, secretary at the Polish Embassy in Vienna, to keep a close watch on Du Paquier's factory and to send him detailed reports.

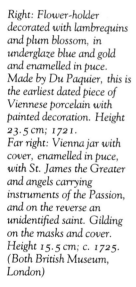

Right: Flower-holder decorated with lambrequins and plum blossom, in underglaze blue and gold and enamelled in puce. Made by Du Paquier, this is the earliest dated piece of Viennese porcelain with painted decoration. Height 23.5 cm; 1721.
Far right: Vienna jar with cover, enamelled in puce, with St. James the Greater and angels carrying instruments of the Passion, and on the reverse an unidentified saint. Gilding on the masks and cover. Height 15.5 cm; c. 1725. (Both British Museum, London)

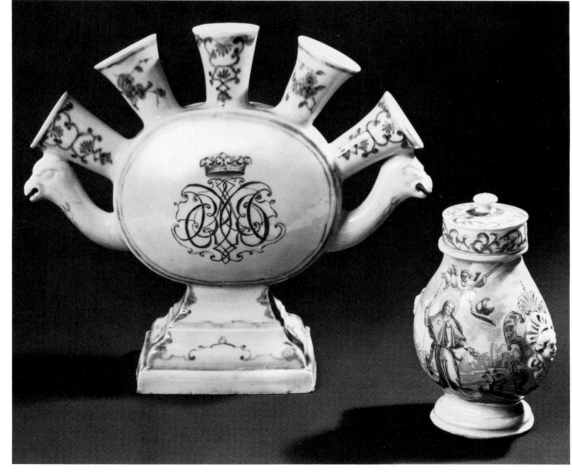

From the beginning Du Paquier had been in financial difficulty. Although the Emperor bought much porcelain he would not provide subsidies and Stölzel and Hunger soon realized that the handsome salaries they had been promised were not going to materialize. Hunger, meantime, had met and employed Johann Gregorious Höroldt, that talented young porcelain painter who had devised a new technique for enamelling porcelain. Hunger was still making use of the methods of a goldsmith-enameller, and the only way he could keep the colours from running into one another was by inserting tiny gold plates. Although he used the same paints, Höroldt had overcome this snag by a method which he was careful not to impart to Hunger.

The affairs of the Du Paquier factory reached a crisis in 1720 when Stölzel, approached by Anacker on instructions from Augustus, swore he had not passed on Meissen's secret and was accordingly invited to return and given fifty thalers to enable him to do so. Before leaving Vienna on 7 April 1720, Stölzel spoiled the stock of porcelain paste, broke up many moulds and seriously damaged the kilns. At his own expense he took Höroldt with him to Meissen. When Höroldt showed the Meissen directors some examples of his porcelain decoration, which he had

carried with him from Vienna, he was given immediate employment. Hunger stayed in Vienna a few months longer, but before the end of the year he was in Venice setting up yet another porcelain factory. Du Paquier, left on his own in a factory that had been largely destroyed, continued undaunted. He transferred what remained to a new location, which subsequently became known as Porzellan Strasse. There, with two kilns and twenty workmen he resumed production.

During Du Paquier's proprietorship of the Vienna factory pieces were unmarked, and there have been mistakes in attribution of some of the early wares, due to the fact that both Vienna and Meissen were using the same raw material. When Saxony ceased to supply clay to Du Paquier he obtained substitute material from Hungary and other places within the Imperial territories, which probably accounts for the variable colour of the body. He must have learned much while the Meissen people were with him, for his products were highly praised, although they were considered expensive. This limited his sales and added to his chronic financial problems. He approached the City Council of Nurnberg with samples of his products, offering to transfer the enterprise there in return for financial aid. This plan did not

Vienna porcelain tureen and cover of the Du Paquier period. The applied decoration and strongly moulded handles are reminiscent of silver work. The Russian coat of arms decorating the lid indicates that the piece was part of an important commission for, or one of the many gifts received by, the Russian court. Height 21 cm; 1735. (Victoria and Albert Museum, London)

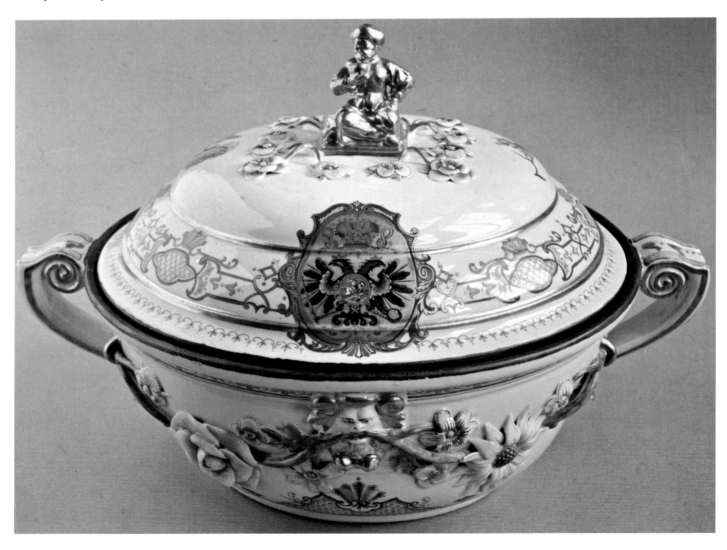

Du Paquier-period wine cooler, decorated in polychrome with naturalistic flowers and a mouse. This European flower decoration was possibly used in Vienna before Meissen. The piece reflects the charm and richness of the Viennese palette. Height 17 cm; c. 1740. (Victoria and Albert Museum, London)

come off, but in 1727 the Viennese authorities gave him some money to enable him to enlarge the factory. In exchange, he was obliged to reveal the 'arcano' to the Emperor. Charles, however, continued to refuse direct grants, and in order to raise money the unsold porcelain was disposed of in 1729, and several times subsequently, as lottery prizes.

Du Paquier was kept going by orders from royal and noble customers. The Emperor commissioned pieces used as gifts for other monarchs. In late 1720 came the important commission to furnish a porcelain room in Count Dubsky's palace at Brunn. As many as 1400 small plaques of porcelain, decorated with 42 different patterns, were inserted into the door frames and panels and in the aprons of stools and tables. The wall sconces, chandeliers, mirror frames and fireplace were all made of porcelain. Unfortunately this prestigious commission did not produce the hoped for rush of other patrons, and by the time his letter patent expired in 1744 Du Paquier was in debt to the sum of 31,500 gulden and had a large stock of unsold pieces. As the only way to clear his debts he offered to sell his business to the Treasury for 55,000 gulden. The Empress Maria Theresa, who had succeeded Charles, authorized the purchase and retained Du Paquier as director at a salary of 1500 gulden per year. He died in a Viennese hospital in 1751.

The most interesting of the Vienna productions coincide with Du Paquier's proprietorship. The ware of the period is easily recognized by the creamy tone of the paste and by the glaze, which is thinner and less glassy than that of Meissen. At first there seems to have been a large output of useful wares such as soup tureens, wine coolers, ewers, beakers, cups and covers and tea and coffee-pots. The forms were inspired by silver models and by far-Eastern prototypes. Often the decoration was in soft pastel colours of pink, copper green, violet, yellow, brown and black. The early painting calls to mind the floral patterns on the porcelain of Arita in Japan, better known as Imari. Occasionally, on pieces of about 1730, there are *chinoiserie* scenes in typical Meissen Höroldt style, an uncommon but highly successful form of decoration attributed to Anton Schulz. At this period the borders are decorated with leaf and scrollwork (*Laub- und Bandelwerk*) characteristic of the Viennese baroque style. This type of decoration, on which the

influence of the French artist Jean Bérain is clearly discernible, was popularized through the engravings of J. L. Eissler of Amburg. This strapwork decoration is often done in a black Italian ink monochrome (Schwartzlot) or a red monochrome, and occasionally it is heightened with gold. Shells and trellis patterns are sometimes incorporated. One of the artists who excelled particularly in Schwartzlot decoration was J. P. Dannhöfer, who introduced the style to Bayreuth and other parts of Germany.

During this period the stylized Oriental flowers were replaced by more European-looking ones, either painted or applied. This naturalistic style, better known as the *Deutsche Blumen*, had for a time considerable influence on the decoration of European porcelain elsewhere, including Meissen. Besides the *chinoiseries* and the *Deutsche Blumen* the decorations included puttis, landscapes and battle scenes.

The sculptural work of early Vienna is of lesser importance. The range of figures produced was very limited, but some sculptural work often appeared on table-ware. For example, the finials on the lids of tureens were sometimes in the form of a seated Chinaman, totally covered in gold. Handles of tankards were made in the shape of a standing man, his feet firmly attached near the base and his outstretched arms and hands fixed near the top, the overall composition taking the form of a figure '7'. Figures of crawling dragons were also used for both handles and finials. Some clock cases of this early period are sculptured, with pseudo-Chinese lions supporting an Oriental-looking building. The colour scheme on these fantastic objects included black, iron red and sometimes violet. The grinning lions and the awkward building they support seem of almost surrealistic construction.

The factory was reorganized when it was bought by the State in 1744. A new way of pricing goods was introduced in which 50, 30, 20 or 15 per cent was added to the cost price according to the quality of the ware that came out of the oven. In 1749 the stock of paste acquired from Du Paquier came to an end and kaolin from Passan, Smolnick and Telkibanya began to be used. For the first time a factory mark was introduced. It consists of a shield in underglaze blue which is the Austrian coat of arms. It has a rounded base and a bar, that is two horizontal lines drawn to divide the field. The Vienna factory still had much to learn. Meissen led the field, and it was to there that the new management looked to find inspiration. Christian Daniel Busch from Meissen was invited to join the Vienna enterprise, but he stayed only a short time before going on to Nymphenburg. His successor, P. E. Klinger, also from Meissen, served for longer. J. S. Fischer was the chief painter and he had the walls of his department hung with engravings of the works of Watteau, Lancret, Pater and other masters of the rococo. This display eventually had its effect, and by 1750 decoration in rococo style was perfected and established, although some of the older styles, such as the *chinoiseries* and the Schwartzlot continued to be produced for a time. The traditional shapes were now embellished with moulded and fluted decoration. Dishes were lobed and very often a

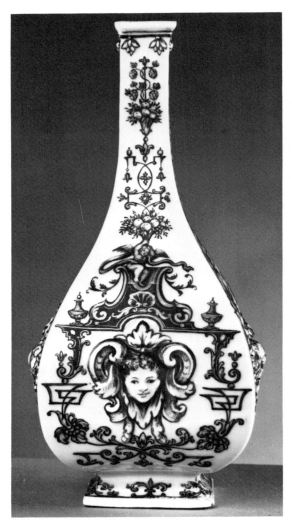

It was largely from lack of competent artistic initiative that the Vienna factory missed the opportunity presented by the disaster of the Seven Years' War, when work at Meissen came almost to a standstill, to capture the lead in European porcelain production. Instead it was Sèvres, which was more responsive to changes in fashion, that prospered most at this time. As early as 1768, W. Beyer, formerly chief modeller at Ludwigsburg, but by then working at Schönbrunn, urged the Vienna people to change their designs and output, but not until well into the 1770s did they bring themselves to study and try to imitate the brilliant productions from Sèvres. However, in 1778, the young and talented modeller, Anton Grassi, a former pupil of Beyer, was appointed as assistant to the chief modeller, J. J. Niedermeyer. He quickly devised new forms, based on classical prototypes, cylindrical cups, rams' head finials on urn-shaped vases and raised medallions. These changes stimulated corresponding modifications in the painting which began to imitate very well the French motifs. Vienna's chief painter, J. Leithner, was so impressed by the brilliance of the Sèvres colours that he went to university to make a serious study of the chemistry of porcelain colours. Subsequently, he collaborated successfully with Schindler in the production of new ground colours and a new paste for biscuit ware.

Maria Theresa died in 1780 and was succeeded by her son Joseph II, a man with little feeling for art and none at all for porcelain. He was more concerned with the expansion of his domains, making the German language compulsory and emancipating the peasantry. He wanted the porcelain factory transferred to private owners as soon as possible, and in spite of a petition against the sale from the workers,

Left: Vienna bottle-shaped vase of the Du Paquier period, decorated in black monochrome. This type of decoration, especially when enriched with gilding, is in the baroque tradition and reminiscent of the decorative techniques used in furniture by André-Charles Boulle c. 1725. (Fitzwilliam Museum, Cambridge)

Below: Vienna figures of a hunter and his wife. Such interesting and attractive figures were not a major product of the Vienna factory until after 1750 and those made during this period are usually attributed to Johann Josef Niedermayer, chief modeller from 1747 until his death in 1748. (Slezské Museum, Opava)

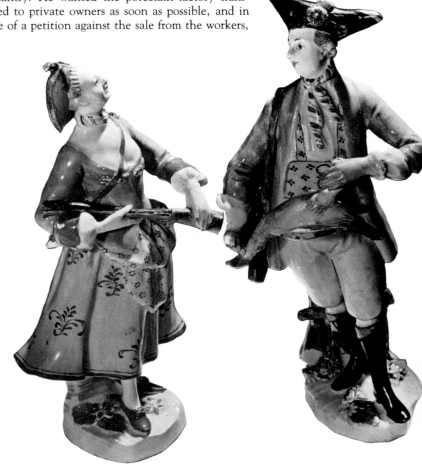

pierced pattern was used. The production of 'toys' (galantéries) included a great variety of fancy articles, from pin trays, snuff boxes and dressing-table jars to buttons. The ware was decorated in a wide range of colours and with a variety of subjects, such as flowers, landscapes and love scenes.

In 1760 P. E. Schindler, formerly from Meissen, replaced Fischer as head of the painting department. His work and that of his pupils bear the stamp of the Meissen style. Moulded and fluted decoration gave way to smooth surfaces. The pear-shaped coffee-pots lost their shell-edged bases. The unobstructed white surfaces were beautifully painted with subjects after Watteau, cupids after Boucher, landscapes, peasants and battle scenes. At first such decorations were framed in fine gold rococo scrolls, but eventually the frames were left out, giving the vignettes an uninterrupted vitality. The colours used at this time were rich and brilliant and the body pure white with a brilliant glassy glaze. The quality of the body and glaze can be best appreciated on pieces decorated in monochrome.

The work of the Augsburg engraver, J. E. Nilson, was much used by the Vienna porcelain painters during the 1760s. His hunting scenes were reproduced in monochrome vignettes, sometimes surrounded by a rich border of ribbons and flowers.

Konrad Sorgel (later raised to noble rank as von Sorgenthal) was called in to value the property and raw materials. Although his estimate was 300,000 gulden, when the sale was advertised in May 1784 the asking price was 45,000, but even so not a single offer was received. Forced to reconsider, the Emperor put Sorgenthal in charge of the factory, and put an end to court appointments, with the exception of one member of the treasury to audit the books.

Sorgenthal's first important policy decisions were to open some show rooms and sell off by auction the surplus stock. The biscuit ware, now winning greater appreciation from the public, was exhibited separately from the coloured and glazed pieces. Sorgenthal also instituted some social measures, such as a pension fund to which management contributed and benefits for widows and invalids, which secured the goodwill of the work force. He soon realized, however, that the commercial future of the factory lay in exports rather than the home market. So many independent factories had been established in the Austrian domains that it was impossible to enforce the original patent. On the other hand, the Near East presented promising outlets, and accordingly thousands of special small, spherical coffee-cups without handles, known as Turkenbecher, were made for Egypt and Turkey. Sweetmeat jars, brightly

decorated with a scale pattern called 'mosaik' were also made. In 1790, a profit of as much as 30,000 gulden was achieved.

For the home market, Sorgenthal concentrated on art productions, and employees engaged in this branch of the business were required to undertake a drawing course at the Vienna Academy of Art. In 1790, Anton Grassi, who had by then become chief modeller, was elected a member of the Academy. Meantime, J. Leithner had invented the blue ground colour for which he is justly famous. This was applied so as to leave reverse panels to be decorated by other skilled painters, such as Seidl and Daffinger who specialized in landscapes and J. Dreschler, a talented painter of flowers. In addition to the blue already mentioned, various shades of violet, as well as lustre colours, were also used as grounds.

A new type of decoration in antique style was also introduced, in which the reserve panels were embellished with rich frames in embossed gold, employing grotesques after Raphael and other antique motifs copied from vases borrowed from private collectors. The white panels were painted with mythological and allegorical subjects taken from masters such as Raphael, Gérard, Fuger, Tenier and Mengs.

The production of figurines and groups had not been well developed during the Du Paquier period,

but from 1750 onwards developments in this direction were encouraged. In the early 1750s, however, the Vienna factory was short of good modellers and sculptors. Pieces from this time that have survived, many of which are glazed but not decorated, suggest that they were worked by local craftsmen or artisans. Some were made without a base, a practice well adapted to the portrayal of ladies with crinolines, since the wide inverted cone of the skirt gives the figure a stable balance. The range of subjects was limited, but characters from the Commedia dell' Arte, groups of lovers and hawkers were all made. There was one sculptor of talent employed during this early period, J. C. Lück, but he left in 1752 and J. J. Niedermeyer, as chief modeller, had difficulty in recruiting help. As late as 1757 the factory enlisted J. M. Peyerl, the court confectioner, presumably because of his experience in modelling table decorations in wax or sugar. But for all the apparent lack of professional artists, the early figures are lively and charming. When colours and bases were used they displayed a true rococo spirit.

The best sculptural work from Vienna is probably that produced later by Anton Grassi. It was he who was the guiding spirit behind the change in style. He rejected all the affectation and frivolity of the rococo mode, and his figures are graceful and slender and shown in natural poses. They are often placed on high bases of stylized rocks, the paste peculiarly abraded to give the impression of rich, thick moss or grass. After a study tour of Italy in 1790, an explosion of Greek and Roman influence becomes apparent in Grassi's work. Very conveniently, Schindler managed to produce at this time a blue colour similar to the Jasper used on Wedgwood classical pieces. It was exploited as a coloured ground with white relief and for colouring reliefs on white.

Under Sorgenthal and Grassi the Vienna products achieved considerable international repute, as well as being distributed to all parts of the Austrian domains. Unlike most other factories Vienna survived the difficult time of the Napoleonic wars. Sorgenthal died in 1805, Grassi two years later, and with them passed the best period of Vienna.

A Nyphenburg group, modelled by Franz Anton Bustelli, of an amorous suitor and a protesting girl. c. 1760. this piece is one of a pair, the other being the group shown on page 78.

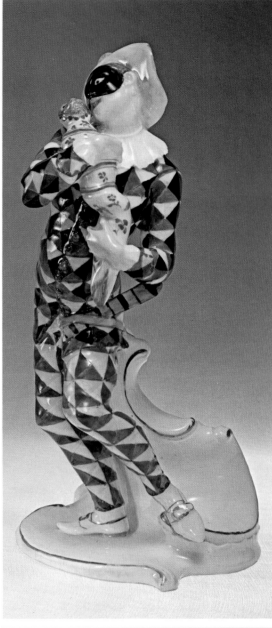

Left: Nymphenburg figures of the Commedia dell'Arte: Leda and Arlecchino. Modelled by Bustelli. 1760. The Commedia dell'Arte, a travelling theatre which used comic mime and masks, was popular in Europe from the fifteenth to the eighteenth centuries. It was noted for improvisations on familiar situations and characters, many of which have been a source of inspiration to writers, painters and musicians over the centuries. The traditional masks and costumes and instantly recognizable poses of the Commedia characters lend themselves particularly well to portrayal in ceramic figurines. Since the art began, European porcelain sculptors have been captivated by the charms of these figures, but perhaps the best of them all, unrivalled in their feeling for theatrical movement, are those modelled by Bustelli at the Palatine Factory of Nymphenburg. (Bayerische Nationalmuseum, Munich)

Nymphenburg

As early as 1729 some experiments in porcelain production were undertaken in Bavaria, but they were unsuccessful and quickly abandoned. Interest was perhaps reawakened in 1747 by the marriage of the Elector Maximilian Joseph III to a grand-daughter of Augustus II of Saxony, the founder of Meissen, for in that same year the buildings of an unoccupied country seat, Neudeck in der Au, near Munich, were adapted for the production of porce-lain. The man who was put in charge, Franz Niedermayer, a stove-tile-maker, was unfamiliar with the complexities of porcelain production, and for the first few years the project was unsuccessful. Help was sought from other German and Austrian factories. Eventually J. Helchis, a well-known painter from the Vienna factory, joined the Bavarian

Below: A design used by Höchst and Fürstenburg for Commedia dell'Arte figures. (Victoria and Albert Museum, London) Höchst (1750–1794) and Fürstenburg's (1753 to present day) reputation is mainly due to the sculptural work of Simon Feilner who was recorded at Höchst in 1752 as only a flower painter. In 1753 he was recorded as a modeller for the Duke of Brunswick at Fürstenburg where he modelled a set of characters from the Comedia dell'Arte. In 1768 he was dismissed 'on account of laziness and insubordination'.

enterprise and became its manager, but even he was incapable of producing porcelain. The situation was saved by the arrival, in 1753, of Joseph Jacob Ringler, a wandering 'arcanist' who had worked at Vienna and Höchst as well as at Strasbourg. He was welcomed by the Elector and by Count Sigismund von Haimhausen, director of the porcelain factory. Ringler remained with the Bavarian concern for only a few years, being dismissed in 1757, but even in this very short time he made a considerable contribution. He was well acquainted with porcelain materials and also with the design and construction of high-temperature kilns, on which subject he had published two books. The necessary kaolin for the porcelain was procured from Passan, an area that became part of Bavaria by the end of the century. Ringler was replaced by a chemist, J. P. Harte, who had been working under him, and thus had learned the whole process of manufacturing. The porcelain produced at Neudeck was a true hard paste, white and glazed with a thin, brilliant glaze. The palette was fully developed and the gilding, when used, of excellent quality. Andreas Oettner, a Viennese, became the chief painter in 1756, succeeded by Christoph Lindemann of Saxony in 1758. It is not surprising, therefore, that the decoration of coffee, tea and table-ware should display a strong influence from both Vienna and Meissen. By far the most

important appointment, however, was that of the chief modeller, Franz Anton Bustelli, on 3 November 1754. His work is comparable in aesthetic quality to that of Kändler at Meissen.

Despite those advantages, the financial situation was insecure. The high cost of production and some disagreements with a neighbouring monastery forced the Elector to remove the factory to Nymphenburg, where new premises were erected within the castle park. By May 1761 the enterprise was in production again, but without the arcanist, Harte. Apparently, he refused to divulge his formula to others, and having displeased both the Elector and von Haimhausen, was dismissed. The workforce increased from thirty-five in 1759, to 171 in 1761. Artistically, Nymphenburg was a success and showrooms were opened in Vienna, Turin, Venice and Brussels, but profits were still meagre. Drastic measures were taken to increase sales, such as large cuts in selling price, but even so, unsold stock accumulated. In the hope of raising money, lotteries were held, with porcelain pieces as prizes, but even this device failed to raise much money. From the foundation of the factory until 1767 there was, according to the books, a loss of 235,000 gulden. Thereafter it was possible to continue production only by drastic reduction in staff. Limprun, who had been manager of Nymphenburg since 1763, coped as best he could,

Nymphenburg table decoration modelled by Bustelli. Bustelli has been able to convey in this all-white composition the atmosphere of a rococo garden scene. yet there is not a single tree or flower. Height 27 cm. (Victoria and Albert Museum, London)

Nymphenburg statue emblematic of Asia modelled by Dominicus Auliczek. Height 19 cm. Auliczek, a Bohemian, succeeded Bustelli as master modeller at the Nymphenburg factory in 1763 and was factory inspector from 1773 until his dismissal in 1797. His work is a mixture of rococo and neo-classicism. The bases retain the characteristic rococo scrolls, while the figures are lifeless and static. (Fitzwilliam Museum, Cambridge)

but the situation got worse, especially after 1769, when state subsidies and support from Haimhausen were both withdrawn. Limprun ran the factory for a few more years, but as the financial situation did not improve, he resigned his position in 1773 and was replaced by Dominicus Auliczeck. Auliczeck had been with the factory since 1762, and had been promoted to chief modeller on Bustelli's death in 1763, a position he clung to until he was pensioned off against his will in 1797. He was succeeded by Johann Peter Melchior, a former modellmeister at Frankenthal and Höchst. Although Melchior was a gifted man, by the time he arrived he was past his prime, and signs of decline in his artistic abilities are evident in his work for Nymphenburg.

The artistic reputation of eighteenth-century Nymphenburg rests essentially upon the work of the remarkable modeller Franz Anton Bustelli. He was born in Locarno, Switzerland in 1723. Where he trained and what he did before being engaged as a modeller at Neudeck in 1754 remains a mystery. At the Bavarian factory he must have been recognized by the management as outstanding, for in 1759 he was made 'arcanist'. Between 1754 and 1763, the year of his death, he wrote no less than thirty-one books on the subjects of chemistry and ceramics. He died just before the advent of the neo-classical style. Bustelli's work was the embodiment of the playful and gay spirit of the rococo style, of which he was certainly one of the most talented, intelligent and versatile exponents. After his death, the demands of the rigidly severe new style took over to such an extent that in 1798 the Nymphenburg director gave orders to have Bustelli's original models in wax or plaster destroyed. A century later they were discovered in pieces and repaired. In the brief space of time that Bustelli worked at Nymphenburg he produced less than one hundred models, but all of them are little masterpieces reflecting the spirit of his age. Even in the creation of religious subjects, like the 'Two Penitents' and the 'Woman at the Well', one sees the languid poses so typical of the art of the time. Sculptural portraits by Bustelli are rare, but the few he executed, like the heads of some children and the bust of Haimhausen, the director of Nymphenburg, are remarkable works of art. The latter could well bear comparison with a Houdon. Bustelli also modelled 'scènes galantes', groups of children bearing subtle allegorical meanings, as well as some cane handles and pipe bowls. All Bustelli's figures are charged with grace and movement, and nowhere is this more evident than in the sixteen figures representing characters from the Italian Commedia dell' Arte. The nervously moulded drapery of the gowns worn by the delightfully sculptured female characters of the Commedia appears as light as gossamer. The bodices fit tightly around the figures revealing beautifully sculptured and almost pulsating breasts. The graceful arms and hands seem full of movement. Long, elegant necks support equally elegant heads and expressive faces. The colours are pastel shades of green and puce, yellow and blue. The females are paired with the male characters of the Commedia. Arlecchino, the most important of the group and the

one who keeps the complicated plot together, is represented in an elongated unfolding 'S' shaped figure. His body is clad in tight-fitting trousers and jacket, covered in a red, black, white and blue diamond pattern, that nevertheless manages to reveal strong acrobatic muscles underneath. Pantalone, the Doctor, Ottavio and all the other characters are created in similarly lively, energetic fashion. The thin, unobtrusive bases and supports fuse so well with the figures that they seem essential to the whole design. For all that the reputation of Nymphenburg rested on the work of Bustelli, he was poorly rewarded. His successor, Dominicus Auliczek, although an accomplished modeller, was less talented than Bustelli, but was paid four times as much. Auliczek's best works are probably his groups of fighting animals, which he sculptured with a great deal of realism.

Although the birthplace of the factory was at Neudeck, and the early output is referred to sometimes as Neudeck-Nymphenburg, the latter name is generally used for the production of both places. Most of the output was marked with the impressed Rautenschild, a diamond-paned shield from the arms of Bavaria. Defective pieces were left in the white and, following the practice of Meissen, the factory mark on these pieces was 'cancelled' by an incised stroke across it. In about 1765 the so-called Lexagram mark came into use in addition to the Rautenschild. This consisted of two interlaced equilateral triangles forming a six-pointed star. Often the impressed initials of modellers accompany the factory mark as well.

Vincennes and Sèvres

Important developments were also taking place in
France at this time. The porcelain enterprise that
started at Vincennes and later became the Royal
Factory of Sèvres came about through the gambling
habits of a French aristocrat, Orry de Fulvy, brother
to the Minister of Finance, Orry de Vignory. De
Fulvy engaged in all sorts of enterprises to try to
recoup his constant losses, and porcelain production
was one of these. It is strange if he thought it was
easy to make money in this way, for in the mid-
eighteenth century porcelain in France was still
technically very imperfect, but maybe for de Fulvy it
was just another gamble. He went so far as to ask the
help of a relative, who happened to be a member of
the Society of Jesus, to try to obtain more informa-
tion on the making of porcelain from Père d'En-
trecolles, a Jesuit missionary in China whose letters
on the subject were well known. It was Père
d'Entrecolles who first noticed 'corpuscles which are
somewhat glittering' in Chinese kaolin. He was
absolutely convinced that the kaolin contained mica
as well as clay. Nothing came of this when de Fulvy
found that the materials required were not available
in France. Nevertheless, he seized his opportunity
when he heard of some workers who had deserted the
porcelain manufactory at Chantilly in 1738 and set
up a workshop of their own in Paris. They were
Gilles and Robert Dubois, Humbert Gerin, a kiln
master, and François Gravant, a potter, who had
previously been a grocer in Chantilly. De Fulvy
visited them, thought highly of their work, and
decided to set them up in a factory.

De Fulvy advanced a sum of 10,000 livres and
managed to obtain the use of some disused buildings
in the Château de Vincennes. His protégés proved
less skilled than he had hoped. Many pieces were lost
during the firing and the Dubois brothers were found
to be addicted to drink. They were dismissed in
1741, their place being taken by Gravant. He had
learned the recipe for making the paste and remained
in charge of this until his death in 1765. Additional
workers were recruited from Chantilly and St.
Cloud, and by 1745 a much more satisfactory body
was being produced. De Fulvy formed a company
with Verdun de Martchiroux and M. Beaufils with a
capital of 100,000 livres. The right to make porce-
lain at the factory in the Saxon style was awarded by
the King on 24 July 1745, to one Charles Adam.
Around this time some important appointments were
made. Boileau de Picardie from the Office of Taxes
was administrator and Jean Hellot, Director of the
Academy of Sciences, was appointed chemist.
Claude Thomas Duplessis, goldsmith and bronze
worker, was given the job of designer, both for the
porcelain and for the bronze mountings. The over-
seer for decoration was Jean Adam Mathieu, enamel-
ler to the King.

The financial position of the Vincennes factory
had never been easy and it was a blow for de Fulvy
when his brother lost his post as Minister of Finance.
The new Minister, Jean Baptiste de Marchault, was
less keen on the porcelain venture, but he did go so

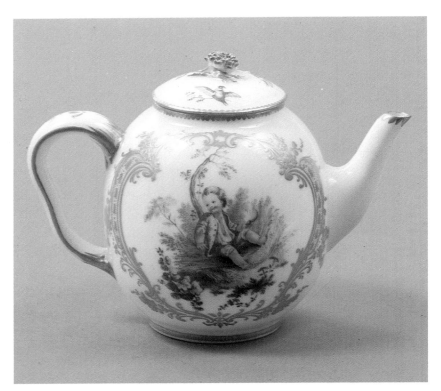

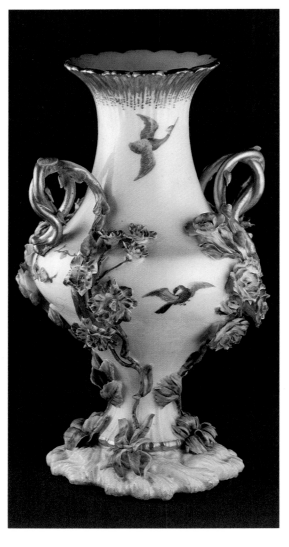

Left: Vincennes soft-paste
vase. The severe white
balustre form becomes a
playful rococo piece with the
application of well-modelled,
enamelled flowers and
crabstock handles, stemming
down to a scrolled foot.
1750–1759. (Museum of
Decorative Arts, Prague)

Left: Tiny Vincennes soft-paste teapot painted by André Vincent Vieillard. The monochrome painting with flesh tones is one of the early Vincennes innovations in the decoration of porcelain. Height 9.8 cm, diameter 7.6 cm; 1754. (Victoria and Albert Museum, London)

Below: Vincennes soft-paste serving dish. The bold blue scroll and the asymmetrical flower design are in a true rococo style and the gilding richly applied, burnished and engraved to produce a fine example of Vincennes tableware. c. 1750. (Louvre, Paris)

far as to issue an order in 1747 forbidding the production of porcelain in France except at Vincennes. Although never strictly enforced, this and other similar regulations promulgated later caused many problems for Hannong at Strasbourg who was also trying to produce porcelain. In this same year, 1747, Jean Jacques Bachelier was appointed as overseer of painting and modelling. It was he who later made use of biscuit for the famous figures and groups.

Some improvement in the financial position came about when Verdun de Martchiroux succeeded in attracting the interest of Madame de Pompadour. Through her intervention, the King granted the factory an annual subsidy of 20,000 livres. The enterprise expanded, and by 1750 about 100 workers were being employed and new capital was sought by offering shares. Unfortunately Vignory died in 1750, followed by his brother a year later, and the factory was obliged to buy back their interests from their executors at the same time as large sums were owing to the King. The set-back necessitated a drastic reorganization.

In 1752 the patent for porcelain-making was transferred to a new holder, Eloi Brichard, and for twelve years from October 1752 the Brichard enterprise was given the sole right of making porcelain, whether painted or gilded, moulded or smooth, sculptural or utilitarian. No one else was allowed to produce wares similar to those of Vincennes, and even the earthenware makers were not allowed to use polychrome or gilding. The capital of the reorganized enterprise was fixed at 800,000 livres. The King contributed 200,000 livres in return for a quarter share of the profits. The workers at the factory were awarded the privilege of some relief from taxes, but their movements were restricted. They had to give six months notice if they wanted to leave, and thereafter they were not allowed to practice their skills elsewhere. The technical staff could leave only with the permission of the King. Painters and sculptors were forbidden to allow their designs and models to be used or even copied elsewhere. Imports of porcelain from abroad were forbidden. All these prohibitions and regulations were backed by the threat of confiscations, heavy fines and imprisonment. The official title of the enterprise was now 'La Manufacture Royale de Porcelaine', and the royal cypher of crossed 'L's, which had been used occasionally before this date, became the official factory mark.

It was at this period that Vincennes porcelain began to make its appearance on the open Parisian

market, in competition with pieces from China and Meissen. Much of the early production consisted of imitation flowers. These became very fashionable, especially after a bouquet was made for the King and Queen. The Dauphine, who was the daughter of Augustus III of Saxony, was very pleased with the Vincennes wares and was convinced that the artistry and quality was equal to that of Saxon porcelain. One of the first and best customers of the factory was the Parisian dealer Lazare Duveaux, who bought for both the King and Madame de Pompadour. The elegant flowers, vases and teapots produced at Vincennes were all made in soft-paste porcelain. The soft-paste body was achieved by most laborious methods, utilizing an incredible conglomeration of materials. Sand from Fontainebleau, alabaster, salt and saltpetre and soda from Alicante were baked for about fifty hours and then ground up in water for about three weeks, dried, crushed once again and then mixed with clay and fragments of paste from the throwing room. Green soap was added to make the mixture plastic.

The glaze was prepared by equally complicated methods. White sand from Fontainebleau, litharge, soda, flint and potash were mixed and fritted and then ground into a fine powder ready for use. The soft-paste body was first fired as biscuit and then glazed. The glaze was applied by spraying rather than dipping, which assured a better adherence, and the ware was then re-fired. After this second firing the ware was ready for decoration. The colours were produced by the application of metal oxides followed by a further firing during which the colours would develop and become fused with and slightly sunk into the clear glaze. If gilding was required yet another firing was needed. Each firing had to be done at a lower temperature than the one before.

Although not one of the specialities of Vincennes, some sculptural pieces were produced from the earliest days, but the figures of this period were seldom embellished with colours. For the rest of the production an array of enamel colours was available. A beautiful deep but uneven blue lapis, as well as yellow and green were in use already before 1753. A method of gilding was employed based on a recipe bought from Brother Hippolite, a Benedictine friar. The process was later perfected by Louis Pierre Massue when he took charge of the gilding shop.

One of the early masterpieces of Vincennes was the magnificent porcelain gift sent by the Dauphine of France to her father in 1749. It consisted of 480 flowers of all kinds, the heads and leaves naturalistically coloured and mounted on metal stems, arranged in a white glazed porcelain vase, which was in turn decorated all over in relief with sprays of flowers. The centre piece was framed by two white glazed porcelain groups symbolizing the Arts, modelled by Depierreux. The whole composition was mounted on a gilt bronze base made by Jean Claude Duplessis.

The Vincennes painters at first tried to decorate the porcelain in a style that was almost Meissen, with naturalistic flowers reminiscent of the *Deutsche Blumen*. The blue lapis was used extravagantly, the porcelain often being totally covered in this colour

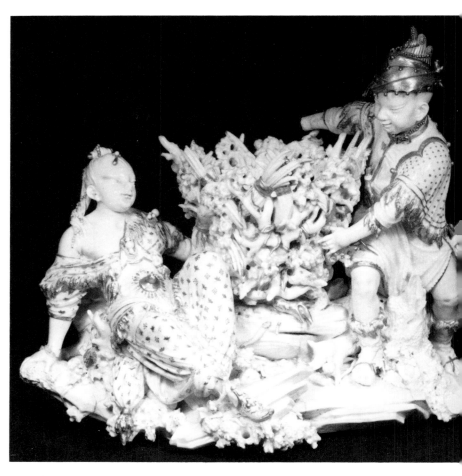

save for some panels reserved in white to take additional decoration. It was also used for table-ware, the rims of plates being coloured with blue lapis, frequently enriched with swags and garlands in gold. The central white reserves were also richly decorated with flowers or birds painted in gold and with a combination of burnished, tooled and matt finishes. The shapes created at Vincennes foreshadowed what was to be made later at Sèvres. There were lobed plates and oval and round tureens supported on scrolled feet resembling celery stalks, with handles in a similar organic motif. The tureen lids were domed and often surmounted by a finial in the shape of a fruit or an artichoke. The pieces were painted overall with a ground colour, but leaving reserve panels framed by gilt scrolls on which were painted naturalistic flowers.

By 1753 it became clear that larger premises were needed, and on the recommendation of Madame de Pompadour a new site was found at Sèvres, near the Château de Bellevue, not far from Versailles. Unfortunately, Lindel, the architect she selected to design the new building, was unfamiliar with industrial requirements. When the new building was taken over in 1756 it was found to be elegant, but impracticable. The three-storey edifice had a pedimented façade, a warehouse for the display of the porcelain, and apartments and a chapel reserved for the King, but it was more like a stately home than a factory, and unsuited to the workforce. This industrial white elephant had cost more than a million

Vincennes soft-paste Chinese boy and girl with pair of Chinese figures flanking a basket. Large Porcelain groups were always difficult to make. Different stresses in firing very often produced firing cracks and some discolouration in the porcelain. The gilt decoration on this group was perhaps used to cover up such a discolouration. The gilded bronze cap on the boy is an early nineteenth-century addition. Height 42 cm, diameter 47.6 cm; 1752.

livres and the enterprise once again fell into debt. By 1759 it owed 500,000 livres and its creditors proposed to sell its effects. Boileau persuaded the King to buy the whole concern, and in 1760 an order was made transferring to the King all the privileges previously enjoyed by the Brichard company. From this date onwards the factory was maintained by a subvention. This was made necessary by the reluctance of the Parisian dealers to handle Sèvres, since it was fragile in comparison with Meissen and Oriental porcelain and the factory was unwilling to replace pieces broken in transit. Moreover, the dealers made a profitable business out of hiring porcelain for banquets, and of course for this purpose the stronger Meissen or Chinese porcelain was safer.

The move to Sèvres coincided with the introduction of new and more exciting colours and decoration. In 1757 the painter Xhrouet, probably in collaboration with Hellot, invented a pink ground colour, similar to that first produced in China in the reign of Kangxi, but deeper and richer and with a different consistency. It is known today as rose Pompadour. It was used for about ten years only, rarely appearing on ware made after Hellot's death in 1766. Over the years, other colours were continually added to the Sèvres palette, facilitating the continuance of the tradition of superb quality and elegance that had been started under almost insurmountable difficulties at Vincennes. It was perhaps because of this accent on quality rather than quantity that the products of the Manufacture Royale were extraordinarily expensive. Any pieces considered unworthy of decoration were broken up. If the defects were comparatively trivial the pieces remained in the workshops undecorated. Much of this undecorated ware eventually found its way out of the factory and was decorated by others and then sold as having been made at the royal factory. Since this was obviously detrimental to the reputation of Sèvres, the practice of disposing of undecorated pieces was discontinued, except during the revolutionary period, when the accumulated stock of undecorated porcelain was sold to procure wages for the workers.

The production of sculptured works, begun at Vincennes, continued on a much grander scale at Sèvres. Jean Jacques Bachelier claimed to have been the originator of the biscuit figures at Vincennes, and some are certainly mentioned in the sale lists of 1753. The biscuit figures must have proved quickly successful with the public, for figures and groups were seldom glazed after 1755. One of the important designers of biscuit figures, who had been with the factory since the Vincennes period, was François Boucher. Initially, Bachelier was in charge of the sculpture department, but Etienne Maurice Falconet took over this position from 1757, when he first joined the Sèvres factory, to 1766 when he left for Russia, after which Bachelier resumed control until the Revolution. Like Pigalle, Falconet had been a pupil of Jean Baptiste Lemoyne and had worked with that master for several years. In 1754 he became a member of the Royal Academy of Painting and Sculpture. According to Bachelier, when he was called to Sèvres, Falconet introduced 'a noble style less subject to changes of fashion'. Before he arrived, however, Sèvres already had a stock of some fifty different subjects, mostly of children, after Boucher and François Duquesnoy—better known as 'il Fiammingo'. At Sèvres, Falconet worked with Blondeau, Fernet and Suzanne. He arrived at an opportune moment. Having been made popular by Madame de Pompadour, the biscuit figures and groups were much in demand. As well as lending moral support, Pompadour spent thousands of livres annually on acquiring new Sèvres pieces. The factory also enjoyed the support of her brother, the Marquis de

Below: Chantilly soft-paste figure of a magot, or grotesque, emblematic of the Continents. His robe is decorated with flowering branches in the Kakiemon style. Height 12 cm.

Far left: Sèvres soft-paste biscuit figure of 'the Little Confectioner', modelled by Etienne-Maurice Falconet after Boucher. 1757. Falconet was a talented sculptor who made several models for the production of biscuit.

Left: Engraving of 'Le Marchant de Gimblettes' by Falconet Junior, one of the illustrations to the 'Premier Livre de Figures, d'après les Porcelaines de la Manufacture Royale de France, inventées en 1757 par M. Boucher'.

'love is sometimes your master', and 'woman bathing' were Falconet's miniaturized versions of his own marble sculpture. One of his models was of a cow held by a boy while a young girl was milking her. This is said to have been made for the decoration of Madame de Pompadour's dairy at her Château de Crécy. A delightful figure of Psyche was made by Falconet in 1761 as a companion piece to his Cupid of 1758. He also made many mythological groups such as Leda and the Swan and Drunken Silenus.

The excavations at Herculaneum and Pompeii which began in 1748 brought a renewed interest in classical mythology, but the Sèvres painters and sculptors also drew inspiration from contemporary theatre and dance, which were becoming very popular. Some of these productions were considered scandalous, because they called for rather sexy movements and the holding of the partner by the waist or shoulders. One of these supposedly risqué dances was immortalized in porcelain in the biscuit tableau *l'Allemande Suisse* and its companion piece *l'Allemande Française*. A somewhat daring play, *Les Trois Contents* by Taconet, performed at the Théâtre des Boulevards, inspired two other well-known biscuit figures, 'Le Baiser Donné' and 'Le Baiser Rendu'. In a more serious vein, Falconet produced a famous bust of Louis XV, after J. B. Lemoyne. The plain white biscuit finish of these figures was sometimes relieved by the use of glaze on the base or pedestal, occasionally enriched with inscriptions, gilding or other decoration.

Marigny, who was the French Minister of Works. During his time at Sèvres Falconet contributed nearly one hundred new models to the stock. Some were after Boucher, but the majority were his own creation. Although biscuit figures were often used for table decoration they were also produced as sculptural pieces in their own right and provided with protective glass domes. Apart from the children already mentioned, the range of subjects was very varied. Some subjects, such as Cupid depicted as

Left: Sèvres soft-paste caisse à fleur. Rose Pompadour ground and the reversed panels painted with birds and trees by Ledoux. The piece is marked by a monogram of intertwined Ls enclosing the letter E and a crescent. The crescent is the sign attributed to Ledoux, a specialist painter of landscapes and birds, who worked at Sèvres between 1758 and 1761. The rose colour was introduced in 1758 and the letter L denotes 1757. Height 9.2 cm; 1757. (Victoria and Albert Museum, London)

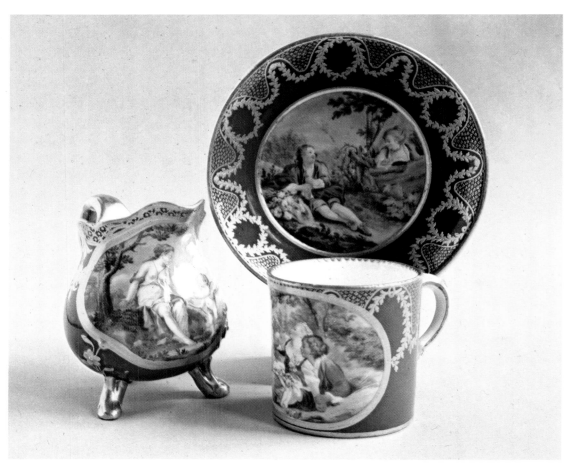

Left: Sèvres hard-paste cream jug, cup and saucer. The jug, of 1775, is rococo in shape, but painted in a neo-classical style with a deep green ground and reversed panels by Noël. The painting of the cup and saucer, dating 1769, is possibly by Asselin, and is still in the rococo style, but the richly gilded borders are already showing signs of neo-classicism. (Victoria and Albert Museum, London)

Right: Two-handled Sèvres vase in 'gros bleu' with marbled decoration of gold on the blue. The painted plaques show 'conversation galante', in the Watteau style, and on the reverse a bouquet of flowers. Height 37.5 cm; c. 1768. (Wallace Collection, London)

Most of the problems with the porcelain body encountered in the earlier years were by now overcome and the soft paste was of a superb quality. Even so, the chemist, Hellot, would not give up the idea of making true hard paste, comparable to Meissen. Elsewhere in France, in Strasbourg, Paul Hannong, presumably with the help of runaway workers from Saxony, had been making hard paste since 1751, but by 1754 the Sèvres monopoly was being rigorously enforced and Hannong was forbidden to continue. All his protestations, and the presentation of samples of his ware to Louis XV, failed to move the authorities. He even tried to acquire shares in the royal factory by selling his secret to them, but Boileau declined to buy. Nevertheless, he and Hellot must have made the most of the conversations, for they got to know that kaolin was the key ingredient, but as no French source was known at that time they did not pursue the matter. Eventually Hannong's kilns at Strasbourg were ordered to be closed and he left the country to set up the famous porcelain factory at Frankenthal in the Palatinate.

While negotiations were going on with Hannong, two 'arcanists', presumably from Strasbourg, Busch and Stadmayer, were experimenting at Vincennes, but their efforts proved costly and unproductive. Following Hannong's death at Frankenthal in 1760 Boileau paid a visit to the inheritor of that enterprise, Hannong's fourth son Joseph Adam, intending to renew the negotiations for the purchase of the 'arcano', but again no agreement was reached. A year later however, a renegade brother of Joseph Adam, who had been a manager at Strasbourg, saw Bertin, the Minister of Fine Arts, in Paris and concluded a secret deal for the sale of the arcano. For this he received 6000 livres in cash and an annuity of 3000, which he subsequently claimed he never received during the lifetime of Louis XV – but he was such an unreliable character it is hard to know the truth of the matter. No sooner had he come to terms with Bertin than he began to try to sell the secret again to others. He was, of course, disowned and disinherited by the successors of the Strasbourg concern.

In 1764, with the death of Madame de Pompadour, the Sèvres factory suffered the loss of a great patron and driving force. Although they were now in possession of the secret of kaolin it took some years to find an adequate source. In that same year, 1764, Busch, who had in the meantime worked as manager at Frankenthal, became involved again in more costly and unsuccessful experiments at Sèvres, making use of kaolin discovered at Alençon. This material was of poor quality, however, and Bertin encouraged the Sèvres people to search for a better source. On 13 November 1765, a chemist named Guettard, who had found kaolin 'in the region of Limoges', read a paper on the subject at the Académie des Sciences. Moreover, kaolin from some source was in use at Orléans for the making of soft paste and earthenware. In 1766, ostensibly in order to stimulate further research, Bertin issued an order relaxing the restrictions on the production outside Sèvres of pieces 'in imitation of the Chinese, with such ingredients as the makers consider suitable'. It

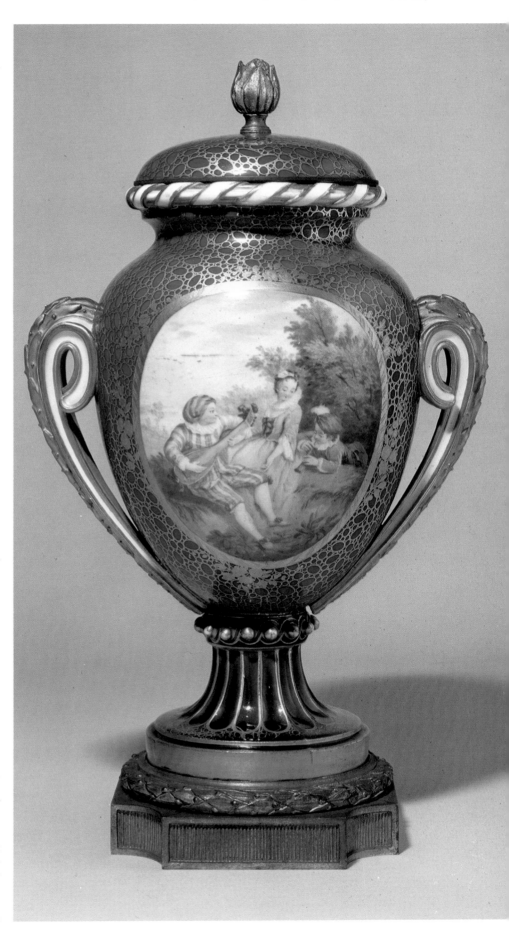

seems probable that the difficulty of enforcing a total ban, necessitating the inspection of every kiln, also influenced this decision. The new dispensation was strictly limited. Each piece had to be marked, and the marks had to be registered with the police. Gilding, painting in miniature, coloured flowers, coloured grounds and sculptural work all remained exclusive to Sèvres.

New deposits of kaolin eventually came to light at St. Yrieux, near Limoges, following a lengthy search by two men, Pierre Joseph Macquer, who had been Hellot's assistant for many years and had succeeded him when he died in 1766, and a kiln master named Millot. It seems odd, in view of Guettard's paper, that the Limoges deposits took so long to find.

However, according to Macquer and Millot, the first sample of this kaolin was sent to Sèvres by the Archbishop of Bordeaux, who had obtained it from a local pharmacist, who had in turn received it from a local surgeon named Darnet, a man totally ignorant of its properties whose wife had been using it for cleaning purposes. The figure of Bacchus, which was fashioned from this first sample, is preserved still in the Sèvres museum. The pharmacist wanted a large sum to reveal the exact whereabouts of the kaolin deposit, so Bertin sent Macquer on a personal search. After looking in vain at Orléans, Blois, Tours and a number of other places, a material resembling kaolin was found near Biarritz. News of this reached the pharmacist, who, in fear of losing his reward, now

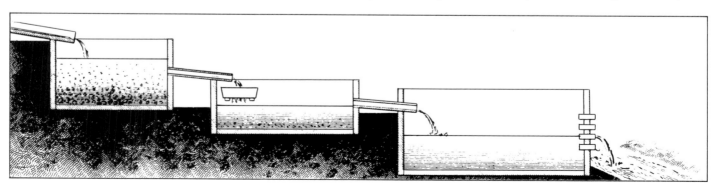

offered to take Macquer and his assistant to the site. When they got there the owner's son did not want them to enter, threatening to set the local mob upon them if they persisted, but he was eventually pacified and a sample was taken to Sèvres. The trials proved highly successful and in the following year the King bought the deposits. Darnet was put in charge of the preliminary preparation of the kaolin on the site and the pharmacist eventually received a reward of 15,000 livres.

At last, Sèvres was producing 'real' porcelain. Macquer, in collaboration with Etienne Mignol de Montigny, presented a paper to the Académie des Sciences in which the new porcelain was described with pride as having been made entirely with French materials. The absence of frit, lead or alkali in the new material was also pointed out, and its hardness and durability emphasized. The new production was duly named 'Porcelaine Royale' and marked with a crowned version of the interlaced 'L's.

At this time Sèvres also received a boost from another source. In 1769 Louis XV gave his new mistress, Madame du Barry, the Chateau of Louveciennes near Marly and made her a duchess. Modelling herself on her predecessor, du Barry became a great patron of the arts and of Sèvres. She spent lavishly on her chateau, employing the royal architect to repair and modernize the early eighteenth-century building. At his distinguished and well-attended 'suppers' at Louveciennes, Sèvres porcelain featured prominently on the dining table. Her influence on the design department at Sèvres was not as great as Pompadour's had been, but among the table services she commissioned was a famous set designed by Auguste de St. Aubin and delivered to her on 29 August 1771. It consisted of 322 pieces, each painted with floral swags hanging from rings and blue and gold vases and bearing, in the centre, a monogram with a 'D' in gold and a 'B' made up of clusters of tiny roses. The following year the factory produced a bust of the Duchess after Pajou.

In 1772 Boileau died and his successor, Parent, expanded the hard-paste production by recruiting workmen from Germany who had had long experience in this line. Orders kept pouring in, from the King himself and from far afield, including Catherine of Russia. These should have been easy times for the factory, but the privileges granted to other potters by Bertin in 1766, the failure to enforce the remaining restrictions, and the fact that the hard-paste ingredients were now public knowledge, combined to produce some damaging competition. The Sèvres factory lost its two most important patrons in 1774 when Louis XV died and du Barry was exiled to an old monastery, the Abbaye de Pont-aux-Dames, pursued by creditors and forced to sell her diamonds.

Also in 1774 the sculptor Louis Simon Boizot was appointed director of the modelling department, a post he held until 1802. The new owner, Louis XVI, continued for a time the extravagant style of the French court, including the tradition of offering porcelain pieces as diplomatic gifts. The coronation of Louis XVI and Queen Marie Antoinette was commemorated in a hard-paste biscuit group by

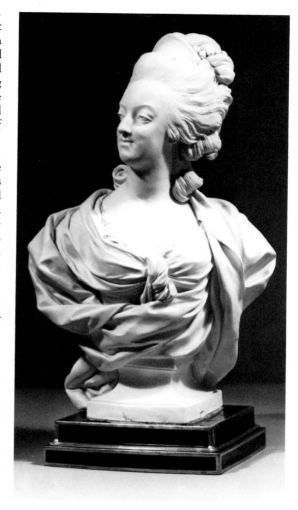

Boizot–'l'autel royale'. From this time onwards the figures and groups were made exclusively in hard paste. By 1774 the factory was making porcelain in a wider range than ever before and employing 400 people. It survived an upheaval in that year when Parent and his accountant, Roger, were both imprisoned after the discovery that they had misappropriated a very large sum–247,000 livres. Reigner took over from Parent and continuing important commissions kept the factory going. A new speciality was the production of porcelain plaques to decorate furniture, in place of or in conjunction with marquetry. The Queen commissioned porcelain to be used at Rambouillet and the Trianon at Versailles. False teeth were also made in porcelain. A new type of decoration, probably invented by Cotteau, came into use about 1780. It consisted of little drops of coloured enamel fused over gold and silver foil to produce an imitation of precious stones, such as ruby, emerald and pearls. The process must have been extremely delicate and costly and surviving specimens are very rare.

Despite its prestigious commissions, the factory was frequently in financial trouble. The service made for Catherine of Russia in 1777–1778 cost over 300,000 livres, an enormous sum on which the profit was comparatively small. In 1790 the finances were so bad that a private buyer wanted to take over the

concern, but the King refused, saying he would pay out of his own pocket. In the next few years much use was made of high-temperature ground colours, employing both in-glaze and on-glaze methods. Beautiful black, aubergine, brown and tortoise-shell colours were applied to the hard paste. Sadly, these developments were short-lived. The political situation became ever more critical. On 10 August 1792, the Paris mob, singing the *Marseillaise*, stormed the Tuilleries Palace and massacred the King's Swiss Guards. National bankruptcy was declared. The legislative assembly suspended the monarchy. On 21 January 1793, the King was guillotined. Sèvres was proclaimed to be national property so it was possible for work there to continue, but only under most difficult circumstances. But at least the factory was safe, and the powers that succeeded Louis XVI, from Napoleon to the Second Empire, each in turn made use of the symbols of prestige that Sèvres continued to produce.

Above: Sèvres soft-paste cup and saucer. The dark blue ground is enriched with gilding and decorated with orange, blue, green and white jewellery. The difficult process of jewelling was used as early as 1773. This cup and saucer date from 1782.

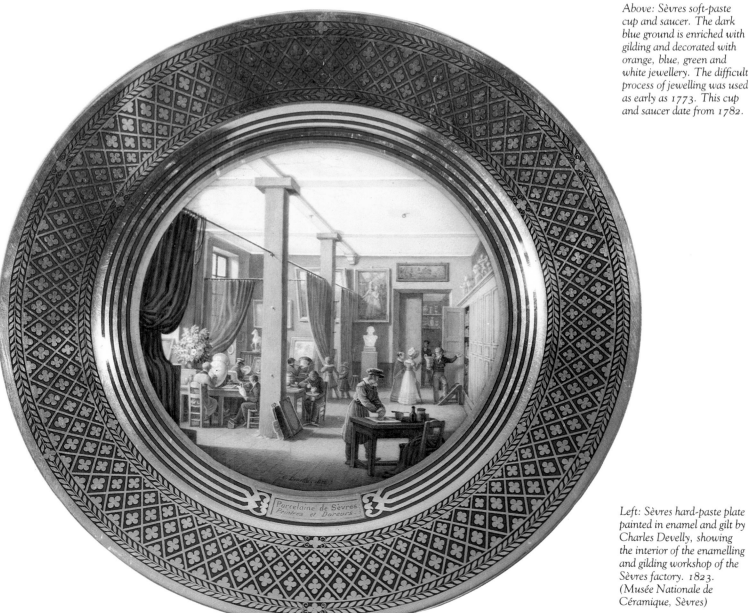

Left: Sèvres hard-paste plate painted in enamel and gilt by Charles Develly, showing the interior of the enamelling and gilding workshop of the Sèvres factory. 1823. (Musée Nationale de Céramique, Sèvres)

Frankenthal

Around the middle of the century important developments were also taking place in Strasbourg, and subsequently in Frankenthal.

Paul Anton Hannong, the head of a large family of potters in Strasbourg, had been interested in porcelain-making since 1745. By 1751, with the help of workmen from Meissen, he succeeded in producing hard paste. This did not please the directors of Vincennes, who had by royal privilege a monopoly of porcelain production in France. Hannong was able to evade the regulations for a time, but by 1754 he was compelled to abandon the production of porcelain. In 1755 he transferred his factory to Frankenthal in the Palatinate, where the Elector Carl Theodor granted him the privileges which were denied him in France. His son, Charles François Paul Hannong, became the first director, but he died in 1759 and was replaced by a second son, Joseph Adam. Joseph bought the factory from his father in 1759 shortly before the latter died. In 1762 financial difficulties forced Joseph Adam to sell out to the Elector. It was under the Elector's supervision that Frankenthal produced most of its porcelain. Adam Bergdoll of Höchst was installed as manager and later the Elector recruited Simon Feilner, one of Fürstenberg's best modellers. The main reason for calling Feilner to Frankenthal, however, was to improve the composition of the paste and to increase the range of colours.

Bergdoll and Feilner did not get along together and in 1775 Bergdoll was dismissed and Feilner succeeded as director. He tried to economize by using kaolin from a local source, instead of from Passau, nearly 250 miles away. This did not do much to improve the appearance of the porcelain, but he did manage to expand and improve the range of colours. By 1775 nearly fifty different colours were available to the painters. Warehouses were opened in the Hague, Basle, Munich and elsewhere. Despite these advances under Feilner the distinctive appeal of Frankenthal porcelain rests on the work of the Hannong period. At this time the glaze was soft and the painted decoration appears to sink into it, almost as if the body were soft paste. The shapes of the table-ware of this early period have a 'French' look, much like those of Strasbourg faience. With their gentle, flowing curves they express the gay spirit of the rococo. Only occasionally, most often on the decorative ware such as pot-pourri vases and clock cases, does the material seem too hard for this light-hearted treatment. The scrolls and curves can at times appear as hard and as wild as the decoration on German rococo furniture, but of course one has to remember that the first proprietors of Frankenthal were from Alsace. Even during the Bergdoll and Feilner directorships French influence on the decoration was strong. This can be seen in the vases and table-ware decorated with exotic birds, landscapes, peasants and textile patterns, all of them reminiscent of Sèvres. The best-known work was done by Winterstein, Osterspey and Magnus whose names appear not only in the factory archives, but also on pieces that survive in different museums. Some

experiments in printed decoration were undertaken in 1769 by Pierre Berthevin, formerly of Mennecy and Marieberg in Sweden, but as very few examples of this technique are known one must assume it was soon abandoned.

From the early days a great deal of attention was given to figures, a branch of the craft that Hannong had already begun to develop at Strasbourg. On moving to Frankenthal he took moulds and modellers with him, including the chief modeller of Strasbourg, J. W. Lanz. Lanz remained in charge of this department at Frankenthal at least until 1761, after which his name no longer appears in the factory records. The range of figures is varied, but includes all the stock subjects of eighteenth-century porcelain – gods and goddesses, peasants, shepherds and shepherdesses, etc. The early Lanz models are rather heavy and clumsy, a possible consequence of adherence to faience traditions and unfamiliarity with hard paste, but the figures never lack vigour and strength, qualities which are enhanced by the uncompromising use of bold colours.

It is uncertain who replaced Lanz, but a new and more sophisticated modelling style was introduced, with figures becoming more slender and elongated. The subject matter also became more varied, including pastoral scenes instead of peasant subjects and more frequent representations of court life. The originators may have included J. F. von Lück, formerly of Höchst, or G. F. Riedel, but the best of the Frankenthal modellers at this time was Konrad Linck, who was appointed master modeller by the Elector in 1762. Born in 1732, Linck had trained as a sculptor in stone at Vienna, Berlin and Potsdam, at

Frankenthal hard-paste 'sampler' plate which reveals the skill of the German colour chemists and the extent of colour variants. In 1775, for example, fifty different colours were available to the Frankenthal painters. Diameter 24.7 cm. (Fitzwilliam Museum, Cambridge)

which places he had doubtless absorbed various interpretations of the rococo style. His modelling displays great understanding of the possibilities of the material, as can be seen in the richly modelled folds of drapery, the expressive gestures of his figures and the uncompromisingly rococo bases. His range of subjects included many familiar themes, but he was at his best in the construction of mythological groups embodying two or more figures. He worked at Frankenthal for only four years, leaving for Mannheim in 1766, but he continued to produce sketches and moulds for the factory until his death in 1793. In 1766 Linck's place was taken by K. G. von Lück who, although an accomplished modeller, was more tame and less inventive than his predecessor. His subjects were mostly taken from everyday life. He created such well known tableaux as 'Concord in Marriage', 'Discord in Marriage', 'Mother's Birthday', 'Father's Birthday', etc. His most attractive compositions are the so-called 'Chinese Houses'. These sculptural groups are shaped like open pagoda towers standing on rocks. They are crowded with male or female Chinese figures kneeling or standing in front of Chinese potentates. Here his inventive and creative skills are seen at their best. When Lück died in 1775 he was replaced for a short period by Adam Bauer, a man of little imagination whose work was mostly a dull and repetitive continuation of mythological figures and symbolic scenes with children. They are notable only for the heavy and uninteresting quality of the modelling. Another modeller, J. P. Melchior, employed at the same time, had more talent than Bauer, but not enough to give the factory a fresh inspiration.

Between 1792 and 1797 invasions by the French repeatedly disrupted the running of the factory. In 1800 the new Elector Maximilian Joseph IV found it necessary to sell the factory. Some of the workmen found employment at Nymphenburg and some of the Frankenthal moulds were also taken and used there.

Early Capodimonte

In Italy there was not very much porcelain produced during the first part of the eighteenth century. A Venetian factory lasted seven years and then failed. The only other centre of note was the Doccia factory, which was under the patronage of the Marchese Ginori. No important new development took place until June 1743, when Charles III, King of Naples, opened the Capodimonte factory. The venture was the outcome of some years of experimentation that had been going on in a small building in the gardens of the Royal Palace in Naples. The results of this experimentation had seemed so encouraging that the King commanded Don Ferdinando Sanfelice, the court engineer, to construct a new building, suitable for a factory, in the woods that surrounded his new palace at Capodimonte, which was on a hill overlooking the town. Over the entrance to the premises the following inscription appeared in Latin:

Charles, King of the Two Sicilies and of Jerusalem etc., leader of the fine arts, protector of the State, found the material and discovered the method to make porcelain articles. These great workshops, established for this work, erected in the years of his health 1743.

The first workers for Capodimonte were probably drawn from the various maiolica factories in and around the Kingdom. One of the earliest to experiment with the porcelain paste was Aurelio Grue, a member of a well-known family of maiolica makers at Castelli in the Abruzzi. White clay from Vicenza was used, mixed with clay from the Maiella mountains, but the mixture failed to yield the translucent material that we know as porcelain. Despite this failure the King's enthusiasm remained strong, no doubt constantly rekindled by the large quantities of Meissen porcelain brought to him by his young bride, Princess Maria Amalia Walburga, granddaughter of Augustus the Strong, whom he had married in 1738. Her dowry included no less than seventeen sets of Meissen table-ware. One of these treasures was a breakfast-set decorated in the newly fashionable emerald-green enamel ground, with medallion reserves painted in the Watteau and Lancret style. With such exciting examples before him, Charles was unwilling to give up the search for the materials that had contributed so much to his grandfather-in-law's fame.

Even before the move to Capodimonte Charles and his administrators had tried in vain to entice workmen from Vienna and from Doccia with promises of better pay and conditions. In 1741, a Flemish man from his own Royal Mint, Livio Ottavio Schepers, was appointed arcanist and put in charge of the paste. On moving to Capodimonte the kilnmaster, Giovanni Cantarella, was provided with four assistants. One of these, Giuseppe Grossi from Genoa, made the first improvements to the kiln. Giovanni Caselli, a famous miniaturist and jeweller, and Giuseppe della Torre were employed as painters and Giuseppe Gricci as modeller. The modelling studio later received two more artists, Stefano Gricci, and Ambrogio di Giorgio.

The soft paste from which the Capodimonte porcelain was made at first gave continuous trouble. Although the Princess had brought large amounts of porcelain to Naples, the secret for making it was left behind. Searches for better quality clays and minerals were undertaken in all parts of Italy and especially in the Kingdom of Naples. Finally, a satisfactory clay was found at Fuscaldo in Calabria. With the prospects thus improved more workmen were recruited, but the expanded workforce added to the troubles at the new factory. Gaetano, the son of Livio Schepers, was recruited from the Mint to help his father, but the two never got on together. The father was jealous of his son's experiments to improve the paste. As Gaetano became more successful in his work, the rows between them worsened, until finally Livio was sent away to act as supervisor of work being carried out on the approaches to the harbour. Left to his own devices Gaetano was able to concentrate his efforts

and eventually he produced the beautiful paste that was to be the great feature of Capodimonte. In June 1744 Giovanni Caselli, the chief painter, was heard to praise the 'white and diaphanous' qualities of the new paste, and other workmen at the factory were equally pleased. In translucency and whiteness, certainly, the porcelain was as good as the Saxon productions they were striving to rival. The whiteness was enhanced with the use of a clean, clear glaze which gave the colours a new brilliancy.

At this period there was no lack of artistic talent available at Capodimonte. In 1745, the King founded the Accademia del Modello and appointed Giuseppe Gricci, the modeller, as its director. Some ceramic historians consider him to be one of the best European porcelain modellers. The successful new paste stimulated the production of a great variety of articles and toys, including small snuff boxes in shapes of familiar seashells. Branches of coral and other decorative marine motifs were frequently used. The coral branch was especially convenient for the handles of ewers. Gricci also took delight in modelling cane handles and figurines of fishermen holding baskets of fish. Indeed the life of the Gulf of Naples is very evident in his work. The Commedia dell' Arte, the popular Italian itinerant theatre, was a great inspiration to many branches of the arts. One of the most successful of Gricci's productions was the series of figurines and groups from the Italian Commedia. A peculiar rapport between the body and the head, which appears small, is typical of the figurines modelled by Gricci. Almost all the Capodimonte figures stand on bases shaped as stylized rocks, sometimes left plain white or occasionally slightly greenish in tone. Leaves are sometimes incised in the paste and left uncoloured. The actions portrayed by the figures seem rather exaggerated and their features look somewhat sketchy. Some small figures of animals were also produced.

In addition to figurines, there was a considerable production of useful wares such as tureens and tea and coffee services. There were also vases in the pyriform shapes popularized by Meissen, better known as Augustus Rex vases (*ad uso di Sassonia*). These largish vases were made in sets of diminishing size to adorn the mantel shelf (*giuochi da camino*). Some of them were painted by Maria Caselli, the director's niece, with meticulously executed flowers or Watteau and Lancret style decoration. On the

wares designed for use the painted decoration included landscapes (*paesi*), picture stories (*istoriati*) and fighting scenes with soldiers wearing cuirasses (*battaglie*).

Charles was as fortunate in his choice of chief painter as he was in his choice of modeller. When he appointed Giovanni Caselli the artist's work must have been already well known to him, for Caselli had been a gem engraver and miniature painter at the court of the King's maternal uncle, Francesco Farnese, Duke of Parma. His talents were quickly appreciated and he was put in charge of the atelier, a position he held until his death in 1752. All the materials used in decoration, including the gold coins needed for gilding, were carefully chosen and imported by Caselli. Turquoise blue and glazes of many colours, as well as brushes, came from Venice. Red, violet and a dark lavender-rose colour were at first imported from Saxony, but later all the colours came from Venice. After 1749 the colours were obtained from local materials prepared in the nearby mills at Poggioreale and Torre Annunziata, which were run by the gold-grinder Giovanni Remici.

The influence of contemporary engravings, prints and paintings is evident in Caselli's decoration. An example is the early cup and saucer, painted with battle scenes taken from engravings by Simonini, now in the Poldi Pezzoli Museum in Milan. Another early example of Capodimonte porcelain decorated with battle scenes is a milk jug in the Victoria and Albert Museum in London. The source for this was an engraving by A. Tempesta. Engravings by Italian artists after Le Brun were also used. In 1746 Caselli wrote to the Duke of Salas, the Neapolitan Ambassador at Paris, asking him to have sent five or six dozen *chinoiserie* engravings showing figures, landscapes and flowers, which he could draw upon for

Below right: Capodimonte soft-paste milk jug with 'a battaglie' decoration in coloured enamels and gold fleur-de-lis mark on base. c. 1744. (Victoria and Albert Museum, London.) The source of inspiration for the decoration of this piece is the battle scene etching (below) attributed to Antonio Tempesta (1555–1630). It was, however, an expensive, and thus short-lived, type of decoration, used also on snuff-boxes, tankards, tea and coffee services and even walking-stick handles. The 'a battaglie' decoration is not spoken of again after 1745.

miniature masterpieces. Some were sold off, others used by the King as gifts for favourites. The larger and more important pieces were often reserved for the King and Queen. In 1757 Charles gave the factory its most extravagant commission, intended as a present for his young queen. This was the fantastic cabinetto di porcellana, a room in the palace at Portici in which the panelling was to be completely covered in porcelain. The fashion for porcelain chambers had originally been set by Louis XIV when he had the Trianon de Porcelaine built for Madame de Montespan in 1670. Then in 1730 Du Paquier of the Vienna factory had constructed a porcelain chamber for Count Dubsky at his palace in Brunn (now Brno in Czechoslovakia). At Meissen, Charles the Strong had started the porcelain furnishing of his newly acquired but never completed Japanese Palace.

The room at Portici was small (18 by 14 feet, or 5·5 by 4·5 metres), and the wall space was interrupted by three doors and six large mirrors; nevertheless, it took no less than 3000 interlocking porcelain plaques to cover it. The flat white plaques were overlaid with coloured porcelain reliefs. It was in the fashionable Chinese mode, incorporating many elements of the rococo style, and executed with great elegance. Slim, tall Chinese figures over the larger plaques were set above the doors and scattered around the walls. Bearded mandarins, wearing precious, coloured silks, children playing musical instruments or resting under palm trees, exquisitely dressed females with doll-like expressions, a profusion of richly coloured garlands, fans and scarves, hanging baskets and swags of fruit, playful monkeys and brilliantly plumed parrots all combined to give an impression of dazzling animation. Suspended from the ceiling was an elaborate, flower-encrusted porcelain chandelier, damaged in World War II, but restored, on which perched fighting herons, a monkey holding a coconut and other figures. The mirrors, providing endless reflections of the fabulous décor, made this one of the finest rococo rooms in the world. At first glance the vistas of blue and mauve against the white and gold background seem overpowering, but they are relieved by a variety of greens and yellows and by the pastel shades used on the robes and human faces. Fur, plumage, soft fabrics and silken sheens are all meticulously rendered by a careful graduation of colour and fine brush strokes. The emblems and figures bear some resemblance to decoration on the *famille verte* of Kangxi or Qianlong, but they are nothing like direct copies. The Capodimonte workers were ignorant of Chinese symbolism and Taoist stories, and the images of imperial dragons, clouds and birds have lost their original significance.

This famous porcelain room is happily still preserved, except for the original porcelain floor, which was dismantled in 1799, just before Ferdinand IV went into exile in Palermo, and is now lost. Since 1865 the room has been rehoused in the Royal Palace at Capodimonte, and since 1956 the original stucco ceiling from Portici, by Raffaele Gasparrini, which blends so beautifully with the wall decoration, has been reunited with the rest at Capodimonte.

ideas for decoration. The response on that occasion was unhelpful, the Duke replying that such engravings were not to be found in Paris. The Capodimonte decorators were also much influenced by Meissen models, from which their Watteau-style paintings were probably copied.

The King took the closest interest in all that went on in the factory. When he was away at the wars, or at his summer palace in Caserta, he demanded monthly reports. It was rumoured that on occasion he might be observed serving at the stalls in the annual Capodimonte fair, or at the small shop in the centre of the town, where the porcelain was sold. Certainly, he knew the names of all his customers and kept a record of them. Surviving documents from the factory reflect what life was like at that time. One document, dated March 1746, records that working hours were from dawn till 11:30 p.m. with a lunch break lasting one to three hours according to season. Differentials must have been problematic. Schepers, the arcanist, received 20 ducats a month, Gricci, the chief modeller, only 15. From time to time key members of the work force were discovered in dishonesties. In 1752 Remici, the gold grinder, was found adulterating the gold to the detriment of the decoration. Although greatly upset, the King dismissed the man without exacting any further penalty. Two talented painters, Francesco della Torre and Antonio Provincale were less lucky. Believed responsible for the disappearance of powdered gold from a strong box in the painters' room they were sent to prison in 1755. Three months later their innocence was established, and the King ordered their reinstatement. Three years later, Provincale and another important painter, Johannes Fischer, fell ill with mushroom poisoning. Fischer died and was replaced by the Austrian miniaturist Christian Adler, but he too died a year later.

Many of the smaller Capodimonte pieces were

Giuseppe Gricci was doubtless the chief modeller for this masterpiece, probably helped by his brother Stefano and by the flower specialists Ambrogio di Giorgio and Batista di Batista. The painters Fischer and Adler both died during the two years the work was in progress. Luigi Restile, the only painter to see it through to completion, claimed that he had done three quarters of the work himself. The cost, 70,000 ducats, was enormous, especially considering the low price of labour.

The royal couple had to leave quite soon after the completion of their extravagant project. In September 1759 Charles departed to take over the Kingdom of Spain on the death of his half-brother Ferdinand VI. He could not bear to leave behind his beloved factory, so all that was moveable was dismantled and transported to Spain in three ships of the Neapolitan fleet. He was joined by forty-four workers and their families. By the end of 1759, eighty-eight tons of equipment and nearly five tons of the precious paste had been landed at Alicante, and by May 1760 Charles could see the kilns at work in the gardens of his new palace of Buen Retiro.

Later Capodimonte

When, in 1759, Charles III inherited the Kingdom of Spain he left his eight year old son Ferdinand on the throne of Naples. The famous porcelain room in the palace at Portici must have been a constant reminder to Ferdinand of the glory of his father's Capodimonte factory. On coming of age in 1771 Ferdinand IV immediately followed in his father's footsteps by making the decision to re-establish porcelain production in the Kingdom. He had the master builder, Ferdinando Fuga, construct a factory in the park of the Villa Portici. A few of the original Capodimonte workers, including Gaetano Tucci, arcanist and kiln master, the painters Carlo Coccorese and Antonio Cioffi and the modeller Saverio Danza, took part in the new venture. Initially the Marquis Ricci was put in charge, but he died in 1772 and was replaced by a Spaniard, Tommaso Perez, who remained until his death in 1780, when the arcanist Tucci also died.

Almost from the outset it was realized that the premises were too small for the enterprise, so Fuga set about to enlarge and convert an old building near the riding school in the Royal Palace in Naples. By 1773 the new factory was in production and Francesco Celebrano and Francesco Ricci were engaged as additional modellers.

The production of this period is very reminiscent of earlier Capodimonte, being made with a very glassy, translucent soft paste covered in a glaze with a slightly yellow colour. The larger or more thickly potted pieces are sometimes marred by firing cracks. Marked pieces bear the monogram R.F.R. (Fabbrica Reale Ferdinandea) surmounted by a crown painted in blue, red or sometimes black enamel. The form and decoration are still in rococo style. Notwithstanding the artistic influence of Meissen on earlier Capodimonte the Carolean production had de-

veloped some indigenous features, but on examining the production of Ferdinand's factory one cannot help noting how much foreign influence on the decoration is in evidence. Tureens and flower-pot containers (*cache pots*) are adorned with applied handles in the shape of flowering twigs or branches of vine with naturalistically coloured leaves and fruit, while the surfaces are painted with a rather loose version of the *Deutsche Blumen* pattern, but rather more reminiscent of Chantilly or Vincennes than of the German prototypes. The little bunches of flowers usually incorporate a rose in full, open bloom surmounted by three or four wild flowers, all richly painted in naturalistic colours and arranged in curvilinear, asymmetrical compositions. On plates, cups and saucers the gilded patterns of the rims resemble the baroque lace decoration derived from Meissen which was used on earlier Capodimonte. Landscapes and views with people also appear, clearly influenced by contemporary native painters and engravers. During the 1770s, some coffee and teasets were made, painted in a miniature technique. Instead of using large brushes to fill in the contours, the decoration is achieved by the use of colours applied with fine brushes in a stippled style. These compositions, especially when they depict young suitors or cupids seated on clouds, have a real rococo spirit. However, on the borders of the plates and saucers, and even sometimes on the cups, one finds a motif more in the neo-classical than the rococo mood, consisting of a frieze made up of two different garlands, one of tiny flowers and the other of little feathers, together forming a kind of chain. Overall, however, the production of these first eight years is in a transitional style between baroque and rococo. The flat ware of the period still has lobate and wavy borders, while the plant holders are in the shape of truncated cones with wavy rims and applied handles modelled like branches of flowering trees.

The sculptural work of this first period of the Royal Ferdinand Factory is again reminiscent of Capodimonte. The figurines have the same exaggerated movement and the same small heads, similar to Gricci's models, but the bases on which they rest are different. A round mound, richly embellished by gilded or painted 'C' scrolls in relief, takes the place of the stylized rocks used by Capodimonte.

Perez, the director, was dissatisfied with the production. He wrote to the King criticizing the modellers and painters for lack of imagination:

> The colours and gilding are as beautiful as those of Saxony, but the paintings are too literal copies of the original designs. There is a lack of good taste in the invention, which is a fault in the country at large. Neapolitan artists are too ready to copy, they find it easy to copy but difficult to invent.

On the death of Perez in 1780 Domenico Venuti was first made manager and then promoted to director. Under his leadership the factory grew in importance and the artists were encouraged to adopt the new neo-classical style. In particular the sculptural output

Naples tureen and stand with accompanying pattern-book. The piece is from a dinner service known as the 'Etruscan' set, consisting of 282 pieces and was a diplomatic gift from Naples to George III of England. The neo-classical style of decoration was inspired by ancient Greek or southern Italian vases. c. 1785. The illustration, one of 179 engravings, is from the 'interpretive' text which accompanied the 'Etruscan Service' to England.

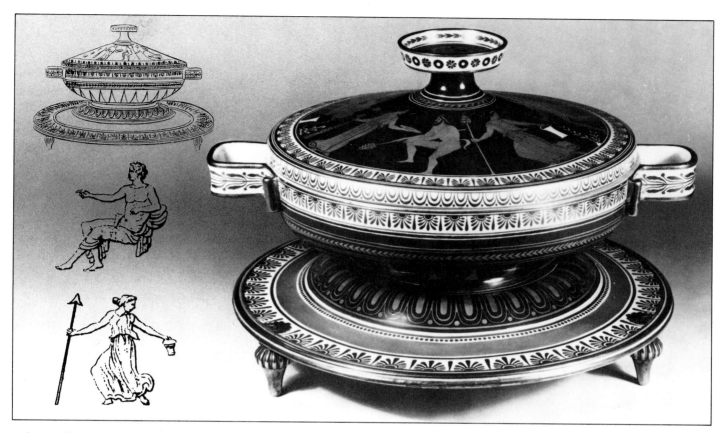

in biscuit developed into a full neo-classical mood. The factory modellers studied to good effect at the Academy of the Nude, which was founded at Venuti's suggestion in 1781. The King seems to have been keen on this kind of production for, in 1782, he asked Venuti for a list of the workers required for the production of 'la creta all'uso inglese' (clay in the English style). He must have confused the biscuit ware with English cream-coloured earthenware.

For a time after Venuti's appointment the paste and glaze continued unchanged, but in 1782 Giuseppe Bruschi and Nicola Pintucci were summoned from the Doccia Factory near Florence to come to work at Naples. Soon after their arrival the porcelain body began to change from its original yellowish colour to a bluish white, the grain of the body became much finer and the glassy glaze was replaced by an opaque greyish looking one similar to that used at Doccia.

As the neo-classical style became ever more fashionable the design and ornamentation of the Naples ware underwent a total change. In 1781 the King gave the factory one of its most important commissions, the Ercolanese table service, a gift for his father Charles III, now King of Spain. The set took two years to complete. Venturi advised the painters to adapt for it some of the pictures found on the excavations at Herculaneum. The centre piece was a biscuit sculpture, representing Charles III encouraging his son to continue with the excavations. This was surrounded by reproductions in biscuit of the latest finds. A book explaining the paintings on the set was also published. The painters Giacomo Milani and Antonio Cioffi went to Madrid to deliver the work in 1783, so presumably they were

the two who had been largely responsible. A second service of 282 pieces was made as a diplomatic gift for George III of England. It was delivered there in 1787 by Tagliolini, who was accompanied by John Chisel (or Casely), an Englishman who had been employed at the factory since 1771, and was to remain till 1804. A large part of this set, known as the Etruscan Service, can still be seen at Windsor Castle, but the centre piece, representing Tarchon, King of the Etruscans attending a gladiatorial combat, which was modelled by Tagliolini, is now lost. The service is decorated with figures in red or black, in imitation of the style of ancient Greek or South Italian vases. Again, an explanatory book, this one illustrated with 179 engravings, accompanied the service.

Other services were produced with borders embossed with arabesque patterns or grotesques and painted in designs from antiquity. Sometimes the borders were segmented, with a little cameo or fantastic animal painted at the intersection of each segment, either in matt or polished gold or else in a combination of the two. Topographical views of the Kingdom of the Two Sicilies, but especially of Naples itself, were also used to decorate the ware. These were reminiscent of the work of the landscape artists Antonio Joly and Philip Hackert. Also popular as decoration were pictures of people dressed in traditional regional costumes walking or resting in a romantic landscape.

The figurines and sculptural groups produced at the Royal Factory, especially during the period 1790–1800, largely reflect the life of the court of Ferdinand IV. Unlike his father, Charles, Ferdinand's interests were not particularly cultural; he

liked fishing, hunting and buffoonery. At court he was surrounded by members of the bourgeoisie and the modellers of his Royal Factory took delight in producing highly spirited representations of these people, revealing them as richly dressed and pretentious, but in manners and attitude somewhat plebeian. The so-called 'le panchine' (the benches) are perhaps the most pleasing of the small decorative figures. In this genre groups of three or four people of both sexes wearing the latest fashions are represented seated on benches in the garden of the Royal Villa, sometimes accompanied by animals or small children. These miniature compositions are very realistically modelled. The lovers are deep in conversation while the chaperone talks to her dog, or a husband being sweet to his wife is interrupted by a child demanding attention from the mother. These groups are made in a beautiful, brilliant porcelain, delicately painted to show even the patterns on the dresses and finely modelled even to the detailed folds of drapery. They create a vivid impression of *nouveaux riches* families enjoying their Sunday outings. Some of these 'panchine' groups were made in biscuit, but the lack of glaze and colour makes them less lively.

Early in 1799 the people of Naples revolted against Ferdinand IV and the Parthenopean Republic was proclaimed. Using Nelson's flagship, Ferdinand left for Palermo, but the republic collapsed in six months and Ferdinand returned. His government took severe and terrible reprisals against the rebels. Whether from disillusionment or discretion, Ferdinand ceased to take an interest in the artisans of porcelain, the factory fell heavily into debt and Venturi relinquished his position. The political situation was unsettled and Napoleon was on the rampage. Undecorated porcelain began to arrive from abroad to be finished at Naples. The wares produced by the factory itself took on a French style. Clock cases, candlesticks and table services were decorated with the Egyptian motifs associated with the Napoleonic era. In 1802 Napoleon became President of the Italian Republic, in 1804 he crowned himself Emperor and in 1806 his brother Joseph Bonaparte was made King of Naples. Joseph had no aspirations to be a patron of the porcelain art and in 1807 he sold the Naples factory to the French firm Jean Poulard & Co. Ferdinand was restored to the throne with the downfall of Napoleon in 1815, but he took no further interest in porcelain.

Ginori Doccia

When Giovani Gastoni, the last descendant of the Medici Grand Dukes of Tuscany, died in Florence in 1737, the Dukedom passed by treaty to Francis Stephen of Lorraine who, as husband of Maria Theresa, later became joint Emperor of Austria. A group of distinguished citizens of Florence, headed by the Marquis Carlo Ginori, went to Vienna to pay homage to their new Grand Duke. The Marquis returned duly rewarded with the Governorship of Leghorn, then a very busy city with an important harbour. Carlo Ginori had an enquiring and en-

lightened mind and was a great entrepreneur. He reclaimed the marshes of Cecina for agriculture, imported and bred Angora goats for their valuable wool and introduced goldfish from China to the Austrian court. His greatest delight, however, was porcelain-making. He had begun experiments in this field as early as 1735, but the porcelain enterprise at his villa in Doccia, near Florence, was not opened until 1737 when he returned from Vienna with a privilege for making porcelain in the Grand Duchy, bringing with him the *Hausmaler*, or independent decorator, Anreiter von Zirnfeld.

Although Anreiter was taken on as a painter he may have had some knowledge of porcelain-making, as it is likely he had done painting work at the Du Paquier factory in Vienna where he could have learned some of the techniques for making porcelain. His young son Anton, then only about twelve years of age, accompanied him to Doccia where he also later worked as a painter. Ginori brought in as arcanist a geologist, Giovanni Targioni-Tozzetti, with Jean Baillou from Lorraine as assistant. The famous Doccia paste, the 'masso bastardo', incorporated clay from Montecarlo, near Lucca, which yielded a hybrid hard paste with a distinctive grey tone. This porcelain is prone to fire-cracks, and on shaped vessels the marks of turning are often visible. The glaze lacks brilliance, and on early pieces often shows a green or yellow tinge. This fault was remedied from about 1770–1800, when the glaze was made opaque and dead white by the addition of tin oxide.

Much of the early production of Ginori, from 1737 to 1757, has a distinctly baroque feeling. This appears most marked in the tall, pear-shaped coffee-pots which stand on massive splayed bases and have heavy handles and domed covers and snake spouts rising almost vertically from shield-shaped joints fixed to the neck by a scroll. Double-walled vessels and cups were made with the outer wall pierced and moulded to give the impression of clinging leaves and flowers. This ware was inspired by Fujian *blanc de chine* porcelain. Extant examples are very rare.

Much of the useful ware of the early period is decorated with flowering plants in underglaze blue or grey, painted 'allo stampino' (with the aid of a stencil), a practice unique in European porcelain of the eighteenth century. The more *de luxe* pieces were decorated by the chief painter, Carl Anreiter, whose signature appears on several cups. The cups were made with and without handles, the latter being taller and narrower. The decoration on the porcelain ranged from religious subjects to flowers and landscapes.

By 1740 the Ginori factory had become so successful that samples taken to Vienna were compared favourably with the porcelain of Du Paquier. Even though it was still subsidized with money from the Marquis, the factory seemed to have excellent prospects. The production was sold both from Doccia and from a warehouse at Leghorn, where Ginori was Governor. New designs from Gaspare Bruschi, the chief modeller, added to the factory's prestige.

Most of the designs and decorative patterns that

Above: Doccia sweetmeat dish in the form of a scallop-shell supported by merman and mermaid. c. 1760.

Below: Doccia figure of a female dwarf, an apparently popular subject as female dwarfs appear in many different guises. Perhaps modelled by the chief modeller Gaspero Bruschi. Height 8 cm; c. 1755.

made the Ginori factory famous were introduced during Carlo Ginori's directorship. They included, among the table-ware, the tulip motif, a vaguely Oriental pattern of stylized tulips as a central feature surrounded, on plates and dishes, with a border of other flowers asymmetrically painted in rich orange, edged with gold. Another pattern was the charming 'a galletto' fighting cockerel, inspired by Chinese porcelain, which was usually painted in red and gold. The Saxon style was also attempted, with Oriental, Turkish or European characters, painted in red, gold or violet, in arabesque-framed vignettes. Sculptural work was not neglected. Under Bruschi's supervision a rich and varied repertoire was produced, ranging from copies after Michelangelo to designs by Massimiliano Soldani-Benzi.

Amorous couple and two putti, Le Nove or Doccia. c. 1785. (Museum für Kunsthandwerk, Frankfurt)

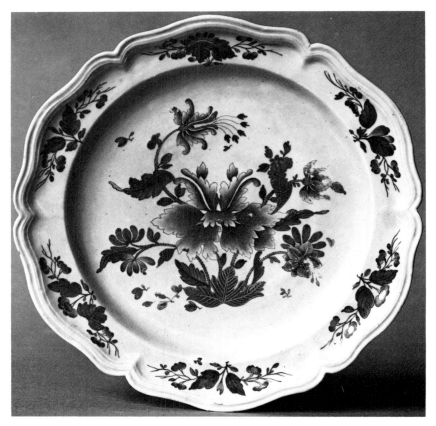

Doccia plate whose centre is decorated with brightly coloured pseudo-Oriental flowers. The lobed shaped and moulded rim is reminiscent of contemporary silver. This popular design is now known under the name of 'a tulipano'. Diameter 29.5 cm; c. 1760. (Fitzwilliam Museum, Cambridge)

Sculptural work in bas-relief, sold either white or painted, was also used to decorate useful ware, such as tea and coffee services, with mythological scenes. These pieces were once wrongly attributed to Capodimonte. Some of the lead moulds used for this type of decoration are in the Doccia Museum at Sesto Fiorentino and one of them bears the signature of Anreiter, which shows that this bas-relief decoration was in use at Doccia before 1746 when the Anreiters left for Vienna. Carl Anreiter died in Vienna in 1747 and his son Anton entered the Imperial Factory.

Snuff-taking was one of the elegant mannerisms of the eighteenth century and snuff boxes were part of every gentleman's accoutrements. At first they were made in precious or semi-precious metals, but when porcelain became available in Europe, porcelain snuff boxes became popular. The Ginori factory produced examples in a variety of shapes, lobed, square and rectangular, with a variety of decoration, painted with *chinoiseries* in the Meissen style, with fruits and flowers reminiscent of Vienna's Du Paquier, with bas-relief decoration, etc. Lids were painted inside and out in a very delicate manner. The appearance of flesh on the faces and limbs in the paintings was achieved with a stippling technique similar to that employed by miniature painters. This part of the production was considered so important that Ginori had a special department created, known as the 'Laboratorio degli Argenti', where up to six people were employed. The head of the laboratory was a Frenchman, Jean François Racine. He worked at Doccia from 1744 to 1746 and was subsequently employed a few more years at Leghorn, where he supervised the daily assembly and embellishment of objects made at Doccia and finished at the Leghorn warehouse.

In 1757 the founder died and was succeeded by his son the Marquis Lorenzo I Ginori. Before deciding on a policy the heirs needed a complete picture of the business and so an inventory of the factory and of the Leghorn warehouse was prepared. It is from this document that much of the history of the early period comes. At first, Lorenzo had some trouble from his brothers, and there was even a threat to open a rival factory at San Donato, not far from Doccia, but this was soon settled. By 1760 Lorenzo was in a position to expand production. During the earlier period under Carlo the designs had been dominated by Vienna and Meissen and the forms were rather baroque. An exception was the table centre piece in the shape of a small triumphal monument, symbolizing the glories of Tuscany, specially commissioned and presented by Carlo Ginori to the Academia Etrusca of Cortona when he was elected a member of it in 1756. This piece from the latter part of the early period seems to incorporate some elements of the rococo style. By the time Lorenzo took over the management of Doccia, Meissen was still feeling the baleful consequences of the Seven Years' War and Sèvres, the grand exponent of rococo, had become Europe's leading porcelain factory. It seemed imperative to catch up with the fashion, so Lorenzo quickly initiated an imitation of Sèvres colours. Later he introduced a rococo style all of its own. The ground colours of Sèvres were used at Doccia with greater originality. The reverse panels were often decorated with landscapes painted in strong, contrasting monochrome purple or red. Vases, cups and *écuelles* (shallow, covered bowls) were given handles in the shape of delicately interwoven twigs, and flowers in relief were scattered over plates and even on saucers. The rims of plates were lightly scalloped and the borders enriched with painted ribbons and bows and garlands of flowers, all in a rich, naturalistic palette. Mythological scenes were never abandoned, but now the gods and goddesses were set among landscapes or classical ruins. Peasant girls and boys are represented, sometimes at work and sometimes doing nothing.

In this second Ginori period the figures, like the useful ware, are in a more rococo style, and modelled in a lively manner. The range of subjects includes religious and mythological groups, or single figures of a more worldly kind, such as shepherds and shepherdesses, Orientals, gardeners, etc. A great variety of bases is used for the figures and groups—small, unobtrusive squares or rectangles, or platforms supported by a fretwork of shells and scrolls or imitation rocks of brickwork. The palette used for the decoration of both figures and bases includes a rich red, puce, pale blue, black, gold and—the most beautiful colour developed at Doccia—a pure, rich, ripe, lemon-yellow. Some of the sculptural work is reminiscent of the earlier period. For example, there is the famous table centre-piece depicting the triumph of Ferdinando I de' Medici, better known in Italy as 'I quattro mori' on account of the presence of four chained negroes at the base. The piece derives from

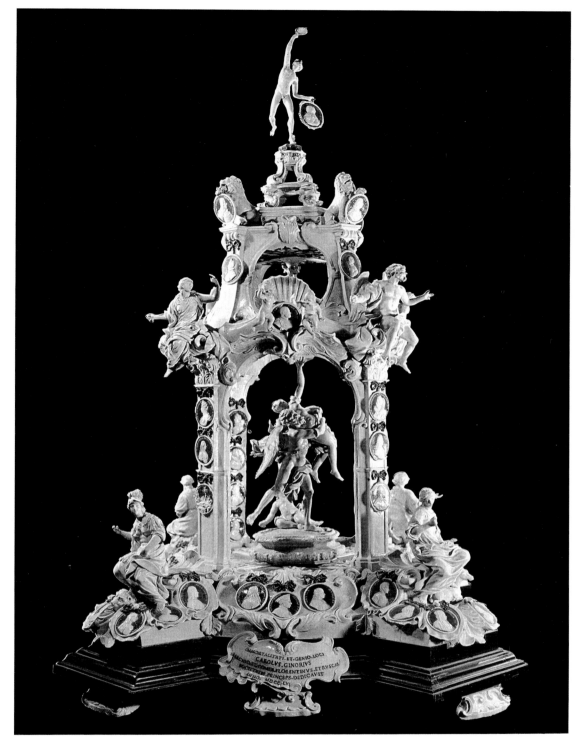

Below: Doccia armorial beaker. The decoration suggests the high esteem in which Doccia porcelain was held.

Left: 'Tempietto dedicato alle Glorie Toscane', one of the most ambitious pieces produced at Doccia. Commissioned by the Marchese Carlo Ginori, founder of the Doccia factory, and presented by him to the Academia Etrusca of Cortona. It was designed and perhaps modelled by Gaspero Bruschi, a Florentine sculptor, and the most talented member of the Doccia enterprise. Height 167 cm; 1756. (Academia Etrusca, Cortona)

the Pietro Tacca monument to Ferdinand which faces the harbour at Leghorn, its famous tritons supporting shells above their heads, probably inspired by Roman fountains.

The chief modeller, Gaspare Bruschi, remained with the factory until he died in 1778. Towards the end of his life he was helped by his son Giuseppe, who apparently took over as chief modeller until 1791, when Lorenzo died. Leopold Carlo Ginori, Lorenzo's son and heir, being a minor, did not accede to the directorship until 1805. Meantime, Anton

Maria Fanciullacci acted as director. During the last two decades of the eighteenth century the Doccia production, like that of other places, took on the neo-classical style. Shepherds and music-makers, rococo scrolls and shells, scalloped plates and dishes and gay, strong colours all disappeared in favour of severe and solid designs, urn-shaped vases, amphorae and coffee-pots, all inspired from classical sources.

The Doccia factory mark of a six-pointed star was not introduced until late in the eighteenth century. All earlier pieces are unmarked.

Venice

True porcelain was first produced in Venice through the initiative of a goldsmith, Francesco Vezzi (1651–1740). In 1716 he and his brother Guiseppe paid 100,000 ducats to be elevated to the ranks of the nobility, and in 1719 they obtained permission to visit Augsburg which was then in its heyday. Vezzi made contact with Hunger, a fellow goldsmith, who is credited with having learned from Böttger some of the Meissen secrets and transmitted them to Du Paquier at Vienna. In 1720, with Hunger's help, Vezzi began to make porcelain, utilizing kaolin smuggled from Saxony. In 1723 Vezzi closed his goldsmith's shop and began to concentrate exclusively upon porcelain. Records of his enterprise are scarce, and in fact it proved short-lived, closing down in 1727, by which time Hunger had returned to Meissen and given information leading to a complete embargo on the export of Saxon kaolin.

In its short life the Casa Eccellentissima, as Vezzi's workshop was known, produced some high quality products, although many of the designs were rather clumsy, being too slavish adaptations of shapes more suited to work in precious metals. The early pieces resembled Meissen and were covered with a brilliant, glassy glaze. The paste was translucent, but varied from a pure white to a yellowish cream. Most pieces were marked with the word 'Venezia' or abbreviations of it.

Following the closure of the Vezzi factory the Venetian Senate advertised that they would grant privileges for the promotion of porcelain and maiolica production, but it was not until 1757 that Nathaniel Hewelcke from Dresden successfully petitioned for the right to make porcelain in the Saxon style. He and his wife Dorothea had been retailers in Dresden and their competence as manufacturers is doubtful. The hard-paste wares they produced were not a success. Their pieces lack grace and finish and few have survived. They are easily identified by the impressed 'V' filled with a red colour. The Hewelckes probably returned to Dresden following the end of the Seven Years' War in 1763. Meantime the Senate had given permission to Pasquale Antonibon of Nove to produce porcelain in competition with Hewelcke, but from the illness of the proprietor and the indiscipline of the workers this enterprise also soon languished.

Geminiano Cozzi, the most important of the Venetian porcelain-makers, successfully petitioned the Senate for a licence in 1765. He may have been an associate of Hewelcke, and he was certainly helped by deserting workers from Nove, but at any rate he claimed to have overcome all the problems of the composition of hard paste. His claims were supported by comments in the *Giornale d'Italia* praising his figures, snuff boxes and other wares. The Cozzi enterprise flourished for many years, aided by duties and import regulations that discouraged competition from Oriental products. Even so, Cozzi experienced financial problems, due to the necessity to borrow capital, and it was not until 1784 that he acquired complete ownership. By that time there

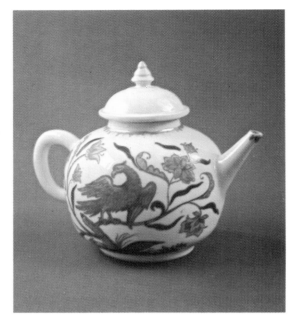

Above left: *Vezzi teapot decorated in iron red and gold. The short-lived Vezzi factory in Venice was the first to produce true hard-paste porcelain in Italy. c. 1725. (Victoria and Albert Museum, London)*

Below left: *Venice plate signed by Cozzi, founder of the third Venetian porcelain factory in 1764. Decorated in the style of Sèvres, the plate is painted with a scene showing Europa and the Bull, after a painting by Paulo Veronese. The reverse panels around the border contain miniatures of the Tiepolo and Tintoretto masterpieces in the Doges' Palace in Venice. 1780. (Victoria and Albert Museum, London)*

Below: *Nove tureen and stand. The Nove factory near Bassano, under the ownership of the Antonibon family, was producing a porcelain of a hybrid paste by 1762 similar in quality to that of the Cozzi factory. (Fitzwilliam Museum, Cambridge)*

were eighty-three employees, output was substantial and foreign imports were being successfully supplanted. The decline of the factory came about through political misfortune. Cozzi's noble patrons began to depart as Napoleon advanced, and with the abdication of the last Doge in 1797 Cozzi also lost his state support. As first the French and then the Austrians took over authority in Venice, the most prestigious orders went to Sèvres or Vienna, and by 1812 the now-aged Cozzi was obliged to close.

Cozzi's porcelain is a grey-toned hard paste with a glistening glaze, coloured in iron red, emerald and violet with a very high quality gilding obtained from melted coins. The best pieces of table-ware are marked with a gold anchor, others with a red anchor, while most figures and groups are left unmarked. A classic example is the plate, dated 1780, painted with a scene of Europa and the Bull (after Paolo Veronese), which is now in the Victoria and Albert Museum. It has a deep blue and gold border with reserve panels painted with scenes after Tieopolo and Tintoretto. Cozzi's output is strongly influenced by both Meissen and Sèvres. It includes much charming *chinoiserie*, mythological groups and figures after engravings by Callot and the Commedia dell 'Arte. Cozzi's later wares, in neo-classical style, display considerable originality of design. After Cozzi's demise Venice never regained its place among the great porcelain centres of Europe.

Berlin

Even as a young prince, Frederick II of Prussia (better known as Frederick the Great) had a keen appreciation of the fine and decorative arts. In contrast to the traditional interior of his father's palace, his own castle at Rheinsberg was decorated in the new rococo style. Frederick was the sponsor of the first Berlin Porcelain Factory. His interest in porcelain was probably first aroused when he accompanied his father on a visit to Augustus the Strong, the founder of Meissen, whose sixteen palaces housed vast collections of porcelain.

When he succeeded his father as king in 1740, Frederick surrounded himself with artists and craftsmen, inundating them with commissions for the refurbishing of his palaces in the latest rococo style. Porcelain was in great demand at this period and porcelain patronage was a popular hobby of royalty. Frederick had hopes of seeing a fine porcelain factory flourish in Prussia. In 1752 he granted premises and the exclusive right to porcelain-making to Wilhelm Kasper Wegely, a Berlin wool merchant who had acquired the necessary 'secret' from Johann Benckgraff, formerly arcanist at Höchst. Kilns similar to the type in use at Höchst were built and clay was obtained from Aue, the source utilized by Meissen. Ernst Heinrich Reichard became chief modeller and arcanist.

Wegely's porcelain was a pleasant white and good quality ware was produced, but the enamel decoration caused problems and the products never equalled those of Meissen. The Wegely table-ware copied

Meissen designs, but Reichard's sculptural work showed rather more originality. Although his models followed Meissen originals, and were not particularly skilful in execution, these early Berlin figurines have a naive attraction. The series of figures of 'Cupid in disguise' and the characters from the Commedia dell' Arte are especially good examples.

As mentioned earlier, in 1756 Frederick invaded and conquered Saxony. His troops occupied the

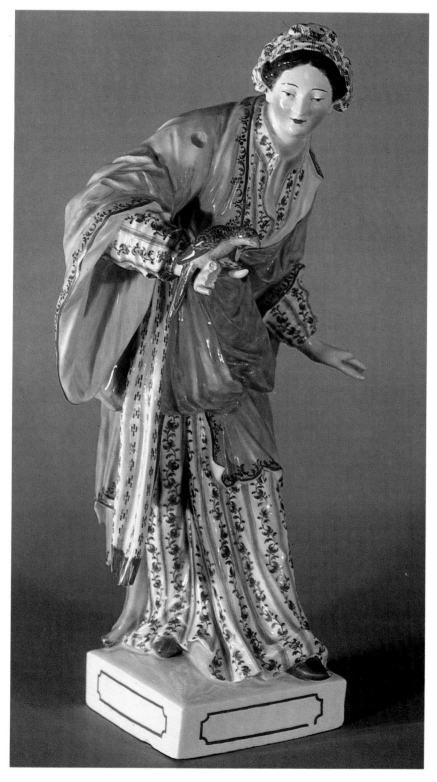

Berlin figure by Friedrich Elias Meyer, master modeller at the Berlin factory till his death in 1785. He was responsible for the design of table-ware and some large classically-posed Chinese figures such as this. (Staatliche Museum, Berlin)

Meissen factory and the factory funds and porcelain stock were confiscated. Wegely hoped to improve his production with the aid of displaced Meissen craftsmen. Frederick, however, was displeased with the quality of Wegely's porcelain and now that he had access to as much good porcelain as he needed he did nothing to assist. Discouraged by the King's attitude, Wegely closed the Berlin Factory in 1757.

Johann Ernst Gotzkowsky, a financier with a passion for porcelain started up a new porcelain factory in Berlin in 1761, receiving appropriate encouragement and manufacturing privileges from the King. The new enterprise emerged, as it were, from the ashes of the defunct Wegely factory. Gotzkowsky was successful in also recruiting Meissen workers, such as F. E. Meyer, who was made chief modeller, and the two painters K. W. Böhme and J. B. Borrmann. These were later joined by K. J. C. Klipfel, a specialist in 'mosaik' (that is, fishscale) pattern. Grieninger, another Saxon man, was employed to direct the factory.

In the early days of the new factory the King was not a faithful patron, being still primarily attracted to Meissen porcelain. In a letter to his mother written from Dresden in 1762, concerning his Meissen purchases, Frederick explained very frankly: 'J'ai commandé ici de la porcelaine pour tout le monde: en un mot je ne suis riche à présent qu'en cette fragile matière.' (I have ordered here some porcelain for everybody: in a word, at present I am rich only in this fragile stuff.) The following year, while Frederick was still spending lavishly at Meissen, the Gotzkowsky factory ran into irremediable financial difficulties and was put up for sale. Frederick bought it up, lock, stock and barrel, and renamed it the Royal Porcelain Factory.

With the coming of peace with his neighbours, Saxony and Austria, in 1763, Frederick was free to take an interest in the well-being of what was now his own factory. He encouraged experiments to try to improve the quality of the porcelain. He instigated searches for sources of kaolin in Prussia which led to the discovery, in 1771, of deposits of good quality kaolin in Brachwitz near Halle. He wanted his factory to achieve the standing in Europe that Meissen had had before the outbreak of the Seven Years' War in 1756. This ambition remained unfulfilled, however, for the Berlin workers were inescapably wedded to the now outmoded rococo style of earlier Meissen. Low-relief border patterns, strongly reminiscent of Meissen ware, appeared frequently on the table-ware that formed the larger part of the production. Coloured grounds, inspired by fashionable Sèvres, and scale-pattern border decorations, were used on many of the services that Frederick commissioned. In the late 1760s the decoration

Berlin urn, ice pail and cover, and plate, a selection from the 'Prussian' service presented to the Duke of Wellington by King Frederick William III of Prussia. The service is richly painted and gilded, and of particular interest are some sixty plates each decorated with topographical views associated with the Duke. c. 1817. (Wellington Museum, London)

became simpler. Wavy rims were abandoned. Circular shapes and plain handles replaced the pear shapes and richly scrolled handles that had previously been used for tea and coffee-pots. The Prussian kaolin, which came into use in the 1770s, produced a cold white porcelain that gave the coloured enamel decoration a strong, almost harsh appearance. At the same time new styles of decoration were introduced, such as the cameo effect, which utilized two colours, pink and grey or red and black, for example, for rendering flowers. This technique, derived from Sèvres porcelain, was also used in monochrome for the painting of figures and occasional landscapes. Pierced border designs, such as are seen on English creamware, were also introduced. English influence was also apparent in the production of plain oviform vases and other ornamental ware.

The factory's sculptural work was at first produced almost entirely by F. E. Meyer, but in 1766 he was joined by his brother Wilhelm Christian, who remained in Berlin until 1772. Their work is very similar, both having a rather 'manneristic' approach. Their figures are gracefully modelled, with slender, elongated bodies and small heads. W.C. Meyer's white porcelain tableau, which symbolized the art of sculpture, is already suggestive of a change of mood in the direction of neo-classicism, and is a good example of the brothers' style. Their most important collaborative work is a very large table-service which was ordered by Frederick as a diplomatic gift for Catherine II of Russia. This masterpiece includes a central figure of the enthroned Empress surrounded by gods, goddesses, muses, Russians and captive Turks. It is now in the Hermitage Museum.

Frederick died in 1786 and was succeeded by his nephew, Frederick William II, but royal patronage continued as the new king carried on the practice of commissioning pieces for diplomatic gifts and for presents to his friends and relatives. At the start of the reign the factory was producing little of artistic importance. In 1785 F. E. Meyer had been succeeded as master modeller by J. G. Müller, an artist of little consequence, known only for some portraits in biscuit and some mythological figures. In 1790, however, Johann Carl Friedrich Riese was appointed master modeller. He established a successful collaboration with another modeller called Schadow and with the court architect, Genelli, who was also a modeller. The trio worked in neo-classical style, making great use of biscuit porcelain. A good example of their work is the Temple of Bacchus which can now be seen in the Victoria and Albert Museum. This large centre piece is a model of a round, classical temple with domed roof. Inside the temple, the figure of Bacchus is a perfect example of porcelain design of the late eighteenth century. The contrasts between the glazed and biscuit porcelain and decorated and white surfaces are remarkable.

Frederick William III succeeded to the throne on his father's death in 1797. His reign coincided with Napoleon's rampages across Europe. He was too preoccupied trying, not very successfully, to defend Prussia to be much concerned with the porcelain factory. The concern kept going, but nothing of

artistic note was produced until after the defeat of Napoleon. In 1818, with peace restored and his territories returned, the King commissioned Schadow to make a table-set for presentation to the victorious Duke of Wellington. The Prussian service made in 1819, which originally comprised some 420 pieces, is richly decorated with burnished and matt gilded borders framing views and scenes portraying episodes in the Duke's life and campaigns.

The tureens are shaped like sarcophagii supported by brightly gilded crouching lions, and lion finials are on the domed lids. Soldiers wearing different uniforms are painted on the *campana* (bell-shaped) vases and wine coolers. The centre piece includes a rectangular porcelain base on which are inscribed porcelain obelisk stands surrounded by river gods, symbolizing the rivers connected with the Duke's military career. This service, now on display at the Wellington Museum, London, is a good example of the style used by porcelain-makers in the early nineteenth century.

Temple of Bacchus from the Berlin factory. In the shape of a classical temple, the piece is made up of glazed and unglazed biscuit and reflects the neo-classical style which had become fashionable in the third quarter of the eighteenth century. Height 58.5 cm. (Victoria and Albert Museum, London)

Chapter Seven

Eighteenth-Century English Porcelain

Left: Worcester figure of a sportswoman surrounded by flowers. c. 1770. Although figures such as this figured prominently among the productions made by other factories at this time, Worcester concentrated on making table-wares, and this is an extremely rare piece to come from that factory. There are only about ten similar pieces in existence. (County Museum, Truro)

Right: A Longton Hall figure representing America from a series of the Four Continents. c. 1758. The moulds for this series were bought by William Cookworthy of Bristol in 1760 when Longton Hall closed down and as a result this figure can also be found in hard-paste porcelain. (Victoria and Albert Museum, London)

IN Europe, porcelain-making of the eighteenth century can fairly be described as a princely sport, with most factories owned by royalty or aristocrats who were more interested in prestige than profit, and whose clients were of the wealthiest class. They had the money to attract well-paid and highly skilled workers who could be given freedom to experiment and innovate.

In England, on the other hand, factories had to depend upon entrepreneurs willing to invest, in the hope of a financial return. Both backers and clients were middle class rather than aristocratic. The prospects were attractive, for porcelain was considered precious and beautiful, on a par with silver rather than base clay. Although it was imported in vast quantities from Europe and the Orient, and shipped into London and Birmingham, the supply could not keep pace with the demand. Even so, the risks were considerable and many of the people involved went bankrupt. Some who came to own or to manage the English factories already had experience in other craft industries. Nicholas Sprimont, for instance, who was first the manager and later the owner of the Chelsea factory, was a silversmith.

Search for a Paste

Most English factories, when they first began around 1745, some thirty years behind their continental counterparts, geared their production towards good quality table-ware. The Chelsea and Derby factories were exceptional, in that they catered for an up-market clientele, and their wares were primarily decorative and not intended for daily use. For success in making serviceable table-ware, a reliable, durable paste was needed. A determined search began, from which three main types of soft paste emerged. A phosphatic paste containing bone ash was discovered and first used at Bow and later adopted by Lowestoft, by some Liverpool factories and, after 1758, by

Chelsea. A steatitic paste was first developed by Lund's Bristol factory and later taken over by Worcester. The soapstone from Cornwall which it contained enabled wares made from this material to withstand boiling water, a property much advertised by the makers.

Various glassy soft pastes developed and used by Chelsea, Derby and Longton Hall were too frail to stand up to constant wear, let alone to boiling water, and were really only suitable for making ornaments.

True hard-paste porcelain, as made by the Chinese, contained two essential ingredients, china stone (petuntse) and china clay (kaolin), which were not discovered in England until some time later. In fact, the first patent for the manufacture of true hard-paste porcelain was not granted until 1768, although the inventor, William Cookworthy, had probably identified the necessary materials a good twenty years earlier.

Most of the early English factories concentrated on traditional plain blue-and-white ware intended for daily use, in preference to the elaborate polychrome enamelled pieces, which required more than two firings and took longer and cost more to produce. As both glaze and paste could be fired at a relatively low temperature, the cobalt blue used by the English potters retained a striking brilliancy. Tea, coffee and chocolate services formed the bulk of the output. Flat ware tended to warp in the kiln.

The designs of wares provide a key to their date. At first, when tea was still a rare commodity, the teabowls were tiny and without handles. Larger cups with handles made their appearance later. As the paste improved, it became possible to make tea and coffee-pots of porcelain instead of silver.

Decoration and style, however, remain the best guides to dating. European hard-paste porcelain was a creation of the rococo period, and the material was well suited to express the playfulness of that style. Initially, all English porcelain was influenced by the swirling graceful curves and asymmetrical whimsicality of the rococo effects so ably developed by talented European designers, such as Kändler, Bustelli, and Boucher. English designs were largely derivative and English craftsmen took inspiration from a variety of sources, from Chinese and Japanese ceramics, from silver and earthenware shapes, and from engravings, as well as from the well-known masterpieces of

Meissen and Sèvres. English fashion, however, always lagged a few years behind European fashion. For instance, the transition from rococo to the severe linearity of the neo-classical style, which began in Europe about 1760, did not happen in England until the next decade.

Transfer Printing

Financial considerations obliged the English to seek speedier and more economical methods of decoration. The introduction of transfer printing on porcelain is an example of necessity proving the mother of invention. On 10 September 1751, John Brooks, an Irish engraver then living in Birmingham, applied for a patent for printing on enamels and china. The method consisted of engraving a design on a copper plate, inking it with colouring material that would withstand the heat of a kiln, putting the plate into a press to transfer the ink pattern onto a piece of thin, tissue-like paper, and finally pressing and smoothing down the inked side of the paper onto the surface of the object to be decorated. After carefully peeling off the paper, the inked design would remain on the object, which could then be refired to fix the decoration. A few years later, in 1756, John Sadler of Liverpool and his partner, Guy Green, applied for a patent for what seems an essentially similar process. They claimed to be able to print a design on 1200 earthenware tiles in six hours. The economic advantages of these techniques are obvious, and faster methods did not necessarily mean a deterioration in quality. Printing could replace the rather sloppy efforts of hundreds of badly paid painters who sat all day reproducing the same Chinese landscape as quickly as possible in a frantic attempt to earn enough to live on.

Left: Goat and bee jugs from the Chelsea factory. The bases of the jugs are formed from two goats reclining head to tail, but only the painted jug on the left has a bee among the entwined flowers. These famous jugs are among the earliest products of the factory and, like most of the pieces from this first period of Chelsea, are generally only to be found in museums. The extremely original high-relief modelling and the slightly speckled, thick, white glaze are characteristic of the incised triangle period. c. 1745. (Cecil Higgins Art Gallery, Bedford)

Chelsea

Chelsea was the only English factory to enjoy something near to royal patronage. One of its backers, Sir Edward Fawkener, was secretary to the Duke of Cumberland (a son of George II), and Nicholas Sprimont, the manager, was silversmith to Frederick, Prince of Wales. Many of his pieces are still in the royal collection. Contemporary sources make it clear that the small output of the Chelsea enterprise was aimed at people who could afford the highest quality. According to Mrs. Papendick, Assistant Keeper of the Wardrobe to Queen Charlotte, Chelsea pieces were 'only for the wealthy' and she could not afford them. Another source describes the ware as 'calculated rather for ornament than for use'. Very little plain blue-and-white came out of Chelsea.

The earliest documented Chelsea pieces are the famous goat and bee jugs, the base shaped in the form of two goats reclining head to tail and the decoration including a bee in high relief. One of these has 'Chelsea, 1745' incised underneath, and it may be assumed that the factory began that year or shortly before. From 1745 to 1749 pieces were marked with an incised triangle. During this period the forms were mostly derived from silver models. Several have been identified as direct copies of Sprimont's own silver designs, a shell-shaped salt holder with a moulded crayfish being one of them. In these four years much use was made of relief-moulded decoration, but polychrome enamels were hardly ever employed. Other pieces reproduced *blanc de chine* designs; they were left in the white and decorated in relief.

From 1749 to 1753 Chelsea pieces were marked with a raised anchor. The range was more ambitious, as enamel colours were by then in use and the glassy white body had become slightly less fragile. During this time and throughout the next period when the mark was a red anchor, many figurines were made, mostly after Meissen originals, but occasionally copied directly from engravings. Many of these were the work of Chelsea's own modeller, Joseph Willems. The range of subjects was wide, including characters from the Commedia dell' Arte, a series of monkeys playing instruments, shepherdesses, and allegorical figures such as the Seasons, the Four Continents and the Senses. At this time Chelsea also made a range of large *trompe l'oeil* tureens in the form of rabbits, hens, or lush bunches of asparagus or cauliflowers. As in the case of the figurines, most of the ideas came originally from Meissen.

Chelsea reached the peak of its production in the 1750s, when the annual auctions held to dispose of stock lasted for about a fortnight. From 1758 to 1769 the factory mark was a gold anchor, and the period was noteworthy for much heavy gilding and for more elaborate designs than previously, the white porcelain being left visible only in small reserve panels, and darker tones being used as ground colours. The painting in the reserves, which were framed by gilded scrolls, depicted exotic birds, mythological subjects, *chinoiserie* designs after Boucher or Watteau, or lush bouquets of flowers. All this reflected the increasing influence of the Sèvres style, but except for their mazarin blue, which was a good imitation, the Chelsea workers never managed to produce the rich ground colours for which Sèvres was so renowned.

A particular speciality of the Chelsea factory was their range of patch and snuff boxes, scent bottles and other little trinkets, commonly known as 'toys'. The idea for these may have come from another factory, established nearby in about 1751, and identified by the use of a slightly different paste. This enterprise, whose productions were formerly attributed to Chelsea, is known as the 'Girl-in-a-Swing' factory, after one of its best-known models. It was apparently short lived, and its stock seems to have been sold along with Chelsea's in the 1754 auction.

The characteristic Chelsea production changed when the factory was bought out in 1770 by William Duesbury, the proprietor of Derby. For a time the two factories were run in combination, and the output was known as Chelsea-Derby, but in 1784 the Chelsea works were finally closed down, and the remaining moulds removed to Derby.

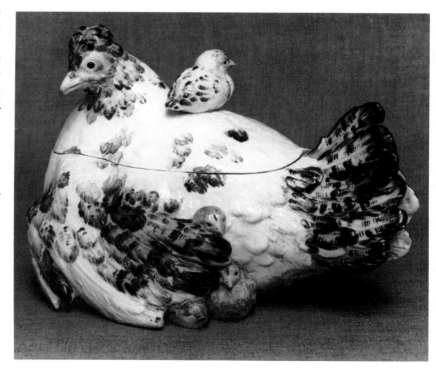

Left: The pen and ink drawing by Francis Barlow (1626–1702) evidently inspired the lovely red anchor Chelsea chicken and chick tureen shown below. The Chelsea range of trompe l'oeil tureens is wonderfully various. The glaze on this piece is smooth and even and the soft enamel colours blend perfectly; it is among the finest examples of Chelsea porcelain. c. 1753. (Cecil Higgins Art Gallery, Bedford)

Right: Bow inkwell inscribed 'Made at New Canton, 1751'. Painted in enamel colours, this is one of the earliest dated pieces of Bow. The reference to the centre of the Chinese export porcelain industry makes it clear that the main interest of Bow from the outset was the market in ordinary blue-and-white wares, hitherto in the control of the Chinese. (Victoria and Albert Museum, London)

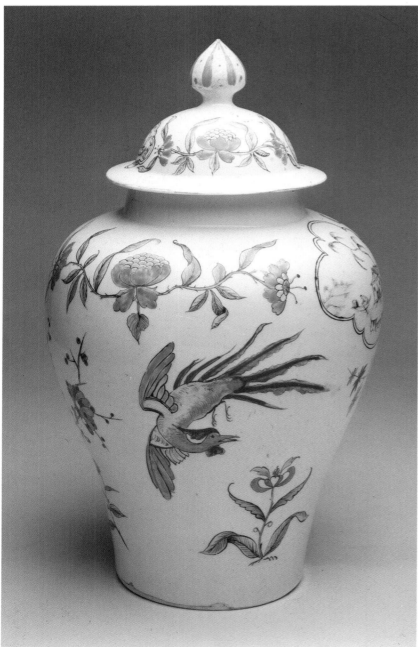

Bow

The other great pioneering factory, second only to Chelsea in historical importance, was started at Bow in London.

A patent for the manufacture of porcelain was issued in 1744 to Edward Heylin merchant, of the parish of Stratford-le-Bow, and Thomas Fry, who was a painter and engraver. Production seems not to have got under way, or at least not sufficiently to provide us with any surviving pieces, until 1749, when a second patent was taken out by Fry, which included the use of bone ash in the paste. A contemporary commentator comparing the ware made from this paste with that of Chelsea and Dresden, described it as not so fine but 'much stronger than either and therefore better for common use'. In fact, the policy at Bow was to produce in quantity and cheaply, to cater to the mass market. At its peak the factory employed 300 people and the output was probably the largest in England. Thanks to the strength of their bone paste, Bow was the only factory at the time to have success in firing large dinner plates on a commercial scale. Because of warping and breakages of flat pieces during firing, other factories had to concentrate on tea-ware and sauce-boats, but Bow succeeded in making an octagonal plate, adorned with *famille rose* decoration, which was sixteen inches across.

According to Thomas Croft, an enameller at Bow, the factory building was modelled on one in Canton in China, and so came to be known as New Canton. Bow specialized in Oriental-style decoration, and some pieces were actually inscribed 'New Canton' including an inkwell bearing the date 1751.

The bulk of the Bow production was in blue-and-white. The early colour was a clear, royal blue, suited to the 'powder blue' technique. This was a form of decoration, derived from the Chinese, in which the colour was sprayed all over the surface save for small white reserves. In later years a darker, inkier version

was introduced which was less attractive. The favourite designs were stock Chinese figures and landscapes painted in a bold, slightly naive manner, betraying signs of haste. The early Bow figurines were less sophisticated than those made by Chelsea. The heads and hands tended to be disproportionately large, but they did have a certain charm, which was later lost, when more sophisticated effects (but with a generally low standard of modelling) were attempted.

As well as the usual gods and goddesses, and characters from the Commedia dell' Arte, Bow produced commemorative pieces, like those often made in Staffordshire pottery, depicting well-known events or people. Two of the earliest and best-known examples were models of Kitty Clive and Henry Woodward in Garrick's farce, *Lethe*. Later, models of the Marquis of Granby and General Wolfe were made after their military successes in Canada. These figures link Bow with the mainstream of British ceramic tradition, in contrast to Chelsea, which based its output entirely on the imitation of foreign ware.

Bow also produced more prestigious enamelled ware. The painting included the usual sprays of flowers of European type, but much striking work was done in the Japanese Kakiemon manner. The Bow rendering of the quail pattern is especially renowned.

Because the colours had to be mixed by the artists,

each factory developed its own palette, and this helps to identify pieces (provided, of course, they were not farmed out for decoration elsewhere). Bow frequently used a characteristic and lovely iron red, as well as a pale mauve. In the period following Frye's retirement from the management in 1759, and especially after 1762, when the factory was flooded, the artistic and technical standards at Bow declined. The factory was bought out in 1775 by Duesbury, who closed it down the following year and moved the moulds to Derby, as he was to do later with those of Chelsea.

Lowestoft

Another early factory was the small-scale enterprise at Lowestoft in Suffolk, started by a local businessman in 1757 and utilizing a paste similar to that of Bow. The production, which continued until 1802, consisted in the main of blue-and-white wares decorated with local scenes, or with dedications to local dignitaries or embellished with the words 'a trifle from Lowestoft'. On one enamelled jug, the scene is a cricket match. Very few figures were made. Transfer printing was employed in later years, but limited to underglaze blue. The products were generally lacking in sophistication, and although some were exported to Holland, most were sold locally. The Lowestoft factory imported Chinese porcelain in

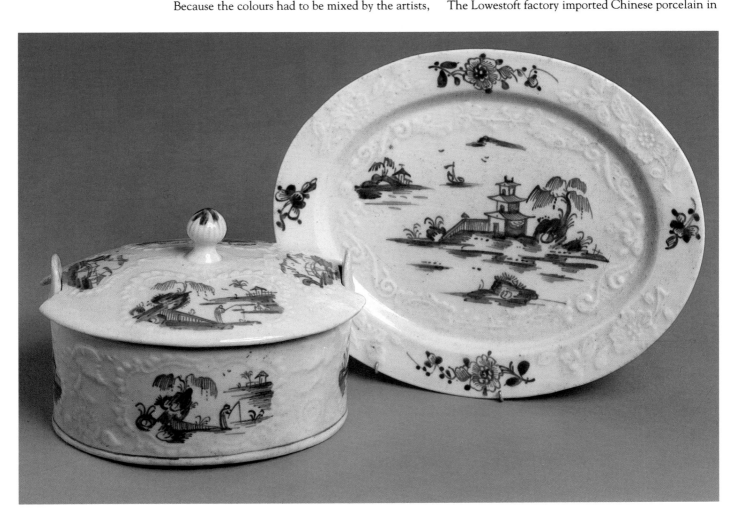

the white, and decorated it with crude imitations of Chinese themes. Such pieces have sometimes been confused with Chinese export porcelain.

Newcastle-under-Lyme

One other factory, which made porcelain as early as Chelsea and Bow, was fairly recently rediscovered. It operated at Newcastle-under-Lyme, near Stoke-on-Trent, Staffordshire, in the area traditionally known as the Potteries. The earliest known dated piece found on the site was a small blue-and-white bowl inscribed 25 July 1746. The factory operated from about 1744 to 1755. It had two proprietors, first William Steers, who had connections with Bow, and

then, from 1747, Joseph Wilson. The porcelain was primitive, and being semi-opaque it bore a certain resemblance to that made by William Reid at Liverpool. The decoration was all blue-and-white, a pattern of peonies derived from the Chinese being quite common.

Longton Hall

Somewhat later, in 1749, another factory was started in Staffordshire at Longton Hall, with William Littler, a former salt-glaze potter, as manager. He was associated with the production of a brilliant blue ground which appears both on porcelain and on salt-glazed stoneware. The factory's earliest works were rather primitive figures, based on Meissen originals, which were so thickly covered with glaze that the details of the modelling were obliterated. Longton Hall table-wares, among which sauce-boats were especially common, were typically moulded in leaf shapes or other natural forms, and decorated with a central vignette surrounded by light green or yellow. Although in time the brittle, glassy paste was slightly improved, the factory never succeeded in producing useful blue-and-white wares in any quantity. The factory suffered a financial collapse and much of the stock and many moulds were sold off in 1760 at a sale in Salisbury, where it is thought they may have been bought by Cookworthy for use at his Plymouth factory. Others were taken to West Pans in Scotland by Littler, who used them for making pieces bearing the coats of arms of Scottish gentry. It is likely that some pieces attributed to Longton Hall were produced by Littler after his departure to Scotland.

Worcester

Early attempts to create a robust, hard-paste body may have been made at Limehouse in London, at a factory owned by Benjamin Lund, who later moved

Above left: Lowestoft jug painted in enamel colours with a local scene. This jug, like other Lowestoft pieces, was probably specially commissioned as a souvenir. c. 1778. (Victoria and Albert Museum, London)

Right: Engraving by Robert Hancock showing the Worcester Porcelain Manufactory in the late 1750s. It is clear from this engraving that extensive alterations had been made since 1752, when the first known picture of these buildings was published.

Below right: A fine Worcester teapot of ovoid shape with transfer print by Hancock showing the Worcester Factory. c. 1760.

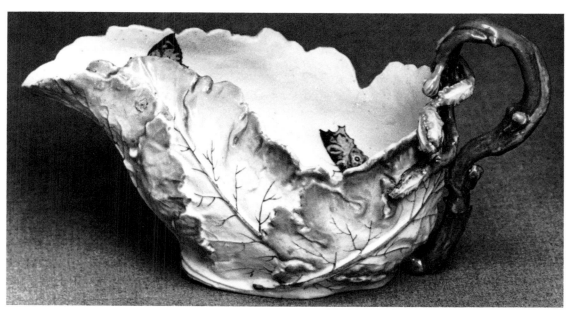

Below left: Longton Hall sauce-boat, with butterflies nesting in cabbage leaves, an example of one of the factory's most successful products. The Longton Hall paste was not very durable and firing cracks are common, especially in flat wares. This is probably the reason these sauce-boats are more numerous than the similar leaf dishes. c. 1755. (Cecil Higgins Art Gallery, Bedford)

to Bristol. His paste included soapstone mined in Cornwall. At Limehouse, however, it is possible that production never got beyond a fine stoneware. Lund's Bristol factory, which started in 1748, was taken over by Dr. Wall of Worcester in 1752. Since early Worcester and Lund's Bristol ware are so similar it is simplest to deal with them as one.

The mainstay of Worcester, as of most of the early English factories, was blue-and-white ware. The profits from this may have financed the incursion into the field of more costly enamel-painted pieces. The paste, which has a greenish tinge when viewed by transmitted light, allowed for fine potting and crisply moulded details. Worcester made few figures, concentrating almost exclusively on table-ware, decorated with the customary Oriental and European motifs. The concern grew to be large and profitable, and is, in fact, the only eighteenth-century English factory still functioning today. Although transfer printing was first practised at Bow, Worcester was the first factory to exploit it on a large scale. The prints were invariably taken from engravings, many of them being published in contemporary magazines, such as *The Ladies' Amusement*, to which Robert Hancock contributed frequently. The best known exponent of

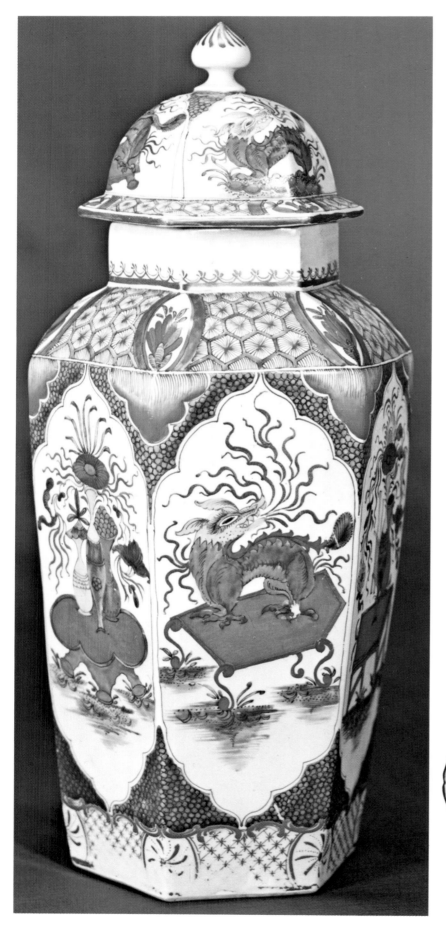

the art, he came, like the technique itself, from the enamelling trade. His engravings were used by both Bow and Worcester.

From the 1760s onward Worcester, like Chelsea, came under the influence of Sèvres and neo-classicism. A dark blue or crimson ground, in a fish-scale pattern, with reserve panels filled with exotic birds and bordered in scrolled gilt, appeared on all kinds of objects, from humble teapots to enormous vases. Worcester porcelain of this period is heavily influenced by the Chelsea gold anchor wares, probably because after the Chelsea factory was taken over in 1769, many of its decorators moved to Worcester. One who made the move, J. O'Neale, specialized in intricate miniatures of wild animals, and another, J. Donaldson, formerly a painter of miniatures, specialized in landscapes with figures in the manner of Boucher. Much of the work of these decorators appears on large vases.

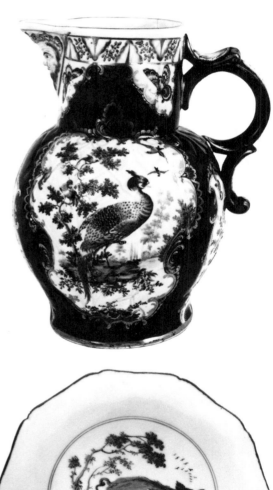

Liverpool and Caughley

Worcester influenced and inspired many enterprises elsewhere. A number of factories were started at Liverpool, mostly by men connected with the Delftware (tin-glazed earthenware) potteries that flourished there. The shapes and decoration of Liverpool porcelain betray this link. Chaffers & Christian, one of the best of the Liverpool factories, at first used a bone-ash paste, but changed to soapstone in 1765 when a former Worcester employee sold them the secret recipe. Liverpool, being a major seaport with access to inland waterways, was a good centre for marketing and distributing ceramics, and many short-lived commercial enterprises sprang up and produced large quantities of somewhat inferior wares. They are difficult to identify individually, but the firm of Penningtons is blamed for making much rather poor quality Liverpool ware.

The factory at Caughley in Shropshire, founded in 1772, is one frequently, and with much justification, regarded as no more than an offshoot of Worcester. Its soapstone paste and the style of its ware were similar, and its proprietor, Thomas Turner, was a former Worcester employee. After 1796, however, this factory branched out into making hard-paste ware in the New Hall style.

Derby

Derby (1750–1848) was the only other factory besides Chelsea to concentrate on figures, but it never achieved quite the same artistic sophistication. Even so, William Duesbury, one of the founding partners, who took over completely in 1756, was so proud of its achievements that he advertised the factory as 'Derby or second Dresden'. Unfortunately

Far left: Large Worcester vase and cover of the late 1750s to 1760s. The overglaze painting on this example shows the influence of Japanese porcelain of the Imari rather than the Kakiemon type, though the interpretation is fairly free. Pieces with this style of decoration are quite common but they are not among the best products of the Worcester factory.

Above left: Worcester blue-scale 'cabbage leaf' jug. This is an example of a very successful Worcester invention, first produced in the 1750s without the mask spout, and with a simpler handle; it continued to be made for many years at Worcester and then at Caughley. The painting on this particular jug was probably done in James Gile's workshop in Camden Town, London, as the bird has that slightly dishevelled look which is the characteristic trait of work done there by a certain unknown painter. c. 1765.

Below left: A rare Chelsea 'fable' saucer, painted by J.E. O'Neale with Aesop's fable of 'The Boar and the Leopard', c. 1750. O'Neale is especially famed for his painting of jungle animals, though his best-known work was done at Worcester where he moved when the Chelsea factory was taken overy by Derby.

Right: Derby group of 'Seeing' from 'the Five Senses'. This early Derby chinoiserie group was probably modelled by Planché. The deep understanding of the nature of porcelain as a material which it displays is unfortunately not often a feature of Derby. c. 1750–1754.

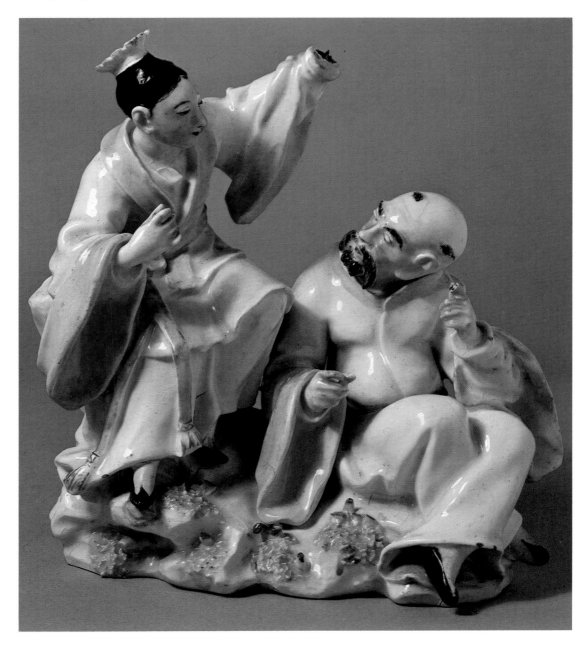

A pair of Derby botanical plates with yellow rims. One is painted with Purple rudbeckia and the other with Althai frutex. This type of decoration, first used at Chelsea, was continued at Derby after 1770 when Duesbury turned his attention from figures to table-ware. c. 1795–1800.

his figures did not really compare in subtlety and charm with those of his European mentors. All the Derby colours look somewhat dirty, and even the favourite overglaze, peacock blue, has a harsh and garish hue. Derby was the only English factory to attempt to duplicate the Sèvres biscuit figures. As one might expect from this rather pretentious firm, Derby figures were usually larger than those made elsewhere.

Blue-and-white was never a major concern at the Derby factory, although a fair amount was produced in the 1770s and early 1780s, as can be seen from the catalogues of contemporary sales at Christies. The secret of soapstone porcelain was bought from Richard Holdship, formerly a partner at Worcester, when he transferred to Derby in 1764. He also introduced transfer printing, but most of the prints appear to be inferior, re-engraved versions of Worcester designs. They resemble similar works on pieces found at Bow, where Holdship may have worked during the interval between leaving Worcester in 1759 and arriving at Derby five years later. The production of blue-and-white seems to have ceased entirely upon Duesbury's death in 1786.

Chelsea-Derby

After taking over the Chelsea factory in 1770, Duesbury turned his attention to table-ware, and this was continued by his son, who carried on the business after his death. The palette of Chelsea-Derby wares was limited in range. The main designs were swags, stripes, motifs from antiquity, including the famous Greek key pattern, and also little grisaille paintings of classical themes. Several pieces were direct copies of antique relics. One of the most famous, a facsimile of the Sphinx vase in Syon

House, outside London, is comparable to the Wedgwood copy of the Portland vase. Flower painting also flourished at this time, encouraged by a new method conceived by William Billingsley. After applying the colour he would wipe out the highlights. This gave the blooms a lovely full look, especially evident in the roses, for which he was famous. But the story of Billingsley belongs to another chapter in the history of British porcelain.

Hard-Paste Porcelain

The only factory in England to produce true hard-paste porcelain was founded at Plymouth in 1768, by William Cookworthy, a Devonshire chemist. It was beset with technical difficulties from the start, due to the fact that the very high firing temperature needed for the paste tended to affect the blue glaze, turning it almost grey. Apparently, there was also a dearth of skilled potters in the area so that in 1770 it was decided to move the factory to Bristol, where Richard Champion, one of Cookworthy's original thirteen shareholders, took charge. A great deal of attention was paid to the delicate painting of this ware in order to compensate for the dull grey glaze. A set of Four Continents was made from the Longton Hall moulds which Cookworthy had bought in 1760. These moulds were extremely successful and their size (they were nearly a foot tall) proves that the Bristol factory had by then achieved a high technical standard. Bristol also used figures by Stefan, one of the Derby modellers. The table-wares produced at Bristol range from cottage china to elaborate Sèvres-influenced pieces. Also made at Bristol was a series of biscuit plaques with applied flowers and busts. These plaques show good workmanship, but are too complicated to be considered really fine designs.

Right: A pair of Bristol figures, the girl playing a triangle and the boy a hurdy gurdy. Figures of children playing instruments or with animals are among the most attractive of the Bristol factory's models. These two have not started to collapse in the kiln, a failing of Bristol which leads to the figures leaning in directions not intended by their creator. The familiar tree-stump which attends these children was an attempt to overcome this problem. c. 1775. (Victoria and Albert Museum, London)

1812, after which bone china was made there. The New Hall range was mostly confined to tea-wares of simple silver-inspired shapes, decorated in standard patterns, each one identified by a number marked on the bottom of the piece and recorded in a book kept at the factory. After 1796, when Champion's renegotiated patent finally expired, many other Staffordshire firms began to make hard paste, often in the New Hall style. Only a few of these manufacturers have been identified, as the wares are rarely marked, except with pattern numbers. However it is now known that Chamberlain of Worcester, the Coalport factory and Thomas Minton, as well as at least three other manufacturers joined in the making of hard paste, but by about 1815 they all had either closed or had changed to bone china production.

On the whole, English eighteenth-century porcelain was not a success. Most of it was no more than a rather prosaic, second-hand rendering of the more artistic European styles, and only a few of the factories survived into the nineteenth century. Porcelain-making in England was not regarded as an art, as it was on the Continent, but rather as a craft. Greater store was set by good workmanship and durability than by creative quality of the sort one would expect to find in works of art. The emphasis in English porcelain was on the practical rather than the aesthetic content, and in that regard it stands up well. The English invention of bone china near the end of the century solved the major technical problem that had beset the industry—that of dealing with an unstable and therefore costly paste. The adaptation of the process of transfer printing for use on ceramics can now be seen as England's one other truly important contribution to ceramic history in the eighteenth century.

Below: A New Hall group. The coffee-pot shows one of the standard patterns used by New Hall. c. 1810. (Victoria and Albert Museum, London)

Champion managed to retain his right to be the sole manufacturer of hard-paste porcelain up to 1796, but by the time he renewed his patent in 1775 the Staffordshire potters, led by Wedgwood, had already gained permission to experiment with the china clay and china stone, and the value of his monopoly was lost. By 1781, financial difficulties forced Champion to sell his secret to a group of six Staffordshire potters and the Bristol factory was closed. Production was restarted at New Hall near Shelton, Staffordshire, and a modified hard paste was made there until

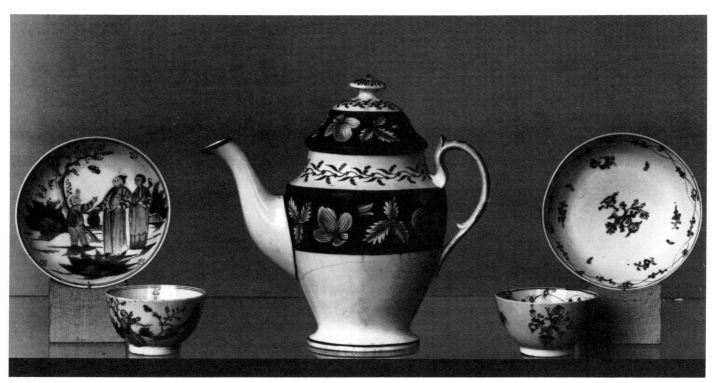

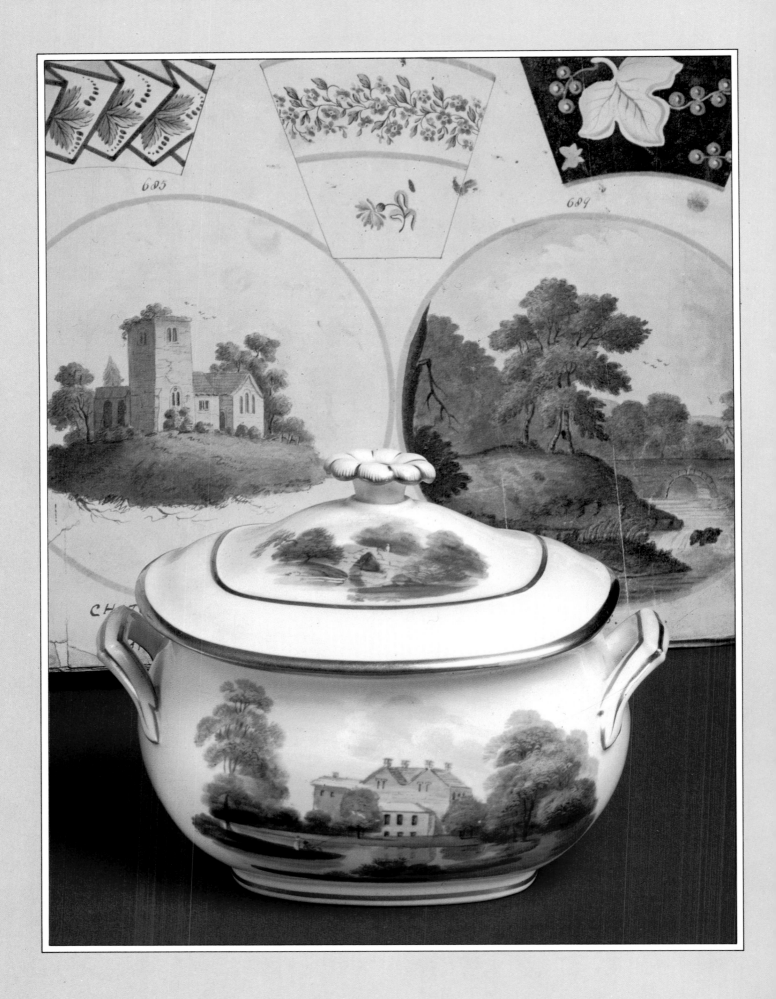

Chapter Eight
The Development of Bone China

BY the time of the death of Josiah Wedgwood in 1795, there were some 150 individual factories in the Staffordshire area alone. The vast majority were making earthenwares, but a few were experimenting with porcelain, both hard paste and bone china. Some of these concerns were still on a very small scale, but a few, including Wedgwood, employed several hundred people. The influence of Josiah Wedgwood himself on the very considerable expansion which had occurred in the preceding half century was outstanding. He had forerunners and he built upon the foundations others had laid. Nevertheless, his organization of the factory, his management and accountancy techniques, his flair for sales promotion and his sure grasp of the technical and scientific aspects of the industry, all contributed, not only to the success of his own firm, but to the rapid growth of the Staffordshire industry as a whole. Thus, when Josiah I died, the industry was already well established and its future expansion assured from a growing home market provided by an increasing population and a steady improvement in the standard of living. Exports too had been rising substantially, though there were serious set-backs occasioned by the Revolutionary and Napoleonic Wars, and the War of 1812 with the United States. But these set-backs were only temporary and in the nineteenth century English wares were to be exported to every continent in vast quantities. In the earlier years covered by this chapter, it was chiefly earthenware products which were exported, but as time passed, the cost of production of bone china steadily dropped, and standards of living improved in the British colonies and elsewhere. Thus the market for bone china was a constantly expanding one, and by 1840 the proportion of porcelain both produced and exported had increased in comparison with the finer grades of earthenware which it tended to supplant.

Throughout the eighteenth century European potters had spent much time and money in seeking to produce a porcelain which, besides being a beautiful material in its own right, would also match up to Josiah Wedgwood's description of his 'Queensware' (cream-coloured earthenware) as 'bearing sudden alterations of heat and cold, manufactured with ease and expedition, and consequently cheap'. Many felt that their porcelain was outstanding, even 'equal to that of the Chinese': hard paste found favour in Germany and elsewhere; the *pâte tendre* (soft-paste porcelain) of Sèvres was a supremely beautiful material and seemed to many the pinnacle of perfection. Yet still the search continued. English potters, like their European counterparts, struggled with formulae and firing cycles to produce a commercial product with the attributes of ease of manufacture, durability and cheapness. Thus the great variety of English porcelain formulae and bodies: soapstone at Worcester and Liverpool, glassy pastes at Chelsea and Longton Hall, hard paste at Plymouth, Bristol and New Hall. And yet for all their interest, and the splendour of the decoration, English porcelains of the eighteenth century were imperfect from the potter's point of view. We, as collectors, admire the unevenness, the individuality of the products of each different factory, but their creators were far from satisfied, let alone enraptured by their products. They were fully aware of the superiority of Chinese and Japanese porcelain, which was imported into Britain in considerable quantities in the eighteenth century; they were also aware of the vast sums of money many of the continental houses had at their disposal—money which literally bought success, and meant that Meissen could rival Ming, and Sèvres achieve a delicacy that equalled even that of Qian-long. The English eighteenth-century porcelain factories had no such wealthy patrons to support them; yet as England was the home of a flourishing industrial expansion, a rapidly increasing population and a growing national wealth, the opportunity for lucrative sales was clearly evident.

The response of the English potters to this challenge is the central theme of this chapter. Against a

*A very rare Neale &
Company coffee-pot and
cover, the foliate moulding
on the spout picked out in
puce, and a formal festoon
border pattern on the rim.
This very sparsely decorated
piece is typical of the 'elegant
simplicity' of neo-classical
decoration. Height
25.11 cm; c. 1778–1786.*

backcloth of rapid industrialization, and a quickly developing pottery industry, they were able, with much experimentation and as many disasters as triumphs, to perfect a porcelain product of a kind which had eluded their Continental counterparts.

This, then, is the story of that purely English invention – or development – bone china. It occupies the years 1790–1840, really quite arbitrary dates, and it is a story which cannot be told in isolation, for throughout this period the influence of Continental styles and forms of decoration on English wares is immensely strong. English bone china, at least in its first half century was remarkably European in its expression. Unlike creamware – the other great English contribution to world ceramics – it did not develop a particularly characteristic 'Englishness'.

If one looks at the scene in 1795 in more detail, one can discern several significant trends. As has been indicated, by far the most important in the long run was the birth of the bone china industry in Staffordshire. The use of calcined bone had been known to English porcelain-makers for many years; two of the great eighteenth-century factories, Bow and Lowestoft used bone ash in their body. But the significant step was taken when potters added up to 50 per cent of bone ash to the classic hard-paste formula of china clay and china stone. This mixture produced bone china. It is usually stated that Josiah Spode II, was the 'inventor' of bone china; or that he 'perfected' it about 1795. Recent research has indicated that the firm of James Neale & Co. of Hanley were making bone china in the mid-1780s. Not many examples from this factory have so far been identified, but from those which have, it is clear that the potting was neat and crisp. The decoration generally tended to be of the narrow neo-classical border pattern, and the wares appear to have carried no pattern numbers and to have been marked with the firm's name only infrequently. More research is needed on the Neale & Co. and Neale & Wilson firms, but it is unlikely that the factory ever produced its bone china in any considerable quantity. The first factory to market bone china in a large way was Spode. The product which Josiah Spode II brought to such a high standard in the mid-1790s is basically the same ware that is produced today. The development of bone china by Spode was as significant for the future of England's porcelain industry as had been the development of cream-coloured earthenware by Josiah Wedgwood a generation previously. In effect, a new product and a new industry was created.

Hard Paste

It is worth stressing, however, that the potters did not adopt the bone-china formula overnight. There was a most interesting transitional period from approximately 1790 to 1815 when a number of factories produced a hybrid hard paste. Various theories have been advanced as to why this happened when it did, but the two most likely explanations are to be found in the apparent success of New Hall hard paste, and the consequent desire of porcelain-makers

to emulate that success by making a similar body at about the time of the expiry of the New Hall patent in the 1790s. An additional spur to the production of hard paste was the cessation of shipments of Chinese porcelain to England by the East India Company in 1791. Prior to this date, a very considerable quantity was imported annually, and the abrupt termination of this supply of true porcelain must have tempted English potters to satisfy the unfulfilled demand. The hybrid hard-paste porcelains have really only been recognized in the last decade. Hitherto, it was always the accepted rule that only three English factories made hard paste, Plymouth, Bristol and New Hall. Now there is a quite lengthy list of factories known to have manufactured the rather grey-bodied wares with their tight-fitting glazes and somewhat cold and hard appearance.

Among the factories which produced the hard paste are some well-known names. In the late 1780s and certainly by 1791, Robert Chamberlain, having severed his connection with the main Worcester factory, began the manufacture of porcelain on his own account and his early production seems to have been in the hard-paste body. Analyzed samples show a chemical composition remarkably similar to that of Bristol and New Hall. The wares made by Chamberlain seem to have been unmarked until about 1794, but thereafter marked examples are known and a regular system of pattern numbering was adopted. By the end of the century Chamberlain's Worcester wares in hard paste ran the full gamut from tea-wares, dinner and dessert sets, to a remarkably elaborate pickle-stand of shell form topped by a fine figure of Apollo which is recorded in a 1795 stock book, and of which examples are known. The most common of these Chamberlain wares are cups, bowls and saucers with a spiral-fluted moulding ('shanked' it is called in the records) often quite sparsely decorated with a deep underglaze blue and on-glaze gilding.

Thomas Grainger, who had worked for Robert Chamberlain, left in about 1801 and set up independently as a porcelain decorator in St. Martins Street, Worcester. Some time about 1805 he began manufacture on his own account, and his early wares, which bear a strong similarity to those of Chamberlain, were in the first few years of a hard-paste porcelain. They are rarely marked.

Also in the Severn Valley area was Thomas Turner, who produced wares in the hard-paste body just before he sold the Caughley factory to John Rose in 1799. Examples of these are exceedingly rare. John Rose himself certainly continued with its manufacture, both on the Caughley site itself and in considerable quantities at his better-known factory at Coalport. John Rose was the dominant personality at this latter factory, which was visited in 1796 by the Prince and Princess of Orange. A large work force of 250 people is recorded in 1803 at the combined Caughley/Coalport factories. Excavation on the sites of both factories and chemical analysis indicates that hard-paste porcelain was made in large quantities. This would appear to have continued until about 1814 at Coalport. The situation, especially with regard to the correct attribution of wares, is compli-

Above: Coalport hybrid hard-paste teapot and cover, decorated in gold with floral and formal motifs, c. 1800–1805. This is one of a number of similar Coalport 'new oval' shaped teapots, and is a shape made by many factories at this time.

Below: The Wolfe-Mason partnership used a heavy, compact-looking porcelain which has become known as 'hybrid hard paste'. It is here exemplified by a saucer, teabowl and coffee-cup bearing the standard Liverpool version of the Pagoda print with a gilt border. c. 1796.

cated by the fact that immediately opposite John Rose's factory at Coalport, with only a canal separating them, a rival factory flourished. This was the firm which in 1803 became Anstice, Horton and Thomas Rose, and which produced hard-paste tea and dessert services very similar to those of John Rose. When John Rose purchased this factory in 1814, he appears to have discontinued using the Caughley site and to have united his two Coalport factories in the production of bone china.

Another factory outside the Potteries which produced hard paste was the Liverpool concern of Thomas Wolfe, Miles Mason and John Lucock, potting at the Islington China Manufactory on Folly Lane, c. 1795–1800. They produced mainly blue-and-white-printed tea-wares. In 1800 Miles Mason left Liverpool and set up his own factory at Lane Delph in Staffordshire. Here he produced some very finely potted and neatly decorated wares in the Regency taste, initially in the hard-paste body. Then for a period c. 1805 hard paste and bone china seem to have been manufactured simultaneously, but shortly the newer material triumphed and all the later wares produced until Mason's retirement in

1812 were in bone china. Miles Mason porcelain is highly esteemed. His production included tea-wares in over 800 different patterns, and was supplemented by dessert wares, and some ornamental items. As a former 'chinaman' he was fully familiar with the hard-paste porcelains of China and Japan, and it is no surprise that his earliest wares at Lane Delph were of the hard-paste body. Mason's porcelain exemplifies some of the best features of the wares of the Regency, with relatively simple uncluttered lines and shapes, often decorated with richly colourful painted patterns and lavish gilding.

Within the Staffordshire Potteries, in close relationship to the New Hall factory, were several other makers of hard paste. The wares of the Turner factory are now beginning to be identified. They are of an extremely high quality and include tea-wares printed underglaze in blue, and beautifully finished painted and gilded specimens which stand comparison with the wares of any factory. The Turner porcelains, with a couple of exceptions, appear to date from about 1800 to 1806. As yet, they are few and far between and no pattern number sequence is known. Only a handful of shapes are recorded from the very limited number of known marked pieces. No bone china wares are recorded from the Turner factory which closed in 1806 and which is far better known for its fine stonewares and earthenwares than for porcelain, but as with so many of these late eighteenth-century Staffordshire concerns, one feels that much remains to be discovered. After all, John Turner I was one of the original New Hall partners in 1781. Did he, like Josiah Wedgwood I, decide that the manufacture of porcelain was too risky an enterprise, and thus when he severed his short connection with New Hall, apart from a few odd trials, keep out of the business? It would seem so.

Still within the heart of Staffordshire, the Davenport factory, which began its life in 1794 as a maker of earthenware, turned to porcelain-making around

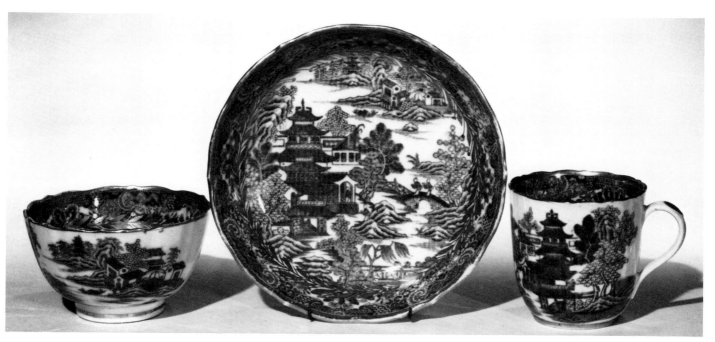

the turn of the century. Here, too, recent research has indicated that some if not all of the early wares were made in hard paste, before bone china became the only body, some time between 1806 and 1810. So far, dessert-dishes, bulb-pots, some tea-wares and a few vases have been identified in hard paste. John Davenport is recorded as having visited France in the 1780s on Thomas Wolfe's behalf, and while there, he studied the French methods of making porcelain. Whether this was a factor in his own subsequent activities we cannot be sure, but the success of Davenport's porcelain, whether hard paste or bone china was fully attested when the factory was visited in 1806 by the Prince of Wales and the Duke of Clarence. As the *Staffordshire Sentinel* records, 'Of the fine Specimens of Porcelain, produced at this Manufactory His Royal Highness observed, *that he considered them in texture and execution equal* to the old Seve ...' John Davenport's objective and that of most of the leading manufacturers was to make a porcelain as good as that of Sèvres. The great French house was the yardstick of perfection. He would have been gratified by the Royal encomium to the success of his ambition.

Three further groups of porcelain deserve mention. Firstly, there is a rare class of wares, some of which bear the curious mark 'W(***)'. This group of hard-paste specimens includes both tea-wares and ornamental items such as bulb-pots. Traditionally, they are ascribed to Enoch Wood, but there is no certainty to this, and indeed there are some who have suggested other Staffordshire potters with appropriate names and manufacturing activities such as J. & P. Whitehead, Thomas Wolfe and P. & F. Warburton as the maker. A Continental origin has even been tentatively advanced. Lastly, it must be recorded that David Holgate, in his fine study of the New Hall factory, separated out two groups of wares by 'the Imitators', which he labelled 'Factory X' and 'Factory Y'. So far, no positive conclusion can be reached which would give us a name for these hard-paste porcelains, which are decorated in the New Hall style and seem to date from about 1800 to 1810.

William Billingsley

While the firms noted above were experimenting with or producing wares in hard-paste porcelain, the early years of the nineteenth century saw not only the triumph of the bone china body, but the last and glorious fling of English soft-paste porcelain of the eighteenth-century type. This was exemplified in two ways. Firstly, the Worcester factory, which was under the control of the two families of Flight and Barr from 1783 to 1840, continued to make porcelain in a version of the famous soapstone body used by the Worcester factory in the great days of Dr. Wall. This was not finally abandoned until about 1830, when difficulties in obtaining the soapstone seemed to have forced the concern, then trading as Flight, Barr & Barr, to change to bone china. The second enterprise was more in the nature of an odyssey than a business venture, and is associated with the name of one of

the most remarkable figures in ceramic history, William Billingsley.

William Billingsley was born in Derby in 1758 and was apprenticed as a porcelain painter at the Derby porcelain works in 1774 for a period of five years, for a payment of five shillings a week. The young Billingsley soon proved to be an outstanding porcelain-painter, and was already well established when, in 1783, Zachariah Boreman joined the Derby staff from Chelsea. The two quickly struck up a friendship, and began to carry out experiments concerned with the manufacture of porcelain at home. The trials in that small kiln in the basement of 22 Bridge Gate, Derby, were the beginning of a journey for Billingsley which was to take him across half of England and Wales, and practically to the production of porcelain perfection in, of all unlikely places, Nantgarw, South Wales.

By the time he left Derby in 1796, William Billingsley was acknowledged to be the outstanding

Water-colour drawing, attributed to William Billingsley, mounted in a small sketch-book dated 1776. Other designs in the book are by Edward Withers and Thomas Pardoe, whose name appears inside the front cover. (Victoria and Albert Museum, London)

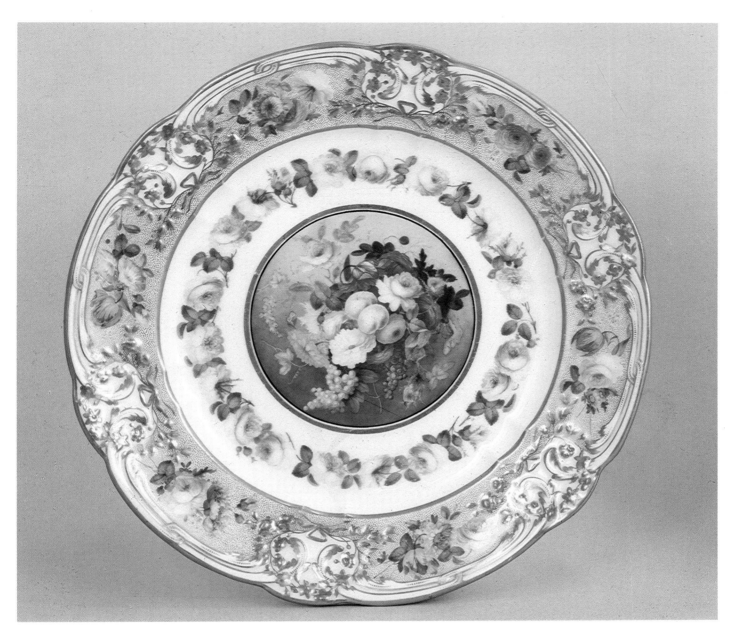

Nantgarw porcelain plate, superbly decorated with floral and fruit painting and gilding. This decoration would probably have been done in London, not at the factory. The mark NANT GARW C.W. (China Works) is impressed. 24.7 cm; c. 1817–1822.

flower painter at the factory, and indeed his rose painting has assumed almost legendary status. The result has been that vast quantities of fullblown roses with the highlights 'wiped out' (the Billingsley characteristic), have been wrongly attributed to him. This is regrettable, for it has led some commentators into a denigration of his talents and abilities which is totally unwarranted. He was a remarkable porcelain decorator. However, his departure from Derby was occasioned by something even more important to him than porcelain painting: he was offered the opportunity to set up a porcelain factory at the tiny village of Pinxton in Derbyshire, to be financed by Mr. John Coke of Brookhill Hall, near Mansfield, Nottinghamshire. To quote the words of his biographer, W. D. John:

> for the remaining thirty years of his life, Billingsley, always devoid of financial resources, during a period of industrial instability in the whole country on account of the Napoleonic wars, forsaking his home and wife, frequently on the verge of starvation, and travelling long distances on foot with his two daughters, obstinately and determinedly pursued his *idée fixe* to make the most remarkably translucent, and strikingly white soft paste porcelain ever achieved.

This ambition he did not achieve at Pinxton for he remained there only until April 1799, but the ware produced was a lovely soft-paste porcelain. The output was mainly of tea-wares, often characterized by unusual angular handles on the major pieces, as well as some bulb-pots and ornamental wares. Occasionally, these bear a factory pattern number or the letter 'p' in script, but more often than not they are unmarked, and correct attribution depends upon recognition of shape, paste and glaze. Many of the shapes, other than the angular ones, are unremark-

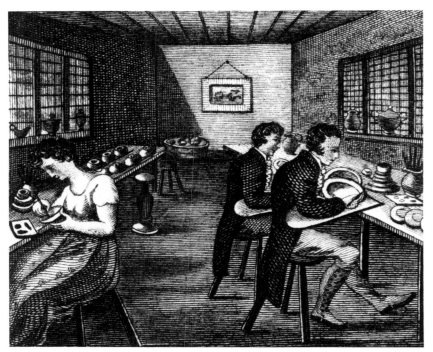

This engraving shows artists and gilders decorating wares. These were the élite of the factory workers. This picture is one of a series of views depicting the manufacture of wares at Enoch Wood's factory, around 1827.

desperate was the situation which led him to leave Torksey in 1807 may never be known, but despite his wife's refusal to join him, he, his two daughters and his partner Samuel Walker, began a journey which took him to Swansea where he failed to obtain work, and to Worcester where Martin Barr engaged Billingsley and Walker. Here for three years they led a tranquil existence. Billingsley continued actively to experiment with the porcelain body, and was financially well rewarded by Barr.

Billingsley, however, was not content to remain as a decorator at Worcester, where incidentally, his decorative work has not been recognized as yet. Thus, in November 1813, he and Walker quit Worcester and moved to Nantgarw, where, under the pseudonym of William Beeley, he was to produce a porcelain body of a translucency and texture equal to, if not better than, the finest French Sèvres. He was again fortunate in securing a financial backer for the business, William Weston Young. The output was small, about 300 undecorated plates per week, but its quality was much esteemed by the London decorating shops. In 1814, apparently as a result of its success, the whole enterprise was transferred to Swansea where the larger factory of L. W. Dillwyn was to be responsible for manufacture. Two new china kilns were erected, and production began on a modification of the Nantgarw body, the famous Swansea 'duck-egg' porcelain. As with all Billingsley's wares, kiln losses were very high, and though the London decorators eagerly bought the pots, Dillwyn was anxious for a more economical production which led to the so-called 'trident' body, far less translucent and in consequence less saleable. Personal relationships at Swansea were never harmonious and in 1817, the tenancy of the Cambrian Pottery and China Works passed to John and Timothy Bevington. Thus Billingsley, whose products had been decorated by such outstanding ceramic artists as Thomas Baxter, David Evans, William Pollard and Henry Morris, once more found himself without a pottery or a patron and retraced his steps back to Nantgarw. As both his daughters had died in that year, his state was one of abject misery. However, his final period at Nantgarw was somewhat more successful. Further financial help was forthcoming and dessert-wares, ornamental items and tea services were manufactured, and mostly still sold in the white and decorated in the London studios. There was to be no final financial flourish for Billingsley. By 1820 the supporters' money was exhausted and the porcelain works closed. Billingsley and Walker departed to seek work at Coalport.

able, but the potting is often thick, and the glaze (at least for a portion of the factory's life) has a thick, heavy appearance and, on occasion, may be seen to have flowed down the sides of vessels, especially the inside, and its surface is in consequence rippled in places, and has a kind of irridescent sheen upon it. But Billingsley was an experimenter, and there is no uniformity about the Pinxton paste and glaze. In decorative terms, the factory ranged from simple Angelôume sprigs, to elaborate gilt borders, flower-paintings of considerable delicacy and, most charming of all, lovely English landscapes in monochrome and polychrome. Both during the Billingsley period and thereafter, there is an affinity in style and decoration to contemporary Derby products.

It must be noted that the factory did not close when Billingsley left in 1799. It seems to have continued up to about 1806 making wares but thereafter, until the final closure in 1813, probably only acted as a decorating establishment under the general guidance of John Cutts, who was to move to Wedgwood at that date.

On leaving Pinxton, Billingsley established a decorating studio at a house on Belvidere Street, Mansfield. Here, painting and gilding blanks bought from Pinxton, Staffordshire, and Coalport, as well as Continental porcelain, Billingsley did some of his finest work. Baskets of flowers, landscapes, figure subjects all are signed 'Billingsley Mansfield'. But they are rare and highly prized pieces, not encountered in one's local antique shop. His stay at Mansfield was relatively short, for in the latter months of 1802 he moved to the small Lincolnshire village of Brampton-in-Torksey and here he stayed until late 1807, once more, it seems, active in the pursuit of the perfect porcelain. Few wares are known from Torksey, but recent excavation has unearthed wasters which may, in due course, be matched to pieces hitherto mainly attributed to Pinxton. How

The Billingsley saga is instructive, for it not only reveals the high cost of manufacturing the 'old fashioned' soft-paste porcelain, but it demonstrates the almost feverish pursuit of perfection which porcelain-makers had engaged in throughout the eighteenth century. There is no denying the translucent beauty of the Swansea and Nantgarw bodies, but production was uneconomic. The romance is with Billingsley and his odyssey, but the financial reward, the crock of gold, was for Josiah Spode II and those who followed him in the production of bone

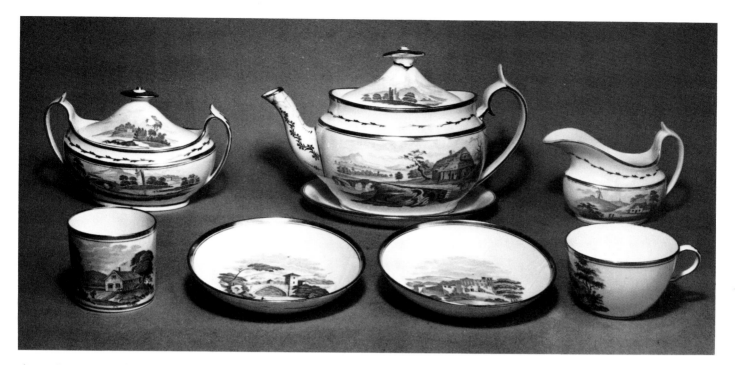

china. It too was white, clean and translucent. It lacked perhaps that indefinable quality of excellence which Nantgarw porcelain possessed, but it was cheap and easy to make, it didn't warp or distort in the kiln, and it sold well. Bone china looked to the future, the Welsh porcelains of Billingsley were the last *cadenza* of the amateur eighteenth-century perfectionist and dreamer. The future lay in the large industrial factory, not in a converted farmhouse. There can be no clearer demonstration of the influence of industrialization than that provided by the failure of Billingsley with his uniquely beautiful product which, in contradistinction to Spode, he never quite 'perfected', and never succeeded in manufacturing or marketing in a business-like way.

Spode

At this point, it would be appropriate to look at the Spode factory and the other early pioneers in the production of bone china. When Josiah Spode I died in 1797, he handed over to his son, also Josiah, a thriving concern. Spode II had served for some years in the London warehouse, but on his return to the factory which stood, as it still does, by the canal in the centre of Stoke, the firm was poised to enter its most significant period. From about 1800 until the factory passed into the ownership of Copeland and Garrett in 1833, it was the foremost producer of English bone china. Leonard Whiter, in his out standing monograph on the factory, points out that Spode 'perfected' bone china and marketed it supremely well. The firm also led the field in design and decoration. No other pottery could match Spode during this period for trimness of potting, consistency and neatness of finish and quality of decoration. In this latter respect Spode was particularly well served for much of its ware in the years *c.* 1805–1822 was

not strictly 'in house' decoration, but was painted and gilded in the decorating studios of Henry Daniel, which occupied a part of the Spode site.

The very early Spode enamelled bone china is comparatively rare, but bat-printed wares are quite common and among the most characteristic products of the factory. The firm produced a considerable range of these on-glaze prints which included flowers, country scenes, animals—from hounds coursing a hare to very plump and homely farmyard pigs—and even narrative subjects such as the beggar at the gate. Most of the bat printing was done in the period between 1800 and 1820 and it is most usually found on tea-wares, especially those with the two common but graceful and useful cup forms the 'bute' shape and the 'London' shape. The latter, with its distinctive angular handle, was introduced in about 1813 and it seems to have been copied by at least a dozen other makers.

Above: Spode bone-china teawares in the 'new oval' shape. They are bat printed with gilt lines and typical rural scenes used on wares marked with the pattern number 557. c. 1805. Compare this teapot shape with the 'old oval' shape below. (Spode Museum, Stoke-on-Trent)

Below: Spode bone-china teapot and cover in the 'old oval' shape. The decoration on this piece is hand-painted, in contrast to the printing on the wares above.

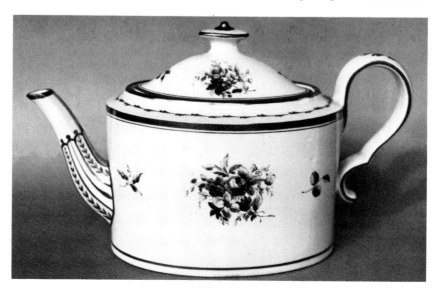

In addition to tea-wares, Spode made a vast variety of useful and ornamental pieces in bone china, from miniature ewers and basins and toy tea-sets to richly decorated, sometimes flower-encrusted vases of considerable size. The factory pattern books which still exist show that Spode introduced new patterns at the average rate of about 150 a year. Thus by 1833 their patterns were in the 4000 plus range. This information is useful as it gives the approximate date–starting at 1800–at which a given pattern was first introduced. Thus a piece bearing pattern number 2000 would not date from *before* 1812. Most Spode wares carry a pattern number which is some aid to attribution, though additionally much of their output was marked with printed, painted or impressed variants of the name SPODE.

Minton

If Spode was both the pioneer and the foremost factory in bone china production, its closest neighbour physically was probably also its strongest competitor commercially and artistically. The Minton factory was situated–and it still is–just across the road from Spode. Here bone china production began just before the turn of the century, and here, too, the old factory pattern books with their delightful water-colour drawings of cup and saucer patterns still exist. Minton's porcelain prior to 1816–when production temporarily ceased until 1824–is not plentiful. It is, however, very stylish, well produced and capably decorated. Minton's range in the pre-1816 period was not as wide as that of Spode, and surviving wares have a heavy bias towards tea-wares, though some dessert ware and a few ornamental items such as spill vases have been recognized. The factory was reasonably consistent in marking wares with pattern numbers–up to pattern number 948–in this first early period, but the use of a painted factory mark of crossed 'L's over the letter 'M' with the pattern number below is much less regular. Thus a good deal of Minton's early tea-ware has gone unrecognized, though many of the shapes have been published in modern ceramic books. Though never quite matching Spode in range, the quality of early Minton wares is excellent and the pieces have a solidity and substance which is very satisfying, as is the range of decorative treatment.

When Minton began bone china manufacture again in 1824, the style had subtly changed and the wares reflected it. These wares are best considered when seen in the context of the period of revived rococo.

Davenport

Contemporary with both Spode and Minton was the pottery of John Davenport. Situated at Longport on the banks of the canal, the production of bone china began there in about 1805. Prior to this date, John Davenport, who acquired the factory in 1794, seems to have experimented with hard-paste porcelain from about 1800, as has already been described. His bone china in its early days now seems to be technically inferior to his hard paste. The former was obviously originally white and probably more translucent, but over the years it has developed a network of fine cracks and it has also a tendency to discolour, and take on a creamy to brown hue. In time, say by about 1812, these faults were rectified, probably by decreasing the amount of ball clay in the mixture, and obtaining a better match of paste and glaze. The early Davenport bone china is often unmarked, but a reasonable corpus of ware is known, dessert wares mainly, and some tea and ornamental items which carry the word 'Longport' with or without an anchor, usually painted, in red script. From about 1815 the marks were altered and all versions include the word 'Davenport'. The factory's production of bone china developed steadily after 1815, and indeed, the proportion of china to earthenware may have shifted in the former's favour in the 1820s. Certainly by 1830 porcelain production was of such a standard that together with Rockingham of Swinton and Barr

Minton cup and saucer simply decorated with floral sprays and gilding, shown with the factory pattern book. The water-colour drawing shows it to be pattern 76. Pattern books such as this are invaluable for attributing unmarked wares to their correct factory of origin. c. 1800–1805. (The Minton Museum, Royal Doulton Tableware Limited, Stoke-on-Trent)

The Davenport factory appears to have specialized in bulb-pots, especially in the hard-paste material, and this is a finely decorated example. They are, however, rare. Impressed marks. Height 16.5 cm; c. 1800–1805.

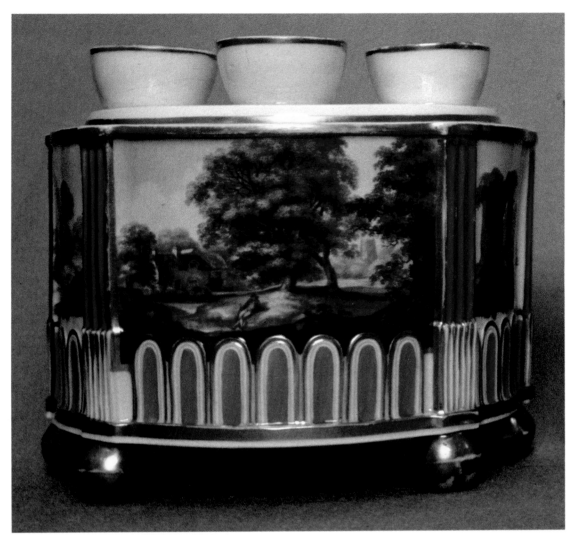

of Worcester, they were commissioned by William IV to make a dessert service for the royal use. More of this later. Alas, no Davenport pattern books have survived.

Wedgwood

The last of the major factories worthy of note is Wedgwood. The death of the great Josiah I coincided almost exactly with the production of bone china by several of his competitors. It has always surprised ceramic historians that Wedgwood himself did not enter the field of porcelain production. He certainly had the knowledge and the technology. He was even approached by Richard Champion in 1780 with a view to his purchasing Champion's hard-paste patent. Wedgwood turned the offer aside and instead it was taken up by the New Hall partners. Examples of trial pieces which show translucency exist in the Wedgwood Museum, the products of Josiah's experiments towards the perfection of jasper ware. But he always steered clear of porcelain, probably because he had witnessed too many of his contemporaries losing money on the vain pursuit of porcelain perfection. After Josiah's death, the Wedgwood factory went

into somewhat of a decline, but eventually, as a result of the pressure of market forces, the factory seemed to have been almost forced into experimenting with bone china, and in 1812 they began to market it. Once again we are fortunate that the factory pattern books exist, enabling us to see the range of decorative designs employed by the firm. The recorded designs fall into a fairly narrow pattern range from pattern 470 to pattern 876 with just one example higher than this, and several Japan patterns from a different series. The wares are exclusively tea-wares and the two most common shapes are the 'bute' cup with a slightly flattened ring handle, and a variant of the 'London' shape with an angular upward-sloping handle. The designs are typical of the period, and include *chinoiseries*, floral designs and gilt and geometric patterns, as well as the typical romantic landscapes of the time. Some of the latter, both in monochrome and coloured enamel, can be assigned to the decorator John Cutts who had formerly worked at Pinxton. The marking was not universal, but where it is encountered, it is the factory name simply printed in red, black or gold, or more rarely in blue on printed articles. Occasionally, the pattern number is included. The period of production was very short-lived, for by 1819 orders were few and

This tea-pot and cover in soft-paste porcelain is attributed to the Pinxton factory. The view is named in script on the base of the pot, and the writing appears to be that of William Billingsley. The shape, especially the angular handle, is very similar to contemporary Paris porcelain shapes. c. 1800. (The Usher Museum and Art Gallery, Lincoln)

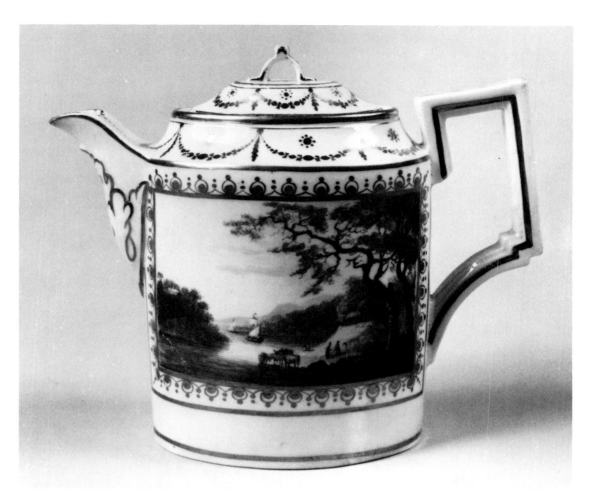

though some ware continued to be made in the 1820s (or perhaps only decorated from existing stock) effectively this once-mighty firm appeared to be unable to compete with the new giants Spode, Minton and Davenport for more than a ten-year period (1812–1822).

Regency style

It should be remembered that all the firms that have been noted so far producing either hard paste or bone china, including Billingsley, were potting in the period which is stylistically termed 'Regency'. This is one of the most difficult of art historical labels to define, as its manifestations appear somewhat differently in the various applied arts. In porcelain terms, one thinks of a period from the late 1790s to the middle or late 1820s, and of a style in which the severity of strict neo-classicism is softened yet which, in terms of shape of vessels, is still restrained, being based upon the straight line.

The English Regency style is subtly different from the Continental Empire style. Yet the two are clearly related. The English industry was eventually, in terms of volume production and even of stylistic influence, to outstrip the porcelain houses of continental Europe; but in the period between 1790 and 1820 England was still looking to Europe for both technical and stylistic inspiration. John Davenport

went to France, and other English makers are known to have copied, sometimes slavishly, the forms and decoration of the great Paris houses in particular. As noted earlier, the criterion of a good porcelain body was its comparability to that of Sèvres. So there are vases attributed to the Herculaneum factory at Toxteth, Liverpool which, were it not for the printed mark, would unhesitatingly be called Paris, and similar instances could be quoted in respect of wares from Minton, Derby, Davenport and Swansea. In fact, in many cases English factories refrained from marking their wares, especially the more elaborate ornamental items, so that they could be sold by the London china retailers as Continental wares. The illustrations and supporting captions indicate the extent of the debt owed by English Regency potters to their Continental Empire style counterparts. Though it should be added that certain Paris houses, notably that of Jacob Petit made tea-wares 'in the English style'. The traffic was not all one way.

The Continental influence was marked both in shape – the angular handle forms noted at Pinxton and elsewhere derive from La Courtille and other Paris houses – and in decoration. The French, and to a lesser extent German and Russian, custom of using a plate or a vase as a ceramic canvas for an imposing painting was much in evidence in England. The Worcester Flight factory was a noted exponent of this type of decoration, the Staffordshire potteries less so. Derby, under the aegis of Robert Bloor, was much

given to scenic painting, often in the English water-colour landscape tradition, but equally frequently, as in some of the work of George Robertson, in large, all-over scenic views. The other most prominent French influence was the lavish use of gilding. Indeed, Regency and Empire are words which evoke an image of interiors in which fine porcelain, heavily gilded, glints in the candle-light which is also caught and reflected from the myriad facets of fashionable contemporary cut glass.

Other stylistic features of Regency are typically English landscape scenes depicting 'ideal' views, rustic byeways, thatched cottages with the hills in the distance, the river running by. Botanically accurate representations of flowers and other natural forms such as shells were also popular. These might be hand painted, or often bat printed. All the English and Welsh porcelain factories of the period followed the style which, as time went on, became heavier, and more ornate, eventually giving way to the overdecoration which characterized many of the more expensive porcelains of the 1830s and 1840s.

Varieties of Porcelain

It must be remembered that though porcelain was always a luxury product, even within the porcelain market there was a considerable degree of class catering. Within all the larger concerns there was a varied range of product to suit different levels of the market. The *tours de force* of painting and gilding from, for example, the Flight & Barr Worcester factory, or Spode, Minton and Davenport are not entirely representative of their output. They and other factories made their money on the bread and butter lines of simply decorated services for the lower range of the middle-class market. Beneath this level, firms such as Hilditch & Son (later Hilditch & Hopwood) provided even cheaper china printed with

underglaze patterns, only rarely embellished with gilding. But it was symptomatic of the major changes produced by the development of bone china, that by 1830 translucent porcelain wares were being made for such a variety of levels of taste and demand and by such a considerable number of manufacturers. Indeed, even by 1820 there were so many factories producing bone china that it is not possible to write about them in the way one can about the limited number of concerns in the eighteenth century. In the Staffordshire Trade Directory of 1822 no fewer than forty-two are listed as china manufacturers. Aside from Davenport and Spode, there are several other concerns whose products have only comparatively recently been identified or collected to any extent, and about whose wares something has been published. Foremost among these were the works of John and William Ridgway, who produced high quality and occasionally distinctive porcelains. The porcelain of Riley is very rare and virtually unidentified, that of Enoch Wood is the subject of debate, and even New Hall bone china is less well known than it should be. No systematic study of its post-1812 bone china products has ever been published, though the firm continued to make tea-wares in the prevailing middle-market taste until about 1834. Wares by Charles Bourne, again, mainly tea-wares, and some delightful animal figures are beginning to be recognized, much aided by the fact that the factory mark consists of a pattern number in a range up to about 500 placed over the initials 'C. B.'. Hilditch & Sons wares too are now quite well known and plentiful, though less is published on the bone china of C. J. Mason and Mayer and Newbould. These are the known makers from the 1820 Directory. We are still left with thirty-two manufacturers of china, about whose wares nothing is known! Some are the names of noted makers of earthenware–Richard and John Clews, John Heath, Hicks, Meigh & Johnson, Job Meigh, Chetham and Robinson–but no porcelain of

This group is of rare pieces of Staffordshire bone china. The plate and jug are from the short-lived Peover factory, c. 1820, and the tureen and stand are from John Breeze & Company, c. 1830.

theirs has ever been identified. And what of Thomas Cope, William Nutt, Amos Shaw and Lockett & Hulme, all listed as china manufacturers? Little wonder that the collector of porcelain, particularly the relatively inexpensive but pleasant tea-wares of the 1810–30 period, has feelings of despair at the daunting task of attributing the host of unmarked wares of the period. It is worth adding to the list above the names of Machin & Co. of Nile Street, Burslem, and Peover of High Street, Hanley as makers of porcelain in the 1820 period, since a certain number of their wares have been authentically attributed. Additionally, as has been noted, Minton recommended the production of bone china in 1824.

Outside North Staffordshire, there were the factories associated with Billingsley, and the Worcester concerns of Chamberlain and Flight & Barr, and in Shropshire, the Coalport factory. In Derbyshire, the Derby factory was still active (its period of decline was principally in the 1830s) and at Liverpool the Herculaneum factory was also making porcelain,

though its wares are not conclusively identified save for a few reliably attributed characteristic shapes. The Rockingham factory in Swinton, Yorkshire began porcelain production in 1825, but its story really belongs to the age of the rococo revival. Clearly the remarkable growth of the bone china industry in Staffordshire meant that these 'out Potteries' were barely holding their own as bone china became the standard body throughout the industry.

It is perhaps worth emphasizing at this point that the English experience was not mirrored on the Continent. None of the French, German, Italian, Austrian or Russian porcelain factories changed the body of their ware to bone china. In many ways this is very singular. The new material completely ousted both soft paste and hard paste in England. It could be argued that what had been good enough for the Chinese for nearly a thousand years and Meissen for a century would–and indeed did–withstand English competition. But unlike creamware, which did find a place in the repertoire of Continental potters, bone

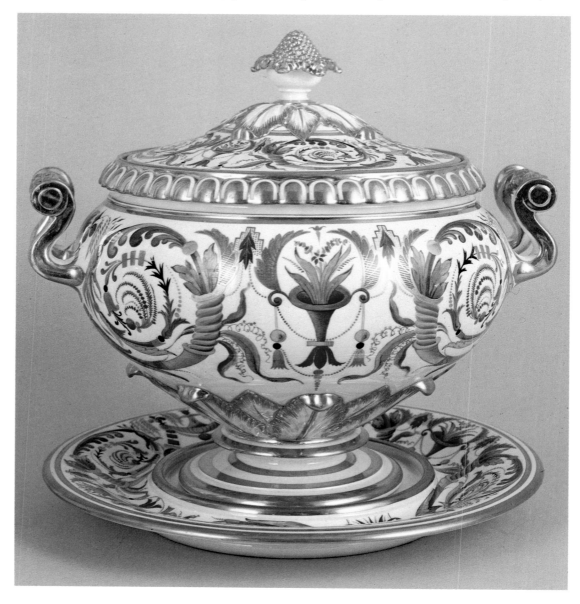

This finely decorated Flight, Barr & Barr (Worcester) sauce tureen and stand is part of a 184-piece dinner and dessert service. The mark is impressed. The high quality of finish is typical of wares from this factory at this time, and very clearly epitomizes the 'Regency' style. c. 1813.

china seems to have made no serious impression in Europe. This despite its (to English potters) known advantages of stability in the kiln, good handling qualities, a wide range of mixtures of ingredients and a lower-temperature firing cycle than the hard-paste porcelains which retained favour throughout the Continent.

Revived Rococo

It has already been mentioned that the prevalent style in ceramics changed somewhat abruptly about 1830. The new style, if it can be called that, was a revival of rococo, and was particularly suited to porcelain, which saw its most forceful expression, though it was also evident in earthenware shapes and decoration. Whereas the Regency had looked to France for its inspiration, the revived rococo looked to Germany, in particular to Meissen and Dresden. The style was a re-enactment of that of the mid-eighteenth century. It represented the frivolous, the exotic, the sumptuous, in contrast to the somewhat academic precision and elegance of the neo-classical and Regency eras. In porcelain terms this change is very easy to recognize. Plates were no longer uniformly circular, they were moulded so that the rims displayed a series of 'C' and 'S' scrolls, often in an asymmetrical arrangement. Ornament too is asymmetrical, three panels of flowers, five pierced holes, seven landscape vignettes and so on. An outstanding feature of the style is the use of applied modelled flowers, not only to the body of vases and other ornamental objects, but even to the rims of plates and sides of teapots and cream jugs. Whole bouquets of brightly coloured flowers, were to be found adorning the wares of the leading porcelain manufacturers. Shells too were a popular feature, often painted, but occasionally, as on ornamental dishes made by the Chamberlain Worcester factory, modelled in the round and applied to the pieces in the same way as the flowers. The Davenport and Rockingham factories even modelled tea-wares in shell form: the Davenport factory produced shell-shaped teapots with a shell finial and handle and spout in the form of coral; the Rockingham factory made cups and saucers in shell form which closely echo those made by Pougat of Paris at roughly the same time.

What the revived rococo seems to lack, however, is some of the grace and wit of its eighteenth-century counterpart. Nevertheless, just as the original rococo catered for the taste of a wealthy aristocracy, so its revived form answered the needs of the rising middle class of manufacturers and *nouveaux riches*. The wares looked grand and colourful, but above all expensive, symbols of conspicuous consumption. The porcelain-makers of Staffordshire, Yorkshire and Shropshire were only too ready to oblige, for in bone china they had a body stable enough in the kiln to bring the extravagances of the style well within their capabilities. It was a perfect match: technology triumphed over taste, and the customers were satisfied.

The making of the more expensive porcelain wares in the post-1830 period once more separated the

Rockingham bone-china figure of John Liston playing the character of 'Lubin Log'. This is one of a series of theatrical images made at this factory. c. 1826–1830. (Yorkshire Philosophical Society Museum, York)

manufacturers into two groups, those who were prepared to cater for the upper- and middle-class taste and those whose sights were set on the lower-middle-class and artisan market, whose ambitions could be satisfied with a well painted bone-china tea-set or some of the smaller and plainer ornaments. It is worth repeating, however, that even the larger factories still made goods for the lower end of the market, though naturally then—as now—they were anxious to advertise and be known for their more prestigious products. In the forefront of the new style was the Rockingham factory in Yorkshire, the Coalport or Coalbrookedale concern in Shropshire, the Worcester factories of Chamberlain, and Flight, Barr & Barr, and, of the Staffordshire firms, all of which produced wares in the fashion, Minton, Copeland and Garrett, Davenport, Daniel and Ridgeway. By 1830 the Derby factory was well into decline, and though it did produce some ornamental wares and figures, its great days were over and it slowly wound down to closure in 1848. There was, however, a renaissance for Derby later in the century.

The Rockingham factory may be seen as typical in its interpretation of the revived rococo. There was a long history of earthenware manufacture at Swinton

before the proprietor Thomas Brameld began to experiment with porcelain in the early 1820s. Commercial production of a standard bone china began in 1825 and the early wares, marked with a printed red griffin, the crest of the factory's patron Earl Fitzwilliam, are in the late Regency taste. From the first, the Brameld brothers were ambitious. Tea services in over 400 patterns (numbers in the range *c.* 400–850) and dessert services in fewer, ornamental wares including large *campana* vases, spill vases and many decorative items are recorded from the early years as well as a most interesting selection of figures – some of contemporary theatrical personalities such as John Liston and Madam Vestris, others representing foreign peasants. Animal models were also popular products. Supported as they were by a noble patron, they made rapid strides and soon after William IV's accession to the throne in 1830 the firm, together with Flights of Worcester and Davenport of Longport in Staffordshire, received a commission to prepare dessert services for the King. The three services survive to this day. The Flight example is comparatively restrained, with *campana*-shaped vases, gadroon-edged plates, all having a blue ground, heavy gilding, the Royal Arms and painted panels of the jewels of various noble orders. The Davenport service has rococo-shaped dishes, with 'C' and 'S' scroll moulding and heavy gilding over a green ground, the centre of the pieces being painted with the national flowers of the United Kingdom. The Rockingham pieces are the most fully rococo. While the plates are relatively restrained, having raised honeycomb gilding over a pale blue border with the Royal Arms in the centre, the comports (dessert dishes on stem bases) are all fully modelled in forms indicative of their purpose. Thus the stem of one is modelled as a pineapple, another is hung with guava

fruit, a third with ears of wheat and so on. The total effect of this *tour de force* in porcelain is quite stunning. It has been most carefully cared for, and is still in use today for royal banquets. Other wares from the Rockingham factory and from Minton and Coalport echo and emphasize this naturalistic and typically rococo theme. Baskets have handles modelled as crossed twigs, cups are moulded as primrose leaves, and to a wide array of decorative wares coloured flowers are applied. Indeed all three of these factories made ornaments consisting entirely of plates or baskets full of modelled and highly coloured fruits and flowers.

The production of the Royal Service occupied the Rockingham factory until 1837, by which time the king was dead. Probably the commission itself overextended the resources of the factory, certainly the Brameld brothers lacked business acumen; for these and other reasons the pottery was forced to close in 1842, bankrupt. In the decade from 1830 to 1840 it produced many remarkable pots both utilitarian and decorative, perhaps none with more appeal than its teapots. The typical Rockingham teapot with its crown finial – a proud reminder of royal patronage – the cups and saucers with rococo scrolls and enamelled scenes or flowers captured the imagination. Another 700 tea-ware patterns were added in the decade 1830 to 1840, and, reflecting royal patronage, the firm's mark became 'Royal Rockingham Works, Brameld, Manufacturer to the King' printed in puce. A Rockingham tea service became a badge of social distinction, and in a sense symbolized the move away from the exclusiveness of the eighteenth-century porcelains to the more provincial and comfortable middle-class attitudes of early Victorian England. Bone china had made the conquest of such a market possible. It was a curious trick of fortune that

Below: Bone-china vase in the revived rococo style by Samuel Alcock & Company, c. 1840. The wares of this company were rarely marked, but clearly they competed with decorated porcelains from Minton, Rockingham and Worcester.

Thomas Brameld, whom Jewitt dubbed 'a man of exquisite taste', had so little head for business, when clearly he was producing in an expanding market. It was doubly unfortunate that the Rockingham factory, which alone among English porcelain producers had noble patronage very much in the fashion of Continental aristocratic patronage, should have been such a failure commercially. Aesthetically, Brameld was easily the most successful interpreter of the revived rococo. It was fitting that examples of its bone china pots were on display in 1851 at the Great Exhibition. Although they had been made ten years previously, the Brameld wares accurately reflected the foremost style of the period.

Conclusion

By the time Rockingham closed, the Minton factory, under the wise guidance of Herbert Minton, was rapidly establishing itself as the foremost pottery in England. Wedgwood had been in decline throughout the century and with the death of Josiah Spode III in 1829, the new partnership of Copeland and Garrett, formed in 1833, somehow lacked the thrust and dynamism of the old Spode concern. The Davenport factory too was less of a force than it had been. Its founder in 1794, John Davenport was an aged and retired man by the early 1840s, and his son William lacked his father's intimate knowledge of the pottery business, as well as his forceful, almost brutal, capitalistic drive. Derby, as has been noted, was virtually leaderless as Robert Bloor deteriorated mentally. The Worcester firms too were in some difficulties, and though other great enterprises were producing vast quantities of wares (for example, the Hill Pottery of Samuel Alcock) they lacked that indefinable element of class which keeps a factory in the forefront of innovation and experiment. Coalport, it is true, was immensely successful and its wares sold world-wide, but for thirty years or more from 1840 onwards, no factory could match Minton, and just as Josiah Wedgwood had provided both commercial and artistic leadership in the eighteenth century, so it was Minton, first under Herbert Minton, from his father Thomas Minton's death in 1836 until 1858, and then under his nephew Colin Minton Campbell until 1885, which was the foremost pottery in the industry. Wherever one turns, Minton leads the way. But the story of that successful leadership lies outside the scope of this chapter.

In the fifty years between 1790 and 1840, English porcelain production was transformed. The early experimental years of the 1790s and early 1800s had given way to a bone china industry of maturity and international importance. English potters might still seek stylistic guidance in Europe, but they lead Europe in the production of industrial porcelain. Bone china was a mass-produced product which reached, if not a mass market, a very much wider one than had ever been within the scope of the European factories. The English home market was catered for, and it could be said that by 1840 English bone china was ready to conquer Europe, America and countries even further afield. Bone china is a uniquely English product and though a limited number of American potteries such as the Tucker factory manufactured it in the nineteenth century, it was not adopted in Europe. This is still largely true today; English bone china is esteemed throughout the world for its delicacy, whiteness, translucency and clean beauty. It has stood the test of time; it has proved itself to be a winner as Josiah Spode, the man who perfected it, knew it would.

Left: Page from the Minton factory shape book, depicting two 'Munster eau de Cologne' vases. These Minton wares closely resemble similar Rockingham and Coalport pieces and are very rarely marked, so the factory records are of prime importance in attribution. (The Minton Museum, Royal Doulton Tableware Limited, Stoke-on-Trent)

Right: Bone-china tea and coffee service made by W.E. Tucker (or successor) of Philadelphia, c. 1830. Though the porcelain is English in derivation, the shapes of the major pieces are reminiscent of Paris porcelain. (Henry Francis du Pont Winterthur Museum, Winterthur, Delaware)

Chapter Nine
Porcelain of the Victorian Era

Left: This Minton candelabra is a fine example of Victorian exuberance. It was exhibited at the Paris International Exhibition of 1862. (Victoria and Albert Museum, London)

Right: Although this Minton vase appears to be the epitome of Victorian taste, it is in fact a replica of an eighteenth-century vase 'à têtes d'éléphant', modelled for the Sèvres factory. 1876. (Minton Museum, Royal Doulton Limited, Stoke-on-Trent)

IN Europe the period from 1790 to 1840 was one of dramatic change. Napoleon's rise to power altered completely both the map of Europe and also every aspect of its economic and social structure. As revolution and change spread across the face of Europe, so the traditional pattern of life crumbled. In France the monarchy and the ruling aristocracy were swept away in a tide of violence whose ripples reached every corner of Europe. In Germany, Austria, Italy and Spain the long process of unification began as the individual states and cities were brought gradually under French control. Even Russia was affected, although Napoleon's ambitions in this direction were ultimately the cause of his downfall. There was a contemporary revolution in Britain, but as it was industrial rather than social or political, Britain was able to concentrate on building an industrial base so strong that it was to dominate Europe throughout the nineteenth century.

The European revolution affected directly the making of porcelain. As ruling dynasties and courts were abolished or taken over, so the ownership of many of their porcelain factories passed to the new regimes. Private patronage was replaced by state patronage and so the potteries were either operated directly by Napoleon's new civil service, or indirectly by the puppets he installed in other countries. These changes inevitably affected style and design. The exuberant and highly ornamental rococo style was abandoned, to be replaced by the stark, simple yet elegant style that came to be known as neo-classicism, a style that Napoleon adopted for official use throughout his Empire. National boundaries and traditions were put aside, and a uniformity was imposed upon artistic production in Europe that had been inconceivable before. The neo-classical style itself was drawn from the art of ancient Greece and Rome, an art whose nature was now being explored and understood for the first time in other countries. Napoleon modelled his Empire on that of Rome, and at the same time he encouraged the first serious

study, by excavation, of Roman history. Discoveries in Italy, North Africa and elsewhere were quickly reflected in the various porcelain factories and so, by 1800, neo-classicism had come to dominate European production. All countries were influenced by this new style, including Britain, where Wedgwood played a major part in its development. However, it was on the mainland of Europe that the most extreme and the most significant forms were created. In France, Paris became the centre of production, and the styles established by manufacturers such as Jacob Petit were copied throughout Europe. Berlin and Vienna were soon competing with France for the stylistic lead and from there the taste spread to Russia, Scandinavia and Italy. Even some American potters chose to underline the totality of their break

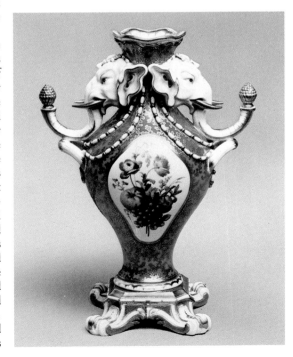

Above: Boxed breakfast set in Paris porcelain. The advanced neo-classical style is typical of the sophisticated taste of the period. This set was owned by Joseph Napoleon and taken from his carriage at the Battle of Vittoria in 1810. c. 1810. (Wellington Museum, London)

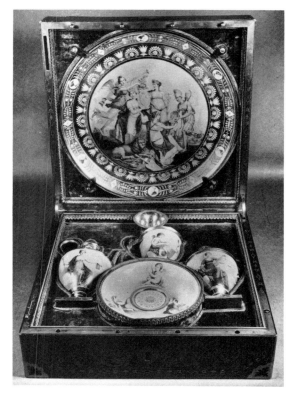

Below: Meisson covered jug from a royal presentation 'tête à tête' service which came complete with travelling case and inscribed 'S. M. la Reine de Saxe'. The complex neo-classical shape contrasts with the views of German towns traditionally painted on each piece. c. 1814.

with England by copying the more extreme examples of neo-classicism.

Closely allied to this was the development of the Egyptian style. By exploration and excavation Napoleon had masterminded the rediscovery of the hitherto forgotten Egyptian civilization. When the main features of this highly formalized and decorative style became known, they were rapidly adopted and developed by the porcelain factories. Thus, by a combination of historical awareness, technological advance and avant garde or revolutionary attitudes to design, the European porcelain-makers had achieved a position of considerable strength by the early years of the nineteenth century. This strength was reinforced by the high level of state patronage, which made financial investment relatively easy to obtain. This pattern continued until 1810 and then began to change, as a direct result of the decline and eventual defeat of Napoleon. Export markets diminished as British control of the seas was re-established and, as Europe returned towards its pre-Napoleonic structure, so the power of the European porcelain industry began to be eroded.

In the 1820s there was a return in many countries to a pre-revolutionary style of government while a new aristocracy, drawn largely from successful bankers and industrialists, reverted to traditional standards and attitudes. Taste became reactionary; the pure classical and Egyptian styles were now blended with other more exuberant and exotic forms to create lavish and extravagant wares suitable for the emerging bourgeoisie. At the same time, there was a widespread revival of interest in the eighteenth century, which encouraged porcelain-makers to turn back to the rococo styles of Sèvres and Meissen. Elaborate and costly forms, rich gilding and complex

and colourful painting became fashionable, and manufacturers began to concentrate on fine craftsmanship at the expense of artistic individuality. Porcelain was increasingly used as a material for the display of technical virtuosity and ostentatious decoration. Factories in Berlin, Vienna, Paris and elsewhere in France and Germany produced vast numbers of services painted with highly finished topographical views and still lives, and plaques decorated with meticulous, but artistically worthless copies of Old Master and other paintings. Such wares appealed to the new buying public. They also blended well with the interiors of the same period, matching in style the over-worked copies of French eighteenth-century furniture. By the 1830s, revived rococo was the dominant style in Europe, and English manufacturers had become the rulers of the market, helped by the well-established pattern of social, economic and industrial stability in that country, and by their large-scale development of bone china.

The Coronation of Queen Victoria in 1837 heralded a new age whose impact was ultimately to be felt throughout the world. Changes in patterns of education, social life and leisure, the spread of industrialization and travel, the dramatic increase in the population, especially in urban areas, and the emergence of a new economic structure had a direct effect upon all areas of industrial production. However, the effects were probably particularly noticeable among those industries who manufactured what are now known as consumer products.

The Industrial Revolution

During the first decades of the nineteenth century, the ceramic industry had come to terms with the large-scale industrialized production of the new bone-china material. Table-wares and ornaments were being produced in vast quantities by the 1830s. Those large manufacturers, established in the late eighteenth century, who had been able to weather the difficult economic conditions following the Napoleonic wars, were now in a strong position to expand their output and their range of products. Many had also begun to develop and exploit the export markets that were soon to become the backbone of the industry. These markets were primarily colonial, and included North America, Australasia, India, the West Indies, and parts of Africa. However, as the confidence of the English manufacturers increased, they were able to expand their influence in other, more demanding markets. By the 1830s English pottery and porcelain was being sold throughout Europe, in Russia, and even in the Middle East, in direct competition with well-established local manufacturers. This expanding market reflected equally the emergence of the new middle-class buyer, who had both the money and the inclination to invest in fashionable new ceramic products, and the increasing confidence of the manufacturer. New materials, new methods of production, and new ways of promoting and selling the wares allowed for a dramatic expansion throughout

the industry. Many new factories were established, while the older ones were improved and enlarged. Steam power became a common-place, both in the preparation of the clay and other materials, and as a source of energy in the factory. Transfer printing from copper plates was established as the standard method of decoration, particularly for cheaper wares, while experiments in colour printing by lithography or other techniques hinted at changes that were to occur later. At the same time, the rapid development of the railway network between 1830 and 1860 made the transporting of both raw materials and finished wares far quicker.

At first, these changes did not benefit directly those working in the ceramic industry. Wages remained low, and working conditions actually worsened during the period of rapid industrialization and expansion. Diseases related to lead, dust, and other equally harmful materials became more widespread than ever. In some areas of production, a worker's life expectancy was between thirty and forty, and until the 1860s children under twelve were commonly employed in the factories. In Britain, in the 1830s, conditions such as these resulted in the first national pottery-workers strike, which brought the industry to a halt for several months. However, throughout the latter part of the nineteenth century conditions gradually improved. First, the use of child labour was brought under control; second, wages increased, although the piece-work system made very long working periods inevitable; third, there was a gradual realization of the need to control the use of lead and other dangerous materials.

Despite the efforts of Josiah Wedgwood and others, the industrial revolution did not really affect the potteries until the first decades of Queen Victoria's reign. However, once underway the changes were immediately apparent; in all centres of production, the new materials and production methods gave extraordinary freedom to artists, designers, decorators and manufacturers. Consistent and balanced materials, new glazes and colours, and controlled firing finally brought to an end the random and erratic production methods of the eighteenth century. For the first time, the potter was able to predict exactly what would come out of the kiln, and how it would look. Furthermore, he could be fairly confident of achieving the same end product again and again and again. Against this background of stable and predictable production, the potters of the Victorian period were able to concentrate their efforts on stylistic development. Freed from the industrial uncertainties of the eighteenth century, the making of porcelain underwent a stylistic explosion, the range and diversity of which had certainly never been seen before, and probably will never be seen again.

The Great Exhibition

The artistic and technical confidence of the Victorian potter was first displayed at the Exhibition of the Industry of all Nations in Hyde Park, London in 1851. This display, familiarly known as the Great

Exhibition, was housed in Joseph Paxton's Crystal Palace, a suitably adventurous setting for a display of the latest and most splendid products of the industrialized nations of the world. In the eyes of many critics, writing both at the time and subsequently, the Great Exhibition was a monument to vulgarity and ostentation; to eyes not accustomed to a riot of colour and stylistic confusion, the displays suggested simply that, left to its own devices, industry would produce nothing of artistic merit. In fact, the Great Exhibition represented a massive celebration of the new freedoms that the manufacturing industry now enjoyed. It was certainly vulgar, colourful and lively; it was also immensely popular and so was followed by a series of similar exhibitions that, throughout the nineteenth century, continued to enliven and entertain the public in cities throughout the world. Inevitably, these exhibitions were used by manufacturers to show their latest technical or artistic developments, and so they became the focal point for the style battles that dominated Victorian design. In London, in 1851, medievalism and the rococo were in control of the nation's popular art. At later exhibitions new and equally powerful styles appeared; classicism, the Renaissance, Japanism and exoticism, all took their places in the Victorian designer's catalogue of sources. Sometimes these

Above: The Great Exhibition of 1851 in London was the first of many Victorian international displays of contemporary design and manufacture. Included in the catalogue was this elaborate flower-encrusted vase in neo-rococo style.

Left: Rockingham 'Rhinoceros Vase', a combination of the neo-rococo style and the contemporary fascination with the exotic. The panels were painted by Edwin Steele. 1830. (Victoria and Albert Museum, London)

styles were used in a very pure and unadulterated form, sometimes they were merged and blended together to form a riotous assemblage of ideas that horrified the purists, but stimulated and excited the buying public. This is why Victorian design appears at first sight to be chaotic and incomprehensible. Yet, out of this chaos there emerged many styles and techniques that were not only revolutionary in their time, but were also highly original. The period is often dismissed by critics for being self-consciously revivalist. However, though based broadly on the past, the styles that emerged during the Victorian period used the past in ways so stimulating and adventurous that they ultimately appeared to be largely novel.

Styles become International

Helped by the exhibitions, many of these styles were able to cross international frontiers at great speed. Style became truly international as designers and manufacturers throughout the civilized world re-

The most universal style to emerge during the nineteenth century was one based loosely on the porcelains produced in France and Germany of the previous century. These broadly classical forms, decorated in pastoral or rococo styles, were made in great numbers by porcelain manufacturers throughout the world.

sponded directly to the same sources and ideas. The rapid transmission of ideas was one of the unexpected advantages of industrialization. Thus, at the international exhibitions of the 1860s, manufacturers from many countries would show products that shared a common approach to style and decoration. At the same time, the new ideas emerging at the exhibition could be rapidly assimilated by the same manufacturers and designers. The exhibitions therefore came increasingly to represent a ferment of ideas, a creative turmoil into which ideas and styles were thrown regardless. The mixture that resulted, frequently impalatable, but more often stimulating and original, formed the basis to Victorian design philosophy. Ideas were also able to move with greater freedom than before because of increasing social mobility. Railways, steamships, the telegraph, newspapers and photography all helped to transmit ideas around the world. Travel, for both professional and social reasons, became a familiar, easy and widely accepted activity; by using modern communications, a manufacturer in America could adapt his products to reflect the new styles emerging from the latest European exhibition without actually visiting the display at all. As a result, consumers in Pittsburgh or New Orleans could enjoy the latest styles and designs within a few months or even weeks of those in Paris or London.

Today it is hard to understand the impact of the revolution in communications during the early Victorian period, and hard to realize that this revolution was far more significant than the changes in manufacturing processes. But at the time the full significance was well understood. In his diary, the great Victorian potter Herbert Minton describes how, in the late 1840s, he was able, for the first time, to breakfast at his home in Staffordshire, travel by train to London, a journey of 150 miles, fulfill a day's business in the capital, and then return to Staffordshire in time for supper. This journey, which had previously taken several days to complete, he correctly saw as far more revolutionary than any of the changes brought about by industrialization.

New Ideas, New Technology

The development of government-sponsored schools of design in Britain and other European countries was a feature of the 1840s. These schools grew initially from a realization that industrial design was so rooted in the past that new ideas were unable to develop. The schools, set up initially to improve standards of design, started a movement of change that ultimately culminated in the Great Exhibition. Gradually manufacturers began to repond to the ideas emerging from the schools, encouraged from time to time by national design competitions. As more trained students found employment in industry, so new design ideas began to make their presence felt. Many of these ideas were also based on the styles of the past, because the training at the new schools had a strong historical bias. However, in the hands of the new generation of designers these styles were manipulated

The Paris International Exhibition of 1862 was one of the first to boast a catalogue printed in colour. Waring's 'Masterpieces of Industrial Art and Sculpture' exploited the new technique of colour printing by chromolithography to illustrate many of the exhibits. This plate from the catalogue shows a group of vases made at Sèvres.

and blended together to lay the foundations for the great outburst of extravagant and unusual design ideas that were to characterize High Victorian taste.

New design ideas were frequently matched by new technology. In fact the new styles often demanded new production methods. The pattern of increased mechanization established during the early years of the century was continued, but potters now spent more time and money in improving their raw materials. Clays were purified and blended with increasing sophistication, while glaze and firing technology also made significant advances. Kiln design and the control of firing temperatures were significant areas of Victorian endeavour. In fact, much of the technology established during this period is still in daily use today. The basic processes of ceramic manufacture have not altered greatly since the late seventeenth century, but it was not until the Victorian period that the need for advanced technology was fully understood. As a result, all major manufacturers began to employ chemists and other specialized technicians, whose task was simply to improve and perfect the basic materials and the end product. By the 1860s, European porcelain and English bone china had achieved extraordinary standards of consistency and reliability, and the new generation of trained designers was able to enjoy far

greater artistic freedom than its predecessors in the eighteenth century.

The marriage of art and industry became one of the great achievements of the Victorian period, a marriage made possible by the new schools of design, the new public museums and in particular by the adventurous and entrepreneurial spirit of the major manufacturers. One of the first fruits of this marriage was the development of parian porcelain. Since the eighteenth century many potters had realized that there was a need for a new, unglazed modelling material, but few had taken any practical steps to achieve this end. The biscuit porcelain used with such panache at Sèvres and Derby during the eighteenth century was simply an unglazed porcelain. The lack of glaze preserved the fine details of the modelling, but it meant that the surface was completely unprotected. The models were easily damaged, but, more important, they quickly became stained by dirt and other atmospheric pollution that was absorbed by the unprotected clay. The figure-modellers of the early nineteenth century, Sèvres, Minton, Rockingham and others continued to use this material for want of anything better, but there was an increasing awareness that a potentially enormous market existed for unglazed figures if only the material could be improved.

Parian

During the late 1830s and early 1840s experiments were carried out in Staffordshire and elsewhere which resulted in the development of a new type of porcelain. First produced at the Copeland factory in about 1843, the material was known initially as statuary porcelain. Made from finely purified ingredients with a high percentage of feldspar, the porcelain was dense, pure white, with a fine granular finish closely resembling marble. It was impervious to dirt and other types of pollution, for the surface was non-absorbent. Stains remained on the surface, and could therefore be removed by soap and water. Models could be cast from moulds using slip, or liquid clay, and the strength of the material allowed the most precise details of the modelling to be retained. This new porcelain was immediately taken up by a number of other manufacturers. Minton was making it by 1846, followed shortly after by Wedgwood and other major British potters. Minton named its version parian porcelain, after the white marble from the Greek island of Paros, and this name was quickly adopted by most other makers. Initially sales were slow, but the material was effectively launched to the public by the displays at the Great Exhibition. Twenty manufacturers included parian among their displays in 1851, and from this moment the future of the material was assured. By the end of the nine-

Left: Parian ornamental vases by James Duke displayed at the 1862 International Exhibition. The elaborate flower encrustation was designed to show the quality of modelling which could be achieved with this new type of porcelain.

teenth century over 200 British potters were recorded as having produced parian, while other countries, in particular America, had also made it in quantity. Perhaps the best indication of the popular success of the material is the Minton figure of Dorothea. Introduced in 1848, after a design by the sculptor John Bell, this figure of a girl seated on a rock was still in production in 1890. When first produced,

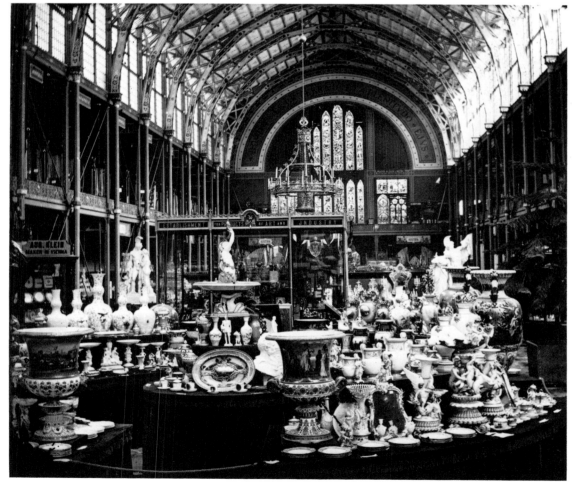

Left: A view of the north-west transept of the 1862 Exhibition which illustrates the imaginative and varied nature of High Victorian design. Items on display reveal the influence of styles as diverse as those of the Renaissance, the eighteenth century, Greek art, the Middle Ages and the Far East.

Dorothea retailed at £2-2-0, a high price in 1848. Despite its relatively high price–a Staffordshire portrait figure or chimney ornament of the same period cost only a few pence–parian became one of the most successful creations of the Victorian pottery industry.

Parian was used for figures drawn from a wide range of sources including classical antiquity, literature, history, politics, sports, religion, myth and legend. Portrait busts were also produced, many of a contemporary commemorative nature. At first, the enthusiasm for the material led many potters to use it also for a great variety of ornamental wares, and even for table-wares. However, its success in these fields was limited, owing to the obvious unsuitability of the matt, slightly rough surface for table use. The only domestic, or functional items to achieve any lasting popularity were the ranges of ornamental jugs decorated with figures and scenes cast in high relief. These were frequently glazed inside to make them more practical.

Although parian was by definition pure white, methods of colouring or decorating it were developed quite early. The parian could be painted with enamels and then fired again to achieve permanence, but the colours tended to be rather flat and drab on the unglazed surface. Gilding could also be added. However, the most successful method was to stain the liquid clay with metal oxides before the piece was cast. By this means a range of rich, permanent colours could be achieved, colours that continued through the whole body of the piece. Tinted parian could therefore be produced that imitated terracotta and other existing materials, and in the strong colours associated with Victorian design. Towards the end of the century very complex multi-coloured models were also produced, assembled from parts cast separately from various tinted slips.

Because of its suitability for modelling and casting, parian was inevitably produced in all the styles that were popular during the Victorian period. As the century progressed, the love of Gothic, Renaissance and classical detail gave way to the influences of Japan and China and other exotic cultures. Eventually, the sinuous curves of Art Nouveau also appeared. This stylistic adaptability was one of the reasons for the great success of the material. Another was the involvement of contemporary artists, especially sculptors, in the design and manufacture of parian figures. As early as the 1840s it was realized that parian provided artists with a unique opportunity to reproduce and therefore popularize their work, so the first manufacturers of parian were quick to encourage artists to submit designs or models. In their turn, artists were quick to respond to the challenge, and leading contemporary sculptors such as Bell, Chantry, Westmacott, Marochetti, Monti, Wyon and others were soon working with Minton, Wedgwood and Copeland. So positive a cooperation between art and industry was rare in the ceramics industry, known for its conservatism; parian provided an opportunity for cooperation on a scale that has never been equalled. For the first time, the industry was in the vanguard of artistic style, and the success

of parian was a measure of the public's appreciation of the chance to enjoy contemporary art on a massive scale. The parian model became for the sculptor what the print was for the painter. As a result, a vast number of parian models produced during the Victorian period were based on existing sculptures by leading artists. Some sculptures were commissioned specifically for reproduction in parian, while others were already well known. An example of the latter is the Greek Slave, an eleven-foot marble sculpture of a decorous nude in chains by the American sculptor, Hiram Powers. This was shown at the Great Exhibition, where it created a popular sensation. It was therefore reproduced in parian by a number of manufacturers, and became one of the best sellers of the period. Sculptors from all over the world were drawn by the attractions of parian; Americans, Italians, French, Germans and Austrians were among those artists whose works were reproduced in it.

There was one other factor that helped to guarantee the success of parian and its artistic status, and that was the method of reproduction. In January, 1844, Benjamin Cheverton had patented his reducing machine. This, effectively a three-dimensional pantagraph, made it possible to enlarge or reduce precisely any existing object by simple mechanical means. The fact that John Bell's original marble sculpture of Dorothea was six foot high was no longer

Above: A rare parian group of a Confederate soldier of the American Civil War being bandaged by a wounded companion. Such pieces were made in Stoke-on-Trent for the American market.

Left: Benjamin Cheverton's reducing machine, patented in 1844. The three-dimensional pantograph made it possible to enlarge or reduce, precisely and in proportion, any existing object. The machine, demonstrated at the Great Exhibition of 1851, was, with parian porcelain, the foundation of the great expansion of the mass-produced sculpture industry during this period. (Science Museum, London)

a problem. With the aid the Cheverton machine, a precisely proportioned reduced model could be made for reproduction in parian. The machine was displayed in action at the Great Exhibition, and so it quickly became familiar and accepted, by both artists and the public.

Until the last decade of the nineteenth century, parian remained the most widely used modelling material. In Britain and America the output was prodigious, but on the Continent parian was only moderately successful. This was because of the existence, since the eighteenth century, of the hard-paste or Oriental type of porcelain which enjoyed many of the same qualities as parian. The major manufacturers had therefore no reason to adopt the new material, and so concentrated instead on improving their technology and selling methods. Styles on the continent did, however, tend to follow the same principles of adventurous diversification that inspired English designers. Towards the end of the nineteenth century, many manufacturers in France, Germany and Austria began to export large quantities of their own type of biscuit, or unglazed porcelain, to England. These wares flooded the cheaper end of the market, and so English manufacturers soon found that the making of the higher-priced parian was becoming increasingly uncommercial. Their sales were also affected by changes of fashion. By the 1890s, the High Victorian and predominantly classical forms of the elaborately modelled and marble-like parian had lost much of their appeal. Buyers of artistic inclination had moved on to other fields, and so the makers of parian had turned steadily to more popular markets, concentrating particularly on commemorative wares. As a result they were in no position to withstand the influx of cheap European biscuit porcelain, and so large-scale manufacture of parian had largely ceased by about 1910. The only significant areas of production to survive into this century were commemorative wares and the rather limited manufacture of glazed parian; the latter was used for the elaborate and complex raised-paste form of decoration known as *pâte sur pâte*, and by specialist factories such as the Irish Belleek pottery.

Taste and Style

The popular belief that Victorian design was essentially revivalist and unoriginal is to some extent born out by the ornate and richly decorated ornamental porcelains. During the early years of Victoria's reign porcelain-makers throughout the world relied on the traditional styles of the eighteenth century, confident that these forms would appeal to new middle-class buyers. Production before 1851 was therefore characterized by expensive and highly skilled craftsmanship, made more impressive by the application of new technology. By contrast, the artistic quality was extremely low. Decoration was entirely eighteenth-century orientated, and so all the familiar styles of that century, the exotic birds, the Fragonard and Boucher pastoral landscapes, the formal and informal flower-painting, the realistic groups of fruit, and the

Minton Queen's Vase, the shape copied from an eighteenth-century Sèvres model. c. 1865. During this period many skilled painters raised the art of porcelain decoration to new heights of excellence, drawing upon both contemporary and historical sources. Some of these artists came from Europe, while others developed further traditional English styles and techniques.

wide variety of decorative ideas drawn from classical and pseudo-Chinese sources, were combined by the porcelain painters during the 1830s and 1840s. All the great names, Sèvres, Meissen, Derby, Minton, Berlin, Worcester were committed to eighteenth-century styles, and inevitably the lesser names and the newly founded companies followed their lead. This conservative approach reflected both the nature of the industry as a whole, and the tastes of the new buyers who measured quality in terms of elaboration, fine painting, rich gilding and other clear definitions of visible expense. Ornamental porcelains were made for display, and to advertise the wealth of their owners. In such an environment, new styles could hardly be expected to survive.

Attitudes towards porcelain were dramatically changed by the Great Exhibition. However some of the more advanced manufacturers had begun to show an interest in more unusual styles before that date. Although the Great Exhibition was the first major international display, there had been a number of more localized, but equally important exhibitions held during the 1840s. These included the Exhibition of Industrial Design in Paris in 1844, and similar events in London, Manchester, and other cities. The Paris exhibition included pieces decorated in Moorish, neo-classical and Oriental styles as well as those in the predictable eighteenth-century

taste. There were also many indications of the increasing popularity of styles using Renaissance and medieval, or Gothic motifs. The porcelain manufacturers in Paris itself, for example Jacob Petit and Honoré, seemed to most willing to experiment with new styles, encouraged no doubt by the relatively advanced and sophisticated tastes of their public. However, these styles were soon to spread to other centres of manufacture, first in France, and then abroad. They even reached Stoke-on-Trent, where Minton in particular reflected the more adventurous styles emanating from Paris.

In 1851 many of these new styles came of age, and were put on display before an enthusiastic public. Replicas of eighteenth-century porcelains were there in force, but designers and artists were now more prepared to adapt the eighteenth-century styles and blend them with decorative ideas from other periods and countries. Shapes taken directly from Sèvres appeared with unlikely and surprising decoration, for example with a tartan-painted ground pattern, while forms associated with the Renaissance were painted in Gothic or Middle-Eastern style. The result of all this stylistic confusion was that manufacturers from around the world returned home from the exhibition determined to be more adventurous in their approach to design. Throughout the 1850s and 1860s this trend continued. Designs became increasingly bizarre

and exotic, as manufacturers and designers vied with each other to produce distinctive and memorable wares. The well-established historical approach to design was abandoned as styles from the past, the present, from Europe and from the East, from primitive and sophisticated cultures were all mixed together. Out of this apparent chaos was born the High Victorian style, a style that was broadly applied to architecture, furniture, interior design, books, silver and jewellery as well as to porcelain. This style was to dominate design throughout Europe and America from the late 1850s to the 1880s. In its most obvious form it is to be seen in the many splendidly ornate buildings of that period; churches, office buildings, town halls, schools, railway stations, banks and hotels were all to be affected by this exciting and exuberant style, and luckily many of these still survive today in many countries as tangible reminders of this period of experiment.

The Influence of Technology on Style

Inevitably the porcelain-makers followed this trend. Helped by their ever-advancing technology they were able to produce wares that were technically better than ever before. The Victorian replicas of eighteenth-century Sèvres, Meissen and Chelsea were impressive not because of their closeness to the originals, but because they were actually better made. Precise control of clays, firing temperatures and enamel colours had removed the unpredictability that marred so much of eighteenth-century porcelain. Victorian potters were greatly aided by the many style manuals and guides to ornament that were published during the mid-Victorian period. Improvements in the technology of printing, and in particular the development of chromolithography, or

mechanized colour printing, made it possible for such manuals and guides to be readily available to a large audience. Many new styles in fact appeared first in book form. These books, with their splendid colour plates, were then acquired by the design departments of the major manufacturers, where the new ideas were absorbed and then applied to the decoration of porcelain. The development of the many exotic and unusual styles, drawn largely from primitive or pre-Christian civilizations, was affected directly by these style manuals. These books were frequently sold internationally, and so they also played their part in helping the spread of design ideas from one country to another.

Museums

Inspiration was also drawn directly from the new public museums being established throughout the world at this time. The collections, displays and temporary exhibitions were a permanent source of ideas for designers, modellers and artists. Many of these museums also published illustrated catalogues of their collections which were widely distributed. In addition, museum keepers were often surprisingly free with items in their care, and were prepared to allow a level of access that today would be quite unacceptable. For example, there are many documented occasions when manufacturers were able to borrow items from the museum collections, and take them back to the factory to inspire the designers. Similarly, historical pieces were often borrowed with equal freedom from private collectors. In other cases, as at Sèvres, the museum and the factory were part of the same building or complex, and so the interchange of ideas was direct. In fact, the role of the public collection, and to a lesser extent the private as well, was quite different from that of today. Essentially, a museum or a collection was seen as primarily educational, as a means of improving standards of design and decoration by making the best products of the past and the present accessible for study. A stylistic dependence upon the past was therefore not only inevitable, but was also actively encouraged from the highest educational, commercial and social levels. By the same token, the buying public was also encouraged to judge contemporary products from an historical point of view.

Exuberance and Change

Although many contemporary critics deplored increasingly the dependence of porcelain decorators and manufacturers upon the styles of the past, they could not dampen the public enthusiasm for these wares. Every international exhibition included pieces that were more extravagant, more exuberant, more outrageous, and, ultimately, more vulgar than any that had been shown before. Manufacturers from all around the world competed with each other in their quest for novelty, and for excellence of technique and craftsmanship. Few bothered to employ leading

contemporary artists from outside their own industry to decorate the wares, because they knew that there was a continual demand for rich, elaborate but predominantly traditional decoration. The replicas of earlier wares, particularly those of eighteenth-century style, were also of lasting popularity. To give one example, Minton made a precise copy of a splendidly vulgar and ornate Sèvres table-centre of about 1780, modelled in the form of a ship. First made by Minton during the 1870s, this extraordinary piece was still in production as late as the 1920s.

When it came to shapes, designers and manufacturers were more adventurous. Although many designs were based directly or indirectly on the past, others were quite specifically Victorian. A number of contemporary sculptors were employed as shape designers, first in France, then later in other countries. Many of these artists came to England to escape the social and political upheavals that followed the

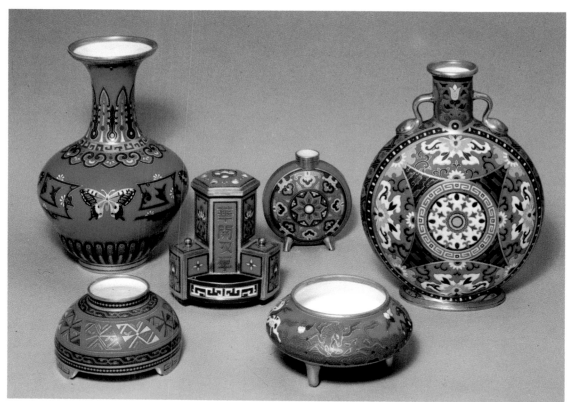

Group of Minton Cloisonnés. c. 1875–1880. The Oriental technique of cloisonné enamel decoration was an aspect of one of the most influential design movements of the nineteenth century, which derived from a fascination with both historical and contemporary Japanese art and style.

revolutions of 1848. In England, and later America, many French, Italian and Austrian artists were able to find employment. Like the Huguenot refugees of the sixteenth and seventeenth centuries, these men and women were to have a significant and lasting impact upon English art and design, particularly in the applied arts. After the Franco-Prussian war of 1870, there was a further influx of French refugees into England and America, which seemed merely to consolidate this European influence. Many came with their families to settle permanently in England, with the result that in Stoke-on-Trent there were whole streets where no English was spoken.

Once in England, many of these artists subsequently moved freely from company to company, and so the ideas and styles they brought with them were spread very quickly. Some even worked for a number of different industries, so stylistic parallels were established between porcelain, glass and decorative cast iron, for example. One such artist was the French sculptor Albert Carrier de Belleuse who came to England during the late 1850s. He worked for Minton and Wedgwood, designing a range of distinctive porcelain figures and ornaments which related in style to the bronzes he had modelled before leaving France. He then worked for the Coalbrookdale ironworks in Shropshire, designing figures and ornaments that echoed the styles of his porcelain. Later he returned to France, and worked there for a number of companies and in a variety of materials. Thus, one man was able to develop a personal style that was acceptable internationally, and recognized in a number of fields; he was able to break down the barriers between the fine and applied arts, and between various media, materials and areas of pro-

duction. Of course, there were many others like Carrier de Belleuse, so it was not surprising that the whole field of industrial design was in a state of turmoil throughout the mid-Victorian period.

Japanese Influence

During the early 1860s a new style appeared, one that was to have a lasting impact upon every area of artistic activity. In 1854, after a prolonged diplomatic campaign, the American naval expedition led by Commander Perry was allowed to land in Japan. The borders of Japan had been firmly closed to outsiders since the eighteenth century, and so the Perry expeditions and those that followed were able to see for the first time a lifestyle and a civilization totally unknown in the West. Trade missions were quickly established, and stories about this extraordinary Eastern country brought back by the first Western visitors created a sensation across Europe. These stories were supported by drawings and by photographs, which gave an accurate visual record not available to explorers in previous centuries. Particular interest and excitement was aroused by Japanese art and artefacts, the like of which had never been seen before in the West. Soon quantities of bronzes, ivories, ceramics, domestic items, fans, prints, lacquer, arms and armour and textiles were being exported to the West, both for display, and for selling.

The first major display of Japanese wares was at the Paris International Exhibition of 1862. The impact was sensational, and soon designers and artists throughout Europe were responding to this new

Oriental style. By the late 1860s exhibitions were including more European wares in Japanese style than actual Japanese items. Many shops were established to sell and popularize the products of Japan. For example, Liberty of London was founded in 1875 specifically to sell Japanese wares; these were imported directly by the shop, which was at first known as The Oriental Bazaar.

At the same time interest was also aroused by the products of other exotic countries such as India, Burma and the Middle East, whose secrets were being exposed at the same time by European travellers and merchants. This opening of international frontiers was greatly encouraged by the spreading network of modern communications systems, in particular the railway and the steamship. However, despite the general enthusiasm for exotica, it was Japan that the West took particularly to heart.

Since the sixteenth century European ceramics had always been dominated by the styles of the Far East. When the first examples of Chinese porcelain reached Europe, they were regarded as mysterious and precious treasures. Later, European potters tried to copy these wares but without understanding the secrets of the material they were only superficially successful, using inferior clays and techniques. It was not until the eighteenth century that European potters were able to produce an adequate version of

Oriental porcelain, and by that time the porcelain market was dominated by the export trade from the Far East. As a result, European decorative styles were to a large extent dependent upon Oriental models. Some were copied precisely, while others were Europeanized to become a part of the decorative *chinoiserie* movement that swept across Europe during the second half of the eighteenth century. When the Oriental export trade ceased during the 1790s, European manufacturers continued to produce wares that were basically Oriental in style. Most were inspired by Chinese porcelains, but Japan had also been important. For example, the rich Imari patterns that have enjoyed continual popularity since the eighteenth century were drawn originally from Japanese export wares. The Oriental tradition of decorative design was therefore firmly rooted in Europe, even though the designs themselves were far removed from their original inspiration.

This long-established enthusiasm for Oriental styles explains in part the Japanese mania that swept through Europe during the 1860s and 1870s. However, this movement was far more than a simple revival of some of the design ideas of the eighteenth century. For a start, due to the free availability of Japanese wares in Europe, designers were able to work from primary sources. Also, designers no longer contented themselves with working at wares in their

The Minton moonflask shows the influence of contemporary rather than historical cloisonné enamel decoration. c. 1880. The Worcester vase on the right combines Japanese decorative details with a shape taken from archaic Chinese jades, and so reflects the exciting Victorian ability to fuse together alien or even conflicting styles drawn from widely different cultures. 1874. Minton and Worcester were the leading exponents of Japanism in Britain.

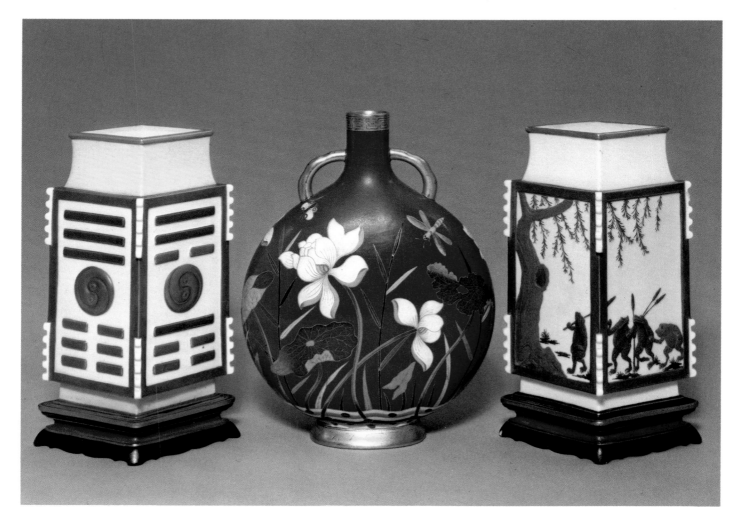

Right: Glazed parian spill vase in the form of a length of bamboo supporting a dead bird under the inquisitive eye of a mouse. Such a bizarre aspect of Japanese art appealed to Western designers and is typical of the many unusual decorative ideas which were borrowed from Japanese ivories, bronzes and prints. c. 1870. (Victoria and Albert Museum, London)

Far right: Royal Worcester octagon vase tells the story of the silkworm. 1874. Its designer, James Hadley, was one of the most adventurous of the Japanese-inspired designers and the vase reflects his enthusiasm for the Far East and his imaginative use of traditional Oriental sources.

The greatest impact of Japan upon European ceramics was felt not in porcelain but in earthenware. Because of its simpler technology, lower firing temperature and ready suitability to small-scale production, earthenware has always been more prone to experimental or artistic production. The complexity and cost of porcelain manufacture have always made a factory environment inevitable, and so experimental or artistic work has only ever occurred in those factories that were prepared to support a studio. Such studios have generally been unproductive in financial terms, but have been of enormous value in the creation of ideas. Many such studios existed in France and Germany during the nineteenth century, and it was from these that the enthusiasm for Japanese arts and design began to spread into the commercial world of porcelain manufacture. Forward-looking English manufacturers, such as Minton, Doulton and Wedgwood, also operated studios; although these were primarily concerned with earthenware, their influence upon the mainstream of porcelain production was considerable. Ranges of rich and elaborate ornamental porcelains were produced, some inspired directly by Japanese porcelain, and others copying or adapting Japanese styles in other media. Porcelain was thus produced to resemble *cloisonné*, lacquer, bronze, ivory and other exotic materials. Combined with traditional European decorative forms, these new styles often looked quite bizarre, and would hardly have been recognizable to a Japanese. Oriental principles of asymmetrical design were freely adapted, and widely misunderstood, by European designers and decorators.

However, there were a number of European factories that managed to produce highly original interpretations of Japanese designs. During the 1860s and 1870s Minton made a distinctive range of ornamental porcelains that followed the bright enamel colours and forms of Oriental *cloisonné*; these often incorporated decoration based on designs by Dr. Christopher Dresser, the leading industrial de-

own field, but drew inspiration from as many areas as possible, and even from the Japanese lifestyle itself. Porcelain was inspired in both shape and decoration by Japanese metalwork, ivories, domestic artefacts, lacquer, and even by prints and textiles. Japanese porcelain supplied only a fraction of the design ideas explored and exploited by European potters. It was therefore the totality of the Japanese dominance of European design that made it quite unlike the Oriental enthusiasm of the eighteenth century. Japanese art became a philosophy for the West, not just a decorative style.

France was the first country in Europe to fall under the shadow of Japan during the 1860s, but from there the styles spread rapidly to Holland, England and other parts of Europe, and then to America, where the style was well established by the 1870s. Other styles and tastes were swept aside in the rush to adopt the arts of Japan, with the result that many were at first followed quite faithfully by European, designers and manufacturers. However, the Victorian enthusiasm for stylistic chaos soon began to assert itself, and the new Japanese styles began to appear in increasingly confused and inaccurate forms, often mixed with other, more European, styles, in a quite unsuitable but rather interesting way. In this form, the enthusiasm for Japan survived well into the twentieth century, having been given a boost by the many art movements of the late nineteenth century which were frequently Orient-inspired. Japanism also gained a new impetus in Europe from the Art Nouveau movement, whose sinuous forms, natural inspiration and exotic styles were largely dependent upon the arts of Japan.

signer of the period, and so were actually far more adventurous than simple replicas of Japanese wares. Other Minton porcelains were loosely based on Oriental bronzes, lacquers, or ivories, but they too were original in their approach to design and decoration. In many of these wares, Japanese and Chinese sources were often mixed together, in a way that must have offended the purists but which added a new dimension to Victorian design. Even more exciting Orient-inspired porcelains were made at the Royal Worcester factory. These were designed by James Hadley, who combined elaborate modelling with complex surface decoration, either painted or raised in relief. Equally unusual but less directly Oriental were the unbelievably complex pierced vases, extraordinary confections carved from the unfired clay by a craftsman called Owens who specialized in this type of work. Similarly exotic and eccentric wares were also made at Sèvres, and by leading Limoges companies such as Haviland, but as a rule, the English potteries led the world at this time, from both design and technical points of view.

For many years both these bizarre and elaborate porcelains of Oriental inspiration, and the more traditional ornamental wares of broadly eighteenth-century or classical taste have been judged purely as examples of craftsmanship and technical skill. Critics and collectors have tended to disregard or ignore the art and design philosophies that inspired their manufacturers, or have failed to understand that, for the Victorians, art and craftsmanship were indivisible. As a result, these wares have been constantly misunderstood, and only grudgingly appreciated, generally for the wrong reasons. At this period, technical command of their medium was not only taken for granted by potters, but was also actively enjoyed and pursued for its own sake. With craftsmanship and technical control under their belts, Victorian designers were able to indulge in imaginative leaps that would have been impossible for their fathers. High Victorian porcelain, whether of Oriental, Middle Eastern, eighteenth-century French, Renaissance, classical or Indian inspiration, should therefore be judged and enjoyed in the same spirit that it was created—as an adventurous and extravagant flight of fancy that set out to push technology to its limits. After all, it was the experiments and advances made by Victorian potters that set the porcelain industry on the firm footing that it has enjoyed until today. Very few significant developments have occurred anywhere in the world since the end of the nineteenth century.

Pâte sur Pâte

Although Victorian porcelain was largely dependent for its inspiration upon the styles of the past or of exotic civilizations, there was one Victorian form of porcelain that came quite close to being truly original, and that was the decorative form known as *pâte sur pâte*. This name, literally meaning paste upon paste, was given to a technique developed initially at Sèvres, during the early 1860s. The

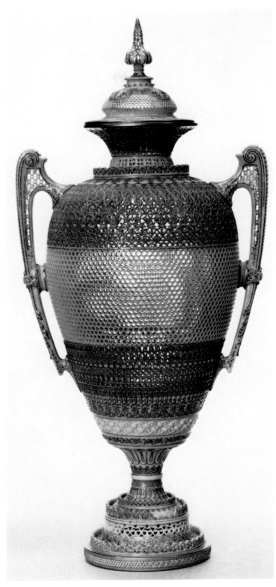

Royal Worcester pierced vase by George Owen. The complex filigree pattern had to be cut entirely by hand before firing. The vase thus reflects not only the broad base of Oriental sources, but also the Victorian fascination with technical expertise. 1893. (Dyson Perrins Museum, Worcester)

technique was first explored commercially by an artist and etcher, Marc-Louis Solon. Essentially, *pâte sur pâte* was a means of producing complex patterns raised in relief upon the surface of the vessel. Upon the unfired vase, plaque or whatever, designs would be painted in liquid slip, using the finest brushes. These would be left to dry and then a second coating of slip would carefully be added. This process would then be continued until the design had been raised in high relief. Precise control was needed at all stages to avoid each successive layer of slip lifting off the one below. When the design had been built up to a sufficient height, the artist would then equally carefully sculpt and carve the design, to introduce contrasting depths of relief and to add delicate detail. By this means a design could be produced that varied between total opacity and complete translucency. Only when all this work was complete could the piece be fired, first in the biscuit oven, and then again with the clear glaze added. If gilding was required, there would be a third firing. *Pâte sur pâte* was therefore a very complex and expensive process.

Minton pâte sur pâte multi-
coloured vase, one of a pair
made by Marc-Louis-
Emanuel Solon for the Paris
Exhibition of 1878, in the
Etruscan style. It was Solon
who came to Minton in
1870 to perfect the pâte sur
pâte technique, one of the
most original and dramatic
creations of the Victorian
porcelain industry.
(Victorian and Albert
Museum, London)

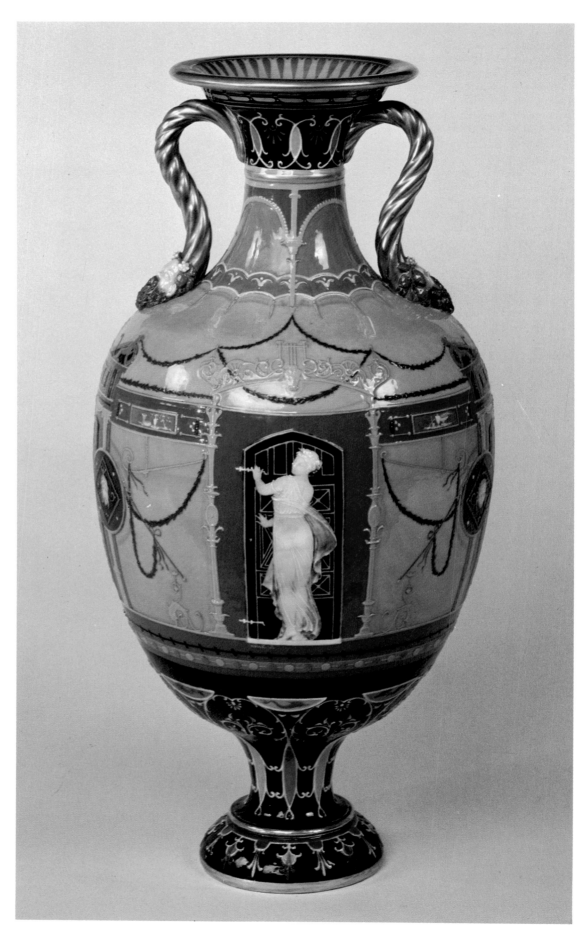

Solon could spend as long as fifty days decorating one vase. Should anything go wrong during the firing, all that work would be irretrievably lost.

The decorations were normally painted in a white slip on a darker-coloured ground. At first celadon green was popular, but later, dark blue, brown and olive green became the dominant ground colours. These dark grounds were particularly effective when they were allowed to show through the thin translucent layers of slip. By this means, flowing diaphanous draperies, for example, could be created, to contrast with the opaque white areas of the design. Sometimes more colours were added to different areas of the design, and so a complex, multicoloured effect could carefully be created. All the colours had to be in the form of liquid slips, clays stained with metal oxides in order to withstand the high temperature of the biscuit firing. Much of Solon's early work at Sèvres was involved in the chemistry of these colours because such effects had never been achieved before, and so he had to be as much a ceramic technician as a skilled artist or craftsman. Even the overall ground colours had to be in the same form. Despite these limitations, a surprising range of colours was developed which enabled Solon to produce a number of vases in the so-called Etruscan style.

At first the output of *pâte sur pâte* was very limited, but the new technique was well received when shown to the public. In order to increase his output, Solon soon left Sèvres, and then began to work with the Paris designer and entrepreneur Emile Rousseau. At the same time he began to sell his wares to a wider market, and developed a reputation outside France. By 1868 he was certainly known in Stoke-on-Trent, for in that year Colin Minton Campbell, the owner and managing director of the Minton factory, bought a number of *pâte sur pâte* panels from Solon. Two years later, the Franco-Prussian war broke out, and Solon, along with many other French artists and designers, decided to leave the country to avoid military service and the resultant disruption to his career. In October 1870 he arrived in Stoke-on-Trent, where he was given employment by Minton, doubtless because of his established links with Campbell. The Minton designers were not unaware of *pâte sur pâte*, for, apart from having Solon's panels, they had also been conducting experiments with the technique during the 1860s. Solon was given a small studio and there set about establishing the large-scale manufacture of *pâte sur pâte* in England. He found that the existing English parian material was entirely suitable, and so, aided by Léon Arnoux, Minton's French art director and chief chemist, he adapted the existing *pâte sur pâte* process and colours for production in tinted and glazed parian. By February 1871 the process was under way at Minton, and within a year pieces of exhibition standard were being successfully produced. Solon at first worked on his own, but by 1872 he had established a small studio with a number of students and assistants under his control. Some of these were later to establish their own reputations as *pâte sur pâte* decorators. Solon continued to work at Minton until 1904, producing *pâte sur pâte* without interruption for over

twenty years. After his retirement he continued to work freelance until his death in 1913, using the Minton ovens to fire the wares he decorated at home.

Pâte sur pâte was enormously successful in England, for both Minton and Solon. Until the 1890s there was a ready sale for every piece that was produced, and the international exhibitions of the 1870s and 1880s established a reputation that made Minton the envy of every porcelain manufacturer in the world. In addition, a number of special presentation pieces were produced to celebrate Queen Victoria's Jubilees, and these pieces were exhibited widely. From the start, *pâte sur pâte* was extremely expensive. During the early 1870s a good Solon vase could sell for as much as 200 guineas (about £10,000 in present-day values). Nevertheless, there were many collectors around the world keen to buy every piece. This price level reveals much about the status of porcelain at that time; today it is inconceivable that any manufacturer could ask and receive such a price for a decorated vase, not once but again and again. The cost was partly explained by the complexity of the process, and by the amount of Solon's time involved in the production of each piece. However, more significant was the position of ornamental porcelain in the art market. The buyer of a Solon vase was buying a leading example of contemporary art, and was prepared to pay accordingly. At that period the barriers between fine and applied art had been removed; modern art could be a painting or sculpture, a piece of porcelain, a painted plaque or a piece of furniture. All fields of creative endeavour were seen as equally significant and relevant. This was an attitude that survived until the outbreak of war in 1914. It is important to understand this attitude in trying to appreciate today the elaborate,

A clockcase vase, part of a garniture decorated by Solon in pâte sur pâte and commissioned by the London retailer James Goode who showed it at the London International Exhibition of 1871. The piece demonstrates how quickly Solon overcame the problems of adapting his pâte sur pâte technique to suit the English method of porcelain manufacture.

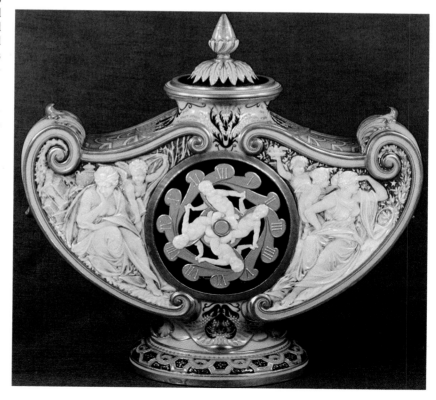

The decorating workshops at the Royal Doulton factory in Nile Street, Burslem, during the early part of this century. Many of the artists at Doulton were drawn from other factories and were thus able to combine varied and imaginative styles to achieve new heights of excellence.

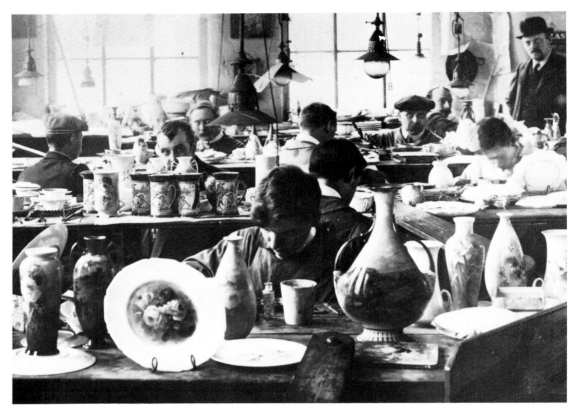

costly ornamental porcelains of the latter part of the nineteenth century.

Pâte sur pâte was certainly an original Victorian process, and this originality even extended into the styles of decoration. Solon was a highly skilled draughtsman with a fertile imagination. Inevitably he drew upon a wide range of sources, including classical art, the Renaissance, the eighteenth century, mannerism and the baroque, the Oriental world and even contemporary book illustrations, valentines and Christmas cards, for his inspiration; however, he seems to have used his sources far more freely than most Victorian designers, adapting and blending all sorts of themes and styles, and never copying one source precisely. The results are therefore highly original and idiosyncratic. He obviously derived particular pleasure from the female form. His vases and plaques are covered with voluptuous and tantalizing ladies, splendidly formed in high relief, and delightfully exposed by their clinging or flowing draperies. His designs have a sensual quality rare in Victorian art, and many of the ladies are depicted engaged in erotic activities that might have caused Freud to raise an eyebrow. However, as many Victorian painters and sculptors, and indeed modellers of parian figures, had already discovered, considerable sexual freedom was acceptable in the cause of art.

Minton was not alone in the field of *pâte sur pâte*. A number of other English companies produced the ware, with greater or lesser success, including Royal Worcester, Doulton and George Jones. Minton continued to make it in a spasmodic fashion until 1939 when the last trained *pâte sur pâte* artist left to join the Royal Air Force. On the Continent, Sèvres continued to make some of the best and most elaborate pieces, particularly those modelled by Taxile Doat. Meissen, Berlin and Vienna also became centres of production, although their wares tended to be rather heavy and Germanic, lacking the freedom, humour and originality characteristic of Solon. In the early 1900s Doat and a number of other French and English *pâte sur pâte* artists moved to America and continued to produce some exciting pieces, now strongly influenced by Art Nouveau, a style particularly suitable for *pâte sur pâte* decoration.

Table-ware Production

Rather less artistic but perhaps of greater financial significance was the Victorian expansion of table-ware production. Table-ware had, of course, been a fundamental if unexciting part of the industry since the eighteenth century, but early production, particularly in England, had been based on a range of earthenware bodies. Even in Europe the output had been fairly limited, for no European potter could compete, either in price or quality, with the Chinese and Japanese export wares. When this trade ceased, the British helped to fill the gap, with the newly developed bone china, and it was this material that made possible a period of intense growth. The story of Victorian porcelain is very much the story of bone china; this adaptable, economical and consistent porcelain was particularly suitable for table-ware production and, at the same time, a vast new market appeared in which there was an apparently insatiable demand for decorative wares of good quality. Several well-known factories, such as Spode and Minton,

were founded simply to make table-ware, for it was in this area that there were many opportunities for growth and profit. The continuing stability of the Victorian industry was also based upon this principle, for all the successful potters knew that, while the exhibition pieces might provide the jam, and the glory, it was the table-ware that provided the bread and butter. Many of the famous names that failed, such as Rockingham, paid the price for ignoring the importance of basic table-ware production.

The wise and successful potters also spent time and money developing their export trades; they looked particularly to North America, where there was a huge untapped market for porcelain, a market whose growing sophistication had been overlooked by many of the large exporters of basic earthenwares. By the latter part of the century it had become common-place for European manufacturers to produce patterns and designs aimed entirely at North America. Indeed, many of these were made as special orders exclusively for American and Canadian retailers, and were backstamped accordingly.

In terms of style, the table-ware market is the most conservative element of an essentially conservative industry, a pattern that has not greatly altered since the eighteenth century. As a result, table-ware tended to follow behind the mainstream of Victorian design, and was rarely innovative. The revived rococo style was dominant throughout the 1840s and 1850s, and has remained one of the standard styles for ornamental table-ware to the present day. At the same time, the French influence was particularly popular, along with a variety of other styles based on a range of predominantly eighteenth-century decorative traditions. For example, pseudo-Oriental designs were always in demand. As other styles came to the attention of Victorian designers, so they were

eventually reflected in the table-ware market. Renaissance motifs were followed by Japanese or Middle Eastern in an entertainingly confused manner. There were also many lavish and exuberant productions, complex pierced shapes with hand-painting and gilding, to match the Victorian taste for ostentation.

Table-ware styles not only develop very slowly, but once established they also continue unchanged over a long period. Shapes in particular are altered as rarely as possible, for a considerable investment is required to introduce a new shape. Styling in table-ware therefore frequently means no more than adding a new pattern to an existing shape. To give one example, Minton's best-selling pattern today is on a shape that dates from the 1890s. This means that table-ware design is largely determined by consumer demand. Time and again the industry has

found to its cost that innovation or contemporary styles have little popular appeal, while there is always a market for traditional flower decoration on elaborate shapes. The Victorian period was no different to today, for it was at that time that the pressures and demands of a large-scale consumer market first became apparent.

In terms of style, Victorian table-ware was unoriginal, but on technical grounds there were many new developments. Processes of clay preparation, casting, firing and glazing were improved as potters strove to find a consistent and highly reliable white bone china body for table-ware, and one that was both strong and chip resistant. Many ornamental shapes still required extensive hand-work, which made them very expensive and time-consuming to manufacture. In 1863 a new process of mechanical decoration was developed, whereby complex lacy patterns were etched into the surface of the biscuit porcelain by controlled immersion in acid. The resulting designs were then gilded and burnished, creating an exciting contrast between the glossy surface gilding and the matt gold intaglio decoration. This acid gold process, as it came to be known, was developed in Staffordshire, but rapidly spread around the world to become synonymous with expensive table-ware. The technique is still in use today.

Another aspect of Victorian table-ware production deserves attention, namely the increased manufacture of special order wares. Fine quality and rich decoration ensured a continual demand throughout the world for personalized, badged and crested and private-commission wares. Queen Victoria and Prince Albert were great supporters of the ceramic industry and ordered continuously from many British manufacturers. Their influence was followed by the rest of the British Royal Family, by the British aristocracy, and by royal families and aristocracy abroad. In America, presidential support was equally forthcoming, and even in more exotic markets such as India, there was great enthusiasm for European porcelain table-ware. In addition, regiments, shipping and railway companies, hotels, government institutions and many other private and public organizations required specially made table-ware in ever increasing quantities. This demand ensured that most major manufacturers maintained large departments solely for the design and engraving of monograms, crests, badges and other special motifs.

The Victorians spent considerable time and ingenuity in developing other methods of mechanical decoration, for automated mass-production was their ideal. Traditionally, decorative motifs had always either been painted by hand, or printed in one colour

Minton plate from a dessert service made for Lord Milton, with corresponding Minton pattern for the rim. Each plate is decorated with a different scene commemorating Lord Milton's exploration of northern Canada. The plates are additionally decorated with the Milton monogram and their borders etched in the new acid gold technique patented in 1863. Such special order services made for the aristocratic families of Europe were an important feature of the English porcelain industry in the Victorian period. (Minton Museum, Royal Doulton Limited, Stoke-on-Trent)

from copper plates and applied by a simple transfer method. Often the two techniques were combined in the process known as 'print and tint' whereby a printed outline pattern was quickly hand-coloured. Inevitably, the Victorians turned their attention towards mechanized colour-printing. During the period 1830 to 1860 a number of experimental colour-printing processes were developed, by Davenport, Minton, Pratt and other companies. These involved a variety of techniques, including the use of a number of wood blocks, one for each colour, multi-colour printing from one copper plate and lithography. All proved to be expensive and unreliable, and it was not until the 1880s that the first full-colour chromolithograph decorative ceramic transfers became available. In terms of quality these were very poor, and so were only used to decorate the cheaper wares. Hand-printing remained the only effective form of high-quality decoration until well into the twentieth century.

Similar experiments were made with photography.

As early as 1854 a method of permanently applying photographic prints to ceramics had been developed in France, and by the 1870s this technique was in fairly regular use in many countries. Methods of photographic engraving of illustrations were also widely used by the 1880s. Despite these experiments, the Victorian dream of highly mechanized, fine-quality decoration for table-ware was not to be fully realized.

Laboratory and Sanitary Ware

The Victorian porcelain industry also witnessed considerable expansion in areas that had nothing to do with either theories of design or consumer demand. The suitability of porcelain for chemical equipment, storage vessels and other laboratory wares had been understood in the eighteenth century, but the material had rarely been available in sufficient quantities or at an economic price. The

Royal Crown Derby plate richly decorated with flower sprays and raised gold by Desiré Leroy. Such baroque extravagance was characteristic of late Victorian and Edwardian design.

great refinements in porcelain manufacture that took place throughout Europe during the first decades of the nineteenth century revolutionized this industry, and so a number of companies became major suppliers of technical porcelain. Many new industries were coming into being at this time and these also brought new demands. The development of photography was helped by the availability of porcelain corrosion-resistant trays and tanks. But the major growth occurred in the electrical industry. From the 1850s, porcelain insulators and other electrical components constituted an increasingly significant area of production, and a number of specialist manufacturers grew up to serve this new industry. In England, Doulton and Bullers were pioneers in this field. The same period saw the development of the sanitary industry, with the realization that porcelain, because of its highly finished and uncorruptible surface, was ideal for the manufacture of baths, sinks, basins and lavatory pedestals. This industry was able to benefit from the sanitary revolution of the mid-Victorian period, when standards of both public and private hygiene became a matter of great concern. The great expansion of school, hospital, public bath and other

institutional building at this time was also a great incentive to manufacturers. Finally, manufacturers were able to develop a number of other markets for porcelain. They started making such items as door knobs and door furniture, handles, switches, cooking, catering and medical equipment and even bedknobs, all of which flourished during the Victorian period.

The Arts and Crafts Movement

During the last three decades of the nineteenth century, a number of leading artists and designers in Europe and America began to move away from the established styles associated with industrial production. Many found the High Victorian habit of blending together a variety of styles drawn mainly from historical sources unappealing and broadly unacceptable. This reaction was closely connected with a popular movement of the time that was essentially anti-mechanistic. Its leaders, William Morris, John Ruskin and others, argued that human skills and crafts had been lost in a machine-dominated environment; they encouraged a return to an earlier tradition of craftsmanship, where the personality of the artist could control any mechanical aids he chose to use. This movement affected all areas of artistic production, but its impact was perhaps least felt in the world of porcelain; porcelain was seen as being unsuitable for artistic use because it was the epitome of a machine-made, and thus wholly predictable, material.

However, the influence of this arts and crafts movement was considerable, and a number of manufacturers responded to it by establishing art departments or studios attached to the factories in which experimental work could be carried out without undue economic pressure. At the same time, other art potters set up their own studios and production units, where they could work away from the industrial environment. Many were inspired by the pure forms and colours of early Chinese porcelain, wares that seemed to show the qualities of the material without industrial limitations, and many glaze and firing experiments were carried out in France, Scandinavia, Germany, America and Britain to try to recreate some of these spectacular Oriental effects. However, the results of these experiments were not apparent on a grand scale until the early years of the twentieth century, when the new styles of Art Nouveau brought together the most exciting aspects of Japanese art, Chinese art, medieval and primitive art, and the decorative traditions of the Victorian period.

Return to Conservatism

After about 1880, the expansion of the porcelain industry slowed down considerably. The uncertain economic climate affected most European manufacturers, particularly the British, who began to lose their dominant position in the market. Cheap

The manufacture of technical and sanitary porcelain became increasingly important during the late Victorian period and many new manufacturers emerged to cater for this demanding market. By the 1850s porcelain lavatories and bathroom equipment were an increasingly common feature of domestic life. This Armitage and Shanks cast-iron lavatory stand, with 'patent porcelaine recessed lavatory basin', appeared in their 1896 catalogue.

One of a pair of centre-pieces of the Irish Belleek factory, this piece is a particularly flamboyant example of the Belleek factory's speciality, which was to produce splendidly realistic imitations of natural shells. This entertaining creation is a fitting reflection of the confidence and assurance that characterized the manufacturers of the late Victorian period.

imports into Britain from Germany, Austria, France and even Japan took over sectors of the market. More important, many major British companies showed signs of losing the confidence that had carried them to the fore during the mid-Victorian period. The direct result of this was that there were fewer innovative designs or styles as manufacturers tended to concentrate on their safer, more predictable successes of the past. There was a greater reliance on the traditional forms and styles of porcelain decoration, such as flower, fruit and landscape painting in a broadly eighteenth-century manner, enriched with more elaborate modelling and gilding. The leading manufacturers of this period, Coalport, Royal Crown Derby, Royal Worcester and Doulton, all tended to concentrate on safe, conservative approaches to design and decora-

tion. Fine painting, of a highly skilled but artistically sterile nature, and over-elaborate modelling in debased Renaissance or rococo styles became the order of the day. Complacency and safe marketing determined manufacturing policy in all the major porcelain factories, as the industry prepared itself to withstand the next stylistic assault, that was to come from Europe in the exotic guise of Art Nouveau.

In the history of porcelain, the nineteenth century was a high point in technical and artistic innovation. Artists, designers, craftsmen and manufacturers all made the most of the opportunity offered by new technology, and a new international marketplace. The great international exhibitions were an accurate reflection of the dynamism, imagination, brashness and even vulgarity that characterized this exciting century.

Popular Nineteenth-Century Porcelain

Left: A selection of popular Victorian pieces. From left to right, top: souvenir ribbon plate of popular German manufacture; beaker commemorating Queen Victoria's diamond jubilee; parian porcelain bust; centre: German-made souvenir shoes; advertising plaque; foreground: a range of doll's house porcelain.

Below: The Goss factory in Staffordshire produced a range of much-collected miniature pieces. The Goss buildings (below) measure only 15 cm. in height.

THERE are some porcelain wares of the nineteenth century which are even now reasonably priced. They are decorative, they have nostalgic value, they are fun. Like popular music of the past, a fairing or a moustache cup gives the flavour of the period in which it was made. While some of these pieces are finely fashioned, it is not primarily for their artistic quality that they are valued, but rather for some meaning they signal, or some feeling they evoke.

Goss

The heraldic porcelain souvenirs of W. H. Goss must be among the most popular of all ceramic collectables, and this has been the case since the time they were first made in the 1880s. A happy side-effect of this longstanding interest has been the availability of reliable documentation. During the late nineteenth

century the Goss factory itself customarily issued lists of new shapes and designs to its stockists and, from about 1900, a Goss enthusiast, J. J. Jarvis, issued *The Goss Record*, a regularly updated handbook of information on all the Goss wares and their design origins. The last issue was published in 1921. With the help of such records as these it is possible to discover both the date of a piece and its design sources as well as other information—a situation that collectors of other objects might well envy.

But William Henry Goss, founder of the W. H. Goss China Manufactory in Stoke-on-Trent, was more than a mere souvenir-maker. He was much respected in his day as a ceramic innovator and while his wares are not to everyone's taste, they are of supremely fine quality. His first important experience in the ceramic industry appears to have been as a modeller and designer at the Copeland (formerly Spode) works, where the newly fashionable parian ware had been developed with particular success and where, by the 1850s, jewelled Sèvres-type wares were also being made.

Goss remained with Copeland for less than a year before opening a small factory in Stoke-on-Trent on his own account, in 1858. There he specialized in the production of parian portrait busts and decorative pieces in 'ivory porcelain'. Most of them, like subsequent examples, are marked 'W. H. Goss' with, after 1862, a goshawk above the name. He also made terracotta wares—notably jugs, water-bottles and tobacco jars with characteristic bands of decoration in blue, green, white and black around the top. These smooth, red earthenwares are rarely marked.

By 1870 Goss had become successful enough to open a much larger factory in Stoke-on-Trent—the Falcon Works, where the family business remained for the next sixty years. One of his early enterprises was an improved process for making 'jewelled' porcelain like that of Sèvres. Goss's method, which he patented, involved setting the jewels—sometimes real stones and pearls—into prepared recesses in the

porcelain body, and was considered much more satisfactory than the earlier technique by which they were simply fused to the surface. He used his process for making vases, scent bottles, pastille burners, pomade boxes and many other decorative items as well as for brooches, earrings, hair ornaments and numerous trinkets. Goss's 'floral jewellery' in glazed biscuit and his 'ivory porcelain' lattice baskets encrusted with coloured flowers are among the finest of his productions and are similar to those produced at Belleek where some of Goss's craftsmen went to introduce the techniques for making it.

It was this ivory porcelain, developed from a parian body, that Goss used from the early 1880s for the heraldic wares for which his factory is most famous. These provided far more lucrative business than his costly virtuoso pieces. Heraldry was one of Goss's longstanding interests, and his first efforts were small porcelain shields displaying the crests of Oxford and Cambridge; the major public schools soon followed, and their success led Goss to decorate other objects—mainly small vases, jars, bowls and similar receptacles—with the crests of towns and seaside resorts all over Britain.

One of W. H. Goss's sons, Adolphus, was a keen archaeologist and through his interest many other models such as copies of Roman lamps, antique vases, urns, tombs and Celtic crosses were introduced. These led to the production of buildings like castles and towers, lighthouses and market crosses, famous houses and cottages. Teapots, mugs, plates and other table-wares were also made, some decorated with crests and others with transfer-printed landscape views. A range of eggshell dolls' china is among the most endearing of his productions.

The extraordinary popularity of the Goss souvenirs grew rapidly and spread overseas. Agents in towns and cities all over Britain and in her colonies were given sole rights to sell the heraldic designs and models connected with their respective areas, and by the early twentieth century few homes were without at least some examples.

The First World War stimulated models of tanks, shells and regimental badges, but sales of crested china began to drop and continued to do so with the post-war slump. By this time, Goss collecting had become a mania with some: the League of Goss Collectors founded by the enthusiastic Mr. Jarvis in 1906 became the International League of Goss Collectors in 1919, and special limited editions were made available to them. Despite this the firm, in the hands of W. H. Goss's sons since his death in 1906, was unable to recover its former prosperity, and in 1929 it was taken over by Cauldon Potteries. Wares made after this time were still marked W. H. Goss but with the addition of 'England' below.

Not surprisingly, the immense popularity of the Goss crested pieces stimulated many firms to copy them, and imitations marked with other factories' names abound. Most of them are from the Staffordshire area but some were clearly imported from Germany, like many other porcelain souvenirs. Few of these copies, apart from the German examples, are of hard-paste porcelain; most are of bone china or earthenware, and none can compare in quality to the Goss originals. Until quite recently they were considered valueless as collector's items, but with the increasing scarcity of genuine Goss pieces and the great popularity of crested china interest in them is on the increase. It is now worth looking for the better examples.

Belleek

It is rare in the realms of porcelain to find any wares which are at the same time immediately identifiable, finely potted, difficult to fake and yet still within the financial reach of the average collector; but just such wares are those of the Belleek factory in Ireland. While they may not be to everyone's taste, their quality cannot be disputed.

It all began in the 1850s when a certain Captain Bloomfield, who owned an estate around the village of Belleek in County Fermanagh, discovered large deposits of feldspar on his land. He approached the Dublin architect Robert Armstrong who sent samples to the Worcester factory in England. They were

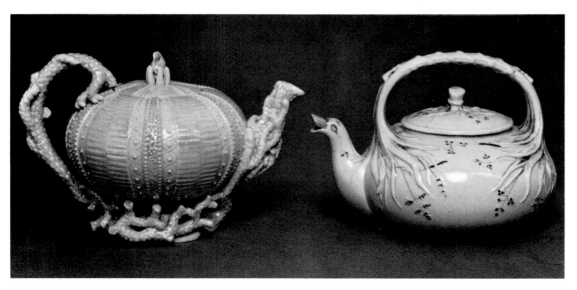

Teapots from the Belleek factory in Northern Ireland. Always popular with collectors, similar pieces are still being made today.

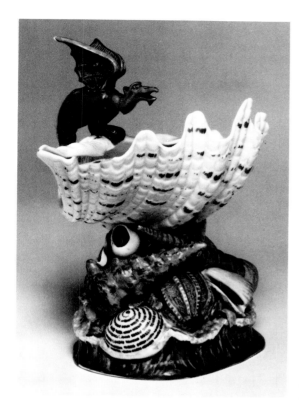

A dramatically colourful Belleek clam-shell and griffin flower-holder, bearing the usual mark of hound, harp and tower. Height 14 cm; c. 1875.

tested with Cornish china clay and found to be of eminently suitable quality for the manufacture of porcelain. Shortly afterwards, in 1857, Armstrong formed a partnership with his friend David McBirney and a factory was set up on an island in the River Erne. Armstrong himself designed the building and harnessed the waters of the Erne to provide power for it. The first wares were sold under the title D. McBirney and Company, but within a short time the name Belleek Pottery Company was adopted, and this is still in use today.

Belleek is invariably marked with one or other of several variants. A printed mark generally takes the form of an Irish wolfhound, a harp, a tower and shamrock with the word 'Belleek' below. More rarely, an impressed harp surmounted by a crown is found. Basket-wares may have an applied strip with the words 'Belleek, Fermanagh' impressed. The inclusion of 'Ireland' in the mark indicates a post-1891 date.

Belleek is a type of parian ware, slip-cast in plaster of Paris moulds which absorb a high proportion of moisture and greatly reduce the thickness of the porcelain. Apart from the eggshell thinness of Belleek wares, their distinctive appearance is due to their pearly glaze which is produced by mixing oil of lavender, salts of bismuth and resin. The process for this *décor de couleurs nacrées* was patented in 1857 by a French chemist, Jules Brianchon, who licensed Armstrong and McBirney to use it at Belleek.

Both table and decorative wares were made in a range of designs and decorated with the nacreous glazes which made the factory famous. Among the most popular were shell forms, often with applied incrustations of marine life, and basket-wares, generally decorated with plants and blossoms. A favourite table-ware pattern took the form of closely woven basketry decorated with swirling sprigs of green shamrock. Parian busts and figures were among the other decorative productions. It is not always remembered that serviceable earthenwares, granite ware, sanitary goods and even electrical insulators were also made at Belleek.

Robert Armstrong, one of the original partners in the firm, was among its most distinguished designers; two others, William Gallimore and William Bromley came from the Goss china factory at Stoke-on-Trent and did much to put the Belleek factory onto a successful footing. Gallimore is generally credited with the introduction of shell forms while another craftsman from Stoke-on-Trent, Henshall, probably introduced the basket-weave patterns and applied flower designs in the 1860s.

The factory's most illustrious period was probably reached during the 1870s when ornate services were made for both Queen Victoria and the Prince of Wales, and when (around 1878) the factory employed as many as 200 hands. Since then the factory has weathered many ups and downs and still survives, producing the same kinds of decorative wares.

In 1876, Belleek exhibits at the Philadelphia Centennial exhibition attracted the attention of the New Jersey potters and it was not long before Belleek began to be made in America. The first in the field, in 1882, was the firm of Ott & Brewer of the Etruria Pottery, Trenton, New Jersey, who employed William Bromley, formerly of the Belleek pottery in Ireland, to introduce wares of a similar type. Bromley later instructed the Willits Manufacturing Company, also of Trenton, in the making of Belleek wares. More Irish immigrant craftsmen soon arrived in America and introduced Belleek techniques into many other potteries in the Trenton area. These included the American Art China Works, the Assanpink Pottery Company, the Columbian Art Pottery, the Cook Pottery Company and the Delaware Pottery Company. Another firm, Knowles, Taylor and Knowles of East Liverpool, Ohio, made a version of Belleek known as Lotus ware.

Belleek wares, because of their fineness and the skills needed for making them, are expensive to produce, and several of the American factories found them uncommercial after a short time. However, several firms continued to produce them until late into the 1890s. American Belleek varies in quality and is often distinguishable from its Irish counterpart by variations in the colour of the body and the glaze as well as by different designs and marks. A significant proportion of the wares produced, particularly in the 1880s, are of superb quality and it is probable that they formed a very real threat to the Irish manufacture.

Fairings

A nineteenth-century fairgoer would be astonished to find that today the humble china figure group given to him as a prize on the hoopla stall or at the shooting range is now worth many pounds – possibly

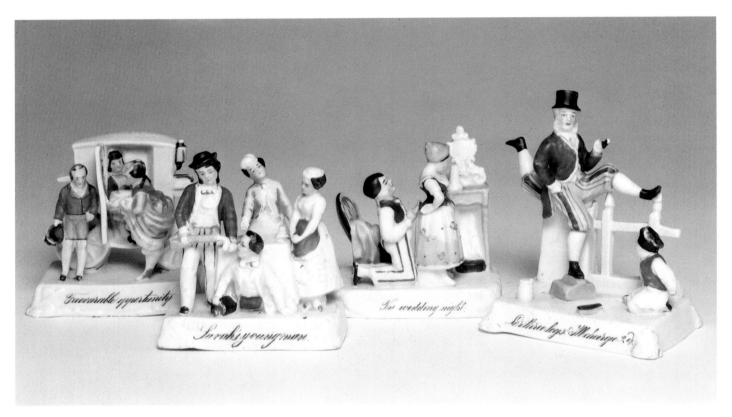

Four fairings of the 1870s and 1880s, ranging from only 8 to 11 cm high. Nearly all fairings were produced by the German company of Conta & Boehme of Saxony. Pieces produced after about 1890 are generally lighter in weight but less delicate in colouring than the earlier examples. Gold captions on the base, instead of black, would also indicate the later date.

hundreds—in the antiques trade. For these china 'fairings'—the late-nineteenth-century equivalent of the plaster-cast souvenirs of our own day—are eagerly sought by collectors who have grown accustomed to paying enormously high prices for rare models in mint condition; even quite common examples can reach three-figure sums.

Their humble origins as mass-produced fairground souvenirs are almost certainly part of the appeal of fairings. Fairs in the nineteenth century were occasions of great excitement for ordinary people and to many, fairings evoke the bustle and thrill of these local festivals. Although they cannot now be picked up for a few shillings as they could a few years ago when their collectability first became apparent, they have at least proved their investment worth.

Fairings were produced mainly during the second half of the nineteenth century, in apparently enormous quantities by the firm of Conta & Boehme of Possneck in Saxony. Due to the similarity of Conta & Boehme's mark (a hand holding a dagger within a shield) to that of Springer & Oppenheimer of Elbogen (now Loket, in Czechoslovakia) fairings were wrongly ascribed, but it is now known that almost all were made by the German firm. A few, however, have been found with the mark of the Royal Vienna factory.

As practically every fairing is captioned in English, it is clear that the chief market for them was in Britain, but a few examples with titles in German, Dutch or French have appeared on the market from time to time. The last are often of superior quality: perhaps French fairmen were more discriminating than their English, German or Dutch counterparts. These captions on the bases of fairings, usually in

black in the earlier period but in gold after about 1890, are among their most distinctive features, but it is known that Conta & Boehme also made uncaptioned figure groups, probably for sale in shops rather than as fairground prizes. Early examples, that is, those produced before about 1870, tend to be heavier and of better quality than later ones. The colours of the later ones show little delicacy, and their modelling often appears shoddy.

Subjects range from rather saucy scenes of courtship, marriage and domestic life: 'The last in bed to put out the light' is one of the most common; 'Shall we sleep first or how?' is another bed-time group. At the other end of the scale are the humanized animals like the family of bears 'Coming home from the seaside', and the more serious scenes of the Franco-Russian war which include several versions of 'English neutrality attending the sick and wounded'. Children were also popular sentimental subjects and were often combined with animals, as in the fairly common fairing of a baby playing with a puppy entitled 'Tug of War'. Altogether, some 400 different subjects are known.

On the whole, historical and political scenes are more rare and therefore more expensive, though such risqué situations as 'Awkward Interruption' in which a man is holding the maid's hand as his wife appears are much sought after. Among costly rarities are 'To Epsom' and certain versions of 'Animated Spirits'—a drunken old man with two girls.

Several different interpretations were made of some titles and conversely certain groups were given varying captions. A scene in which two girls almost collide on their bicycles is sometimes entitled 'A Dangerous Encounter' and sometimes 'Girls of the

Period'. Similary, 'An Awkward Interruption', besides being the compromised maid, can be a man getting out of bed with a cat on his back. 'Five O'clock Tea' is either a tea party of kittens or one of mob-capped little girls.

Inspiration for these groups was generally drawn from British sources; it seems probable that the importing agents often provided Conta & Boehme with new subjects which they could translate into models. Some have been traced to English comic papers of the 1860s and 1870s, while several are derived from sheet-music covers of the period. The fairings entitled 'Pluck' and 'The Decided Smash' come from the cover 'Full Cry Gallop', while the cover of the song 'Please Give Me a Penny Sir' inspired the fairing 'A Penny Please Sir?' 'Champagne Charlie is my name' was derived from an 1860s song popularized by George Leybourne. More unusually, 'How's business?' and 'Slack' are based on the transfer-printed designs on each side of a Staffordshire mug. Without such known sources, precise dating of fairings is difficult, although such subjects as 'Can-can' are likely to have been made in the 1880s, while the political and historical subjects can usually be linked with specific events. Costume, too, provides a clue, though usually an imprecise one.

The spectacular increase in the value of fairings over the past decade or so has given rise to fakes and reproductions, so collectors should beware. There is no substitute for knowledge acquired through handling genuine examples and every opportunity should be taken to gain such useful experience.

Souvenir Wares

The habit of collecting mementoes of travels abroad was well established in the days of the eighteenth-century 'grand tour'; on a less exalted level, the souvenir wood-wares of Tunbridge Wells and the china treasures marked 'A Trifle from Lowestoft' represent the souvenir market in eighteenth-century England. By the early nineteenth century, potteries, especially those in Staffordshire and Sunderland, were producing quantities of wares decorated with landscapes or views of famous towns for sale to visitors at such resorts as Bath, Brighton, Harrogate or Cheltenham.

However, it was in the middle of the nineteenth century, when the new railway system had spread its network of communications across the length and breadth of the country and numbers of ordinary people were able to travel, that a mass market was created. The first important occasion for souvenirs in England was probably in the year 1851, when over six million people travelled to London to visit the

A selection of early twentieth-century crested china souvenirs from some of the many factories which copied those of Goss. But few succeeded in rivalling Goss in quality.

Great Exhibition. Without doubt, hordes of them returned home with some souvenir of their trip.

It was Germany, fount of all fairings, that best fulfilled the need for cheap souvenirs. From about 1880, porcelain factories like Schumann in Bavaria, Donath in Silesia, Unger & Schilde in Saxony and many others, besides several in Austria and Bohemia (now Czechoslovakia), produced a positive flood of china decorated with transfer-printed views of towns and cities, spas and seaside resorts, buildings and landmarks. They were exported in huge quantities, particularly to Britain, and were eagerly snapped up by trippers who gave them to their friends and relatives or put them on shelves and mantelpieces in their own homes.

But it was not long before this pictorial china with its views of distant attractions was overtaken by photography although, ironically, many of the ceramic views were themselves produced by photographic methods. The demand for German souvenir-wares had already begun to drop before 1914, when allied animosity towards anything German spelt the end of their export market. After the First World War their place was taken by picture postcards and most souvenir china was forgotten, consigned to the attic or the jumble sale as valueless trash. It is only recently that interest in these pictorial china souvenirs has revived, and even now they are among the cheapest of all ceramic bygones.

Cheaply produced as they were, and vulgar as is the design of many, they have enormous appeal as representatives of early mass tourism, and the views on them can reveal fascinating details of nineteenth-century pride. They record favourite tourist haunts–Stratford-on-Avon, Bridlington, Stonehenge, Ramsgate, Weston-super-Mare, Yarmouth, Bath and hundreds of others in Britain, Europe and even America–before the days when picture postcards were widely available, and many give an incidental view of contemporary costume, transport and social habits. Some can be roughly dated: recognizable buildings like post-offices, art galleries, seaside piers and railway stations as well as early motor-cars, omnibuses, ships and so on can give precise clues.

Several English porcelain factories, among them Worcester, Minton, W. H. Goss, Hammersley & Co, Hammersley & Astbury, Ridgways, Grafton China and Powell & Bishop produced pictorial souvenirs during the nineteenth century. They were generally of higher quality than the European imports, and consisted chiefly of tea-wares and mugs.

By contrast, the souvenirs produced in Germany, Austria and Bohemia embraced an extraordinary range of objects from table-wares, tobacco jars, miniature baskets, vases, ashtrays, bottles, candle-sticks and moustache cups to novelties like cruets in the form of binoculars and lighthouses, or models of cottages, top hats, coal scuttles–even a bathing machine. By far the highest proportion were plates–some plain but most with pierced edges. These are known as ribbon plates and were clearly designed to be hung on the wall rather than used.

Most of the imported souvenir wares had solid-colour backgrounds to the transfer-printed views,

A moustache cup from the Hammersley factory. Clearly visible is the inner ledge designed to protect the moustache from the liquid drunk. A gimmick in more ways than one, this example commemorated the coronation of Edward VII in 1901. Height 8 cm.

unlike their English counterparts which were white; after about 1890 the European background colour was almost invariably pink. Gilding nearly always denotes a Continental origin and so do the words 'A Present From . . .' followed by the name of the view. Many souvenir wares are stamped or impressed at least with their country of origin, but a helpful number have clearly identifiable factory marks. A few bear the names of retailers too.

Commemorative Wares

Ceramic commemorative wares have a history stretching back many centuries but the great majority have always been made of pottery rather than porcelain. Indeed, the production of commemorative pottery souvenirs was an important cottage industry during the nineteenth century, and few of the major porcelain factories bothered with them.

The exceptions were the bisque and parian portrait busts, mainly of Queen Victoria, made in celebration of her jubilees, produced by such firms as Minton and Worcester. Among the last of all parian productions were the figures of George V and Queen Mary made in celebration of their coronation. German porcelain factories as well as English were quick to exploit the market for these coronation figures.

Porcelain was not often used for commemorative wares like plates, bowls, mugs and tea services until the end of the nineteenth century. Some of the earliest were the patriotic reminders of the Boer War made by Copeland (sometimes for the retailer Thomas Goode) and Royal Worcester. The coronations of Edward VII in 1901 and George V in 1911 stimulated a large number of porcelain teasets, mugs and other wares, some of high quality. George V's Silver Jubilee in 1935 was another royal event which gave rise to appropriate commemorative wares. Among those most prized by modern collectors are

the coronation souvenirs of Edward VIII, 'the king who was never crowned'.

Since the Second World War, many of the major porcelain factories such as Spode, Minton, Royal Worcester and Coalport, have issued limited editions in celebration of such royal happenings as the Prince of Wales's Investiture or the Queen's Silver Jubilee, and they have also snatched every opportunity for issuing limited edition commemoratives of other events. These include centenaries of cathedrals and of all kinds of institutions, anniversaries of the births or deaths of famous people, celebrations of scientific inventions, the opening of buildings and all manner of other occasions. Many people buy these limited editions at considerable expense in the hope that they will prove to be a good investment, but collectors should be very careful: some of them are less strictly limited than they should be and a large proportion of those sold have little or no artistic merit.

More interesting both from a collecting and an artistic point of view are the commemorative Christmas plates which have been produced by several Scandinavian firms, notably Bing & Grøndahl and the Royal Copenhagen factory in Denmark, since early this century.

The market in ceramic commemoratives has changed a good deal over the past few years. Whereas during the nineteenth century and well into the twentieth, coronation and other commemorative wares were mass-produced for the lower end of the market, they have now become pretentious 'investments' designed for middle-class collectors. As such, they have far less social interest and their value as reflections of their age in years to come is likely to be minimal.

Lithophanes

Among the many porcelain novelties of the nineteenth century were the ingenious pictures known as lithophanes. Visible only through transmitted light, they are to be found in the form of lamp shades or nightlights, plaques to be viewed through a sunny window and in the bottoms of mugs or jugs.

A lithophane is a panel of porcelain into which a picture is intaglio moulded, the body showing through transmitted light at different depths. Some lithophanes are unglazed and uncoloured but they may be glazed, made in a coloured body, or coloured on the surface. Subjects range from reproductions of old master paintings and romantic landscapes and seascapes (stormy seas seem to have been especially popular) to portraits of well-known contemporaries.

The process for making lithophanes, with a wax original and then a plaster cast, was patented in Paris in 1827 by a certain Baron de Bourgoing but the idea was taken up most enthusiastically in Germany; the Meissen factory acquired the rights to make them from 1828, but the technique was developed chiefly at the Königliche Porzellan Manufactür in Berlin, where large quantities were produced until about 1850. So prolific was this factory that lithophanes became known also as 'Berlin transparencies'.

Manufacturing rights were acquired in England by Robert Griffith Jones in 1828, and he licensed the firm of Grainger Lee & Company at Worcester to make them. Several other English factories produced lithophanes by a slightly different method from that used on the continent. Among them were Minton, Coalport, Wedgwood, the South Wales Pottery at Llanelly, W. T. Copeland, W. H. Goss and the Irish Belleek factory. On the Continent they were made at Sèvres, at the Royal Copenhagen factory in Denmark, and at centres in Czechoslovakia, Belgium and Portugal. Germany was always the chief producer: among the most prolific manufacturers of lithophanes was the factory of Von Schierholz, of Plaue, now in East Germany. Later in the nineteenth century American firms began to take up the process, among them the Phoenix Pottery Company of Phoenixville, Pennsylvania. There is a museum of lithophanes at Toledo, Ohio, owned and run by a collector, Laurel G. Blair. Lithophanes are still being made, sometimes from old moulds, at several German factories and at Herend in Hungary. Modern examples tend to be much thicker and heavier than those of the nineteenth century.

A similar technique was that of *émail ombrant*, supposed to have been invented by the French Baron du Tremblay in the 1840s. An intaglio design impressed into the porcelain (or pottery) body was covered with a coloured glaze, allowing the varying depths of the design and thickness of glaze to create light and shade effects in monochrome. The process

German porcelain lithophane, or 'Berlin transparency', from the Plaue factory in Brandenburg, impressed with the mark PPM. The photograph on the right shows the lithophane lit from behind to show the contrasts between the thicker dark portions and the thinner, translucent parts of the picture.

was taken up by several factories, notably Wedgwood in England, but with less spectacular results than was that for making lithophanes.

Mass-produced Figures

As well as prolific copying of eighteenth-century figures and groups in glazed and enamelled porcelain and, sometimes, in unglazed biscuit, the later decades of the nineteenth century saw the widespread use of parian ware, or statuary porcelain, for mass-produced ornaments.

In England, the firm of Robinson & Leadbeater in Staffordshire became one of the main suppliers of mass-produced parian figures, while in America the first factory to introduce this 'happy substitute for marble in statuettes', during the 1850s, was the United States Pottery Company in Bennington, Vermont, whose productions, in a form of biscuit porcelain closely imitating the English parian and introduced by a former employee of Copeland, were generally of a high standard. Other factories soon followed their lead, some of them confining their efforts to expensive 'art products' while a great number mass-produced parian busts and figures for the cheaper end of the market. Many of these were copies of models made at the more important factories.

Among other American factories making parian or 'biscuit parian' figures were Ott & Brewer (later the Ceramic Art Company) of Trenton, New Jersey who were probably the first in America to make true parian ware, from 1875 onwards; Knowles, Taylor & Knowles of East Liverpool, Ohio; Charles Cartlidge of Long Island (later the American Porcelain Manufacturing Company) who employed Staffordshire craftsmen to model 'biscuit busts of celebrated Americans'; Morrison & Carr of New York; the New England Pottery Company of Boston; the Phoenix Pottery Company of Pennsylvania, and the Chesapeake Pottery and Edwin Bennett, both of Baltimore. The Swedish factory of Gustavsberg was one of the few outside Britain and America where parian porcelain was used for figures and other wares.

In the late nineteenth and early twentieth centuries, firms in Germany, France and Britain began to mass produce figures which were based on original models rather than historical reproductions. Among the best known are the 'Hummel figures' mainly of children, made at the factory of Wilhelm Goebbel in Bavaria since 1879. Designed by a nun, Bertha Hummel, they have enjoyed enormous popularity, especially in the United States. Equally popular have been the figures of ladies in crinolines, children, and eccentric character-types, produced in England by Royal Doulton since 1913.

China Dolls

Porcelain of one form or another was widely used for the heads, and sometimes the limbs, of dolls from the 1830s until after the First World War. Very rarely, a doll made entirely of china is to be found. Although

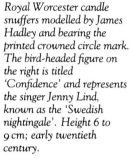

Royal Worcester candle snuffers modelled by James Hadley and bearing the printed crowned circle mark. The bird-headed figure on the right is titled 'Confidence' and represents the singer Jenny Lind, known as the 'Swedish nightingale'. Height 6 to 9 cm; early twentieth century.

Three glazed porcelain heads for dolls dating from the mid-nineteenth century. China heads, which were developed in Germany, became very popular during this period. The hair was usually coloured black, as in these examples, but some heads were produced without any hair, for wigs to be fitted. Unglazed white porcelain (biscuit) was also used extensively until the advent of less breakable man-made materials.

ceramic heads for dolls had been made sporadically for many centuries, it was not until the late 1830s that hard-paste porcelain began to be seen as an ideal medium for popular dolls. It was durable, washable, could imbue a doll with life-like features and colouring, and was well adapted to mass-production methods.

The first factory to produce porcelain dolls in quantity was probably the Königliche Porzellan Manufactür in Berlin, and examples marked KPM can be reliably attributed. However, by the 1840s many other factories, mostly in Germany, were producing unmarked dolls' heads.

Dating is often as difficult as attribution, since the same moulds appear to have been used for several decades: moulded hairstyles showing the fashions of the 1830s and 1840s are to be found on dolls dressed in clothes of the 1860s and even later. 'Biedermeiers,' or 'black spots' date from the 1840s. Each of these had a black spot on the crown and a wig instead of moulded porcelain hair.

Although most porcelain dolls were made in Germany and were exported widely, the Royal Copenhagen Factory in Denmark produced some fine examples between 1844 and 1884. They are marked with the factory's three wavy lines. France and Britain also had porcelain doll-making industries but they were of minor importance compared with Germany's at this time.

Around the 1850s, unglazed porcelain known as bisque began to be used for dolls. More delicacy of colouring and realism of features could be achieved in this material, in contrast with the glossy coldness of glazed porcelain. Early bisque dolls are sometimes known as parians, though they are not made of true parian ware. 'Blonde bisques' were pale and pink-tinted, often of child-like appearance.

Factories in Germany continued to pour out the majority of dolls for the popular market, but from the late 1850s France was producing dolls of the most exclusive quality. The earliest of these were known as Parisiennes. Perfectly equipped, with superbly made clothes and accessories, and realistic in appearance, they were modelled, like almost all china dolls up to the 1870s, on ladies rather than on children or babies.

Among the earliest established makers was Madame Rohmer of Paris, but factories such as Bru and Jumeau later became more famous. Many dolls' heads and limbs (a china-legged doll was considered particularly desirable) were sold loose for assembly elsewhere, and dolls can be found marked with the names of both manufacturers and retailers; quality also varied greatly, even among dolls bearing the same factory's mark. As before, many dolls were altogether unmarked.

From the 1880s both French and German factories were producing bisque dolls in the image of children rather than ladies. They are known as bébés even though they represent children (almost always little girls) of about eight to twelve years old. Realistic baby dolls were not made regularly until the early

A selection of German carved ivory pipes, all with handpainted Meissen porcelain bowls, all made around 1800. The chased silver gilt bowl cover and Y section of the centre pipe has English hall marks, and would have been done in England.

These and many other German factories continued to supply most of the world's demand for dolls up until the First World War. But although bisque-headed dolls, especially for dolls' houses, continued to be made until the 1920s, new and more child-proof materials gradually superseded them.

Miscellaneous

Well-heeled little girls of the nineteenth century were superbly equipped, not only with beautiful china-headed dolls dressed in fine clothes but also with tea and dinner services from which they could feed their elegant 'bébés'. These were sometimes made in imitation of adult-sized china, but nearly always with appropriately small patterns or subjects of childish interest. Many are of pottery, but some of the major porcelain factories, especially those of Germany, produced miniature wares both for dolls and dolls' houses. They range enormously in quality but almost all are collectable—even the recent reproductions of Georgian wares made in miniature by Royal Worcester or Spode. Some of the finest of all toy wares were made by the firm of W. H. Goss.

From the mid-eighteenth century, German smokers had a predilection for pipes made of porcelain. Some fine examples were made at Meissen and Nymphenburg among other factories, and by the nineteenth century more ordinary pipes were being produced in the porcelain factories of Austria and Bavaria. Before 1850 most of them were hand painted but transfer printing was widely used in the second half of the century. Production virtually died out after the First World War, but a few are still occasionally produced today. Subjects included sporting or patriotic scenes, portraits of the famous, religious or fairytale illustrations and souvenir-type views. Most popular of all were pretty girls.

The porcelain pipe-bowl never apparently caught on in England, where smokers preferred pipes of porous clay which allowed the juices produced from the smoked tobacco to evaporate or be absorbed into the body. To overcome the problem of this 'distilled tobacco' in the non-absorbing glazed porcelain, the bowl was fitted into one arm of a specially-shaped reservoir and the stem and mouthpiece into the other. The Y-shaped piece could be disconnected and emptied at intervals.

Though used for quite separate purposes, moustache cups and shaving mugs tend to be lumped together in the collecting world, probably because both were designed for hirsute men. A moustache cup is a drinking cup (with a saucer) with a protective shelf across one side to keep the user's moustache from being wetted while he is drinking.

The first of these ingenious novelties are said to have been made by the firm of Harvey Adams & Company of Longton in Staffordshire in the mid-nineteenth century, but before long they were being produced by factories throughout Europe and America. Among the best-known English firms to have made porcelain examples were Minton, Derby and the Worcester Royal Porcelain Company.

years of the twentieth century and then mainly by German firms such as Kammer & Reinhardt.

A number of dolls are marked SFBJ (Société Française de Fabrication de Bébés et Jouets) representing a syndicate of French doll-makers who set up a company in 1899 in an endeavour to compete more strongly with the German market. However, the German factories, situated mainly in Thuringia and Bavaria, easily dominated the trade, producing about half the world's output of dolls.

Many German dolls' heads were made in general porcelain factories as a sideline; mass-production methods and farming out of assembly work helped to keep prices down; in contrast the French dolls were always expensive. Armand Marseille was, despite his French-sounding name, a German maker of prodigious output, and dolls made by this firm are still widely available. Simon & Halbig, and Heubach are others whose productions are widespread. Bisque heads were made by these firms (manufacturers of all kinds of porcelains) and often sold to others to be assembled. Kammer & Reinhardt made some of the best quality German dolls from heads made by Simon & Halbig especially for them. Kammer & Reinhardt eventually took over this and another head-making firm, Heinrich Handwerk.

Sometimes, as at Belleek in Ireland, moustache cups were made as optional extras for tea services, while others formed pairs with ordinary cups and saucers—'his and hers'. These were also made in Germany, like the souvenir pairs marked 'A Present from Scarborough' or something similar. Most, including a vast proportion from the many German porcelain factories operating in the later years of the nineteenth century, were made singly, as clever gifts for 'the man who has everything'.

Shaving-mugs, or barbers' mugs as they are often called, had a more functional and less luxurious purpose, and were more varied in their basic design. The most usual was a pottery or porcelain vessel with a double spout, one for the shaving-brush and the other for the razor, but many had soap-drainers and other features incorporated into the design. By far the greatest number were made in America where more than ninety patents for different types of shaving mugs were taken out between 1860 and 1940. Among the many American makers were Thomas E. Hughes of Birmingham, Pennsylvania, Smith Brothers of Boston, Koken Barbers' Supply Company of St. Louis, Herold Brothers of Cleveland and J. Hambleton & Son of Philadelphia. German factories were among the most prolific suppliers of porcelain examples, and several English factories also made them.

It was customary for barbers to keep racks of shaving mugs with the names of their regular customers on them, but the habit began to wane after the First World War, when men increasingly took to shaving themselves instead of going to the barber. The advent of the safety razor effectively killed the demand for shaving mugs and few were made after the 1920s.

No Victorian lady's dressing table was complete without a toilet-set. Those of the rich were often of silver or, more splendid still, silver-gilt, but pottery or porcelain sufficed for the vast majority, and factories all over Europe and America turned out porcelain equipages which ranged widely both in quality and price. The set usually comprised a pair of candlesticks, a brush and comb tray, a ring stand, and an assortment of cosmetic pots and bottles, but there were many variations.

The German factories were, as always, at the forefront of the popular market, but several factories in England and America specialized in toilet-sets, notably John Tams of Longton, Staffordshire, the International Pottery Company of New York City, and Burroughs & Mountford of Trenton, New Jersey. Most porcelain dressing-table wares date from the later years of the nineteenth century or the first decades of the twentieth, and some particularly eye-catching sets were made in the Art Deco style.

Small porcelain boxes with moulded figures of people or animals on their lids were made by the German firms who produced fairings, notably Conta & Boehme. Some were designed as pin boxes while others, with roughened striking surfaces, were for matches. They were especially popular between about 1855 and 1870, and are in much the same style as fairings though they are not usually titled.

Porcelain match-holders were produced in other forms: a miniature vase rising from an ashtray base was one of the most usual types in the last decades of the nineteenth century, and some decorative though rarely high-quality examples can still be found.

Among the most appealing of Victorian trifles are the porcelain menu-holders now often to be found singly, but rarely in the pairs of sets in which they would have first appeared. Each was simply a small stand with a slot for the menu, and the object lent itself to a great variety of decorative forms. There were animal and bird shapes, fruit, nuts and flowers while many were simply painted with enamels, or transfer printed. Some incorporate posy- and candle-holders and others include blank spaces for names.

Porcelain was used for such a variety of purposes that it is easy to overlook some of the smaller oddments. The collector should look out for such items as buttons, cane heads and chessmen, all of which were produced by many factories on both sides of the Atlantic. Some of these things are of extremely high quality.

Porcelain advertising wares can be another comparatively cheap source of socially interesting pieces. Most are late nineteenth or early twentieth-century pieces, and many can be accurately dated.

Plaque with a transfer print advertising 'Watling's Picnic Pies'. It was the rapid advance in printing techniques which gave such a strong impetus to advertising during the late Victorian period.

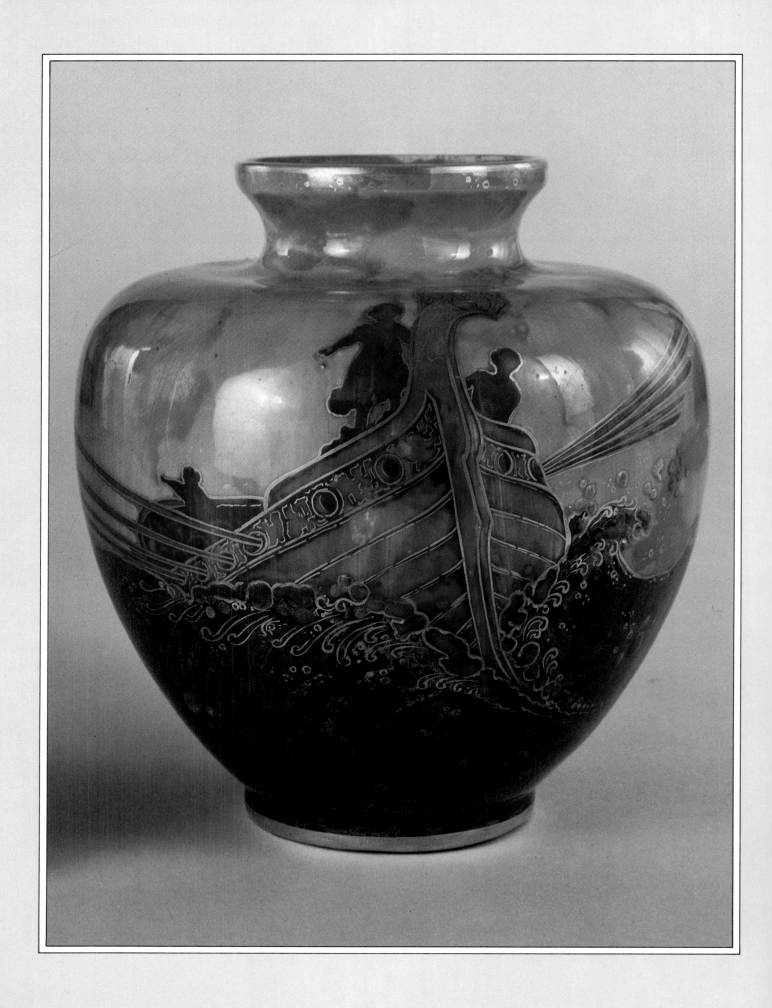

Art Porcelain

IN the last twenty years of the nineteenth century there was an explosion of activity in the Western ceramic world. Large and small potteries and a new breed, the independent studio ceramists, were swept up in a wave of technical experiment and innovation in a drive to achieve the most dramatic, exciting or beautiful effects. Fresh influences took pattern, decoration and shape into new realms of fantasy and artist-intellectuals argued principles which swept ceramic production into the first of the major twentieth-century design movements.

Oriental Influences

One of the most important developments in the late 1860s was the 'discovery' of Japanese art. As with all other branches of design, ceramics benefited from the vital and, for the West, revolutionary principles inherent in the flood of Japanese products brought to Europe by such enterprising retailers as Samuel Bing in Paris and Arthur Lasenby Liberty in London. These deceptively sophisticated objects introduced designers and artists to the decorative possibilities of a flat, graphic, even calligraphic style. Vibrant colours used in unexpected juxtaposition, an entirely non-Western sense of balance, and the rejection of all but essential ingredients resulted in an immediate effect, dazzling in its simplicity. The confident yet delicate woodcuts of Japanese artists such as Hokusai soon affected ceramic decoration, from Limoges and Sèvres to London and Copenhagen, and each pottery produced its more or less well-understood version of asymmetrically placed motifs against a plain background. In its best interpretations, the West produced stylish and individual examples in porcelain and combined these with technical innovations in the work of Arnold Krog and other painters at Copenhagen or J. Juriaan Kok at Rozenburg. Some of the artists also combined with success the Japanese lesson with the later Art Nouveau style. Art

Nouveau at its worst and most superficial was exemplified by those productions by a myriad of potteries, small and large which applied without thought or understanding a landscape with a fan, off-centre on a scroll-edged dinner plate.

While Western porcelain-makers owed much to Japanese graphic arts, they benefited even more from the appreciation of Eastern glaze effects. For these they looked further, to the art of the Chinese potters, for centuries much prized by European collectors and ceramists. Probably the greatest achievements in the 1880s and 1890s were in the art of the *grand feu*, the unfailingly magical activity within the kiln under high temperatures, which results in glowing, jewel-like, dramatic glaze effects. These glazes are known as *flambés* or *flammées*. They derive their colouring power from copper and iron and during the firing are subjected to direct contact with the flames. The

Above: One example from the range of new shapes designed by Alexandre Sandier at Sèvres to give the maximum surface on which to display the new glazes and, as in this case, the generous sweeping decoration of the Art Nouveau style. Height 18 cm; 1901. (Musée National de Céramique, Sèvres)

Right: Figure from the table setting 'Jeu de l' écharpe', designed by Agathon Léonard, a medallist and sculptor, for production in biscuit porcelain. It was shown at the Paris International Exhibition of 1900, and at least part of the set was also made in gilt bronze by Susse Frères. Height 39 cm; 1900. (Victoria and Albert Museum, London)

critical factor is the more or less gaseous condition within the kiln, known as a reducing or oxydizing atmosphere and caused by controlled starvation or flow of oxygen through the fire mouths. The variance in the atmosphere results in different effects in the glazes. At the high temperatures reached there is an extremely delicate balance between disastrous failure and a successful combination of chemicals and pyrotechnics. While experience brought a considerable degree of control to such firings there was still an element of chance and surprise in the quality and depth of colour achieved. Major advances were made in the technique of such specialized firing on porcelain during the later years of the nineteenth century, as well as on the artist-potters' favourite material *grès*, or stoneware, and while discussing porcelain it is essential to remember the importance of contemporary and complementary stoneware experiments. Nevertheless, for brilliancy and glowing colour, porcelain, as the underlying body, won the greatest adulation, particularly as it was used by the ceramist Ernest Chaplet, and also by several major firms such as Sèvres, Copenhagen and Doulton, who produced some of the most beautiful industrial glazing.

From the late 1880s even more possibilities opened up with the discovery and development of crystalline glazes. In these, the reaction of metal oxides during the firing and the controlled cooling of the kiln produced a range of effects from delicate to spectacular, in the depth of the glaze or on the surface. *Craquèle*, or crackled glazing was later developed, again in emulation of the Chinese, although this remained within the province of the larger industrial factories, Copenhagen particularly. In order to display these glazes to their best advantage, shapes became simpler, also returning to their Oriental sources.

France

France was the centre of ceramic activity both in industrial and individual production. Sèvres was the senior porcelain factory in age and importance and it was also one of the first to attempt the production in the West of the Japanese and Chinese painted and glazed decorations. With the collapse of the Second Empire, the factory underwent a period of adjustment and difficulty in patronage and artistic direction. A succession of directors, including Albert Ernest Carrier Belleuse and Théodore Deck, affected the style of production and with the help of the technical and artistic staff, gradually shifted Sèvres from its position as one of the most famous producers of enamel painting to the forefront of *grand feu* experiments. As early as the International Exhibition held in London in 1851, Sèvres had shown a number of small pieces, plainly but brightly coloured under the glaze, similar to the Chinese. Although these can be seen as forerunners of later developments, their true significance at the time was to demonstrate Sèvres's historicism. It was not until the 1880s that the manufactory really began those

experiments which truly represent the nineteenth-century ceramist's passion for the Oriental.

Two important figures who were at Sèvres during this critical period and who contributed considerably to the new Sèvres production were Taxile Doat and Théodore Deck. Taxile Doat joined the firm in 1877 at age twenty-six. Following in the footsteps of Marc-Louis Solon, who was by then at Minton in England, he made a speciality of the elaborate technique of *pâte sur pâte* decoration. In the thirty-two years he was at Sèvres he produced innumerable pieces in this delicate method, ranging from paperweights to major vases. At the same time, during the late 1880s and 1890s he experimented continually on special glazes. He also worked privately at his home, the Villa Kaolin in Paris, where he built up an important study-collection of wares by other manufactories and potters. He exhibited his own work at the International Exhibition held in Paris in 1900, demonstrating his successful and astonishing combinations of experimental glazes with *pâte sur pâte* decorations. In addition to this technical wizardry he had brought the *pâte sur pâte* style from its initial source, the Renaissance, to the contemporary Art Nouveau. Following the exhibition he wrote what amounted to a major thesis on the high-temperature glaze effects to which every artist potter aspired. He gave a brief account of the recent history of Sèvres, but the much larger part was devoted to detailed technical directions for glazing and firing. These articles were translated in 1903 by Samuel Robineau in Syracuse, New York, and printed as a fourteen-part series in his monthly publication *Keramic Studio* in 1903 and

1904. They caused an immediate sensation in America, coming as a revelation to many potters, and were seen as vital to those potteries already engaged in similar experiments. Doat left Sèvres in 1905 and in 1909 he was persuaded by Edward G. Lewis to leave France and join the People's University at University City in St. Louis, Missouri, to set up a new school of ceramics.

Théodore Deck began work with ceramics in 1856 when he established a workshop with his brother Xavier. He concentrated on earthenware and developed a highly successful studio from which, after early experiments with St. Porchaire-type earthenware, and other historic techniques, he produced his own Persian and Turkish influenced designs. Many of these are extremely striking, both his original creations and the accurate copies which he made. The friends who worked for him widened his production. Albert Anker painted some charming scenes, bordering on the whimsical, while Eleanor Escallier and Felix Bracquemond produced some of the finest and most powerful expressions of the Japanese influence.

After successful earthenware showings at the International Exhibitions of 1867 and 1878, Deck began making porcelain, following his conversion to the art of the Far East. He worked on *flambé* glazes in particular and with considerable success. His wide experience in both pottery and porcelain led to his appointment as Art Director at Sèvres between 1887 and 1891, after the death of A. E. Carrier Belleuse. During this period, under Deck, the Sèvres chemists began to achieve triumphs with their *flambé* glazes.

In 1884, the *porcelaine nouvelle* was exhibited for the first time, in Paris. This new soft-paste porcelain, developed after years of experiments by Lauth, the Sèvres chemist, was able to take enamel glazes in a range of strong and deeply translucent colours. At the same exhibition, Sèvres also showed a few pieces with crystalline glazes, and these were responsible for the dramatic developments in Denmark, at the Royal Copenhagen factory. With the publication in 1888 of the process by which they had obtained these remarkable effects, Lauth and his fellow-chemist Dutailly provided Copenhagen with a basis for further experiments. Thereafter, Sèvres itself followed in the wake of the Copenhagen achievements until the International Exhibition of 1900 in Paris, when both factories showed a dazzling display of superb crystalline glazes in company with a range of rich and glowing *flambés*.

To accompany these developments in glazing and firing, the Sèvres artists also considered the question of new shapes to take and show to advantage the special effects. In 1897 Alexandre Sandier became Director of Works of Art and his appointment coincided with the preparations for the forthcoming exhibition. With a choice of four pastes at his disposal—the old hard and soft pastes, *porcelaine nouvelle* and stoneware—he revolutionized the range of forms, introducing a number of new shapes of all sizes and types from ornamental to table-ware, to fit painted, modelled and glazed decoration. While some of the most dramatic developments were taking place in glazing, much of the Sèvres production

1900 was reflecting the shift in emphasis from the Japanese influence to the Art Nouveau style. Both shapes and decorations were based on plant and other natural forms and both embodied the sinuous and swirling movement characteristic of the style. One of the most successful interpretations of the Art Nouveau manner was in yet another material, biscuit porcelain, recently revived for modern designs. It was in this medium that Sèvres scored a further notable achievement at the exhibition, with a fifteen-part table-setting of female figures in loose and flowing garb holding a variety of musical instruments. The group was inspired by the American dancer Loie Fuller, who caused a sensation on her appearance in Paris. The figures were modelled by Agathon Léonard, and the set was entitled 'Jeu de l'écharpe' after Loie Fuller's notorious dance. It was such a success that it was subsequently produced in three different sizes.

By the late 1890s, the Sèvres team of designers was composed not only of factory staff but, equally importantly, of outside artists. It included A. P. Avisse, Louis Mimard, Taxile Doat, Albert Dammouse, Joseph Cheret, Hector Guimard (who designed stoneware shapes), L. Kann, Ernest-Emile Drouet and Bernard-Louis-Emile Jardel.

While such developments were taking place in the major industrial manufactory, equally exciting achievements were being made by individual artists. The master in the dedicated independent production of *flambé* glazes was Ernest Chaplet, leading all other artist-potters in France. For many years Chaplet was associated with the Haviland factory at Limoges, where other ceramists and artists such as Albert Dammouse and Felix Bracquemond were also employed. Bracquemond was responsible for one of the most famous Japanese-inspired undertakings of the period, a painted dinner service made by Eugene Rousseau in faience. However, Haviland's main effort was put into the production of *grès* or stoneware and in 1885 Chaplet left to concentrate on porcelain with high-fired glazes, first at the Haviland factory at Vaugirard, ceded to him in about 1884, and then at Choisy-le-Roi from 1887. His first success was with the *sang de boeuf* glaze, with which he also made his reputation.

Ernest Chaplet (1835–1909), probably in his studio at Choisy-le-Roi (from Roger Marx's book, 'Art et Décoration', 1910). Chaplet was the master ceramist of the French artist-potters and his grand feu glazes, particularly the sang de boeuf, were also admired and emulated in Germany and Denmark.

Left: Vase by Eugène Colonna, one of the principal designers for Samuel Bing's gallery, L'Art Nouveau. The vase is an explicit example of the elegant and sophisticated style which Colonna applied not only to porcelain but to jewellery, cutlery, textiles, and furniture. 1902. (Musée des Arts Decoratifs, Paris)

Above: Vase by Taxile Doat, an example of the extraorinarily skilful technique of combining pâte sur pâte and flambé glazing which Doat developed while he was at Sèvres. The vase also typifies Doat's distinctive 'gourd' or organic shapes. Height 35 cm; 1903.

war in 1870, Bing left for Paris; changing his first name to Samuel, he set up as a critic and dealer initially in Japanese art, at 22 Rue de Provence. His interest and energy in the cause of *Japonisme* did much to further an understanding of the art and the development of decorative and fine arts based on Far Eastern sources generally. However, by the mid-1890s he was ready to move on to new fields. About 1894 he went on an official visit to America, where he established a valuable contact with Louis Comfort Tiffany. Tiffany's production represented Bing's new ideal – a high quality artistic production in a wide range of materials, and in a new and unmistakably contemporary style. Resolving to educate the public to greater refinement, and to inspire artists to more beautiful and harmonious design, Bing returned to Paris. He cleared part of his shop and on 26 December, 1895, opened the gallery, L'Art Nouveau. His policy was to support the best and newest of artistic trends, especially in France but also from abroad, and this included painting and sculpture as well as all aspects of interior design and wares. He showed and sold pieces by the currently innovative generation of ceramists in the Art Nouveau style, particularly Eugéne Colonna and Georges de Feure, a proportion of whose work was made at Limoges. Both these artists worked in a variety of materials including porcelain, both specialized in a particularly elegant and refined version of the Art Nouveau style and both were patronized by Bing. In the late 1890s they produced designs for individual pieces as well as for table-ware, and these were manufactured by Bing under the name 'La Maison Bing' or 'L'Art Nouveau Bing'. In 1900 a private exhibition of de Feure's work was held at the gallery.

In addition to stocking the best of contemporary French porcelain Bing also sold pieces made by Scandinavian factories such as Rörstrand and Copenhagen, as well as stonewares by the American firms of Rookwood (famous for their 'cat's eye' and 'tiger's eye' glazes) and Grueby, and glass by Tiffany. From 1900 to 1903 he acted as European agent for Rookwood, selling for them from the International Exhibition in 1900 where he had his own private pavilion, and from the Turin Exposition in 1902, where Rookwood received a Diploma of Honour and Bing handled the display. Bing died in 1905, ten years before Rookwood began to produce porcelain, but his efforts had given them a foothold in Europe for the sale of such porcelain.

In 1898, another influential shop, La Maison Moderne, was opened at 82 Rue des Petits Champs, Paris. It was founded by the German critic, Julius Maier Grafe, with the express purpose of bringing the Art Nouveau style to a wider public. As with La Maison Bing, several important designers such as Maurice Dufrène and Paul Follot were associated with the enterprise. Both worked in several materials, including metal and leather, and Dufrène was responsible for a porcelain tea service made in about 1900 and marked with the shop's backstamp. La Maison Moderne also exhibited porcelain by Bing & Grøndahl and Theodor Schmuz-Baudiss, with faience by Max Läuger and Elizabeth Schmidt-Pecht.

Chaplet's work was the apex of French artist-potters' achievements. It was bought by collectors and his influence spread abroad, particularly to Denmark. In France he was surrounded by a circle of distinguished fellow artists, one of whom was Auguste Delaherche, to whom Chaplet sold the Vaugirard studio in 1887. Most of these artists began by specializing in stoneware and subsequently came to work in porcelain. Delaherche himself did not turn to porcelain until near the end of his life, in about 1925. Adrien Dalpayrat, however, was an early convert, beginning his researches in 1889 at Bourg-la-Reine. Emile Decoeur began making porcelain in 1907 at Fontenay-aux-Roses, Raoul Lachenal began in 1911 at Boulogne (following work in stoneware for his father Edmond). For all these artists, their previous concern with glaze effects on stoneware gave them good experience in firing at higher temperatures and achieving the dramatic reds and purples so closely associated with their work.

The production of porcelain in the Japanese and Art Nouveau styles in France by smaller manufactories and independent potters and artists received its greatest and most influential support from Samuel Bing. Born Siegfried Bing in Hamburg in 1838, he worked for some years in a ceramic factory in his birth town. On the outbreak of the Franco-Prussian

'Saigon couvert' vase by
Fernand Thesmar. Height
24 cm; 1895. In 1893
Thesmar was made
responsible for porcelains
and enamels at Sèvres.
Decorative pieces, such as
this vase, were produced
under the direct control of
the Minister for the Arts
specifically for the Sèvres
Museum and other prestige
showplaces and collections.
In 1895 Thesmar was given
his own studio in which he
produced these most
sumptuous porcelains,
decorated with a
combination of enamel
painting and gold cloisonné
enamelling. (Musée Nation-
al de Céramique, Sèvres)

Scandinavia

In 1884 Philip Schou, the new owner of the Royal Copenhagen works, removed the porcelain factory to Smallegarde, to the site of the Aluminia faience pottery which he had run and partly owned since 1868. He renovated and rebuilt the buildings, kilns and equipment, and in 1885 appointed a young architect and painter, Arnold Krog, as director.

Krog brought fresh ideas to the factory and set it on the road to a second renaissance. It was he who was responsible for the adoption and development of the underglaze painting technique which became a hallmark of Copenhagen production. In 1885 Krog and Schou went to London and Antwerp in search for new ideas and a new identity for the factory, studying Sèvres production particularly closely, wherever they saw it. The following year, an exhibition of Japanese and Chinese art was held in Copenhagen and, also in 1886, Krog visited Samuel Bing's shop in Paris where he saw the newly arrived consignment of Japanese and Chinese art and bought one or two examples. Copenhagen began to take on a look and style reflecting contemporary international stylistic developments, while retaining a freshly individual flavour in the new Copenhagen idiom.

Krog first experimented on Copenhagen's fine hard-paste body with the factory's technical consultant, Adolphe Clément. Their experiments resulted in the addition of underglaze red and green to the cobalt blue already in use, fired successfully at unusually high temperatures for such colours – between 1400° and 1500°C (2552° and 2732°F). The combination of the new underglaze range with Krog's style of painting and choice of subjects was an instant success. At the 1888 Scandinavian exhibition of Industry, Agriculture and Art, which was held in Copenhagen and contributed to by all the major northern countries, the manufactory established itself in the foremost ranks of innovative porcelain factories. The following year, Royal Copenhagen repeated its successful showing of underglaze-decorated wares at the International Exhibition in Paris and was awarded a *Grand Prix d'Honneur*, while also attracting very favourable comments from Alexandre Sandier of the Sèvres works and the influential critic Roger Marx. The limitations of the firing temperatures gave rise to the unmistakable colouring, particularly the blues and greens with which Copenhagen is most recognizably associated. These were thought extremely beautiful, particularly by the Sèvres chemists who had encountered enormous difficulties with underglaze blue on their own *porcelaine nouvelle*. The high quality of the porcelain and the simple shapes both gave the utmost support and scope to the painted scenes. These were generally based on the Danish landscape, and executed in styles varying from studied copies of the Japanese graphic arts to an atmospheric Danish romanticism. Individually painted pieces in the underglaze range were signed by the artist who painted them, and each piece is unique. The team included Krog himself, C. F. Liisberg (who was a sculptor and also modelled figures), F. A. Hallin, and Erik Nielsen, who

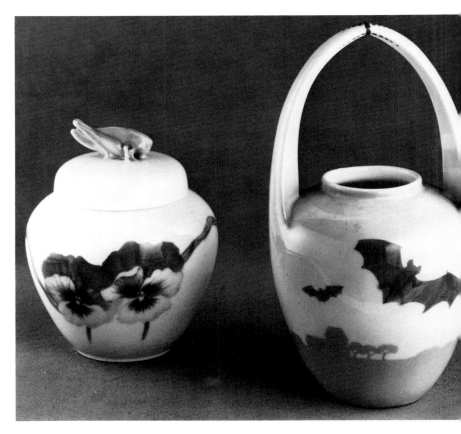

specialized in animal paintings; later, Christian Thomsen joined them, modelling small figures and groups and painting underglaze decoration. C. Mortensen, Th. Madsen and C. I. Bonnesen also contributed to this field. Other painters included Vilh. Th. Fischer, Gotfrede Rode, Benjamin Olsen, Stephan Ussing and Gerhard Heilmann. All these artists and others kept the Copenhagen factory supplied with a stream of painted or modelled subjects which proved enormously successful. The general art range included plaques, vases and ornamental subjects as well as table-ware, and also the well-known commemorative plates introduced by Krog in 1893. Also decorated underglaze were the figures of peasants, animals and children, each modelled directly from nature. In addition, Krog himself was responsible for many of the factory's table services. Particularly famous are the 'Marguerite' service (1894–1899) and the 'Fan' service (1909) which are fine examples in porcelain of the Art Nouveau and Japanese influences respectively, both perfectly merged with the Copenhagen style.

While Krog and Clément were re-establishing underglaze painting with such remarkable success, they were also aware of the contemporary passion for glaze decoration in the Chinese manner. The centre of this activity was Paris, but Copenhagen had its own similar movement and by 1888 the Danish collector William Salomonsen had brought examples of Chaplet's work to show his fellow enthusiasts. Karl Madsen, critic and connoisseur, through his connection with Samuel Bing, was able to bring a group of Japanese arts and crafts to the Scandinavian exhibition, and as a result of such activities and also of

personal visits to Paris by Krog and other ceramists the movement spread. Indeed, Royal Copenhagen itself exhibited a small group of vases with 'coloured glazes' at the Scandinavian exhibition in 1888.

The credit for the discovery and development of crystalline glazes must go to Sèvres and Copenhagen simultaneously. However, it seems certain that Clément saw the account of the Sèvres experiments published in 1888 and, working on the Copenhagen hard paste, showed his own results possibly as early as 1889 in Paris. On Clément's departure in 1891, his work was taken over by Valdemar Engelhardt, who was responsible for the development and fruition of the glazes, for their gradual appearance in exhibitions and contemporary factory and museum collections, for their purchase by Tiffany and other dealers and finally for their triumphant showing in Paris in 1900 alongside similar pieces by Sèvres and Berlin. Krog took full advantage of this new glaze development at Copenhagen and his team produced such figures as a frog on a waterlily leaf and a polar bear at a pool, to which the crystalline glaze gave an added and authentic dimension. Engelhardt was responsible for the development of a number of other glazes such as the 'cat's eye', 'tiger's eye' and 'snake's skin' and by 1911 his crackled glazes were exhibited. Soon they were in production with complete control, the network of cracks in the glazing manipulated in the firing from fine to coarse across the body of the piece. This *craquèle* ware became one of the outstanding features of Royal Copenhagen's art range in the twentieth century.

Arnold Krog maintained his position as director until 1915, then became artistic advisor until his death in 1931. Around 1900 he reintroduced overglaze painting to the production and in 1905 began new manufacture of the plain white 'Juliane Marie' porcelain. This was taken from earlier, rare examples, sometimes also painted overglaze and marked additionally with a crow to distinguish it from the earlier white porcelain. With the 'Blue Fluted' service (which also attracted renewed attention at the 1888 exhibition) and the continued manufacture of domestic and utilitarian wares, the firm had a range of wares which ensured Copenhagen's reputation in all fields of porcelain production.

Bing & Grøndahl, Royal Copenhagen's competitor, was opened in 1853 by F. V. Grøndahl, a modeller from the larger factory. Joining with M. H. and J. H. Bing, owners of a large retail shop (apparently not connected with Samuel Bing in Paris), he began producing figures and reliefs in parian porcelain based on the work of the Danish sculptor Bertel Thorvaldsen. Grøndahl died while production was still at an experimental stage, and the Bing brothers continued the business by employing foreign craftsmen. They began to contribute to industrial exhibitions and in London in 1871 they showed the large parian figure of Hebe, now in the collections of the Victoria and Albert Museum. Their first important international success was in Paris in 1889 with the ambitious 'Heron' service, designed in elaborate and sumptuous Japanese style by the art director Pietro Krohn, who was one of the central figures in the

Copenhagen circle of *Japonisme* enthusiasts. In this service the manufactory employed for the first time an underglaze technique of fully painted decoration executed with complete mastery. This service established Bing & Grøndahl, and by the time of the International Exhibition in 1900 their pieces were as widely acclaimed as Copenhagen's. Figure production formed an important part of Bing & Grøndahl's work. Kai Nielsen, who joined the company just before the First World War, modelled the most individual pieces—heavily sculptural, plastic forms which took figure production into the field of fine art. J. F. Willumsen became responsible for art production, and Effie Hegermann-Lindencrone and Fanny Garde, from the late 1890s until well into the twentieth century, gave the firm an individual line, although many of their standard painted wares were very much like those of Royal Copenhagen.

The two Danish companies raised figure-making to a new level. Moving away from the eighteenth-century rococo style which had persisted under various guises throughout the first three quarters of the nineteenth century and from the classical, parian phase they entered into a new field, producing small ceramic sculptures in the modern idiom. Also, as in the field of glaze experiment, Copenhagen led with the work of Arnold Krog, who developed an impressively advanced abstract technique, partly as a natural result of his own artistry and partly in response to the necessary limitations of slip-casting and the underglaze colours. By the early years of the twentieth century such progressive work was further developed by German firms such as Meissen, Berlin and Nymphenburg.

The two other great Scandinavian firms were Gustavsberg and Rörstrand. Gustavsberg began making porcelain in the early 1860s. Like most Scandinavian potteries it followed the British in making a bone china. Gustavsberg's nineteenth-century porcelain productions were fairly cautious

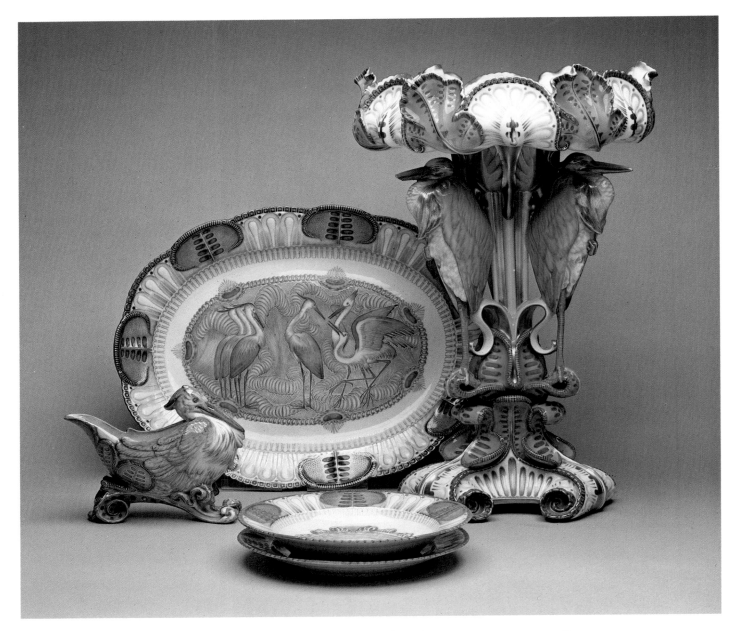

Pieces from the Bing and Grøndahl Heron service designed by Pietro Krohn. Krohn was a sculptor, ceramist, illustrator, artist, and central figure in Copenhagen Japanism circles, and in using the traditional underglaze blue on this elaborate service in the Japanese style, he raised the technique to previously unimagined heights, and scored a notable success at the International Exhibition in Paris in 1889. Height of centre-piece 51 cm; 1889.

although some handsome pieces were made under Gunnar Wennerberg's direction between 1897 and 1914. Wennerberg worked both in a *sgraffito* technique and also in a broad, flat, patterning that gave Gustavsberg a distinctive style; this was also used by Josef Ekberg on the *grès* and faience side of the production.

Rörstrand began production of a bone china in 1857 but turned to making hard-paste porcelain in the 1870s. Between 1895 and 1914 Rörstrand's most influential designer was the art director, Alf Wallander. With several colleagues including Nils Erik Lundström, Algot Erikson, and Karl and Valdemar Lindström, Wallander produced a wide range of decorative and table-wares in an attractive Art Nouveau style which achieved its main effect through delicate, sculptural modelling of flowers and figures, very often in deep relief and merging into the body of the piece, enhanced by subtle underglaze colours.

Russia

One other interesting area of production was Russia, where the making of ornamental figures had become established shortly after their first appearance in the eighteenth century. Representing the many different peoples within the Empire, each figure was distinguished by local costume and craft. The major factories, particularly the fast-growing Kuznetsov pottery, all made their own range, and all maintained an unmistakably Russian style, attractive but simple and directly representative, quite unrelated to the romanticized and fanciful European figures, despite their contemporary beginnings. In 1901 the Imperial Porcelain Manufactory was reorganized and from 1907 it too issued such figures in its 'Peoples of Russia' series designed by P. Kamensky. These were also produced by the same factory after the Revolution, as Soviet State Porcelain; they were then made with a fine accuracy of detail.

Parallel with this independent development, Russian factories generally followed European stylistic fashions, reviving the rococo with gilding, painting and modelling in identical manner to other manufactories. In addition, by the early 1890s they too had taken note of the glaze experiments in France and Denmark and were making their own 'art ware', decorated with mottled and splashed glazes. They also produced underglaze painting in a somewhat diluted imitation of the Copenhagen style, and this they exhibited in 1900 with a number of *pâte sur pâte* wares.

The United States

While European potteries were making such technical, chemical and stylistic advances there was a similar burst of activity across the Atlantic. A number of American potteries produced porcellaneous (hard-fired stoneware) or porcelain wares. Mary Louise McLaughlin embarked upon a significant enterprise at her home in Cincinnati, Ohio. Her porcelain wares were entitled 'Losanti' after the original name of the city, Losantiville. Beginning as a china painter, McLaughlin experimented for eleven years with earthenware. In 1898, she began production of a hard-paste porcelain. After exhibiting the successful body at the Pan-American Exposition at Buffalo in 1901, McLaughlin turned her attention to decoration of the new porcelain. In this she experimented with carving and cutting and also with various high-temperature glazes in which the colouring ranged from blues and greens to pinks. Her achievements were noted and praised by two of the most important and interesting potters to be engaged in experimental porcelain in the United States, Adelaide Alsop Robineau and her husband Samuel Robineau.

On their marriage in 1899 the Robineaus moved to Syracuse, New York, to found the magazine *Keramic Studio*, with George Clark. At that time Mrs. Robineau, like Mary Louise McLaughlin, was a china painter, and *Keramic Studio* became the official publication of the American League of Mineral Painters. In 1903, when Samuel Robineau was translating Taxile Doat's text, *Grand Feu Ceramics*, he and his wife determined that they should themselves try producing porcelain with such glaze effects. Adelaide Robineau attended a summer course in ceramics at Alfred University, New York, and by 1904 they were exhibiting the first examples of their porcelain at St. Louis; later that same year they exhibited crystalline glazes at the Art Institute in Chicago. Within a few years they were employing the most advanced techniques including, in 1908, experimental *flambé* glazes in a wide range of reds and purples. Achieving mastery in all aspects of porcelain production from throwing (up to 17 in, or 43 cm in height) to elaborate decoration in the form of detailed carving, perforation and incising, their crystalline glazes were of a quality to impress Taxile Doat, to whom Mrs. Robineau sent examples shortly before his departure for America in 1909. Samuel

Robineau worked with his wife constantly, developing glazes and supervising the firing of each piece. The 'Scarab' vase, made for the American Women's League at St. Louis, was one of their most ambitious projects, representing a thousand hours of carving work. Doat was by then director of the ceramics school, and it was he who advised on repairs to the base, which cracked in the first firing. Adelaide Robineau's work also included the even more elaborate and skilfully carved egg-shell porcelains, expertly fired by her husband.

The American Women's League had been launched in 1907 by Edward Gardner Lewis and was centred around the People's University correspondence courses at University City in St. Louis, Missouri. It was dedicated to the 'integrity and purity of the American home, with wider opportunities for American women'. Exceptional students were invited to University City to study in the various departments which included, in the Art Institute, painting, metal and leather work as well as ceramics.

Below: 'Losanti' vase by Mary Louise McLaughlin. The pierced decoration between the blossoms and the tendrils has been closed over by dipping in thick white glaze. Height 13.4 cm; c. 1902. (Cincinnati Art Museum)

Right: 'Scarab' vase by Adelaide Alsop Robineau, shown with other Robineau porcelains at the Turin Exposition of 1911. The entire group was awarded the Grand Prix, a Diploma della Benemerenza, and described as 'the best porcelain in the world'. Height 41 cm; 1910. (Everson Museum of Art, Syracuse, New York)

Early in 1909 Taxile Doat made his first visit to supervise the design and construction of the pottery and its equipment. He returned towards the end of that year with two colleagues, Eugene Labarrière and Emile Diffloth (former director of Boch Frères, La Louvière, Belgium) and a collection of his own work.

The first firing under Doat's supervision was made in August 1910, the year of the 'Scarab' vase firing, and in 1911 the department's work was exhibited at Turin where it was awarded the Grand Prize. Their range of glazes included matt and glossy, crackled and crystalline, and an unusually wide spectrum of colours. Unfortunately, in the year of the Turin success, the League itself collapsed, closely associated as it was with Lewis's other unstable activities. Frederick Rhead, the Staffordshire man who was Inspector of Pottery, and the Robineaus departed.

By 1912 the Pottery had recovered somewhat, thanks to an influx of new staff, and Doat continued to work on the production of porcelain and porcellaneous bodies. However, three years later there were plans for the removal of the Pottery to the Lewis's home in Atascadero, California, an offshoot colony of the League, and Doat returned to France.

Aside from the work done at University City, some other American potteries produced porcelain or porcellaneous art wares. These included the Teco Pottery in Illinois, which experimented with crystalline glazes, Knowles, Taylor & Knowles, Ohio, producing their 'Lotus' porcelain glazes and blanks for decorators, the Union Porcelain Works, New York, Ott & Brewer (egg-shell, Belleek-type wares) and, confusingly, Edward Lycett at the Faience Manufacturing Company, New York. Finally, the Tiffany Studios made porcellaneous art ware between 1905 and 1919 and the prestigious Rookwood Pottery Company began producing a porcelain body in about 1915. However, most American ceramists based their experimental glazes on stone or earthenware bodies.

Britain

This was also the case in England. The majority of individual potters and smaller potteries in Britain hardly considered porcelain or bone china at all for experimental art work. The Burtons at Pilkington, W. Howson Taylor of the Ruskin Pottery, Owen Carter at Poole, William De Morgan and William Moorcroft eventually all took an interest in exotic finishes, but concentrated on lustred effects and stoneware glazes. However there were a few exceptions. One was Richard Howson, working just before the First World War. Rather earlier, according to Llewellynn Jewitt in 1883, Thomas Bevington at Burton Place Works, Hanley made a range of china, known as 'Victorian Ware', in which the surface was covered with feldspar crystal decorated with veins of gold in imitation of gold-bearing quartz. G. L. Ashworth also put into use its experience of making ironstone china and produced a few experimental glazes under J. V. Goddard, although it seems these glazes were applied to their earthenware production only. The only manufacturers to carry out specialized glaze production on an internationally successful scale were Doulton and Bernard Moore.

Doulton began making bone china in 1883 following the establishment of the Staffordshire branch of the company in Burslem. It was J. C. Bailey who, after a trip to Limoges, finally convinced Henry Doulton that the firm could never compete with its Continental rivals without this superior material. The company's team of designers and painters was enlarged to include both local artists and artists from rival potteries in Staffordshire and abroad, even from Sèvres.

Doulton's bone china was produced initially for painted decoration and these wares were exhibited for the first time in a major display at the Chicago exhibition in 1893. There they attracted great praise, the elaborately modelled and decorated pieces outstripping all rivals in size and technical bravura. At this time an important new entrant to the firm was Charles John Noke, subsequently one of Henry Doulton's most influential directors, who joined the company in 1889 as a modeller. His first figures (that is, free-standing and not ornamenting a vase or other piece) were produced in the early 1890s in Doulton's parian-type body. They were quite unlike anything

Taxile Doat working on a dish for the American Women's League at the School of Ceramic Art of the People's University, University City, a suburb of St. Louis. c. 1910.

Above: Doulton jar from the 'Sung' range by Noke in the high temperature flambé glaze he helped to develop. Height 37.5 cm; c. 1925.

Below: Worcester vase from the 'Sabrina' range, a rather cautious 'art' range, dating from 1894, which was unlike their usual exquisitely and naturalistically decorated wares. Height 20.3 cm; 1907. (Dyson Perrins Museum, Worcester)

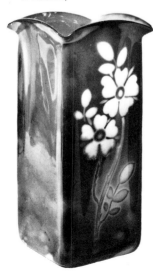

produced on the Continent and were a deliberate attempt on Noke's part to revive the Staffordshire figure tradition, an attempt which finally succeeded when he turned his full attention to the subject in about 1910.

In 1895 Noke introduced 'Holbein Ware' and in 1898 the 'Rembrandt Ware' range, both of which were based on special bodies and which remained in production until the First World War. However, the experimental *flambé* glazes on bone china for which Doulton became famous and which led to further dazzling achievements in the 1920s, were not developed until the early years of the twentieth century. Noke himself and colleagues John Slater and J.C. Bailey's son, Cuthbert, worked to obtain those same effects in which Sèvres and Copenhagen already excelled. Bernard Moore, experienced in such techniques but without the resources of a large industrial firm, willingly advised and acted as consultant and by 1904 Doulton's first successes were exhibited at St. Louis. Not only had they succeeded in producing the jewel-like glowing colours, but they had the technical control to produce them in quantity and consistently, using them on all types of decorative wares, including figures. The Doulton team added a further dimension to their pieces by painting them in dark colours with landscape and other scenes, which merged in the firing with the brilliantly *flambé* glaze. Cuthbert, Bailey and Noke were also responsible for the production of crystalline glazes, following again in the wake of Continental achievements. These were mastered by 1907 and shown with success in Brussels in 1910. While the crystalline glazes were dropped after 1914, the *flambés* were not only continued after the war, but were further developed. Noke and his son, Cecil

Jack, went on to create the Titanium glaze and the sumptuous Song, Chang and Chinese Jade effects, pioneering spectacularly in the inter-war period.

An admirer of the work of Théodore Deck and of that other lover of Persian art, William De Morgan, Bernard Moore was the only influential individual potter working on porcelain glazes. From 1872 to 1905 he owned St. Mary's Works, Longton, making porcelains under the name Moore Brothers, and experimenting first on lustres and later on *flambés* with Cuthbert Bailey. In 1905 he acquired premises in Stoke-on-Trent, whence he ran a consultancy and a workshop concentrating on porcelain and earthenware. The range of shapes were thrown and turned to special designs by another pottery in Fenton. Some were then reserved purely for glaze effects while others were decorated in reds, silver, gold or overglaze enamelling by a team of designers and decorators, some resident, some part-time, some still students at the local art schools.

In company with Doulton, in 1910 Moore sent some of his most brilliant pieces to Brussels, where almost his entire display was destroyed in a disastrous fire. During the following year, some replicas were made of those wares which had been destroyed, and Moore and his artists went on to produce various special pieces. In 1913 George V and Queen Mary visited the works and Reginald Tomlinson painted a vase nearly 3 feet in height to commemorate the occasion. Over these ten years Moore also widened his range of specialized glazes, adding Persian blues, aventurine and crystalline glazes to the basic *flambés* and lustres with which he had made his reputation. Although he had such a diverse team of artists, Bernard Moore's painted wares reflect his own interests. Many are based on Islamic motifs and painted freely in rich colours.

Holland and Bohemia

Most potteries, in addition to other types of production, had their own version of painted or printed contemporary motifs—either Far Eastern or Art Nouveau, or a combination of both. The manufacturer of some of the most notable painted porcelains in the Art Nouveau style was the Rozenburg factory in The Hague, Holland, founded in 1884 by W. van Gudenberg. From 1884 to 1889 Theodorus A.C. Colenbrander was chiefly responsible for the design of shapes and decoration. He had trained under the architect L.H. Eberson in Arnheim and had then studied in Paris. His work for Rozenburg reflects a sophisticated knowledge of Japanese decoration and pattern-making, rather than of the pictorial graphic arts so influential elsewhere, and also demonstrates his interest in textile design. In 1895 Colenbrander left Rozenburg to head a carpet factory in Amersfort, returning to the pottery industry in 1912 when he joined the faience works at Gouda. After his departure the most influential artists at Rozenburg were S. Juriaan Kok, who joined in 1884 and became Director after Colenbrander from 1895 to 1913, and S. Schellink, who was to invent some of the most

exotic decorative patterns of the period. With Kok and Schellink and a few other designers such as J. M. Van Rossum the firm produced what may be considered to be the ultimate and most distilled introspective Art Nouveau creations. Kok was responsible for a series of extraordinary shapes and Schellink designed delicate and sensitive patterns painted in a series of tense, nervous spots, lines and areas of subtle colour combinations which accurately enhanced the incredibly light, egg-shell-thin porcelain body unique to Rozenburg and developed by the firm's chemist, M. N. Engelen, under Kok's direction. These porcelains were shown in Paris in 1900 and were made until the First World War.

To a large extent, developments in Germany reflected those interests already described in the sections on France, Scandinavia and England. Glaze experiments were carried out on stoneware by Richard Mutz and Johann Julius Scharvogel at Munich, and these spearheaded similar developments by porcelain manufacturers.

In neighbouring Bohemia, some most extraordinary pieces were made by the Amphora Works established in 1892 at Turn (Trnovany). The pottery was primarily a porcelain works, although it also made stoneware. As early as 1893, in Chicago, Amphora exhibited its carbuncled, encrusted and exotic pieces with modelled masks and plant forms and eccentric outlines, which won prizes there, and in the following year at San Francisco and Antwerp.

Sugar-bowl, part of a service decorated with green dots, and with dots implied in the spaces in handles and top. Made in Bohemia at Elbogen (now Loket in Czechoslovakia). 1900. (Museum of Decorative Arts, Prague)

Germany

In 1884, Dr. Hermann Seger, the chemist at the Royal Porcelain Manufactory in Berlin, had introduced the *flambé* glazes, developing the special 'Seger porzellan' in the course of his experiments. Previously, Seger had his own workshop at Karlsruhe and was in contact with both Théodore Deck in Paris and Arnold Krog in Copenhagen. In 1878 a chemical-technical-experiments institute was established and Albert Heinecke was appointed director in 1888. Here he worked on crystalline glazes and these, with the *flambés*, were exhibited by the Berlin works at Paris in 1900 although apparently rather cautiously. Taxile Doat, in his *Grand Feu Ceramics*, says that these were subordinated in the Berlin display to the vast and elaborately painted porcelains, and only during the course of the exhibition, and after the much-publicized attention given to such porcelains, did the Manufactory give their pieces some prominence. Nevertheless, Berlin was making extremely successful high-temperature glazes for several years before the exhibition. Seger's own work had far-reaching effects in the porcelain industry. He wrote a number of invaluable text-book accounts of his technical experience and was responsible for the development of kiln test equipment such as 'Seger cones' (in 1882) and 'rings', used throughout the pottery industry today. While Berlin and Meissen were the only major porcelain works in Germany to commit a proportion of their output to these special glazes, some smaller manufactories also took up

crystalline and other experimental effects.

Design at Berlin was dominated by Theo Schmuz-Baudiss, who, working in a typically Art Nouveau style, was responsible for the introduction of a technique previously unpractised in Berlin, *sgraffito*. Schmuz-Baudiss joined Berlin in 1902 and was Director between 1908 and 1926. Previously he had studied at Munich and then learnt modelling, throwing, glazing and other aspects of the potter's art at a small pottery in Diessen before working in 1900 and 1901 for Swaine & Co porcelain works in Hüttensteinach. There he developed an individual style which combined modelling of small figures (animals, etc.), with relief and pierced work, and gilded and painted decoration. He was a close friend of the influential designer and earthenware ceramist in the Art Nouveau style, Max Läuger.

Nymphenburg also produced distinguished designs. Particularly notable was the fish-set designed by Herman Gradl and Louis Levallois between 1904 and 1906. On this service, the influence of the Japanese graphic decoration merged with the Art Nouveau style with superb success. While these developments in glazes and design paralleled similar work in other countries, Germany, in particular, made great advances in the specialist field of figure-making. Nymphenburg enjoyed something of a renaissance, and with Berlin produced some most stylish and elegant forms, modelled by Josef Wackerle, a distinguished designer who worked for both potteries between 1906 and 1909. Paul Scheurich shared his talents between Meissen, Berlin and Nymphenburg as well as other smaller potteries.

Theodor Kärner worked for Rosenthal and Nymphenburg for whom he designed, with faultless sophistication, bird figures such as the 'Guinea-hen' which, despite its naturalism, has a graceful decorative appeal. Adolf Amberg had studied in Berlin and Paris, worked in a number of different fields and designed for Berlin the table setting for the German Crown Prince's wedding in 1905. The set was not used on the intended occasion, perhaps because the bride was shown semi-naked as 'Europa on the Bull'. It was, however shown at the Berlin art exhibition in 1911, and the complete set consisted of nineteen pieces. It combined a striking, robust quality with fine, restrained painting, resulting in pieces that are vigorous, decorative and unmistakably of the twentieth century, despite their eighteenth-century heritage. The German potteries were particularly expert at such sophisticated production and were able to combine technical mastery with artistry of unusual power and effect. This applies both to the biggest manufactories and to smaller firms such as the Schwarzburger Werkstätten für Porzellankunst, Unterweissbach, Thuringen, founded by Max Adolf Pfeiffer in about 1908. To him goes the credit for

Nymphenburg 'Pierrot' group designed by the prolific sculptor Josef Wackerle. Although the group reflects its nineteenth-century heritage, its style is unmistakably twentieth century and illustrates the artist's sense of the exotic. Painted in underglaze colours, by Ludwig Carl Frenzel. Height 33.5 cm; 1910.

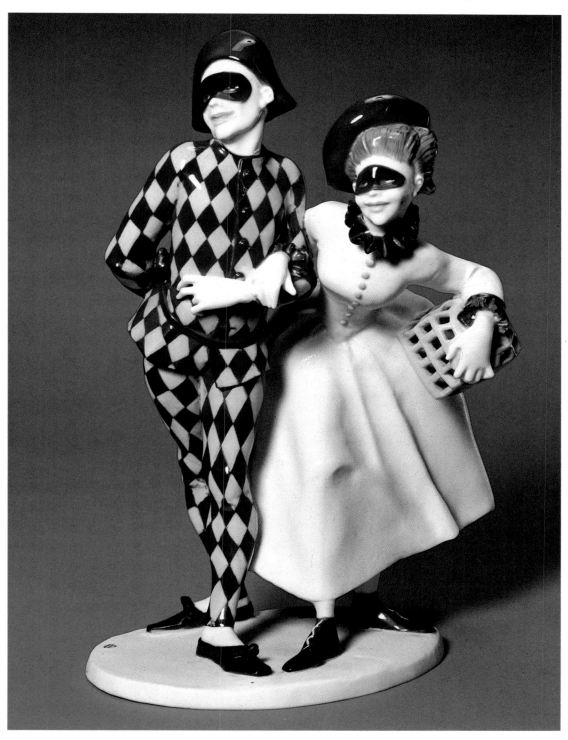

making a series of figures after models by the expressionist graphic artist and sculptor Ernst Barlach. These extraordinarily powerful figures were modelled by the artist after he had made a trip to Russia in 1906 and Pfeiffer then produced them in plain white porcelain for maximum effect. The same series was also produced in stoneware by Richard Mutz at his own pottery in Berlin in 1906 and 1907.

While elsewhere much of the porcelain manufacture was based on consolidating experimental glazes, in Germany, apart from the development of figure production, the early years of the twentieth century were distinguished by the first true products of the Modern Movement. As part of the impressively advanced and largely experimental work of the

Below: Table-ware from the 'Darmstadt' range by Philipp Rosenthal, a demonstration of his commitment to clean-lined, elegant forms. This was one of his earliest designs. 1905.

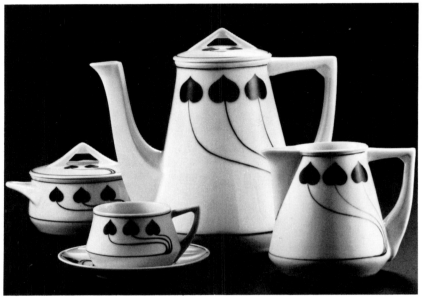

Darmstadt Kunstlerkolonie, founded in 1901 by a number of young architects and designers, Peter Behrens designed two table services in the first year. These were produced by the Gebruder Bauscher porcelain works in Weiden, Bavaria. One of the Darmstadt porcelain designers was the painter and graphic artist Hans Christiansen, who worked with the colony between 1902 and 1911; his rather ostentatiously 'smart' style perhaps reflects his international training in Munich, Italy, America and Paris. Albin Muller also achieved a highly sophisticated decorative style.

The Rosenthal Porcelain Works was founded by Philipp Rosenthal in 1880 at Selb, in Bavaria. This pottery, like its present-day counterparts in Sweden and Denmark, was to become one of the major innovatory works and even in its early years was responsible for much forward-looking design. Artists included Theodor Kärner, Karl Himmelstoss, who also worked for Berlin, Ferdinand Liebermann and Philipp Rosenthal himself who, between 1904 and 1910 designed three important services 'Darmstadt' (produced as part of the Darmstadt colony's output), 'Donatello' and 'Isolde'. All were produced initially in plain white and relied on their simple clean lines for effect. Subsequently, delicate heart-shaped motifs in Art Nouveau manner were added to the 'Darmstadt' set, and 'Donatello' was decorated with underglaze *pâte sur pâte*, painted decoration of cherries and also a surprisingly modern geometric pattern. These services set a precedent for high quality production and design with their functional shapes, characteristic of the best of twentieth-century production.

Meissen, the senior hard-paste porcelain factory in Germany, took on a new lease of life around the turn of the century and employed a number of contemporary artists. As in Berlin and Nymphenburg, some of

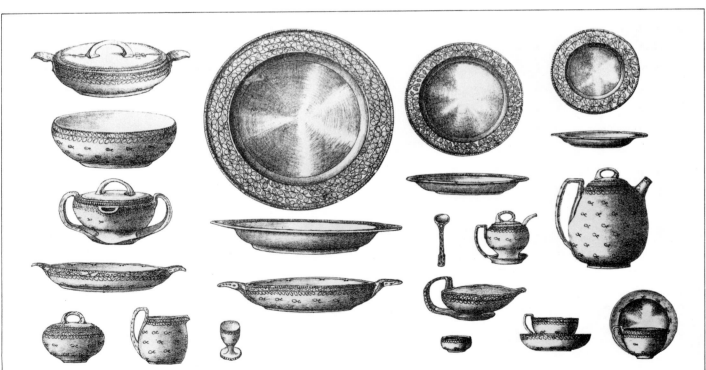

the best production was of figures—human, animal and bird—by Paul Scheurich, Max Esser and Hermann Fritz among others. In addition, Meissen apparently also took note of the developments at Darmstadt, and in about 1905 the architect, artist and designer Henri van de Velde designed a tea service for the Meissen factory. At this time a number of smaller, progressive porcelain works mushroomed into importance such as Gebruder Heubach, Thüringen, founded in 1822 and already famous for its manufacture of porcelain-headed dolls. In the early years of the twentieth century the Heubachs employed such artists as Paul Zeiller, who specialized in animal figures.

Austria

While events in Darmstadt were beginning the Modern Movement in Germany, activities in Austria were establishing similar ideas. The Vienna Secession was founded in 1897 by a group of young painters, sculptors and architects dedicated to the overthrow of conservatism in the arts and design and to revolutionizing taste. Fired with a missionary zeal, the associates of the Secession included Gustav Klimt, Josef Hoffmann, Koloman Moser, Oskar Kokoschka and Dagobert Peche. Hoffmann, Moser and Peche designed tableware and decorative porcelain. By 1898 they had contacted the ceramic department of the Weiner Kunstgewerbeschule and the Wiener Porzellan Manufaktur Josef Böck. In the same year the first experimental designs were made by Moser and a student at the school, Jutta Sika.

In 1900 the work of Charles Rennie Mackintosh and C.R. Ashbee was featured in the Secession's eighth exhibition with that of Henry van de Velde and La Maison Moderne of Paris. As a result, Moser and Hoffmann visited England and Scotland and, impressed with the Ashbee workshop principle they returned to Vienna. In 1903, they founded the Wiener Werkstätte, the central association of artisans in various branches of the applied and decorative arts and architecture. It was supported and directed by Fritz Wärndorfer and its programme was devoted to an intense and complete revival of aesthetic standards. Porcelain production was undertaken until 1914 by a number of manufactories, including Josef Böck, with designs produced by Hoffmann, Moser and Peche and ex-students from the school such as Sika and Thérèse Trethan. Most of the designs were innovatory in both shape and pattern. A number of people were involved in this artistic renaissance. Emil Adam, for instance became a professor at the Kunstgewerbeschule between 1899 and 1901 after a long career in ceramic chemistry, and some experimental glazes were made by the school at this time. In 1902 he became technical consultant with the Kunstkeramischen Fabrik A. Förster & Co. This firm was bought out by the Wiener Kunstkeramische Werkstätte Busch & Ludescher (whose designers included Anton Puchegger, Robert Busch and Michael Mortl) in 1908. In 1910 Busch & Ludescher were exhibiting underglaze

painting and crystalline glazes in the International Exhibition held in Brussels. Other porcelain manufactories which were responsible for some Wiener Werkstätte production were Pfeiffer and Lowenstein, Schlakenwerth (around 1910) and, after the First World War, Keramos (the Wiener Kunstkeramik und Porzellanmanufaktur), and even the Berlin factory.

In 1905 Michael Powolny and Berthold Löffler founded the Wiener Keramik studio which produced not only porcelain but also a number of advanced table-ware and figure designs in earthenware. In 1912 it joined with the Gmundner Keramik to become the Vereinigte und Gmundner Keramik.

Art Nouveau as a style developed over a short period from the mid-1890s until the International Exhibition in Paris in 1900 which saw both its highest and its final glory. After 1900 the style was spent and quickly deteriorated. Its place was taken by the first intimations of the Art Deco or Jazz Modern fashion which in turn culminated in the display at the next Paris exhibition in 1925. Many of the motifs associated with the Art Deco style can be seen quite early on, in some Wiener Werkstätte designs and in the work of Bing & Grøndahl, particularly the decorative figures with their rounded, pierced decoration, swags of flowers and bright colours. At the same time the progressive designs of Hoffmann, Sika and others laid the foundations, with the Darmstadt production, of a more cerebral and socially concerned modernism which during and after the First World War became the foundation of the international Modern Movement.

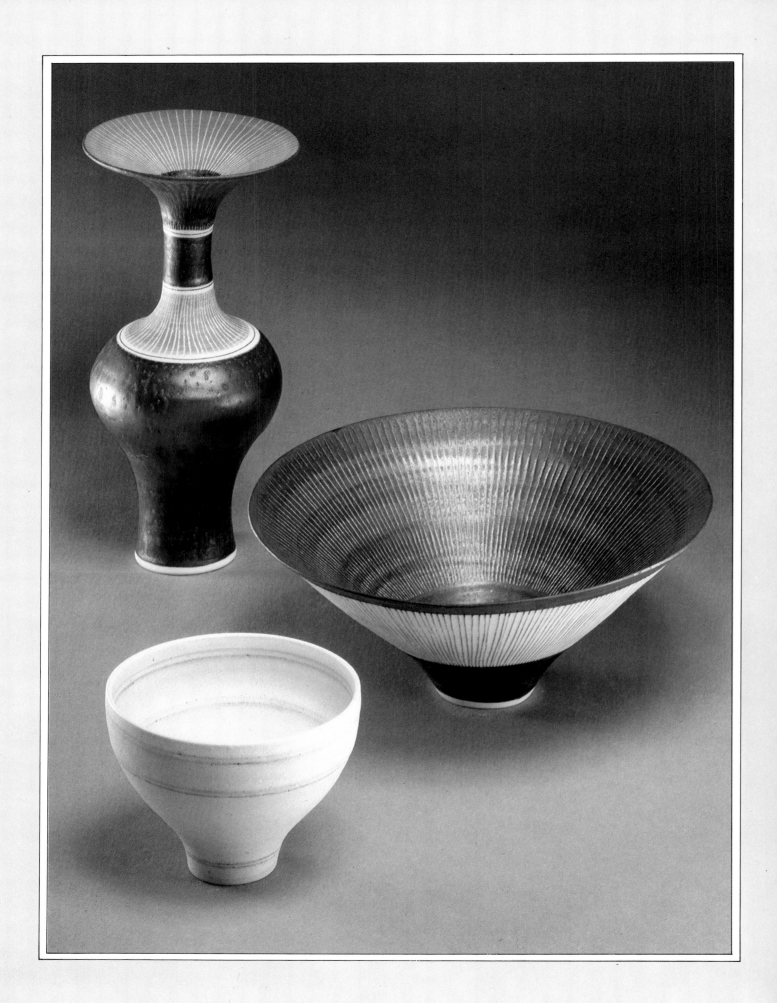

Chapter Twelve
Twentieth-Century Studio Porcelain

Vase and bowls by Lucie Rie, an Austrian potter who has worked in England for many years. The vase is one of her most characteristic forms with its wide flaring rim, while the bowls demonstrate her dexterity in surface decoration with a combination of sgraffito and inlay techniques. Height of vase 22.5 cm; 1981; diameter of foreground bowl 12.7 cm; 1976.

PORCELAIN is generally considered to be the most complex and uncooperative clay body to work with. Countless problems can beset its successful production. For example, it is more liable than stoneware or earthenware to kiln disasters, such as distortion, glaze shrinkage or total collapse. Many porcelain bodies are also more difficult to manipulate than other clays, being of a less plastic consistency.

To some extent, these drawbacks accounted for the scarcity of studio or individual potters working in the medium in the first half of the twentieth century. Many considered it beyond their resources, and concentrated on stoneware and earthenware as their medium of expression. Aesthetic as well as practical considerations determined this preference. Porcelain tended to be associated with over-refined industrial production, whereas stoneware appeared to offer greater scope for experimentation in scale, texture and glaze effects.

However, over the last thirty years there has been increasing interest in porcelain, and today there are many specialists in the medium, and most potters include some porcelain in their range. Technical knowledge is now readily available through art colleges or recent specialist publications. Commercially produced porcelain bodies can also be purchased, to avoid time-consuming ingredient mixing.

The situation was by no means simple for the earliest studio potters. Their knowledge had to be gained empirically. The porcelain factories of Europe with their long-standing expertise were the obvious sources of technical knowledge, but even their skilled chemists could not provide the recipes for some of the desired new effects.

Early Twentieth-Century France

Pioneer artist-potters in France, Théodore Deck, Ernest Chaplet and Albert Dammouse were striving to simulate the monochrome *flambé* and *sang de boeuf*

Oriental glazes of the Chinese Qing dynasty which were much admired at the 1878 Paris Exhibition. The problems they faced with chemistry of bodies and glazes were enormous, but gradually, exciting effects were achieved on both stoneware and porcelain. Much of their early success can be attributed to the cooperation of the porcelain industry. In his experiments Chaplet had the support of the Haviland factory at Limoges. The state porcelain factory of Sèvres also played an important role; many of these early potters had worked there at some stage in their careers. Deck ultimately became art director, the first practising potter to be so honoured.

A new wave of inspiration from the Far East affected the next generation of French studio potters. The earlier wares of the Chinese Tang and Song dynasties came to be appreciated in Europe at the beginning of the twentieth century. Soon these majestic and restrained pieces displaced the jewel-like Qing wares and set new standards of ceramic beauty to aspire to. Most of the French potters concentrated on accomplishing the new, subtle glaze effects on stoneware bodies but there was some interest in the early Oriental porcelains which ranged from the delicate translucent Ding wares to the thickly glazed celadon types—more aptly called porcellaneous stoneware. August Delaherche worked in both stoneware and porcelain during his extremely long career. At the turn of the century, like many others, he was involved with glaze experiments on both bodies but later he concentrated on porcelain, producing during the years 1925–1930 some very delicate white pieces with engraved decoration. Fernand Rumebe was achieving some interesting flame-like glaze effects on porcelain during the inter-war years. The sculptor Seraphin Soudbinine, having developed an interest in ceramics, also used porcelain as one of his media. His bowls and vases, conceived in sculptural terms, display a sensitivity new to the craft. Emile Decoeur also devoted much of his energy to porcelain experimentation as well as

to the more usual stoneware. By 1927 he had developed a particularly fine and plastic porcelain body which he used to effect in his refined Oriental forms. As one of the most accomplished French potters of the period, Decoeur was commissioned by Sèvres to design shapes for quantity production and eventually was elected their artistic adviser.

Britain before 1950

In Britain a different studio-pottery aesthetic had developed which tended to preclude such beneficial cooperation between potters and industry. Based on Bernard Leach's interpretation of the spirit and techniques of Far Eastern ceramics, the potter assumed total responsibility for the creation of his pot from the digging and pugging of his own clay and the throwing, to the firing, ideally in a personally constructed kiln. By stressing the discipline of tradition and encouraging this intimate contact with the material Leach believed that the timeless spiritual qualities of the pot would prevail over the idiosyncrasies of personal vision.

Leach had developed these theories while studying ceramics in Japan under the supervision of the Sixth Kenzan. During his studies he experimented with a wide range of bodies and glazes including some porcelain. His earliest pieces date from 1911 and are derived from Ming dynasty wares with underglaze enamelled decoration. Other early experiments were of the Yingqing type, quite thickly potted porcelains with pale blue-green glazes.

On his return to England in 1920 his porcelain

production became sporadic. There were occasional experiments, notably some porcelain plates with incised and coloured decoration reflecting his early etching interests. Leach became more engrossed, however, with English country pottery traditions. For several years he produced mostly slipwares or stonewares in the early Oriental tradition. He confined himself to unrefined clays and glazing materials of local origin and, as porcelain bodies could not be achieved in this way, they did not feature prominently at this time. The enthusiasm with which many other English potters greeted his theories meant that they, too, temporarily ignored porcelain.

Eventually recognizing the limitations of slipware in contemporary life, Leach's enthusiasm for low-

Above: 'Company Car', a model by Anne Potts who specialized in this type of novel figurative group at the studio established by Bullers, the English manufacturers of electrical porcelain. 1937.

Left: Lidded pot with underglaze decoration by Bernard Leach. One of Leach's earliest porcelain pieces, this was made at the pottery of his teacher, Ogata Kenzan, in Tokyo. Diameter 10 cm; 1913.

Right: Bowl with pierced floral motifs by Lisbeth Munch Peterson. The Danish pottery, Bing and Grøndahl, commissioned the artist to produce translucent, intricately pierced porcelain of this nature, as well as stoneware. c. 1972.

fired wares abated and he once more experimented with high-fired porcelain. He greatly admired the noble simplicity of Tang and Song wares and of the Korean Koryo dynasty, and set himself this standard. However, for many years he found it difficult to achieve a satisfactory porcelain body suitable for throwing like the ones he had worked with in the East.

A porcelain body which could be hand-thrown easily was, in fact, already available within the ceramic industry. Bullers, the manufacturers of insulators and other electrical porcelain components, worked with such a body and its potential for craft use was recognized by Gordon Forsyth, the principal of the Burslem School of Art. He purchased a quantity of their hard-paste clay for the use of his students and it was so successful that he was encouraged to suggest to Bullers that his students be allowed to experiment within the factory. In 1934, a studio was established under the guidance of Guy Harris, Bullers' chemist, and under the nominal control of Anne Potts, a protégée of Forsyth. With an excellent body, sophisticated kilns, the technical expertise of Harris as well as the patronage of Bullers, the studio had extraordinary potential.

Anne Potts specialized in novel figurative groups, revitalizing the Staffordshire figure tradition, whereas Harris was concerned with recreating Oriental glazes, celadon, *temmoku*, *craquèle* and *flambé* on either thrown or slip-cast shapes. These works attracted considerable interest at various exhibitions and many items were bought for museum collections. In 1939 when Anne Potts left to marry, the studio's future was in jeopardy but she was successfully replaced by Agnete Hoy, a Danish potter recently arrived in England. Her working methods at the studio reflected her Scandinavian training. She was responsible for most of the shape designs which were produced in series on the wheel, then decorated by herself or her assistants. Until its eventual closure in 1952, Hoy developed an industrial studio which rivalled many of its better-known Continental equivalents.

Scandinavia

A studio within a porcelain factory, although unique in twentieth-century English industry, was commonplace in Scandinavia. Between the wars, Gustavsberg and Rörstrand in Sweden, and Arabia in Finland established studios where individual potters could take advantage of all the technical resources of a large concern. In this system the potter would conceive the piece and technicians would provide the necessary clays, glazes and firing conditions.

Surprisingly, considering the wealth of porcelain knowledge at their disposal, the majority of studio potters conformed to the current European vogue for stoneware, and only a limited amount of studio porcelain was produced in the inter-war years.

At Royal Copenhagen in Denmark the excellent porcelain bodies developed by Arnold Krog seem to have been more fully exploited. Thorkild Olsen was

their most versatile artist, able to turn his hand to overglaze decoration on *craquèle* porcelain bodies as well as designing vases and bowls in *blanc de chine* ware, often with delicate ribbed and pierced decoration. This beautiful, milky-white porcelain body was frequently used at Royal Copenhagen for sculptural groups by modellers such as Gerhard Henning and Arno Malinowski.

The enlightened management of the Scandinavian factories continued to flourish after the Second World War. At Arabia, a permanent staff of twenty-five artists, each with his own studio, concentrated on different aspects of studio pottery. Aunne Siimes and Friedl Kjellberg are the leading specialists in porcelain. Kjellberg has developed a special carved decoration somewhat after the style of Bohemian cut

Right: Vase painted in underglaze colours by Thorkild Olsen, one of the major artists at the Royal Copenhagen factory between the wars and during the early post-war period. As well as excelling in underglaze painting on porcelain, a process particularly associated with Royal Copenhagen, Olsen also produced finely ribbed and pierced porcelain bowls.

glass. She has also revived the complicated Oriental technique of rice porcelain while Siimes has used porcelain effectively for costume jewellery.

The Rörstrand factory also supports salaried studio potters who alternate between designing for mass-produced porcelain table-wares and producing individual pieces. Notable at this establishment is the work of Hertha Bengtson who plays with the contrast between shiny and matt glazes on porcelain boxes and bowls; and also the Orient-inspired wares of Harry Stalhone, one of Sweden's leading ceramic artists.

Gustavsberg has specialized for nearly a century in the production of bone china, a material rarely used on the Continent. Stig Lindberg, their chief designer

and studio potter, has used it successfully in a wide range of designs and exonerated a material previously contemptuously regarded by studio potters.

Several potters, after training at one or another of these establishments, have set up individual studios to make porcelain. Ursula Mogensen, for example, has worked at both Gustavsberg and Royal Copenhagen and now uses the technical skills acquired there to make a variety of porcelain wares, from lampshades to jewellery, in her studio at Holte.

Britain, America, after 1950

From the technical point of view, the porcelain produced in the Scandinavian factory environments has rarely been rivalled. However, in Bernard Leach's view, the alliance between potter and industry was achieved at a price. There were, he believed, aesthetic limitations imposed by the Scandinavian working method, and he was not prepared to make similar compromises in order to work within British factories. Consequently, a state of mutual scepticism developed between the studio potter and industry.

For quantity production, particularly of wares for daily use, Leach advocated the sharing of a studio by several potters. Each individual potters still retained total responsibility for his own work, but there was the advantage of a lively interchange of ideas, techniques and recipes. Leach's own pottery at St. Ives was organized on this basis and manned by his sons, a succession of experienced potters, and students of the craft from all over the world.

Most of the work produced in series was stoneware, but around 1950 Leach finally developed a porcelain body that satisfactorily fulfilled his requirements. The new body was effectively used for both individual pieces and for table-ware ranges which appeared in the catalogue. It was not of the dazzling white or translucent variety, both qualities expected of porcelain in the West, but much quieter and heavier, closer to jade or marble in appearance. Leach described it as a cross between early Korean and Chinese porcelain.

One of his most successful porcelains, in his own opinion, was a celadon-glazed bowl of 1950 with free-hand rhythmic fluting which achieves the serenity of its Oriental precursors. Other works of the period include Song-style bottle-vases and bowls and occasional table-wares, usually decorated with bluish-green celadon-type glazes.

Also working with porcelain at St. Ives was the American potter Warren McKenzie. On his return home in 1952 he continued to experiment, producing some excellent Oriental glaze effects, mainly on vases, jars and bowls. Through his teaching at Minneapolis, McKenzie was also influential in establishing the Song standard among young American studio potters and, indirectly, dispersing Leach's philosophy.

Bernard Leach's son, David, became increasingly interested in porcelain during his last years at the St. Ives pottery in 1951 to 1955. He was concerned with achieving a translucent, as well as a highly plastic

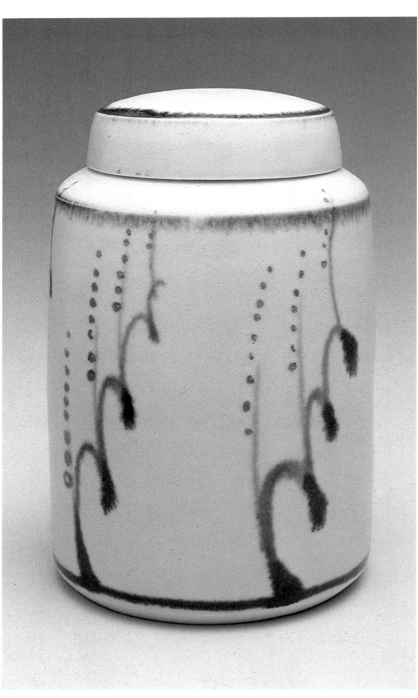

Jar and cover with painted decoration by David Leach. Leach played a unique role in the popularization of porcelain among English studio potters both by his successful experiments with porcelain bodies and by example of his own work, Oriental style functional wares.

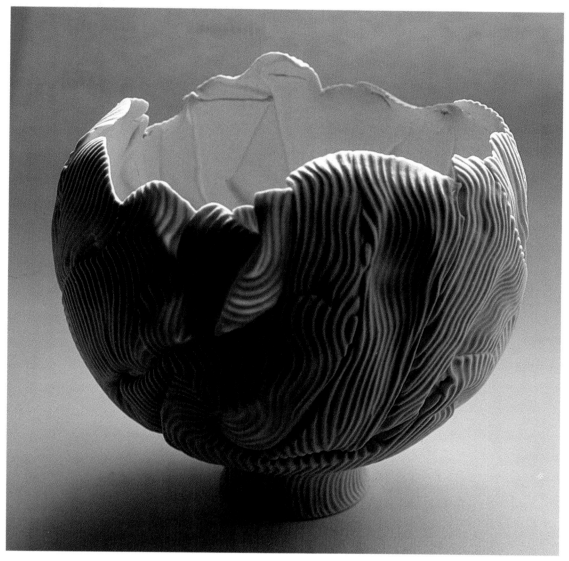

In an effort to create the effects of natural forms Mary Rogers has turned to making pottery by hand. Her 'Interpretation of a folded flower' (right) is one such hand-built form, folded and then carved to create a pattern of light and shade, thus further enhancing the translucency of the porcelain. Height 13 cm. Her 'Poppy head unfurling' (below) shows how, by pinching and otherwise manipulating of the porcelain body, the normally elusive quality of an opening bud can be captured.

body. His early studies at the North Staffordshire Technical College helped to equip him for this task. With considerable help, also, from the chemist Edward Burke, he eventually refined his experiments to one successful recipe which is still widely used by potters for either throwing or hand-building. This recipe also formed the basis for a body which Podmore & Sons have produced commercially. With a porcelain clay so readily available, more potters were disposed to tackle the medium. Thus David Leach has played a unique role in the recent renaissance of porcelain among studio potters. An excellent example has also been set by his own work, which consists mainly of functional wares derived from Oriental forms and decoration.

The wares of the early Chinese and Japanese potters have had the most profound and enduring influence on the studio pottery movement. During the fifties, however, new directions began to be explored, some of which have not only led to a rejection of Oriental standards but have ultimately revolutionized traditional ideas about pottery.

When Lucie Rie arrived in London in 1938 she was totally overwhelmed by the work of Bernard Leach. Her own style, developed in Austria, was submerged by the new aesthetic. In the late 1940s, however, Lucie Rie recovered her own individual style, experimenting with strong, clear-cut shapes which would harmonize with functional furniture in a modern setting. Until that date, most of her work had been in stoneware, and although she continued to make quite massive pieces in this medium, it was inevitable that she should eventually choose porcelain when striving for a pure profile and wafer-thin quality. She developed a wide range of exquisite forms on which she devised various glaze effects and finishes. Glossy or matt glazes in shades of white and cream, black and a distinctive yellow were often textured with fine incised lines or inlaid with contrasting pigments. These refined and sensitive works were superb illustrations of a modern European aesthetic applied to porcelain.

Another European who has been extremely influential in Britain and America is Ruth Duckworth. Of German extraction, she began to work as a sculptress in London in 1944. After encountering Lucie Rie on a scheme to make ceramic wall reliefs, she decided to concentrate on pottery. She began by

making functional wares but her sculpture background soon suggested to her the greater potential inherent in the clay, and she started to experiment with new forms during the late 1950s.

Throwing as a technique had dominated the studio pottery movement, mainly owing to the Eastern ideology of Bernard Leach. Ruth Duckworth, however, took advantage of all the building methods at her disposal. By coiling, modelling, slab-building, slip-casting, throwing or sometimes combinations of these techniques, she has produced a wide range of work from robust stoneware constructions to fine porcelain abstractions. As a medium for sculpture, clay has exceptional potential which Ruth Duckworth has admirably exploited. It is capable of a great variety of surface texture from rich glaze effects to exposed rough and tooled bodies or highly polished finishes. No stone has been left unturned by this talented sculptress, and her prolific and diverse output has exploded traditional concepts. Her work and her contagious enthusiasm, channelled through her teaching, have been an important stimulus to pottery both in Britain and America, where she has lived and taught since 1964. Most of her porcelain pieces are pinched into shape. Rounded forms predominate, often in conjunction with thin wing or fin shapes. Natural imagery is her main source of inspiration, whether it be elements of expansive sea and landscapes or tiny bones and shells. The microbiological world is also a source of reference.

Making pottery by hand leads to a heightened awareness of natural forms according to Mary Rogers, who rose to the challenge of porcelain in 1960 and is

Left: Hand-built sculpture by Ruth Duckworth, whose main source of inspiration is natural imagery – in this case bone formation. Height 21 cm; 1975.

now one of the leading exponents in the field in England. Hand-building inevitably gives organic and asymmetrical effects similar to those in naturally growing forms, and a virtue can be made of necessity. By pinching and otherwise manipulating the uncooperative porcelain body, Mary Rogers has captured the normally elusive qualities of shells, veined leaf forms, lichen growths, opening buds, fungi, dehydrated vegetables and feathers, all of which she has been collecting for many years. Undulating landscapes punctuated by trees and rippling waters

Left: Group of porcelain constructions by Geoffrey Swindell. 1974. During this period Swindell was particularly fascinated by crustacea and other sea forms.

are also areas of stimulation, but she does not always confine herself to the resources of the countryside. Urban decay, such as rusting cars or peeling posters is also rich in imagery. Using the natural translucency of porcelain she has also experimented with light and colour effects, again inspired by natural phenomena. Speckled, dappled and camouflage patterns have been achieved with precisely applied specks of pigment.

Natural imagery also inspired the early work of British Geoffrey Swindell. He was particularly fascinated by crustacea and other sea forms and this is reflected in his tiny porcelain constructions. Later he became more interested in mechanical forms suggested to him originally by his tin toy collection. For these more recent works he has used press-moulding and hand-building techniques in conjunction with casts of assorted odds and ends, pen tops, buttons, nuts and bolts and aircraft kit shapes. Ultimately he hopes to achieve in his work a synthesis of organic and man-made forms and he has been experimenting with half-fish, half-beast assemblages. In Swindell's work the porcelain material is a means to an end. That is not to say that he is not sensitive to the material or that he would have equal satisfaction or results working in plastic, but rather the clay and glaze mania of Leach's era has not absorbed him. The material matters, but only within the total concept of the object.

The belief that idea and interpretation are of paramount importance is now quite common among makers of ceramic objects. This self consciousness has caused a division within the studio pottery movement. As well as traditional potters there are now also ceramic sculptors. Work produced by artists in the latter category is extremely diverse and can range from allegorical statements in clay to studies in formal relationships. Those inspired by natural phenomena can be conveniently classed together in an 'organic school' which includes artists such as Mary Rogers and Peter Simpson, who is also British. In his early work Simpson was fascinated by fungi forms but recently he has concentrated on images evolved from bone structures, and which frequently also have a narrative theme inspired by Greek mythology.

The 'abstract school' has Gordon Baldwin as one of its main exponents in Britain. His porcelain and semi-porcelain constructions display an awareness of trends in contemporary sculpture in other materials. His sculptures also reflect his interest in the Surrealist Movement, particularly in the work of Arp and Duchamp.

Avant-garde movements in painting and sculpture have provided a wealth of new imagery for the ceramic artist. In Britain, Alison Nisbet has been making porcelain constructions reminiscent of the forms associated with Miro's work. Surrealist iconography has influenced the work of Canadian Ann Marie Schmid-Esler who makes 'fluffy' porcelain beds and pillows. It also pervades the witty presentations of Ingeborg Strobl who has made mugs with handles of bones or eggcups which stand on realistic hens' feet and claws.

In the fifties in America, clay began to be treated in accordance with the Abstract Expressionist philosophy. There were no preconceived notions; instead the material was handled spontaneously, pushed, hammered and torn as part of an emotional experience. Peter Voulkos is generally considered to have pioneered this revolutionary approach which became known as the West Coast Movement. Most of the work is in stoneware, this being a more robust, flexible material, but Voulkos occasionally experimented with porcelain. A few others followed suit, such as Ann Stockton, who treated porcelain plates like Abstract Expressionist canvases. She used splashes of pigment and created a wide variety of texture by placing shiny pools of glazes next to crackled areas.

'Stack of cards on brown book' by the American Richard Shaw. Inspired by the collages of artists such as Picasso and Schwitters, Shaw recreates familiar objects in slip cast porcelain and uses new ceramic silk-screening processes to simulate the originals. Height 40 cm; 1974.

New Techniques

Pop Art, Funk Art, the media, television and the movies have inspired a new wave of American ceramic art which has become influential throughout Europe. New techniques have been developed to cope with the new imagery. The airbrush as a means of applying colour is becoming increasingly popular as well as ceramic stencils, and photo-silk-screening. One of the most interesting American artists working

with these new techniques in porcelain is Richard Shaw. The collages of Picasso, Schwitters and the neo-dadaists have influenced his sculptures, which are assemblages of familiar objects. Newspaper cuttings, corrugated cardboard, letters and playing-cards are fashioned in porcelain, and silk-screened with ceramic inks to simulate the originals. But despite this increasing interest in new imagery and technology, wheel-thrown functional objects are still the staple products of the majority of potters in the United States, and to a certain extent throughout Europe as well.

The thrown form, however, might well provoke the envy of the sculptor when examples such as those of the German potters Karl and Ursula Scheid are considered. A husband and wife team, he creates most of the new shapes while her speciality is glaze effects, although she does also throw her own pots. Karl Scheid worked with Henry Davis in England during the early fifties and since then he has invented a great variety of excellent forms and has also designed for mass production in industry. Apart from pure thrown shapes he also constructs pieces that are a combination of hand-built and thrown elements.

Gerald and Gotlind Weigel, who are also West German, take the thrown form as their point of departure but then manipulate it to make a variety of entirely new forms. They are interested in glaze effects as well and have developed a particularly interesting crystalline glaze.

In Britain, Nicholas Homoky has arrived at very simple pleasing vessels by a process of elimination. The porcelain is left unglazed and inlaid with black pigment, giving a graphic quality to his work.

On the wheel it is difficult to make porcelain pieces higher than about eight inches as the clay tends to slump, whereas with other building

Above: Double-walled form and small covered box by West German potter Ursula Scheid. Working as part of a team with her husband, Karl Scheid, Ursula Scheid has evolved many stunning glaze effects. Her shapes remain independent, however, and are usually very soft and rounded. Large form height 15.8 cm, box 7.2 cm; c. 1979.

Left: Oval vase by West German potter Gotlind Weigel. Using the thrown form as a starting point, Weigel has manipulated many interesting new shapes. 1980.

Right: 'Jungian Shadow II' in slip cast bone china by Glenys Barton. This sculpture was produced during her association with the Wedgwood pottery which allowed her to introduce greater technical precision into her symbolic work. Height 17 cm; 1976.

for example, has executed porcelain wall reliefs but there is still much need for experimentation in this field.

Slip-cast bone china, previously considered solely an industrial process, is now being used in the individual craftsman's studio. Leach would no doubt have been horrified at the use of this hybrid porcelain body having disparagingly referred to it in *A Potter's Book:*

> Western potters from the early days of industry and especially in making porcelain have travelled further and further away from a natural conception of clay towards an ideal of over-refined mixtures which are aptly called pastes.

Some excellent work is being produced in England with these 'pastes', however, particularly by Angela Verdun and Jaqui Poncelet. Both artists leave the dazzling white body in an unglazed state achieving a novel silky texture by wheel polishing. Angela Verdun decorates her cast forms with drilled or scratched decoration while Jaqui Poncelet is concerned with the exploration of form and often encourages distortion at the biscuit stage.

Glenys Barton also works in slip-cast bone china but her work is considered separately not only because of its intellectual content but also because she has had the added advantage of working within industry. Her work in the early 1970s was concerned with geometrical shapes and patterns but, more recently, her imagery is figurative and symbolizes ideas about man's relationship to his environment, his isolation and loneliness. In 1976 Wedgwood recognized the potential of her work and offered her

methods, a much larger scale is possible although this has not until now been exploited. Kurt and Gerda Spurey, two Austrian artists, are hand-building porcelain in an exploratory and creative way and on a scale and with a confidence that is rarely seen in the material. Porcelain is also being used in an architectural context, particularly in Czechoslovakia where ceramics are widely used in conjunction with architecture. The Czech artist Antonin Bartoš,

Right: Unglazed bowl with inlaid design by Nicholas Homoky. A Hungarian-born potter, Homoky works in England creating very refined thrown and carved forms with graphic type decoration. Diameter 12 cm; 1978.

Artists and Potters

the opportunity of developing her ideas and techniques at their factory. All their resources were at her disposal and, with considerable help from the craftsmen, she was able to evolve casting and silk-screening processes to a new degree of precision in her pieces.

Sculpture in biscuit and metal by Francois Xavier Lalanne. This bizarre piece was commissioned for Sèvres by art director Serge Gauthier who instigated several such liaisons between the factory and modern artists. The ostrich's wings open to reveal a bar, and the egg functions as an ice bucket. Width 193 cm; 1964.

The artist-potter on the factory floor is an innovatory experiment in Britain, but much more familiar elsewhere. The Scandinavian precedents have already been discussed and in Europe also many porcelain factories have employed studio potters as designers or consultants. More frequent, however, has been the collaboration with contemporary painters and sculptors.

Some of the most dynamic artist-designed porcelain issued from the kilns of the first Russian State Porcelain factory. The October revolution had stimulated all the arts in Russia, including porcelain, which is not normally associated with political propaganda. However, revolutionary themes and emotive inscriptions began to appear on cups, plates and even entire dinner services, expounding the same political message as was to be found in the newspapers. Initially the decorative style adopted reflected this parallel, with symbolical emblems depicted in a graphic fashion. These first political porcelains were produced by painters of the 'The World of Art' group, notably Sergei Tchekhonine, but other artists such as Ivan Puni, Vladimir Tatlin and Nathan Altman were drawn to the medium during the years 1918–1919. Revolutionary language and the trappings of the new state portrayed in luxurious colour predominated until the 1920s when new themes began to be explored by a younger generation of artists. Perhaps the most exceptional of these new artists in porcelain was Alexandra Chtchkotikhina-Pototskaia whose imaginative fantasy subjects were in a lively, painterly style.

In Europe during the inter-war years there was a widely held belief that the quality of design in

Conservatism

More conservative attitudes have prevailed in the British porcelain industry. Royal Worcester have commissioned the ever-popular bird and animal studies from traditional sculptors such as Dorothy Doughty and Doris Lindner. The technical virtuosity displayed in these and similar works by other artists, notably the American, Edward Boehm, has always been much admired and they are highly prized among collectors.

It is the mass market's idea of art which has been reflected in decorative porcelain designs commissioned by most British and American manufacturers. An abundance of sentimental imagery – chubby children and doleful animals, and romantic moonlit sea- and landscapes – has been created on plates by respected artists and has proved to be exceedingly popular. Occasionally, a major manufacturer might take a gamble and produce designs by artists acclaimed in the fine art world. Edward Ardizzone, John Piper, David Gentleman and Eduardo Paolozzi all applied their diverse talents to the ceramic media but, unless popular taste radically alters, these ventures will continue to be few and far between, for the porcelain industry cannot afford to ignore the general public.

Left: 'Redstart cock in gorse' by Dorothy Doughty, produced in a limited edition by the Royal Worcester factory. The naturalistic rendering and the virtuosity displayed have made these bird studies very popular among collectors. Height 28 cm; 1968.

Below: Annual plaque by Victor Vasarely, one of several contemporary artists commissioned by the Rosenthal factory to create sculptures in porcelain. 1977.

industry could be improved by drawing on the talents of freelance artists. Most factories at this time commissioned designs for sculptures and decorative wares in porcelain as well as for surface patterns to be applied to existing wares. Sèvres had a very active period from 1920 to 1937 during the directorship of George Lechevallier-Chevignard, who estabished a very good working relationship with artists such as Henri Laurens, Ossip Zadkine, Paul Vera, Jean Dufy, Giorgio de Chirico and Marie Laurencin. This progressive policy was revived in the 1960s by Serge Gauthier who persuaded Hans Arp to design several porcelain vases with delicate polychrome glazes. Alexander Calder's gouaches were reproduced on porcelain plates in limited editions of 48. More bizarre was the association with the sculptor François Xavier Lalanne who created a large porcelain sculpture which also functioned as a bar. This consisted of two ostriches who supported a shelf bearing an egg in their beaks. The ostriches' wings opened to reveal the drinks and the egg was the ice-bucket.

The German factory of Rosenthal is also renowned for its association with famous painters and sculptors. In 1964 it approached some of the most significant living artists with the idea of producing porcelain wall-reliefs in limited editions. Hajdu, Vasarely, Konïg, Nicholson and Moore were among those who tried their hands, with varying degrees of success. The experiment was extended to include three-dimensional forms as well, and Henry Moore excelled in this field producing the sculpture 'Moonhead'.

Chapter Thirteen
Industrial Porcelain

Left: Pieces from Bauhaus Hommage I, a Gropius tea-set decorated by Herbert Bayer for the Rosenthal Studio Linie, designed in 1968 to translate Bauhaus thought into contemporary terms. The set is based on the shape of a traditional teabowl; with the teapot, sugar-bowl and creamer this shape is inverted. The curved handle on the teapot makes it unnecessary to use both hands while pouring the tea.

Right: Wedgwood plate from the 'Florentine' range. This pattern first appeared in the Wedgwood pattern-book in 1872, and has weathered the vagaries of time for over a hundred years, being still very popular today. this is a fine example of the basic conservatism that dominates the porcelain market.

THE massive Exposition Internationale des Arts Décoratifs et Industriels Modernes held in Paris in 1925, and the reactions to it, provide illuminating indications of attitudes towards, and practice in, architecture and the decorative arts, including the commercial porcelain industry. The holding of the exhibition, plans for which had been approved as early as 1912, was delayed by the First World War, and when it finally opened, the French exhibits occupied two thirds of the space, and, not surprisingly, Germany was a notable absentee. Though intended as an 'international' exhibition there were other gaps: India, Persia, Norway, and perhaps most important as far as commercial porcelain production was concerned, the United States. The Japanese did not show any examples of their commercial porcelain, but most of the pavilions devoted substantial space to it; although some British firms seem to have regarded the occasion as an art exhibition rather than a trade fair and declined to attend because they considered there was limited commercial advantage in doing so.

The brief prepared by the organizers followed closely the regulations of the 1902 Turin Exhibition, and stipulated that the objects shown, whether folk art, studio produced, or in commercial production should fulfil a practical need and show 'modern inspiration' and 'real originality'. The British exhibition committee reacted rather negatively to the demand for 'originality', and argued that it must be interpreted as meaning 'the development of existing art forms' as well as 'the invention of the entirely new'. Certainly the ceramic exhibits from Wedgwood, Doulton, Copeland, Minton, Worcester, and Wood & Sons were competently manufactured, but in decoration, as well as in form, the individual pieces seem to have been based almost exclusively on traditional eighteenth and nineteenth-century wares.

The 1927 Department of Overseas Trade report on the Paris Exhibition, compiled by the British observers, represented a considered retrospective assess-ment of the quality of the exhibits and acknowledged that the 'artistic' as opposed to the 'technical' side of the industry was less than innovatory. The same report also contained comments on the foreign exhibits, and expressed concern that the exhibition, far from providing a representative exposure of the products of the individual countries may have tended to lay disproportionate emphasis on 'divergencies'. In this class were placed the 'Futurist' part of the Italian section, and certain of the Russian exhibits. The State Porcelain Manufacture of Leningrad staged a spectacular display almost entirely ignored by the British commentators. The vigorous tradition of Russian folk decoration had, by 1925, been inte-grated with equally striking revolutionary motifs by Tchekhonine, and placed on items suitable for everyday use. Similarly imbued with 'modern inspiration' were the pieces of 'suprematist' table-ware. The Italian government section featured porcelain from the Doccia factory of the Societa Ceramica Richard-Ginori. Italian porcelain was characterized by its

Left: The few internationally respected designers tended to migrate between companies and countries, as exemplified by Jean Luce. He was associated with the French industry into the 1930's, when he designed this coffee service for Limoges. In the 1950's he collaborated with Gretsch on several of Porzellanfabrik Arzberg's new and successful lines.

bright and precise linear decoration, and the jugs were short and spherical, reflecting the new trend.

The Danish exhibits from Bing & Grøndahl and Royal Copenhagen Porcelain Company designed by Jean Gauguin and Jais Nielsen were considered by the British to have been the most impressive of the ceramic displays. The best of these pieces were animal and figure sculptures in a new ceramic body invented by Gauguin. The Swedes concentrated on table-ware: mainly white porcelain, notable for its attention to simple forms and textures rather than decoration. The Sèvres porcelain on show was criticized by the partisan British report for being as 'dull' as the majority of the British products, and less well manufactured; but certain French designers, Jean Luce, Suzanne Lalique, and Claude Lévy were praised for their decorative inventiveness. Certainly Chabrol's coffee set with its faceted spheres for knobs, a motif repeated on the handles, was a novel departure from traditional shapes.

Though the Department of Overseas Trade report was not an objective comment on the 1925 Paris Exhibition, it does focus attention on various points which continue to be issues in the commercial porcelain industry today. There is the problem of the relationship between function, form and decoration. Gordon Forsyth, the commentator on the Pottery Section, stressed that ornamentation must be 'integral', but he made no direct comment on the desirable relationship, if any, between the form of different items of table-ware, and the use to which they were put. He did not see 'functionalism' explicitly as a problem to be solved in modern terms. However, he did say that '. . . the chief lesson to be learned by British Potters from the exhibition is the necessity for increased attention being paid to the artistic possibilities of their craft', and specifically called for separate departments in commercial potteries to develop the 'artistic side'. As principal of Stoke Art Schools he was already trying to integrate his students into industry. In asserting, as Herbert Read was to do again a decade later, that British potters 'must be creative artists and not complaisant tools of retailers' he isolates unambiguously the potential dichotomy between commercial considerations, es-

pecially in table-ware manufacture, and an interest in aesthetic quality, and suggests that the best commercial products should cultivate taste rather than be constrained by it.

The Bauhaus Ideology

These three considerations: the relationship between form, function and decoration, the role of the artist or designer in the industry, and whether commercial table-ware in particular should create or answer a need, together with another knotty problem, that of the assimilation of the mechanical aspect of modern industrial porcelain production, had been among the main preoccupations of the designers of the Bauhaus design school in Weimar since its foundation in 1919.

Left: This 1923 Mocha machine, designed by Bauhaus student Theodor Bogler to be mass-produced by the Staatliche Porzellan-manufactur, Berlin, is a self-conscious example of Bauhaus concepts. The undecorated white body was relatively cheap to make and showed the quality of the material. But as a consequence of his attention to the different handling considerations of each part of the machine, he has created an object that does not fit later characterizations of Bauhaus products as austere, and bleakly geometric nor can it be annexed as an 'art object' as many Bauhaus products have been. (Bauhaus, Archiv Museum für Gestatling, Berlin)

Whereas the 1925 Paris Exhibition reflected a trend towards decorative inventiveness, the Bauhaus was infused with an ideology of a more fundamental kind. Though there were continual internal disagreements, the ideas of its director, Walter Gropius were, in practice, the most influential as far as the design of domestic objects, including porcelain, was concerned. Gropius believed that a dynamic interplay between the artist and industry was of crucial importance and that, in the modern world, industry and the machine were inextricably linked. Though many of the departments of the Bauhaus were involved in craft rather than machine production the pottery workshops were, by 1923, using industrial techniques. The designers of porcelain at the Bauhaus, like Otto Lindig, who also worked for the State Porcelain Manufacture in Berlin, tried not to overlay their products with an artistic gloss. Instead they used their trained sensibilities to create new shapes which combined a return to the first principles of functional demand–pouring ability, ease of handling and storage etc.–with an aesthetic interest in making these forms, which were constrained by practical considerations, as beautiful as works of fine art had traditionally been. The role of form in relation to function is stressed in Bauhaus theory, but function was not the only factor in determining form. Bauhaus design practice was not really cold functionalism but a balancing of function, aesthetics and technics to supply a commercial demand.

The 'commercial demand' aspect raises particular difficulties, because, in retrospect, it can be seen that the simplicity of Bauhaus design did not coincide entirely with consumer taste either in the 1920s or in any decade since. Because design concepts at the Bauhaus were infused with an idealistic notion of a new society, whose outlook and artefacts would be intregrally related and mutually expressive, however suitable they were (and porcelain, especially, was) for mass production, there was a sense in which these objects were didactic rather than consumable. They were the symbol of an allegiance to an idea, rather than merely things to eat your supper from or pour tea out of. A survey carried out by the State Porcelain Manufacture, Berlin, in 1930, in which 150 cups from museums were collected and the preferences of a sample of the consuming public recorded, revealed a marked preference for a simple white cup made in Berlin in 1750; certainly the State Porcelain Manufacture, Berlin, did find a satisfactory domestic market for its Bauhaus-influenced products. In Britain, though, despite the efforts of Herbert Read, the British Art in Industry Exhibition 1935, and its accompanying volume *The Conquest of Ugliness*, any attempt to provide a rationale for a new direction for British design based on the undiluted principles formulated by Gropius, Marcks and their students, had only a limited impact.

Art Deco

In more general terms, functional simplicity with a concentration on decoration which emphasized, rather than obscured shape, was a distinct feature of British as well as Continental porcelain. The linear qualities of Art Deco became transformed in the 1930s by Susie Cooper, Freda Beardmore (E. Brain & Company), Agnes Pindar-Davies (Paragon) and others. Concentric lines and bands and single calligraphic motifs, carefully placed, highlighted cup-rims, handles, the edges of flat ware and the sides of pots and jugs. There was a distinct market for Art Deco wares exemplified by Clarice Cliff's 'Bizarre'

Doulton's response to Art Deco was 'Tango', characterized by triangular handles and linear geometric motifs. However, the lace table-cover and the figurine in this publicity photograph (c. 1930) created a 'traditional' setting for the 'moderne' service. Obviously Doulton's customers could stand only a limited assault on their life-style.

This table-ware of 1917–1923 illustrates the dramatic change in the decorative vocabulary of factories like the State Porcelain Manufacture in Leningrad after the Revolution. The large plate was designed by Tchekhonine. Monograms of the nascent state and revolutionary symbols like the hammer and sickle, together with decorative motifs derived from both folk and 'modern' art predominated. Apart from these fairly superficial reactions to the demands of the new régime, from 1920 onwards a network of Vhutemas was set up by the ministry of Culture to integrate the training of artists and designers.

shape which was the antithesis of functionalism and was taken up by several other earthenware producers. E. Brain & Company did produce a line in china called 'Mayfair', which had triangular handles and what they called 'austere' modern decorations 'modified' by brilliant colour reminiscent of Jean Luce's work.

Bauhaus Influence in the United States

Even though the Bauhaus has been criticized for imbuing essentially luxury products with a spurious machine aesthetic which made them appear to be mass-produced, general consumer items, this charge seems to be inaccurate as far as porcelain was concerned. Bauhaus' basic concepts, as well as being influential in Europe, were quickly assimilated into the American design scene. It was claimed by Paul Frankl that the United States was absent from the Paris Exhibition because it had no products which could be called 'decorative art' and that the public was 'quite unconscious of the fact that modern art had been extended into the field of . . . industry', but in 1934 the Museum of Modern Art in New York mounted an exhibition of 'Machine Art' which had a

large section on Household Accessories, including porcelain table-ware. The catalogue illustrated some plain white porcelain plates and an absolutely cylindrical porcelain vase, both in commercial production, and made by Lenox Inc. The accompanying text provides an interesting background to this choice. Barr (the museum's director) invokes Plato's dictum that geometrical shapes have absolute rather than relative beauty, and asserts that the main characteristic of machine production is its ability to reproduce perfect geometrical forms with complete precision. Because human intervention, after the design stage, is limited, the most important aesthetic constituent of the machine product is the character of the material out of which it is made: in the case of porcelain, strength, delicacy, whiteness and translucency. Barr argues that function is not more important than beauty, and that perfect functionalism does not necessarily make an object beautiful. Rather, form which is indicated by function, and which possesses the best attributes of machine manufacture – precision and quality material – will be beautiful in a more lasting way than anything produced in response to the dictates of fashion or apathy which ignores these qualities. Though the fact that these remarks were made in the context of an art exhibition rather than a trade magazine would seem to place them in the theoretical rather than the

commercial sphere, these concepts have infiltrated the commercial design area to a considerable degree, even if they have not entirely percolated through to the consumer market. They have also contributed to the appearance of a dichotomy between products which win design awards and those which constitute the staple selling lines in the consumer market.

Before the Second World War there were three distinctive extremes towards which commercial porcelain table-ware production could gravitate: the idealistic Bauhaus dream which tended to be denounced as bleak, merely functional, and overtasteful; the bizarre and spectacular 'moderne' denounced by Pevsner in the late thirties as 'modernistic', 'not truly innovative'; and those designs which, though not always entirely faithful copies of their eighteenth and nineteenth-century prototypes, still appeared 'traditional' to the consuming public. The porcelain industry today is still characterized by these extremes and perhaps even more particularly by the plethora of modifications and dilutions of them.

One of the main drawbacks of Bauhaus design, as far as gaining widespread popularity was concerned, was its lack of decoration. It was deemed suitable for hotel-ware and for the growing market of air as well as ocean liners (in 1935 the *Orion* was one of the first British ships to have modern, not 'period' décor and used very simple Wedgwood table-ware), but most people, and the American bridal market, wanted something more obviously decorative to set their own tables with. In Britain at least, both during and directly after the war the production of decorated table-ware was prohibited, so that lack of decoration had the unpleasant connotation of 'austerity' as much as of Bauhaus idealism. Even though stackability had been a necessary feature of hotel-ware for some time, it was a novel enough concept in the domestic domain to be a potentially compelling selling feature when described in advertisements as 'the nesting principle'. In America too, stackability was a selling aid. The Iroquois China Company billed its stackable 'Casual China' as the only way for the modern woman to cope with the 'servantless' meal. To what extent stackability was an artistic 'concept', this time successfully imposed, and to what extent it was a response to consumer demand is not entirely clear.

Search for the 'Ideal'

In an editorial of the late 1950s, the Editor of the *Studio Yearbook of Decorative Art* observed that 'as hands and mouths do not change, it should be possible to find an "ideal" shape for cups, jugs and plates, which will then never need to be changed.' The Editor went on to say that this time had not yet been reached. This slightly facetious remark does underline yet again the separation between the striving for a timeless ideal design which will work perfectly and have a correspondingly decisive aesthetic appeal, and the fact that consumer preferences are subject to change and, though in part controlled by manufacturing and retailing decisions, are asserted by

mass buying power. However much the table-ware consumer may be supplied with newly designed products she may only buy traditional floral ranges, so in the end, this is what manufacturers will provide. The porcelain industry is subject to fashion, and the victim of entrenched ideas, as much as it is influenced by the design ideals of a minority of its manufacturers.

Certainly there were interesting technical innovations in the 1950s which one can either interpret in the light of the search for the ideal shape, or as transient fashions, or as concepts too innovative for the conservative taste of the table-ware consumer. A case in point is the attempt by various Scandinavian designers to get rid of handles. These are tricky and expensive to fit; they make packaging and transport hazardous; take up a lot of storage space; drop off in dishwashers; are notoriously difficult to design coherently—but they have been a traditional accoutrement of the Western cup for some time. There is considerable precedent, in modern Japanese porcelain in particular, for handleless cups, and with this in mind, Gertrud Vasegaard designed a teaset for Bing & Grøndahl which was distinctly Oriental, with a bamboo-handled teapot. The cups were lipped and rather large so that they were easy to hold and did not need to be entirely filled. A less derivative answer to the problem of holding a container of boiling liquid without a handle was provided for Danemark by Axel Bruel, who designed a double-walled porcelain body, which had considerable insulating properties and a cylindrical shape, and was thin enough to be easily grasped in one hand.

The transmigration of industrial concepts to the domestic setting is illustrated by this 'Casual China' designed by Russel Wright and made by the Iroquois China Co. The changing social conditions which had earlier directed attention to the need for organizational changes in the catering industry reached the domestic front by the 1940's and prompted a description of the service as an 'informal luncheon table set for a servantless meal, a durable porcelain for everyday use and convenient stacking.' While the likelihood of the potential owner of the table depicted being seriously inconvenienced by want is slight, and ease of transportation from the factory rather than restricted kitchen space may have been the compelling motive for 'stackability', the intrusion of such austere economic sentiments would have been unthinkable a decade earlier.

The Mass Market

The post-War resurgence of preoccupation with decorative patterns continued throughout the 1950s. 'Strawberry Hill', a range with a fairly traditional floral pattern, designed by Millicent Taplin and Victor Skellern, won a British Design Award in 1957. Jean Luce, who had first achieved fame at the 1925 Paris Exhibition, continued to do decoration designs for the German company, Arzberg, which had a modern, rather than a particularly Art Deco, flavour: single-leaf imprints and linear intertwined doves and fishes. Linear motifs mixed with dots seem to have been a fashionable decorative form in Britain and America. Also favoured in America was white-bodied ware with muted and elusive patterns which, it was thought, had the dual quality of showing off the quality of the porcelain and not dating. Moderate pricing became as important a consideration as decorative appeal in ensuring the continued success of the American industry. Rosenthal Bloch Continental China produced 'Rhythm' and 'Relief' for the American market in the early 1950s. In these ranges the bowls were handleless, and scaled in size but not different in shape, thus cutting down the number of expensive hand processes involved in manufacture. Similarly conscious of economy, the Salem China Company devised a cheap method of producing the rounded square plate shape, previously a characteristic of expensive lines. American companies also adopted the idea of dual purpose flat and hollow ware, facilitating a reduction in the overall size and price of the complete dinner service.

It was to the prospering industry in America that Roy Midwinter looked when he was searching for new ideas to inject into the recumbent post-War British pottery scene. Although not directly involved in porcelain production, the fortunes of Midwinter's reflect the state of the British ceramic industry in the 1950s and 1960s because, unlike the large companies, it had to succeed with new designs. The first of these, launched in 1952 was 'Stylecraft' which was modified throughout the 1950s and characterized by the rounded square shape so popular in America. The range found an important distributive outlet through Rowan Benthall, and sold so well that in 1954 demand overtook supply capability. The 'Stylecraft' salad range was remarkable for the number rather than the consistency of its shape designs. It featured myriad square, triangular, and simply amorphously shaped bowls with apparently arbitrarily placed single or multiple vegetable motifs: the eggcup was decorated with half a tomato. The next range, 'Fashion' was also developed by a designer outside the industry, Terence Conran, and to Midwinter's chagrin the best selling decorative pattern was not Hugh Casson's 'Riviera' scenes, but a rose and its shadow of staggering photographic realism. After the success, in the early 1960s, of the 'Fine' shape devised by Queensbury, the 'MQ2', which relied not on the proven cylindrical design, but on a new bulbous 'ultra modern' coffee-pot on which the other items were closely based, was commercially catastrophic, though a similar shape by Rosenthal did survive at

The mainstay of the French Industry was new decorative treatments of traditional shapes, but some factories did risk expenditure on novel lines, such as this 'Service Soleil' (later called 'Coquet') which was made by the Porcelainière de la Haute Vienne in the early 1970s. These pieces were the antithesis of the self-conscious 'functionalism' which had more or less successfully characterized the 'contemporary' part of the market for forty years.

the top of the market. The firm was only saved by the success, in America, of a new oven-to-table range and a takeover by Wedgwood in 1968. So the importation of good innovative designers, whether from the pottery industry or outside, did not guarantee commercial success nearly as surely as the devising of a popular floral pattern: to be even superficially avant-garde was disastrous.

The 1960s then, do not seem to have been characterized by any particularly striking innovations in the porcelain industry, nor were there such easily recognizable fashions as the sub-Art Deco table-ware of the 1930s. But there does appear to have been a growing market for products which were, in the advertisers' terms, 'contemporary'. Scandinavian and German firms tempered their simple shapes with bold decorative motifs, which meant that a move away from the 'traditional' did not entail foregoing decorative interest. Certainly, during the 1960s it became increasingly obvious that many 'contemporary' styles, supposedly so appropriate to modern living, were usually derived from, and often travesties of, shapes thought up by Continental designers in the 1920s and 1930s, whose interest in geometry and practicality had led them to shapes that could easily degenerate (when imitated rather than understood) into empty and imprecise geometrical forms. These were not as easy to use as the 'traditional' lines which often retained the exact design characteristics which had ensured their continuous popularity. There was, however, one area in which there was improvement, not regression. The development of ranges of oven-to-table ware, flame resistant, dish-washer resistant, freezer resistant, and finally microwave-oven resistant, porcelain bodies meant that at least some of the demands of modern living were met with beneficial changes in product specifications.

The statistics of the French trade fair, SIFE, show that in 1972, 30 per cent of the pottery table-ware

Right: Japanese manufacturers produce a large quantity of table-ware for the European and American market which is indistinguishable from its Occidental competition. At the other end of the spectrum are these pieces by Masahiro Mori, dating from 1977 (striped) and 1979. They were made for the Hakusan Porcelain Company, and are a contemporary reworking of indigenous traditional themes. (Victoria and Albert Museum, London)

*Right: One quality people
perennially tried to associate
with 'modernism' is the
emphasis on natural forms
as crucial prototypes for
anything from engineering
structures to easel painting,
so it is not surprising to find
that Tapio Wirkkala's
'Century' 'Perlband'
(commemorating
Rosenthal's centenary,
1880–1980) was inspired
by the translucent strength
and subtle surface of the sea-
urchin's shell.*

was classed as 'contemporary' rather than 'tra-
ditional', compared with only 5 per cent a few years
earlier. Although much of it was very similar in
design to the products of the preceding decade, the
early 1970s, in France at least, marked a move
towards extremes of tradition and novelty, as well as
the production of the more usual simple shapes
which, ironically enough, had been synonymous
with 'modernism' for nearly fifty years. Haviland
brought out two new ranges on the traditional
Choiseul and Sèvres shapes; Porcelainière de la
Haute Vienne and Bernadaud came up with 'Service
Soleil' and 'Saturne', wares with fantastic spouts and
handles, characterized by their absolute disregard for
the appearance of practicality, and sold as suitable for
'space age' living. Against this background, the
search for new table-ware designs solving practical
problems continued. If the solutions were not entire-
ly new, they were always advertised as better answers
to problems. So, Hertha Bengtson's oven-to-table
design for Thomas, 'Corda', has holes in the lids
instead of handles or knobs, and large lips around the
rims for easy handling with gloves in and out of
microwave ovens. On the other hand, quasi-func-
tionalism and novelty were intermingled in products
like Villeroy & Boch's 'Avant Garde' where stacking
and storage problems were said to be solved by a
nineteen-piece dinner service which fitted together
to form a large ball; a feat only accomplished by the
plates being shaped like dog bowls. In the trade fairs,
the decorative trend was towards ranges whose
components came in single colour, geometric band,
and floral designs which had enough colour unity to
enable the decorative devices to be mixed. Through-

out the market the preference for floral (and vege-
table) patterns was as marked as it has always been.
At the upper end of the price range, Villeroy & Boch
offers 'Botanica' a botanically detailed and labelled
design; Pickard's 'Misty Garden' is a small greyish,
stylized, floral border pattern, and 'Evesham', one of
Royal Worcester's most continuously popular pat-
terns, consists of lifelike depictions of single fruits
and vegetables disposed haphazardly over every item.

Above: 'Blind Earl' with its distinctive raised pattern, first produced by Worcester c. 1760, apparently at the request of the Earl of Coventry, who was blinded in a hunting accident, is one example of a traditional design still in production (Royal Worcester – Spode).

Below: Though this range from the Lucca Factory of Luciano is, as its name, 'Antica Medici' suggests, reminiscent of a pre-twentieth-century idiom, it is a product of sophisticated technology, freezer- and oven-proof, flame-resistant, and so perhaps deserves its publicity slogan, 'A living tradition'.

Selling Techniques

Apart from an increase in mug production, there was very little on the porcelain table-ware market that either was new, or that fulfilled particular needs in normal life. This meant that much of the energy in the 1970s was devoted to improving selling techniques. In America, television advertising became important (Franciscan launched a massive campaign in 1977); so did the production of different kinds of ranges, and gift packaging. One of these new selling 'concepts' which was firmly rejected was the 'short set' of a mug, a plate, and a bowl, which, it was hoped, would suit any casual meal. In the 1978 Atlantic City trade fair, only a few years after the first appearance of 'short set' ranges like the Dansk 'BLT' and Mikasa's 'Le Buffet', manufacturers bemoaned small sales, and attributed them to 'a lack of understanding of the concept'. Another more popular sales idea taken up in the 1970s was the 'tabletop concept'. Rosenthal, Raynaud, and others produced coordinated ranges of porcelain table-ware, cutlery, glass, and finally, table linen. The concept was also tailored to appeal to specified, and potentially profitable markets. Thus, for instance Ceralene's 'Love Set', which was designed to appeal to the more romantic end of the American bridal market, included porcelain napkin rings and a candelabra.

Porcelain Today

Several general points emerge from this brief chronological survey. First, the porcelain market and industry is characterized by its conservatism. Japanese export figures are so good because as well as producing high-quality traditional Japanese porcelain which commands a substantial overseas market, their industry answers the Western need for traditional European floral patterns, making ranges such as Noritake's 'Versatone'. Noritake, for instance, exports 68 per cent of its vast output to Europe and America. Franciscan's floral pattern, 'Desert Rose', has been a best seller for over thirty years in America, while in Britain the most popular china pattern, with huge trans-Atlantic exports sales, is Royal Albert's 'Old Country Roses'. A leading British manufacturer, Spode, brought out no new shapes between 1958 and 1972, and all the large companies have traditional or very bland modern lines to finance their occasional forays into new territory.

Secondly, what is sold as new and contemporary today, is usually heavily dependent on ideas which were 'modern' in the 1930s. There certainly does not seem to be a similarly revolutionary spirit of modernism in most parts of the present industry.

Thirdly, the close relationship between artists and designers and the industry, called for in the 1920s, has not been fully accomplished; there are still ranges produced that look like arbitrary modifications of their predecessors. The tendency to import design personnel from other fields which was so marked in Britain in the 1930s when Nash, Sutherland and others applied decoration to commercial products, is still considered a sales advantage (thus Hardy Amies was recruited by Wood & Sons) but it does not seem to have injected the fundamental vitality into the industry that it might have been expected to. Nor, unfortunately, have new commercial manufacturing techniques always been exploited very positively. The growing tendency for even porcelain to imitate rather primitive studio pottery with haphazard glazes and rough edges is a negation of both the qualities of

Villeroy and Boch's 'Die Kugel', first marketed as 'Avante Garde', caused what Tableware International called 'a minor sensation' at the Frankfurt International Fair in 1971. That this should have been the case is more a reflection of the conservatism of the porcelain industry than of any astonishing innovatory quality of the pieces.

the material and the highly developed and sophisticated technology associated with it.

Finally, there is an unresolved dichotomy between ideals and mass commercial reality, highlighted by a company like Rosenthal which promulgates an interest in design development and has didactic show-rooms explaining the rationale behind, and history of, its products, but which does not cater, in price or in concept, for the buying tastes of most table-ware consumers. The vision of a new world in which the majority of necessary objects would combine perfect functionalism with a possibly timeless aesthetic quality above the level of mere fashion, though still advocated by Rosenthal, does not have the appeal of tradition, however misinterpreted, or of the 'modernism' of other decades, made bland and innocuous by modification. The porcelain industry is highly successful in terms of shareholders' profits, and for this to continue to be true it has to be cautious.

Though the twentieth-century porcelain industry has concentrated most of its efforts on table-ware rather than on purely decorative pieces, commemorative ware continues to be important, marking occasions as diverse as the post-War Royal Tour to Australia, and the centenary of the death of Dickens. There are two common approaches to the

manufacture of these pieces: either they are cheaply mass produced, with transfer designs on popular selling items like mugs, and so steeped in custom that it is difficult to differentiate Coronation and Jubilee wares; or else the opportunity is taken to produce a one-off design which purports to be, and sometimes is, a high quality souvenir of the occasion. For instance, Spode, which devotes a separate department to its commemorative wares, brought out a 'Cutty Sark' plate on which was an engraving from a painting by Sperling and a border motif derived from the ornamental border of the ship's name-board. The German porcelain company, Rosenthal, commissioned a commemorative design for their own centenary, 'Century', designed by Tapio Wirkkala, which, it was hoped, embodied the design ideals of the company.

Items like Spode's 'Cutty Sark' and 'Tewkesbury' commemoration plates are sold at the upper end of the price range, and the most popular sales gambit for this class of commemorative porcelain is its description as a 'limited edition'. Bing & Grøndahl's 'Munich Olympics' plate, which was advertised as being a 'limited edition' of 10,000, is just one example of the increasing interrelationship between the commemorative and 'limited edition' markets.

Forgeries and Deceptions

THE word 'fake' in common usage to describe an imitation of a work of art is something of a misnomer, since it should, strictly speaking, be applied to an object that has 'been tampered with for the purpose of deception' as the *Oxford English Dictionary* has it. A reproduction is a copy, but it is not necessarily made with the intention of deceiving. Probably the best word to apply to deceptive works of art is 'forgery'.

This chapter is not intended as instant expertise; it would be impossible to learn to differentiate between real and fake pieces without having the objects themselves to compare. A great deal depends on weight and feel, and on subtle differences in body and glaze that become apparent only when the light strikes them in different ways. It is rather a general series of hints on the more obvious pitfalls that the unwary may fall into. Genuine forgeries, if one may describe them as such, are few and far between, and have had considerable time and effort expended on them. The original must be expensive to warrant this outlay and the finished result will probably provide hours of debate for experts as to its genuineness. The vast majority of look-alikes do not fall into this category—they are objects copied with varying degrees of success, almost invariably bearing the factory mark. The imitating of works of art has a long history. Certainly many Greek statues were copied and sold as originals to Roman collectors, these in turn being copied and passed off as genuine during the Renaissance.

During the eighteenth century the Continental porcelain factories dominated Europe. England produced no more than pale imitations of Oriental or Continental porcelain. But by the beginning of the nineteenth century, the position was beginning to reverse. The industrial revolution was in full swing and the Staffordshire potteries were exporting to America, the Colonies and to Europe and making innovations and improvements to processes, bodies and glazes. The industrial revolution also created a whole new class of wealthy people, eager to spend their money on luxurious objects and works of art. Some supported contemporary art but most, probably in an attempt to imitate the style of the landed gentry to whose levels they were raised by wealth and title if not by pedigree, collected what we would now call antiques. To supply this demand many Continental factories turned their hands to producing reproductions of the more famous eighteenth-century pieces. The lack of expertise at the time, together with great demand, meant that copies to which we

would no longer give a second glance were easily passed off as genuine. They were rarely full-blooded forgeries, but much more commonly imitations close enough to fool the inexperienced. These copies approximate the originals in one or more salient features, but they do not get all the details right, and the features that are wrong proclaim their inaccuracy loudly. Less seriously, the deception usually involved the use of famous factory marks, often applied to objects that the factory never made—a Chelsea gold anchor on a flower-encrusted hard-paste porcelain box, for example. These are being made today in large quantities on the Continent and sold in home decoration and souvenir shops but, inevitably, some end up in 'antique' fairs, shops and country auctions.

The most important factor—the difference between hard and soft paste—is something that cannot be learned from a book. An understanding of the difference can only be acquired through frequent handling, with the help of an expert. As far as forgeries of English eighteenth-century pieces are concerned, if the object to hand is in hard paste then it is not genuine. There are exceptions (such as those produced in Bristol) but they are not significant here. Castings from originals are always smaller than the original, caused by the clay shrinking somewhere between 10 per cent and 30 per cent as it dries. Familiarity with known models is a great safeguard.

The best-known of the copyists, who certainly made it clear in his advertisements that he was selling reproductions, was Emile Samson of Paris (1837–1913). Although it was not an undercover operation it is not clear whether all the pieces he made, which covered the ceramic range from maiolica, through hard and soft-paste European and Oriental porcelain, to enamels, were marked with some appropriate identification that they were not originals. It seems unlikely, given the numbers of copies in his style on the market, that they were. His work can be found with his marks ground off or with appropriate marks added. As the quality was generally high and the pieces are decorative, Samson is now collected in its own right; however, much is attributed to Samson that is not his work.

A late nineteenth-century development that causes some confusion was the surge of interest in painting on ceramic blanks by amateurs at specially held classes. Competitions were arranged and prizes given. The problem here is that the blanks frequently bear impressed names which enable them to be passed off as products of the factory. The quality of painting ranges from atrocious to good, but it usually

has some characteristic to distinguish it from the factory product. The amateur is proud of his work and splashes his (or more frequently her) name not only on the painting but also on the reverse, larger than would the professional, and complete with full date. The designs were mostly copies of famous paintings, portraits of historical, or more rarely contemporary figures. The best guard against buying such a piece is through knowledge of the factory products and its painters.

As an extension of this subject it is perhaps worth pointing out that the porcelain plaques that were so popular from the 1840s to the end of the century were very infrequently factory products; they were blanks supplied like canvasses to professional painters. Thus the premium paid for Berlin plaques *per se* is quite unjustified. Overall the standard of painting on Berlin plaques is higher than on, say, Dresden, but this is probably because Berlin produced far finer blanks than the other factories and they must have been preferred by the better painters. Do not be persuaded to buy a badly painted plaque simply because there is a Berlin sceptre impressed thereon.

China and Japan

The Chinese attitude to the use of a reign mark earlier than the contemporary one is difficult to understand in the West. The Chinese applied earlier marks not to deceive, but as a compliment to the earlier reign, or because the pieces they were copying came complete with mark. Deception was not intended. This is not to say that at a later date the inevitable confusion was not used to the advantage of the unscrupulous—particularly in the West. The insatiable demand for Chinese porcelain during the nineteenth century was certainly in part satisfied by the Chinese making forgeries to order. Samson and Herond of Hungary both made passable copies of Chinese and Japanese wares, some of their 'Imari' being particularly deceptive.

Worcester

This factory suffers more from the attention of fakers than the other English factories in that its wares lend themselves to 'improvement'. Take a tankard painted by James Giles with exotic birds on a plain body, add an apple-green ground, regild and multiply the price tenfold. The problem for the faker, as with Sèvres, is the temperature; it is very difficult to fire on the new ground without affecting the original painting and almost impossible without having some effect on the original gilding although, contrary to popular belief, enamel can be fired over the gilding without it burning off. Samson and other Continental forgers also copied eighteenth-century Worcester, and at the end of the nineteenth century Booths of Tunstall reproduced much Worcester blue-scale work by transfer, complete with marks. They were using an earthenware body, not porcelain, but it could fool some people. Royal Worcester itself produced a number of figures in the style of Capodimonte which they called 'Raphaelesque', not all of which were marked, but it is difficult to believe that anyone would be misguided enough to buy these as originals. Later in the century the tables were turned and Continental factories started copying Royal Worcester. Austria, in particular, made reasonable interpretations; Rudolfstadt went so far as to do a passable imitation of the mark. I have seen an Austrian copy of a vase painted by James Stinton, with the original mark ground off and a transfer of the Royal Worcester crowned circle substituted.

Chelsea and Derby

Thousands of nineteenth- and twentieth-century forgeries and imitations of the figures from the Chelsea and Derby factories change hands every year bearing red or gold anchors, or crossed batons and crown marks. Many are models that the original factory never produced, others are reproduced in the wrong size. The fakers are usually anonymous, but Samson's copies are well made, and were generally marked as his copies.

Sèvres

Starting with fakes as defined in the opening paragraph, the most difficult problem with Sèvres is later decorated wares. At the beginning of the nineteenth century quantities of white ware from Sèvres found their way into porcelain factories both on the Continent and in England. It has been stated by some authorities, and it seems likely, that some of the English factories, among them Minton and Coalport, decorated the blanks in Sèvres style and applied Sèvres marks, sometimes inappropriate ones. These and their continental equivalents are often hard to detect since the body is right, but very often the decorator would not get the temperature of the enamelling kiln correct for the glaze which then pitted in the firing. This is almost invariable on another popular nineteenth-century fake or 'improvement'. Take an inexpensive and uninteresting product of a factory such as a shaped dish from a service decorated only with small flower sprays within a colour border, etch off the original design and repaint with something far more elaborate—exotic birds on a coloured ground for example. Not infrequently the 'ghost' of the original pattern can be detected under the new design by tilting the pieces in a raking light. It is particularly obvious where the engraver has not even bothered to etch off the original pattern and has painted over the top, the original design appearing in slight relief.

Generally, refired pieces display an overthick and/or streaky ground which has also pitted. In addition refired pieces most often display their dubious history on the back. The glaze here will have either pitted, run, or, frequently, picked up a haze of ground colour towards one edge. Sèvres, because of its immense prestige, suffered more than other factories from the

misuse of its name and marks. Apart from the numerous French, German and Bohemian interpretations of Sèvres' finely painted services, vases and boxes, many large and some very large ormulu-mounted vases with figure and landscape panels on blue ground were made. Sèvres did not produce these at all during the nineteenth century. Good examples are now being made in Spain.

Vienna

The finely painted wares of the late eighteenth and early nineteenth century from the Royal Vienna factory were much admired and copied during the last century, both within Austria and in Germany and Bohemia. As with Sèvres, undecorated wares were sold in the white and then decorated elsewhere, so that date coding by the factory is an unreliable guide to the date of the piece. The shield, popularly known as a bee-hive, was used by many copyists.

Meissen

During the nineteenth century, Meissen continued both to reproduce from its eighteenth-century moulds and to introduce new ones. It is not generally difficult to distinguish between eighteenth-century and nineteenth-century Meissen, except in the case of a few pieces which bear the mark of the late director, Marcolini, but which seem to have been painted later. Meissen maintained (and still does maintain) a very high standard of quality control, always rejecting pieces that badly misfired in the white. These bore the full factory marks: impressed

and incised numerals and underglaze-blue crossed swords – but the latter were cut through once or twice on an abrasive wheel. The pieces were then sold off to outside decorators who sold them on their own behalf. I have not yet seen the cancelled mark restored to disguise its rejection, but when the market eventually distinguishes between the reject and the fully original with a sensible differentiation in value, this will no doubt come. More of a problem are the numerous Dresden factories which reproduced Meissen figures and wares, some of them using the original marks. The most notorious of these was Helena Wolfsohn, who used the Augustus Rex (AR) monogram which had not been used after 1730, but which was applied indiscriminately by her to reproductions of much later wares. She was eventually banned by law from using any Meissen mark. In England during the eighteenth century the major factories reproduced Meissen, sometimes with the mark; but faking was not a common practice in England in the nineteenth century, and direct copies are rare. John Bevington of Hanley, Staffordshire was the closest to a faker; his crossed swords and JB looked suspiciously like the early Meissen and KPM mark, but his copies were in soft paste, not in the Meissen hard.

Capodimonte

Although marked figures from this factory do not exist, the crowned N mark of the factory was applied in the last century to a large number of objects including figures. Rudolfstadt in Thuringia is recorded as having used the mark but it was certainly not alone.

Capodimonte

1 *Capodimonte cup and saucer moulded with scrolls and brightly enamelled, c. 1745. Painted fleur-de-lis mark. Capodimonte moulded wares were much admired during the nineteenth century, and vast quantities of reproductions were made.*

2 *Tureen stand moulded and brightly enamelled. Height 29.7 cm; c. 1870.*

3 *Mark of 2: crowned N in underglaze blue and old paper label, probably late nineteenth century, with price of £8 (which price includes an almost matching ewer) and a later label, probably dating from just before the First World War, bearing an erroneous*

attribution. Misinformation of this kind is not uncommonly found on porcelain and should always be discounted.

Meissen Figures

1 *Meissen mushroom-seller. Height 14 cm; c. 1750.*

2 *Detail from 1.*

3 *Many eighteenth-century figures were marked with 'underglaze' blue crossed swords, but the base was not glazed and was often ground flat, erasing the mark. It was impossible to photograph the faint traces on **1**, and the presence of crossed swords on such a figure is strong grounds for suspicion. A common position for the mark was at the rear of the figure near the base, the swords of small size, such as this mark from a similar figure.*

4 *Meissen gallant. Height 15 cm; c. 1880.*

5 *Detail from Meissen gallant.*

6 *This mark is of a Meissen figure of similar date and style to **4**, and used here for the grouping and clarity of all the marks, including the blue crossed swords which are under the glaze on the hollowed portion of the base. The grey streaked area at the top left is the actual foot of the piece and the glaze has here been wiped away. On this area, is the impressed 'repairer's' or modeller's number, and below it is the incised shape number. The small numeral 6 is painted on and is the painter's mark. Quality control has passed this piece despite a small firing crack.*

7 *Dresden gallant based on the Meissen gallant shown here, but remodelled to larger size. Height 19.5 cm; late ninteenth century.*

8 *Detail of **7**.*

9 *Crossed swords in underglaze blue on **7**.*

Meissen Wares

1 Meissen sucrier and cover, brightly painted with landscapes within gilt borders on a canary-yellow ground. Height 11.5 cm; 1744.

2 Detail from **1**.

3 Underglaze-blue crossed swords and gilder's mark of sucrier **1**.

4 Meissen sucrier and cover painted with figures in a garden within gilt scrolls on a deep blue ground. Height 10.5 cm; c. 1870.

5 Detail from **4**.

6 Underglaze-blue crossed swords mark of **4**.

7 Meissen sucrier and cover rejected by the factory after the white firing, and outside decorated with horses and figures within gilt scrolls. Height 10.5 cm; c. 1880.

8 Detail from **7**.

9 Mark of **7**, showing cancelled crossed swords.

10 Meissen cup and saucer painted with lovers within gilt scrolls on a deep blue ground. Saucer 13 cm; c. 1870.

11 Detail from **10**.

12 Mark on cup **10**, underglaze-blue crossed swords.

13 Helena Wolfsohn cup and saucer, painted with panels of figures within gilt scrolls on a pink ground. Saucer 14 cm; c. 1890.

14 Detail from **13**.

15 Mark on cup **13**. pseudo AR monogram of Augustus Rex in underglaze blue.

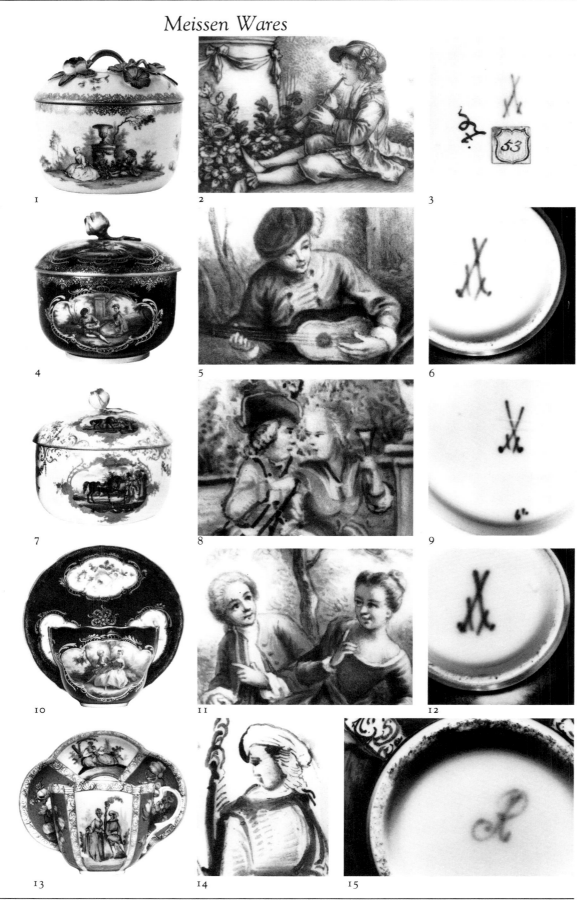

Meissen Wares continued

16 Meissen saucer painted
in underglaze blue, with
exotic bird, flowers and
rocks, after a Chinese
original. Further decorated
with contemporary
hasmalerei or outside
painting. 12.5 cm; mid-
eighteenth century.

17 Detail of **16**.

18 Mark of **16**.

Meissen Influenced Marks

1 John Bevington Hanley.

2 Rudolfstadt.

3 Samson of Paris.

4 Ernst Teichert, Meissen.

5 Used by Eichwald,
Bohemia or Teichert, Meissen.

16 17 18

1 2 3 4 5

Berlin

1 Berlin coffee service,
enamelled and gilt with
named views. Tray 43 cm;
c. 1875–1880.

2 Marks: Underglaze blue
sceptre, circle and eagle
within Koeniglische
Porzellan; overglaze red
printed orb and KPM
(Koeniglische Porzellan
Manufactur) and hand-
painted script title.

3 Mark of eagle and TPM
in underglaze blue from a
plate. This mark could easily
be confused with the
different elements of the
Berlin marks in **2**. It was
used by P. Donath GMBH,
Tiefenfurt Schleisische
Porzellanfahn. c. 1875.

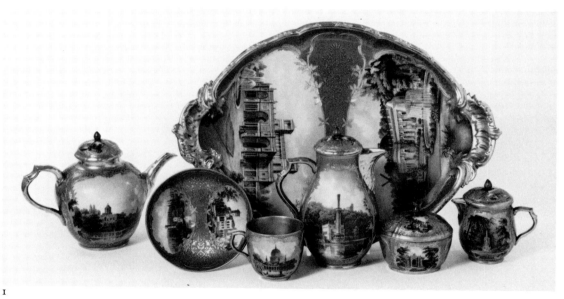

1

2 3

Sèvres

1 Sèvres tray from a solitaire set, brightly enamelled and gilt. 18.5 cm; 1765.

2 Mark from **1**.

3 Paris tray painted by E. Costier with a portrait of Napoleon Bonaparte, the green border with gilt scrolls. 30.3 cm; c. 1890. The Sèvres painters are all recorded, and Costier is not among them.

4 Mark from **3**, which should date 1804–1814.

5 Genuine eighteenth-century Sèvres dish, well painted with birds on a turquoise ground. 22 cm. The decoration probably c. 1835. The dish has been cracked either in the firing or possibly before it, though this is unlikely, and the enamel ground has run into the split.

6 Base of **5**, which includes genuine incised numerals at **a** and **b**. The titles and interlaced Ls have been added. Itinerant gypsies toured Britain throughout the nineteenth century and into the twentieth, selling clothes pegs, recaning chairs, and mending porcelain with rivets. Since it is not uncommon to come across the cheapest crocks sewn together with large numbers of rivets, it seems likely that householders saved damaged articles for the gypsies to work on, either out of kindness, or to get rid of the gypsies. The presence of rivets thus does not indicate either great age or value.

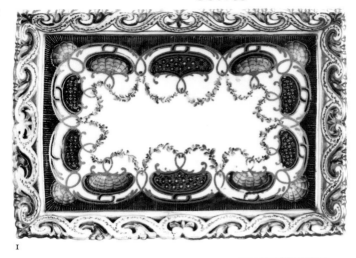

1

2

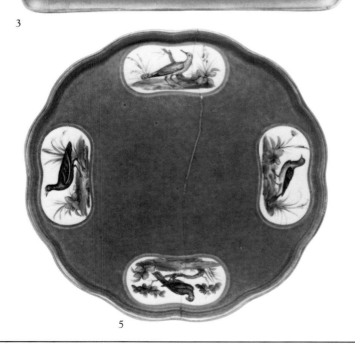

3

4

5

6

Sèvres continued

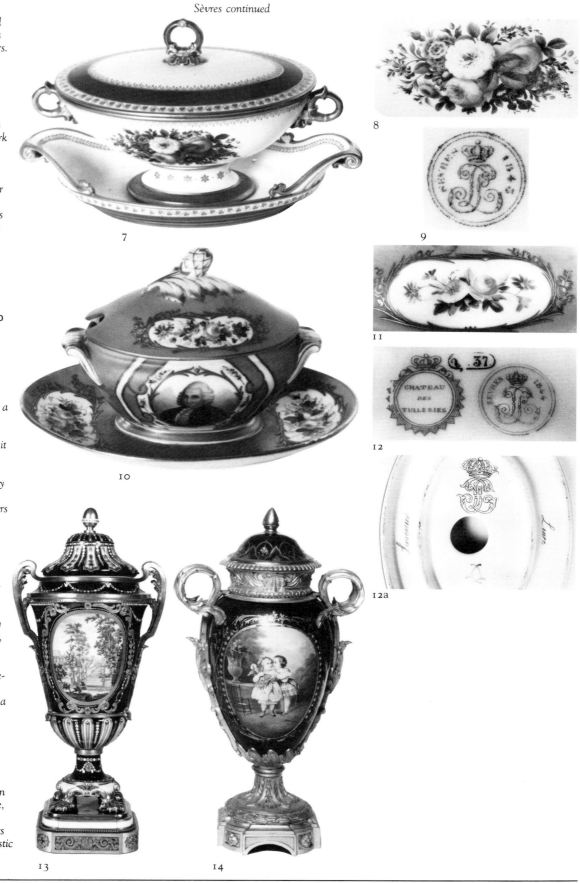

7 *Sèvres écuelle, cover and stand, painted with flowers within green and gilt borders. Width 26 cm; 1843.*

8 *Detail from **7**.*

9 *Printed overglaze-blue mark of **7**, date and initials of Louis Philippe. This mark is found only in blue and gold on genuine pieces.*

10 *Écuelle made in Paris or Limoges with enamelled named portraits of courtiers and panels of flowers, on a pink ground. Width 23.5 cm; c. 1870.*

11 *Detail from **10**.*

12 *and **12a** Spurious printed marks on base of **10** include blue interlaced Ls, gilt, printed, crowned LP monogram, printed S37 (date of firing 1837) and decorating and location marks dated 1844. The Chateau des Tuilleries was a favourite terminus for fakers' pots. Had all the pieces apparently made for it ended up there, gaining entry would have been impossible. The discrepancy between firing and decorating dates also appears on genuine examples.*

13 *Sèvres vase on an ormulu base, the finely painted panel within a 'jewelled' border on a bleu-de-roi ground. c. 1781.*

14 *Late nineteenth-century ormulu vase in Sèvres style, painted with panels of children within enamel 'jewel' borders on a bleu-de-roi ground. Height 44 cm; c. 1850. The painting is of a fairly high standard, but does not have the crispness of **13**. But the subject-matter of **14** is the obvious give-away. In eighteenth-century paintings, children are not sentimentalized as in the nineteenth; furthermore, these are dressed in contemporary costume. Forgers frequently make anachronistic errors in their 'props'.*

Vienna

1 *Vienna cabinet-cup and saucer, enamelled and gilt with a named classical subject. Saucer 14 cm; c. 1870.*

2 *Detail from **1**.*

3 *Mark of cup **1**, underglaze-blue shield and painted title.*

4 *Carl Magnus Heutchenreuter cup and saucer printed in colours and gilt, with classical subject. Saucer 14 cm; c. 1900.*

5 *Detail from **4**.*

6 *Printed mark of cup **4**, gold shield and green name.*

7 *Vienna sucrier and cover, originally decorated with a simple underglaze-blue leaf border, gilt rose, and leaves, but 'improved' in the late nineteenth century by the addition of a grey classical bust. 40 cm; c. 1770.*

8 *This eighteenth-century Vienna shield mark is actually from a figure, but is similar to that on any Vienna ware.*

9 *The original gilding of **7** has managed to survive later firings only as a ghost. Enamel colour is almost never applied over underglaze blue on continental hard-paste porcelain as it lies unhappily on top of the glaze.*

10 *Vienna plate painted by Wagner, signed, within richly gilt blue border. 25.5 cm; c. 1900.*

11 *Marks on **10** including underglaze-green Rosenthal of Porzellanfabrik Ph, Rosenthal of Kronach, Bavaria, now partially obliterated by gilt flower. Kronach supplied numerous blanks and the gilt obliteration is common, but it is unusual to be able to decifer the original mark.*

1

2

3

4

5

6

7

8

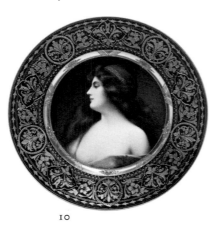

10

11

9

Japan and China

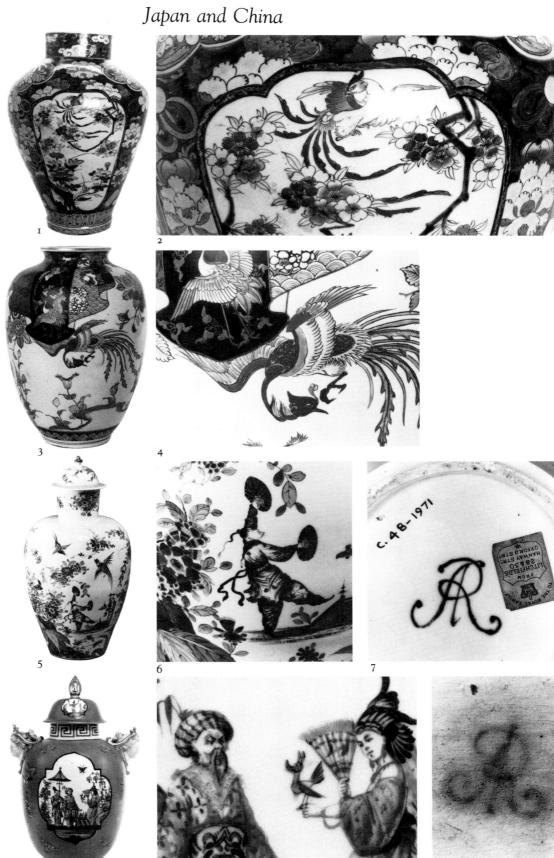

1 *Japanese Imari vase painted in underglaze blue, red, black and gilding. Height 53 cm; late seventeenth or early eighteenth century. This vase displays the baluster form typical of the period, unlike the ovoid of **3**, below.*

2 *Detail of **1** which shows the bold and slightly jerky irregularity of seventeenth- and eighteenth-century Japanese painting, the brush being used to create variations in the thickness of line and intensity of colour.*

3 *Samson copy of Imari vase, painted in underglaze blue, iron red, green and gilding. Height 31 cm; late nineteenth century.*

4 *This detail of **3** shows where European copies invariably fail to imitate early painting. All the tension has gone and been replaced by a smooth and regular line with little variation in breadth or density. Here, the flower on the left displays some of the characteristics of Art Nouveau. A forger, no matter how he tries, or how hard he has studied, invariably unconsciously introduces into the forgery elements of his own period.*

5 *Meissen vase, probably painted by J. G. Höroldt, with a chinoiserie scene. 39.3 cm; c. 1730.*

6 *Detail of **5**.*

7 *Genuine Meissen AR monogram 1725–1730.*

8 *Helena Wolfsohn (Dresden) vase. The apple-green ground with chinoiserie panels after a Meissen original painted by J. G. Höroldt. Height 50.8 cm; c. 1870.*

9 *Detail of **8**.*

10 *Fake monogram in underglaze blue from vase similar to **8**.*

Worcester

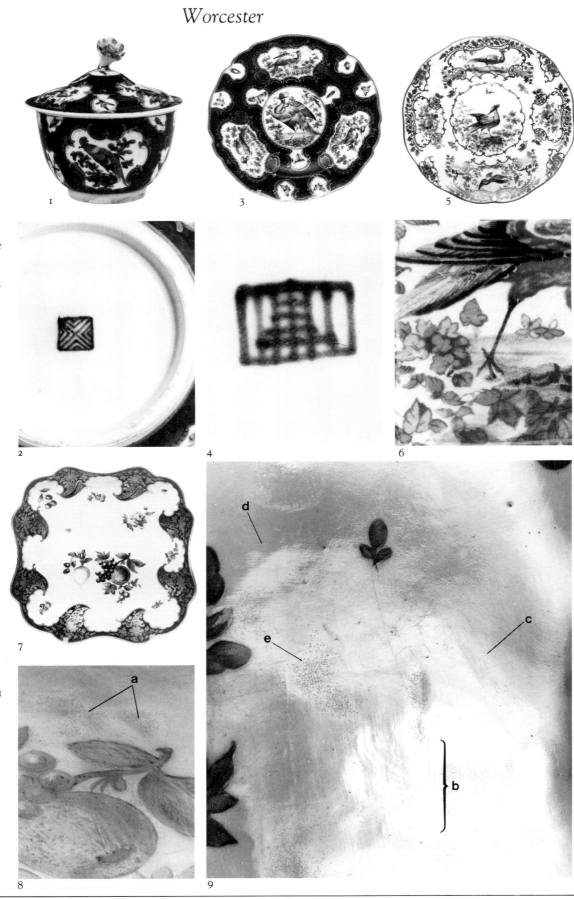

1 Worcester sucrier painted in the atelier of James Giles. Height 11 cm; c. 1760.

2 Underglaze-blue 'fret' mark (after the Chinese) of **1**. The glaze 'creep' from the footrim is a distinctive feature on Worcester of this date, occurring round the entire rim.

3 Samson copy of a Worcester plate. The blue scale does not have the subtlety of the original; the enamels, being on hard paste do not sink into the glaze and the gilt scrolls are mechanical. 23 cm; c. 1890.

4 Underglaze-blue seal of **3**.

5 Booth's earthenware dish, printed in the style of **3**. 23 cm; c. 1910.

6 Detail of the transfer used in **5**, showing the 'painting' composed of dots.

7 Genuine first period Worcester dish. This dish started life with little decoration, possibly monochrome enamel scrolls, central lozenge, and dentil rim. 20 cm.

8 Detail of **7**. A faker has lately ground off the decoration, leaving depressions where the wheel has bitten deeply, as at **a**.

9 These photographs are enlarged and intensified and the traces of the original design, just visible at **b**, are difficult to discover. Other clues are more easily seen which, although present on a genuine dish, are here overabundant. The faker has had to reglaze, with a brush and not by dipping, over what was no longer a smooth surface, leaving a streaky surface, as at **c** and **d**. Pitting, as at **e**, can be found on Worcester of this period, but rarely so much or so small. The glaze creep has disappeared. The new decoration is slightly mechanical.

Royal Worcester

1 *Royal Worcester vase pierced by George Owen with a honeycomb pattern. Height 17 cm; c. 1910–1920. (Worcester became Royal Worcester in 1862.)*

2 *New York and Rudolfstadt earthenware vase. Height 16.5 cm; c. 1900. This piece is copying the Royal Worcester vase, in its turn copying Sèvres from the middle of the century, Sèvres having lifted the cell-piercing from Chinese linlong work of the eighteenth century.*

3 *Mark of* **1**.

4 *Mark of* **2**.

5 *Royal Worcester vase printed and painted with flowers. 31.8 cm; 1909; the mark would be similar to* **3**, *but without the incised signature.*

6 *Austrian interpretation of vase* **5**.

7 *Mark of* **6**.

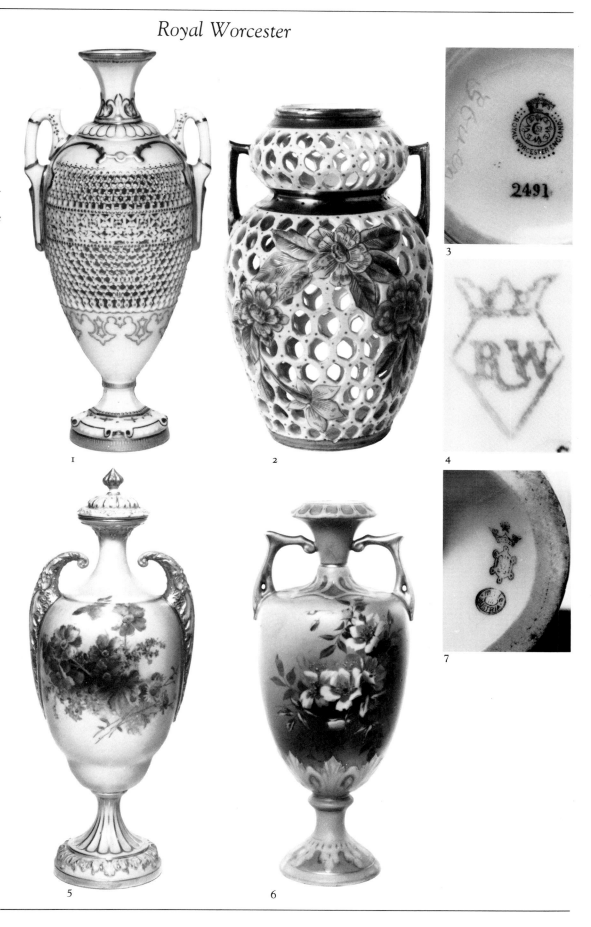

Glossary

Abstract Expressionism an American movement in painting, generally abstract in style, of the late 1940s and 1950s, influenced in its development by Surrealism, particularly automatic writing techniques, and characterized by large-scale, painterly brushwork, often vivid colour, and great involvement in the actual process of painting.

acanthus leaf ornament derived from the Mediterranean acanthus plant and found in particular on column capitals of the Corinthian order of Greek architecture. Some decorative forms are similar to thistle or celery leaves.

acid gold process intricate designs are etched with acid into the china body, then gilded and the surface burnished, resulting in a shining relief design offset by the matt gold intaglio or incised part.

amorini, amoretti cupids with wings.

amphora a large, tapering jar with a moderately wide neck and foot, and two handles stretching from the neck or mouth to the shoulder. Amphorae were originally ancient Greek vessels for storing wine or oil.

arabesque intricate rhythmic linear ornamentation of scrolling and interlaced tendril patterns.

arcanist an initiate of the secret (Latin: *arcanum*) of the processes and materials used in the manufacture of hard-paste porcelain.

Art Deco a style which developed from the anti-historical aspect of Art Nouveau and which was less concerned with the principle of fine craftsmanship and the use of naturalistic decorative motifs, more with mass-production and machine-age design characterized by streamlining, garish colour combinations and geometric patterns, particularly circles and zig-zags.

Art Nouveau an art style at its peak from about 1895 to 1905, manifested in the decorative arts, painting, sculpture and architecture and characterized by the swelling line of sensual and organic forms, a predominance of flower and plant motifs and asymmetry, but also incorporating more rectilinear elements derived from *e.g.* Celtic and Japanese art.

aventurine glaze a crystalline glaze, high in iron and low in alumina, the lack of which during slow cooling allows the iron to crystallize. The result is a deep, black glaze with surface speckles of brilliant red-gold.

baroque a style originating in Italy and fully developed by about 1620, characterized by a sense of grandeur and expansive scale, extravagant decoration and curving forms.

bas relief (French: 'low relief') relief decoration in which the figures or motifs project slightly from the ground and the carving relies on light and shade for sculptural effect.

bat printing a means of transferring engraved decoration to ceramic ware. Having filled the engraving with printing oil it is printed onto a gelatine pad or bat; this is applied to the ware, thus transferring the design, which is then dusted with powdered ceramic colour which adheres to it.

beading an impressed repeat pattern made with an embossing wheel.

biscuit, bisque unglazed ware, once fired.

blanc de chine (French: 'white of China') white Chinese porcelain imported into Europe during the late seventeenth and early eighteenth centuries.

blue-and-white a form of decoration originating in China in which porcelain was decorated with scenes and decoration in cobalt blue, first by painting and later by transfer printing. Used also extensively on earthenwares.

body the constituents of any type of ceramic ware: the clays and any other earth materials deliberately mixed to produce certain desired qualities. 'Paste' often refers to the body in the case of porcelain. Also, the main part of a piece, not including the handle, neck, spout, etc.

bone china translucent, vitreous ware of great strength and quality, so called because of the addition of calcined bone acting as a flux.

Callot figures grotesque dwarf figures in soft-paste porcelain similar in appearance to Callot's engravings (1622) but in fact derived from *Il Calotto Resuscitato* published in 1716. First produced at Meissen in the eighteenth century, then Vienna, Chelsea and Derby.

cameo painted replica of the ancient technique of carving in relief the upper, differently coloured layer of a gemstone or shell with a portrait head or small scene.

casting technique of using slip to fill segmented plaster of Paris moulds which, left to stand a short time, absorb water from the slip so that a wall builds up. The unadhered slip is then poured out, the mould left to drain and dry, during which the pot shrinks from the mould, aiding its eventual removal.

celadon Chinese stoneware or porcelain with a delicate olive-green glaze resulting from the effect of reduction firing on iron oxide. It was much admired and prized for its resemblance to green jade. The decoration is normally under the glaze, either incised or impressed or in relief.

chatter marks a succession of shallow vertical grooves caused by a blunt or incorrectly held trimming tool.

chinoiserie European artefacts strongly evocative of Chinese art rather than being strictly accurate imitations.

cloisonné a technique derived from metal enamelling in which a decorative design outline of raised clay separates the *cloisons* or compartments of different coloured glazes.

coiling a method of hand-building pots using clay rolled into ropes which are coiled on each other to form the walls.

cold colours ceramic or glass decoration using unfired oil or lacquer colours, thus occasionally referred to as 'lacquers' or 'Japanned colours'. Few examples survive since this decoration was not durable and wore badly.

Commedia dell'Arte popular Italian theatrical form of the seventeenth and eighteenth centuries, whose characters appear frequently as models in German, Austrian, French and English porcelain.

craquéle (French: 'crackled') an intentional *crazing* effect in a glaze produced by unequal contraction of it and the pot body during firing.

crazing fine cracks in a fired glaze. Originally unintentional, by the late Sung period in China it was being deliberately caused for decorative effect.

creamware lead-glazed earthenware with a cream-coloured body containing calcined flint (silica), which was light yet durable and as thin as porcelain. Josiah Wedgwood's 'Queen's ware' of the 1760s, an improvement on the earlier forms, was the precursor of modern white earthenware.

crystalline glaze crystallization may occur in a glaze when it has a low alumina content and is allowed to cool slowly. This beautiful effect is encouraged by adding zinc, rutile or titanium oxides to the glaze (up to 20%).

delftware English and North European tin-glazed earthenware. Similar wares of true Dutch origin have the same name beginning with a capital D.

Deutsche Blumen (German: 'German flowers') naturalistic flower painting in an accurate European style, originating on German ceramics of the first quarter of the eighteenth century.

earthenware non-vitreous, opaque, soft-fired ware. The biscuit firing temperature is usually 1100°C and the glaze 1080°C.

embossing impressed decoration made by relief stamps or rollers when the pot body is not fully dried.

enamel enamel pigments fuse at a temperature of approximately 750°C and are therefore applied after the initial ceramic firing. This comparatively low temperature permits a far wider range of colours than is possible with a higher glazing temperature (eg *underglaze decoration*) which would simply burn them away. Hence enamel is also often referred to as 'on-glaze' or 'over-glaze' decoration.

Etruscan a style concurrent with *neo-classicism* and attributed to Robert Adam c. 1774. So called because the motifs and the mainly black, white and terracotta colour scheme were influenced by Greek vases considered at the time to be Etruscan.

faience tin-glazed earthenware, originally the French version of maiolica and named after Faenza in Italy. The term has become generally extended to include any glazed earthenware.

Famille rose, famille verte nineteenth-century French terminology for Chinese Kangxi and Yong Zheng *enamelled* porcelain largely made for European export. Famille verte ('green family') is so called because of a predominant bright green, whereas famille rose refers to a rose pink of European origin (Purple of Cassius).

feldspar a mineral containing all the essential components for a glaze (silica, alumina and flux).

festoon ornamental device formed by a garland, normally of flowers and fruit, suspended in a loop at either end and tied with ribbons.

finial a knob on a lid or cover, often in a decorative form such as a fruit or flower.

flambé (French: 'flamed') a reduced copper-red glaze named after its flame-like streaks of colour and similar to *sang-de-boeuf*.

fluting incised grooves which run parallel and vertically.

flux a component of enamel colours, glazes and certain clay bodies. In enamels it eases the process of fusing them to the glaze; in glazes it reduces the melting point of other constituents, such as silica, adapting them suitably for use; in the clay body, flux facilitates the blending of the other components, decreasing porosity and increasing strength.

frit either all or some of the ingredients of a glaze which have been heated from a raw, dry state to a molten glass or frit in a frit kiln, then cooled and pulverised.

gadrooning an edging of inverted fluting or convex curves.

gilding applied gold decoration.

glaze a vitreous or glassy coating applied by dipping, spraying or painting for practical (non-porosity) and aesthetic reasons, made permanent by firing.

grand feu (French: 'great fire') high-temperature glaze firing.

grès (French) stoneware.

grisaille a technique of painting in varying tones of grey to give a *trompe l'oeil* or relief effect.

grotesque a fantastical type of ornamentation combining ornate foliage-inspired decorative devices and a profusion of human figures, half-figures, sphinxes, masks, cameos, etc.

ground overall, underlying colour or texture.

hard paste a phrase used to describe the hard, usually feldspathic Oriental type of porcelain associated with the Far East, Meissen, and some other European factories, and to distinguish it from its softer European imitators.

in-glaze decoration decoration applied to the glazed but unfired surface of ware in order that during firing the oxides in the pigment may sink into the glaze, as in *maiolica* and *delftware*.

intaglio (Italian: 'cut') engraved or incised design.

ironstone china fine white porcellaneous stoneware, so called because of its strength. Patented by C.J. Mason in 1813 and also produced by other manufacturers.

istoriato a type of crowded, overall decoration of Biblical, historical, mythical or genre scenes on maiolica wares, which are more for ornamental than practical use.

jasper ware Josiah Wedgwood introduced this vitreous stoneware in 1774. The body is coloured by staining with oxides in a wide range of subdued colours which complement the white sprigged decoration of figures and ornamental bands in bas relief based on classical prototypes.

kaolin (Chinese: 'high peak') white china clay, the essential ingredient (40–50% of the body) of hard-paste porcelain; so called after the geographical location in China where it was supposedly first found.

lead glaze a low-temperature, transparent glaze in which lead oxide is the major flux and contributes to a clear brilliancy.

litharge lead monoxide, also known as 'massicot' with properties similar to red lead. Frequently preferred as a flux by slipware potters, either as a frit or raw.

lithography a process of printing from stone or metal which has been treated so that only the image to be printed retains the ink and the remainder of the surface resists it.

lithophane a nineteenth-century decorative technique also known as 'Berlin transparency', the relief patterns relying on the translucency of porcelains for their effect.

lustre glaze effect achieved by the addition of metallic salts or carbonates to, normally, a low-temperature glaze which during cooling is exposed to a strong reducing atmosphere.

maiolica a term initially describing Italian tin-enamelled earthenware similar to Spanish lustre wares imported via Majorca, from which the word 'maiolica' derived. It has become the generic term for most types of tin-enamelled earthenware throughout Europe.

Mannerism an eclectic style developed from the Renaissance, first distinctly identifiable in paintings of the 1520s in Florence and Rome, characterized by contorted, elongated and sinuous forms, particularly human figures, a bizarre compositional and decorative sense, and lurid colour.

moulding a means of making pots and other pieces without throwing and in theory identically; the mould is a plaster of Paris replica of the prototype of original pot (see *slip-casting*). In *press-moulding*, a bat or slab of clay is pressed over a plaster hump mould or inserted into a hollow mould.

neo-classicism a style which emerged in opposition to rococo in the 1750s and was established by the 1770s in Europe. Classical antiquity was the source for its subject-matter, its rectilinear, restrained forms, sober colours and sparing use of Greek and Roman architectural ornament and geometric designs.

oxidation adequate oxygen in the kiln during firing ensures that the oxides present in glazes are not affected and give their oxide colours.

parian a white, biscuit-ware body named after its similarity of appearance with the white marble of Paros.

pâte-sur-pâte (French: 'paste on paste') decoration is bas-relief achieved by painting on successive layers of slip which are then intricately carved.

petuntse white china-stone, which is the ingredient necessary to vitrify and fuse the kaolin or china clay at a high temperature in the formation of hard-paste porcelain. The name refers in Chinese to the 'little white bricks' which were the form in which the pulverised stone was sent to the potters.

pietra dura hard or semi-precious stones such as jasper, chalcedony, agate, etc.

press-moulding see *moulding*

print and tint decoration consisting of an engraved outline transfer pattern which was applied and then hand-coloured.

pugging the preparation of the clay material by a mechanical mill which removes all the air.

putti wingless cupids.

reduction firing, reducing atmosphere a means of affecting oxides in glazes and bodies by starving the kiln atmosphere of oxygen at some stage in firing.

Renaissance a movement popular in Italy during the fifteenth and sixteenth centuries, affecting all art forms, whose decorative details were drawn broadly from classical sources and models.

rococo an elegant decorative style which followed the baroque, echoing its curvaceous forms but without its solemn grandeur. It is characterized by fresh, bright colours with gold and white, and delicate, fanciful effects from the combination of s-shaped curves, naturalistic motifs and non-representational ornamentation.

saggar protective fireclay box used during firing, particularly in bottle kilns.

saltglaze a hard, thin, slightly pitted glaze resulting from salt being introduced into the kiln late in firing. The colours are dependent on the clay and range from browns and buff to grey.

sang-de-boeuf (French: 'ox blood') a deep red, mottled glaze achieved by reduction firing of copper-red.

scalloped a rim modelled or cut with regular semicircles, or occasionally elaborate eccentric curves.

Schwarzlot seventeenth- and eighteenth-century German black enamel decoration, occasionally relieved with iron-red and gilding.

sgraffito (Italian: 'scratched') a pattern incised through a slip or ground colour in order to show the body colour beneath it.

silica silicon dioxide, occurring naturally as sand, quartz and flint. A major element in glaze and an essential component of ceramic mixtures.

slip clay combined with water to a fluid consistency either for slip-casting, luting, or joining parts, such as the handle to a body; or for decorating pottery by trailing or pouring (see *slipware*).

slip-casting see *casting*

slipware brown, black or creamy white slip decoration used on red earthenware.

soft paste a type of non-feldspathic, glass-like porcelain developed in Europe in the eighteenth century, largely by factories unable to produce true Oriental or hard-paste porcelain. This creamy substitute material was associated particularly with English factories.

sprigging a type of press-moulded bas-relief decoration.

stoneware durable, opaque, vitreous ware, normally brown, buff or grey although there are white stonewares (see *ironstone*).

strapwork ornamentation representing bands interlaced in the manner of fretwork or leather thonging.

Surrealism an art movement begun in the 1920s which acknowledged the creative force of the subconscious and consequently valued the irrational, dream imagery and experience, and bizarre and unexpected juxtapositions.

temmoku a Japanese term applied to stoneware with a rich black and iron-brown glaze.

terracotta (Italian: 'black earth') strictly speaking any ware which is fired but unglazed, but generally used of low fired, porous earthenware.

tin glaze a lead glaze rendered opaque and white by tin oxide, normally used on earthenware.

transfer decoration an engraved, lithographed or silk-screened decoration printed on transfer paper and applied to ceramic ware.

trompe l'oeil (French: 'deceive the eye') an illusionistic style of either photographically realistic painting or architectural perspective effects.

underglaze decoration applied in the *biscuit* stage then covered with a transparent glaze. Because of the comparatively high firing temperature of the glaze, only those colours which can withstand it can be used.

vignette a small scene without clearly defined borders and whose edges merge into the ground colour or other background.

wash technique application of a dilute, semi-transparent coat of colour, usually as a ground or background to a decorative scheme.

Bibliography

Chapter One
The Origins of Porcelain

Addis, J. M. *Chinese Ceramics from Datable Tombs* (London, 1978).
 Chinese Porcelain from the Addis Collection (London, 1979).
Ayers, J. *The Seligman Collection*, vol. 2 (London, 1964).
Burton, W. *Porcelain: A Sketch of its Nature, Art and Manufacture*
 (London, 1906).
Donnelly, P. J. *Blanc de Chine* (London, 1969).
Garner, Sir H. M. *Oriental Blue and White* (London, 1970).
Gompertz, G. St. G. M. *Chinese Celadon Wares* (London, 1980).
Hobson, R. L. *Chinese Pottery and Porcelain*, vol. 1 (London,
 1915).
Hughes Stanton, P. and R. Kerr *Kiln Sites of Ancient China*,
 Oriental Ceramic Society (London, 1981).
Legaza, I. L. *Malcolm Macdonald Collection of Chinese Ceramics*
 (London, 1972).
Medley, M. *The Chinese Potter* (Oxford, 1976). *Tang Pottery and
 Porcelain* (London, 1981).
Pope, J. A. *Fourteenth-Century Blue and White in the Topkapi Serayi
 Muzesi, Istanbul* (Washington, 1970).
Rawson, J. *Chinese Pots, Seventh–Thirteenth Century AD* (London,
 1977).
Teagear, M. *Catalogue of Chinese Greenware in the Ashmolean
 Museum* (Oxford, 1976).
The Edward T. Chow Collection (1, 2 and 3) Sotheby sale catalogues
 (Hong Kong, 1980).
Transactions of the Oriental Ceramic Society (London, 1921
 onwards).
Wood, N. *Oriental Glazes* (London, 1978).

Chapter Two
Qing Dynasty Porcelain for the Domestic Market

Arts Council of Great Britain and the Oriental Ceramic Society
 The Ceramic Art of China (London, 1971).
Ayers, J. *The Baur Foundation Collection*, 3 vols. (Geneva,
 1968).
David, Lady *Illustrated Catalogue of Ch'ing Enamelled Wares in the
 Percival David Foundation of Chinese Art* (London, 1973).
Donnelly, P. J. *Blanc de Chine* (London, 1969).
Jenyns, S. *Later Chinese Porcelain* (London, 1971).
Medley, M. *Illustrated Catalogue of Ming and Ch'ing Monochromes in
 the Percival David Foundation of Chinese Art* (London, 1973).
 *Porcelains Decorated in Underglaze Blue and Copper Red in the
 Percival David Foundation of Chinese Art* (London, 1963).
Oriental Ceramic Society *The Arts of the Ch'ing Dynasty* (London,
 1964).
Spence, J. *Emperor of China: Self-Portrait of K'ang Hsi* (London,
 1974).
van Oort, H. *Chinese Porcelain of the Nineteenth and Twentieth
 Centuries* (London, 1969).

Chapter Three
Korean and Annamese Porcelain

Ceramic Society of Indonesia *Annamese Ceramics in the Museum
 Pusat Jakarta* (Jakarta, 1974).
Cheng Te K'un 'The Study of Ceramic Wares in Southeast Asia'
 reprinted from *Journal of the Institute of Chinese Studies*, vol. 2
 (Hong Kong, 1972).
D'Argence, R. Y. L. *Les Céramiques à base chocolatée au Musée
 Louis-Finôt de l'Ecole Française d'Extrème-Orient à Hanoi* (Paris,
 1958).
Garner, Sir H. M. *Oriental Blue and White* (London, 1970).
Gompertz, G. St. G. M. *Korean Celadon and Other Wares of the
 Koryo Period* (London, 1963).
Korean and Chinese Ceramics in the Fitzwilliam Museum (Catalogue)
 (Cambridge, 1975).

Chapter Four
Japanese Porcelain

Hayashiya *et al.* ed. *Nihon No Toji*, vols. 23–26, 29, 30 (Tokyo,
 1976–9).
Impey, O. *Chinoiserie: the Impact of Oriental Styles on Western Art
 and Decoration* (Oxford, 1977). 'A Tentative Classification of
 the Artia Kilns' in *International Symposium on Japanese Ceramics*
 (Seattle, 1973). 'The Earliest Japanese Porcelains: Styles and
 Techniques' in *Decorative Techniques and Styles in Asian Ceramics*
 ed. M. Medley (London, 1978).
Jenyns, S. *Japanese Porcelain* (London, 1965).
Mikami, T. 'The Art of Japanese Ceramics' (trans. A. Herring), in
 Heibonsha Survey of Japanese Art, vol. 29 (Tokyo and New York,
 1973).
Nagatake *et al.* ed. *Sekai Toji Zenshu*, vol. 8 (Tokyo, 1978).
Sanders, H. H. *The World of Japanese Ceramics* (Tokyo and New
 York, 1967).
Smith, L. 'Japanese Porcelain in the First Half of the Nineteenth
 Century' in *Transactions of the Oriental Ceramic Society*, vol. 39
 (London, 1974).
Volker, T. *The Japanese Porcelain Trade of the Dutch East India
 Company After 1683* (Leiden, 1959). *Porcelain and the Dutch East
 India Company* (Leiden, 1954).

Chapter Five
China for the West

Ayers, J. and D. Howard *China for the West* (London and New
 York, 1978).
Beurdeley, M. and C. *Chinese Ceramics* (London, 1974). *Porcelain
 of the East India Companies* (London, 1962).
Crossman, C. L. *A Design Catalog of Chinese Export Porcelain for the
 American Market* (Salem, 1964).
Donnelly, P. J. *Blanc de Chine* (London, 1969).

Du Boulay, A. *Chinese Porcelain* (London, 1963).
Garner, Sir H. M. *Oriental Blue & White* (London, 1970).
Godden, G. A. *Oriental Export Market Porcelain and its influence on European Wares* (London, 1979).
Gordon, E. *Collecting Chinese Export Porcelain* (New York, 1977).
Howard, D. S. *Chinese Armorial Porcelain* (London, 1974).
Jenyns, S. *Japanese Porcelain* (London, 1965). *Later Chinese Porcelain* (London, 1971).
Le Corbeiller, C. *China Trade Porcelain; Patterns of Exchange* (New York, 1974).
Lloyd-Hyde, J. A. *Chinese Porcelain for the European Market* (Lisbon, 1956). *Oriental Lowestoft* (Newport, 1954).
Phillips, J. G. *China Trade Porcelain* (Cambridge, Mass., 1956).
Scheurleen, D. F. *Chinese Export Porcelain – Chine de Commande* (London, 1974).
Volker, T. *The Japanese Porcelain Trade of the Dutch East India Company after 1683* (Leiden, 1959). *Porcelain and the Dutch East India Company* (Leiden, 1954).

Chapter Six
The Development of European Porcelain

Berling, K. ed. *Meissen China, an Illustrated History* (New York, 1972).
Hayward, J. F. *Viennese Porcelain of the Du Paquier Period* (London, 1952).
Lane, A. *Italian Porcelain* (London, 1949).
Liverani, G. *Catalogo delle porcellane dei Medici* (Faenza, 1936).
Morazzoni, G. and S. Levy *Le Porcellane Italiane* (Rome, Milan, 1960).
Perotti, A. C. *Porcellane e terraglie napoletane dell' Ottocento Estratto della Storia di Napoli*, vols. VIII and IX (Naples, n.d.).
Polo, Marco *Travels* (London, 1967; New York, 1968).
Riccio, C. M. *La Fabrica della porcellana in Napoli le sue Vicende* (Naples, 1878).
Rollo, C. *Continental Porcelain of the Eighteenth Century* (London, 1964).
Savage, G. *Seventeenth and Eighteenth Century French Porcelain* (London, 1969).
Tait, H. *Porcelain* (London, 1972).
Tasnadi-Marik, K. *Viennese Porcelain* (New York and London, 1971).
Verlet, P. and S. Grandjean *Porcelaine de Sèvres* (Paris, 1953).

Chapter Seven
Eighteenth-Century English Porcelain

Austin, J. C. *Chelsea Porcelain at Williamsburg* (Charlottesville, 1977).
Barrett, F. A. *Worcester Porcelain & Lund's Bristol* (London, 1966); with A. L. Thorpe *Derby Porcelain, 1750–1848* (London, 1971).
Cushion, J. P. *Connoisseur Illustrated Guides: Pottery and Porcelain* (New York, 1975).
Dixon, J. *English Porcelain of the Eighteenth Century* (London, 1952).
Gilhespy, F. B. *Crown Derby China* (Leigh-on-Sea, 1951).
Godden, G. A. *Caughley and Worcester 1755–1800* (London, 1969). *Lowestoft Porcelain* (London, 1969).
Hillier, B. *Pottery and Porcelain 1700–1914* (London, 1968).
Holgate, D. F. *New Hall and Its Imitators* (London, 1971).
Honey, W. B. *English Pottery and Porcelain* (London, 1969).
Hughes, B. *English Porcelain and Bone China 1743–1850* (London, 1977).
Lane, A. *English Porcelain Figures of the Eighteenth Century* (London, 1961).
Sandon, H. *Royal Worcester Porcelain 1751–1793* (London, 1974).
Transactions of the English Porcelain Circle (London 1928–1932).
Transactions of the English Ceramic Circle (London, 1933 onwards).
Watney, B. *English Blue and White Porcelain of the Eighteenth Century* (London, 1973). *Longton Hall Porcelain* (London, 1957).

Chapter Eight
The Development of Bone China

Aslin, E. and P. Atterbury *Minton 1798–1910*, Exhibition Catalogue (London, 1976).
Atterbury, P. and L. Irvine *The Doulton Story*, Victoria and Albert Exhibition Catalogue (London, 1979).
Barrett, F. A. and A. C. Thorpe *Derby Porcelain* (London, 1971).
Cushion, J. P. *Pottery and Porcelain Tablewares* (London, 1976).
Eaglestone, A. A. and T. A. Lockett *The Rockingham Pottery* (Newton Abbot, 1973).
Eyles, D. *Royal Doulton 1815–1965* (London, 1965).
Des Fontaines, J. *Proceedings of the Wedgwood Society*, vol. 10 (London, 1979).
Godden, G. A. *Coalport and Coalbrookdale Porcelains* (London, 1970). *Godden's Guide to English Porcelain* (London, 1978). *Minton Pottery and Porcelain of the First Period 1793–1850* (London, 1968). *The Illustrated Guide to Ridgway Porcelains* (London, 1972).
Haggar, R. G. and B. E. Adams *Mason Porcelain and Ironstone 1796–1853* (London, 1977).
Halfpenny, P. and T. A. Lockett *Staffordshire Porcelain 1740–1851*, Exhibition Catalogue (Stoke-on-Trent, 1979).
Hillier, B. *Pottery and Porcelain, 1700–1914* (London, 1968).
Holgate, D. *New Hall and Its Imitators* (London, 1971).
John, W. D. *William Billingsley (1758–1828)* (Newport, 1968).
Lockett, T. A. *Davenport Pottery & Porcelain 1794–1883* (Newton Abbot, 1972).
Rice, D. G. *The Illustrated Guide to Rockingham Pottery and Porcelain* (London, 1971).
Sandon, H. *Flight & Barr Worcester Porcelain 1783–1840* Antique Collectors Club (Woodbridge, 1978).
Whiter, L. *Spode* (London, 1970).

Chapter Nine
Porcelain of the Victorian Era

Bemrose, G. *Nineteenth-Century English Pottery and Porcelain* (London, 1952).

Godden, G. A. *Bristol Pottery: An Illustrated Guide* (London, 1974). *Encyclopaedia of British Pottery and Porcelain Marks* (London, 1964). *Victorian Porcelain* (London, 1961).

Haggar, R. O. and C. W. Mankowitz *Concise Encyclopaedia of Continental Pottery and Porcelain* (London, 1957).

Rhead, F. A. and G. W. *Staffordshire Pots and Potters* (York, 1978).

Shinn, C. and D. *Victorian Parian China* (London, 1971).

Chapter Ten
Popular Nineteenth-Century Porcelain

Antique Collecting (Woodbridge, August, 1972).

Antique Finder (Woodbridge, May, 1974).

Antiques: vol. CVI (Salop, 1974).

Bridgeman, H. and E. Drury *Encyclopaedia of Victoriana* (London, 1975).

Bristowe, W. S. *Victorian China Fairings* (London, 1964).

Emery, N. *William Henry Goss* (Stoke-on-Trent, 1969).

Fleming, J. and H. Honour *The Penguin Dictionary of Decorative Arts* (London, 1977).

Godden, G. *Victorian Porcelain* (London, 1961).

Henderson, I. *Pictorial Souvenirs of Britain* (Newton Abbot, 1974).

Howe, B. *Antiques from the Victorian Home* (London, 1973).

King, C. E. *Dolls and Dolls' Houses* (Dudley, 1977).

Lyle Publications *Victorian Fairings* (Glen Mayne, 1975).

Mackay, J. *Encyclopaedia of Small Antiques* (London, 1975). *Commemorative Pottery and Porcelain* (London, 1971).

Rees, D. and M. Cawley *A Pictorial Encyclopaedia of Goss China* (Newport, 1969).

Rodgers, D. *Coronation Souvenirs and Commemoratives* (London, 1977).

Savage, G. *Dictionary of Nineteenth-Century Antiques and Later Objets d'Art* (East Rutherford, 1978).

Scott, A. and C. *Tobacco and the Collector* (London, 1966).

Smith, G. M. *Belleek Porcelain and Pottery* (Channel Islands, 1979).

Chapter Eleven
Art Porcelain

Adams, J. *Potters' Parade no. 6, Pottery and Glass* (November, 1949).

Atterbury, P. and Irvine, L. *The Doulton Story*, Victoria and Albert Exhibition Catalogue (London, 1979).

Barber, E. A. *The Pottery and Porcelain of the United States* (New York, 1909; reprinted 1976).

Bodelsen, M. 'Sèvres – Copenhagen. Crystal Glazes and the Stoneware at the Turn of the Century' in *The Royal Copenhagen Porcelain Manufactory, 1775–1975* (Copenhagen, 1975).

Borrmann, R. *Moderne Keramik, Monographien des Kunstgewerbes, no. V* (Leipzig, 1902).

Bott, G. *Kunsthandwerk um 1900, Jugendstil* (Hessisches Landesmuseum Catalogue) (Darmstadt, 1973).

Brunet, M. and T. Préaud *Sèvres. Des Origines à nos Jours* (Fribourg, 1978).

Clark, G. and M. Hughto *A Century of Ceramics in the United States, 1878–1978* (New York, 1979).

Doat, T. *Grand Feu Ceramics, Keramic Studio* (Syracuse, May, 1903–Sept., 1904).

Europäische Keramik des Jugendstils (Museum Hetjens Catalogue) (Dusseldorf, 1974).

Evans, P. F. *Art Pottery of the United States* (New York, 1974).

Eyles, D. *Royal Doulton 1815–1965* (London, 1965).

Helsted, D. 'Arnold Krog and the Porcelain' in *The Royal Copenhagen Porcelain Manufactory 1775–1975* (Copenhagen, 1975).

Jewitt, L. *Ceramic Art in Great Britain* (London, 1883).

Leistikow-Duchardt, A. *Die Entwicklung eines neuen Stiles im Porzellan* (Heidelberg, 1957).

Neuwirth, W. *Wiener Keramik* (Braunschweig, 1974).

Nikiforova, L. *Russian Porcelain in the Hermitage Collection* (Leningrad, 1973).

Pelichet, E. and M. Duperrex *La Céramique Art Nouveau* (Lausanne, 1977).

Pelka, O. *Keramik der Neuzeit, Monographien des Kunstgewerbes, No. XVII/XVIII* (Leipzig, 1924).

Porzellan Kunst, Teil II, Kunst-Porzellane und Keramik um 1900 (Schloss Charlottenburg Catalogue) (Berlin, 1969).

Sandier, A. 'La Céramique à l'Exposition', *Art et Decoration*, vols. VIII and IX (Paris 1900, 1901).

Musée National de Céramique *Cahiers de la Céramique* (Sèvres, 1955).

Musée National de Céramique (Catalogue) *L'Art de la Poterie en France, Rodin à Dufy* (Sèvres, 1971).

Weisberg, G. P. 'Samuel Bing: Patron of Art Nouveau' *The Connoisseur* (Sept. 1969–Jan. 1970).

Werke um 1900 (Kunstgewerbemuseum Catalogue) (Berlin, 1966).

Chapter Twelve
Twentieth-Century Studio Porcelain

Birks, T. *The Art of the Modern Potter* (London, 1967).

Burton, W. *Porcelain, its Nature, Art and Manufacture* (London, 1906).

Cameron, E. and P. Lewis *Potters on Pottery* (London, 1976).

Casson, M. – *Pottery in Britain Today* (London, 1967).

Charleston, J. *World Ceramics* (London, 1968).

Cooper, E. *New Ceramics* (London, 1974).

Hettes, K. and R. Pravoslav *Modern Ceramics* (London 1965).

Lane, Peter *Studio Porcelain* (London, 1980).

Leach, B. *A Potter's Book* (London, 1945). *A Potter's Challenge* (London, 1976). *A Potter's Work* (London, 1967).

Rhodes, D. *Stoneware and Porcelain* (London, 1960).
Rogers, M. *On Pottery and Porcelain* (New York, 1979).
Sandeman, A. *Working with Porcelain* (London, 1979).
Stachelin, W. A. *The Book of Porcelain* (London, 1976).

Chapter Thirteen
Industrial Porcelain

Arts Council *The Thirties* (London, 1979).
Battersby, M. *The Decorative Twenties* (London, 1976). *The Decorative Thirties* (London, 1976).
de la Valette, J. *The Conquest of Ugliness* (London, 1935).

Pevsner, N. *An Enquiry into Industrial Art in England* (Cambridge, 1937).
Read, H. *Art and Industry* (London, 1934).
Veronesi, G. *Into the Twenties* (London, 1965).

Appendix
Forgeries and Deceptions

Grasse, J. G. *Porzellen und Fayence* (Dresden, 1974).
Neuwirth, W. *Markenlexikon für Kunstgewerke* (Vienna, 1978).
 Meissener Marken und Wiener Binderschild (Vienna, 1977).
Pelka, O. *Keramik der Neuzeit* (Leipzig, 1924).

Acknowledgements

Museums and Art Galleries
Arita Ceramics Museum, Japan, 53 top; Ashmolean Museum of Art and Archaeology, Oxford, 16 bottom, 42, 44 top, 45 bottom left and right, 46 bottom right, 47, 48, 50 top, 52 top, 53 bottom, 73 bottom left and right; Bauhaus-Archiv, Berlin, 220 bottom; Collections Baur, Geneva, 32 bottom; Bayerisches Nationalmuseum, Munich, 99 top; Bibliothèque Nationale, Paris, 92 top right; Braunstein Gallery, San Francisco, 213; By courtesy of the Trustees of the British Museum, London, 10, 13, 14 top, 20 top and right, 21 top right, 24 top left and right, 44 left, 46 top right, 190; Capodimonte Museum, Naples, 114; Cincinnati Art Museum, Cincinnati, Ohio, 199 left; City of Manchester Art Galleries, Manchester, 23, 25; Dyson Perrins Museum of Worcester Porcelain, Worcester, 133 top, 134 left, 169, 201 bottom; Escher Foundation, Haags Gemeentemuseum, The Hague, Netherland, 6, 32 top; Reproduced by permission of the syndics of the Fitzwilliam Museum, Cambridge, 36 bottom, 37 above, 38, 96 top, 101, 111, 114, 120, 122 bottom; Gulbenkian Museum of Oriental Art and Archaeology, University of Durham, 12 bottom, 16 top, 17 top; Hessisches Landesmuseum, Darmstadt, Josef Bock Porcellan Manufactur, 205 top; By courtesy of the Trustees of the Cecil Higgins Art Gallery and Museum of the Decorative Arts, Bedford, 89, 128, 129, 132; Holburne of Menstrie Museum, Bath, 130 bottom; The Hurst Collection, Yorkshire Philosophical Society Museum, Yorkshire, 151; Metropolitan Museum of Art, New York, 61 bottom right (Gift of Mrs. Maurice Hawkes), 81; The Minton Museum, Royal Doulton Tableware Ltd, Stoke-on-Trent, 146, 152 right, 174, 201 top; Musée des Arts Décoratifs, Paris, 194 top; Musée National de Céramique, Sèvres, 79, 80 bottom, 110, 192, 195; Musée National du Louvre, Paris, 103, 105 bottom right; Museo Argenti, Florence, 97 top; Museum für Kunsthandwerk, Frankfurt, 119; Museum für Kunst und Kulturgeschichte de Stadt Dortmund, Schloss Cappenberg, Dortmund, 92 top left; Museum of Decorative Arts, Prague, 86, 102 bottom, 196 top; The National Gallery London, 54; The Oxfordshire Museum, Woodstock, 69; The Harry G.C. Packard Collection of Asian Art, Gift of Harry G.C. Packard and Purchase, Fletcher, Rogers, Harris Brisbane Dick and Louis V. Bell Funds, Joseph Pulitzer Bequest and the Annenberg Fund Inc. Gift 1975, Metropolitan Museum of Art, New York, 49; The Palace Museum, Peking, 17 bottom; Percival David Foundation of Chinese Art, University of London, 18 bottom, 28 top, 33; By gracious permission of Her Majesty The Queen, London, 104, 108 top right, 109, 110 top right, 117; Réunion des Musées Nationaux, Paris, 192 top; Royal Institution of Cornwall County Museum and Art Gallery, Truro, 126; Royal Worcester Spode Limited, Worcester, 226 top left; Science Museum, London, 161 bottom; Slezske Museum V Opave, 96 bottom right; Spode Museum, Stoke-on-Trent, 145 top; Staatliche Museen Preussischer Kulturbesitz, Berlin, 123 right; Tate Gallery, London, 72 bottom; Topkapi Saray Museum, Istanbul, 21 bottom right, 41; Usher Art Gallery, Lincoln, 108 top left, 148; The Victoria and Albert Museum, London, Jacket, 8, 50 bottom, 80 bottom right, 82 top right, 85 bottom left, 88 bottom, 94 bottom, 95 top, 99 bottom, 100 bottom, 102 top, 106, 113 bottom right, 122 top and centre, 124 bottom, 125 top right, 127, 130 top, 132 top, 137, 142, 154, 157 bottom, 159, 162, 164, 168 top, 170, 192 bottom right, 225 bottom; The Wallace Collection, London, 107 right, 235 bottom; By courtesy of the Trustees of the Wedgwood Museum, Barleston, 138, 144, 215 top; The Wellington Museum, Apsley House, London 156 top; The Henry Francis du Pont Winterthur Museum, Winterthur, 152 bottom right.

We would like to thank the following for lending us their materials: Armitage Shanks Ltd, Nottingham, 176 top; Art and Decoration, Vol XXVII, 193 top right; Astleys, 109 Jermyn Street, London W1, 118 left; The BBC Hulton Picture Library, London, 160; Bing & Grøndahl Copenhagen Porcelain Limited, 197 bottom right, 198 top, 209 top right; Bridgeman Art Library, London, 90 top, 91, 126, 127, 135; 'Britannia', Gray's Antique Market, London W1, 178, 183 bottom, 189 top right; Casson Gallery, 73 Marylebone High Street, London W1, title page; Christie, Manson & Wood Ltd, London, 39 right, 56 bottom right, 78, 84 top, 88 left, 91, 98 bottom, 105 top right, 121 right; Clandon Park, Guildford, Surrey, 135; Jeremy Cooper, 9 Galen Place, Bury Place, London WC1, 168 bottom; D. Cowell Collection, 59 bottom, 60 top; By kind permission of the Cultural Relics Publishing House, Peking, 19; The Decorative Arts Studio Year Book, 1914–1948, 223 bottom; Vivien Fifield, London, 157 top; Geoffrey Godden of Worthing, 56 top left, 57 top, 61 top left, 63, 64 top right, 69 bottom, 71 top right, 73 top left, 75, 76, 131, 141, 147, 149, 152, 184 top right, 185; G. St. G. M. Gompertz, 36 bottom, 37 bottom; Harrods Ltd, Knightsbridge, London SW1, 219 bottom right; Messrs Heirloom & Howard Armorial Antiques Ltd, London, 62 top, 65 bottom, 70 top, 74 bottom; Nicholas Homoky, Bristol 215 bottom; IGDA, 115, 121 left; The Japanese Foundation, Tokyo, 9, 151; David Hyatt King Collection, London, 52 bottom; Konigliche Sachsische Porzellan Manufaktur, Meissen, 204 bottom, 205 left; Dr. P. K. Kunstkammer, Albertusstrasse 4, 4050 Mönchengladbach, 212; Dr. P. K. Kunstkammer/Jochen Schade, 214 top, 215 bottom; Nicholas Lynn, Hope & Glory, 131a Kensington Church Street, London W8, 222; Luciano Mancilio, 55011 Altopascio, Italy, 226 bottom; Manufacture Nationale de Sèvres, France, 216; Collection F. Marcilhac, Paris, 194 right; Milano Civica Raccotta/Bertarelli, G. Costa, 113 bottom left; Nimtallah/IGDA, 97 top; Porcelaines de Limoges, 224 top; Private Collection, England, 77, 145 bottom, 173 top; Private Collection, Hong Kong, 34, 39 left, 40 top, 40 bottom right, 166; Mary Rogers, 211; Rosenthal China (London) Ltd, 204 top, 217 bottom, 218, 225 top; The Royal Copenhagen Porcelain Manufactory Ltd, Copenhagen, 191, 196 bottom, 209 bottom; Royal Doulton Collectors' Club, London, 172, 221; The Royal Worcester Porcelain Co. Ltd, Worcester, 217 top, 226 top; Sammlung Brohan, Berlin/Nymphenburg Staatliche Porzellan Manufaktur, 203; Seemuller/IGDA, 79, 80 bottom, 110 bottom; Sotheby Parke Bernet & Co., London, 14 bottom, 15 top left and right, 18 top, 22, 26, 27, 28, 29, 30, 31 bottom, 40 bottom left, 58, 64 bottom, 66, 67, 71 bottom, 83 top, 85 bottom right, 118, 130 bottom left, 133 bottom, 134 top and bottom right, 136, 140, 143, 150, 156 bottom, 158, 161 top, 163, 165, 167, 171, 173 bottom, 175, 177, 179, 180, 181, 182, 186, 220 top; University City Public Library, University City, 200; Villeroy & Boch, Mettlach, 227; Pat Walker, 'Antiquarius', Kings Road, London SW3, 178; Winkworth & Co., London, 31 top.

Finally, we would like to thank these photographers for their help and cooperation:
David Cripps, Title Page, 210; Mark Fiennes, 62, 65, 70, 74; Courtney Frisse © 1979, 199 right; Michael Holford, 93, 156 top; Don Honeyman, 206; Angelo Hornak, 52 bottom, 102 top, 106 top, 178, 189, 222; Norman Jones, 155; Peter Kinnear, 208 bottom; Masahiro Mori/Zoom, 9, 151; L. Sully Saulmes, 194 left; Bill Thomas, 212 bottom; Gabriel Urbanek, 202.

Index